THE CRAFTER'S DEVO-TIONAL

Q U A R R Y B O O K S

365 Days
of Tips, Tricks, and Techniques for Unlocking Your Creative Spirit

BARBARA R. CALL

First published in the United States of America by
Quarry Books, a member of
Quayside Publishing Group
100 Cummings Center
Suite 406-L
Beverly, Massachusetts 01915-6101
Telephone: (978) 282-9590
Fax: (978) 283-2742
www.quarrybooks.com

Library of Congress Cataloging-in-Publication Data
Call, Barbara R.
The crafter's devotional : 365 days of tips, tricks, and
techniques for unlocking your creative spirit / Barbara R. Call.
 p. cm.
Includes index.
ISBN-13: 978-1-59253-531-6
ISBN-10: 1-59253-531-3
1. Handicraft. 2. Scrapbook journaling. I. Title.
TT149.C33 2009
745.593--dc22

 2008052263
 CIP

ISBN-13: 978-1-59253-648-1
ISBN-10: 1-59253-648-4

10 9 8 7 6 5 4 3 2

Design: everlution design
Lovebirds cover pattern: Lara Cameron
Illustrations by Judy Love
Photo, page 99, courtesy of Glidden, an ICI Paint Company/www.glidden.com

Printed in China

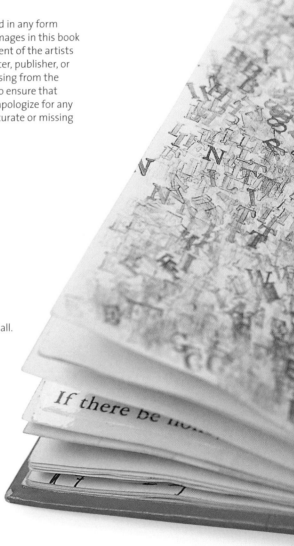

"There is a vitality, a life-force, an energy, a quickening that is translated through you into action and because there is only one of you in all of time, this expression is unique. And if you block it, it will never exist through any other medium and be lost."

—MARTHA GRAHAM,
twentieth-century choreographer and pioneer of modern dance

THE ARTIST HAS BUT ONE IDEA HE IS BORN WITH IT AND SPENDS A LIFETIME DEVELOPING IT AND MAKING IT BREATHE

HENRI MATISSE

ARTIST / Maura Cluthe

Artist Paula Grasdal found inspiration in the courtyard gardens of Persian miniatures for this paper collage. The piece represents her vision of an idyllic sanctuary.

contents

Introduction:
Breaking Crafter's Block

Whether you're a beginning crafter, just trying your hand at knitting, paper crafts, or mixed-media collage, or a seasoned craftsperson who has been creating pieces and artwork for years, finding—and harnessing—inspiration is a constant need. Though there are as many sources of inspiration as there are means of expression, we all hit dry spells. Creative block can take the form of a blank canvas, idle knitting needles, or an untouched stack of paper—waiting, hoping for that spark to reignite the flames of creativity and allow the process to flow, unencumbered, from your brain to your chosen tool and beyond.

When you hit that dry patch—and it will come, however brief—reach for this book, open to any page that resonates with you, and allow the creative fire to reignite. The lessons, writings, quotes, meditations, rituals, and techniques here can be used as is, as a jumping-off point, or as fodder for your own creative process.

This book is not strictly about following set directions, examining step-by-step illustrations, or adhering to strict guidelines—it's eclectic, organic, and occasionally random, all in the name of inspiration.

We devised a set of organizing principles based on the days of the week, the major sources of inspiration, and the time you have for working to give this book a framework. It may feel like a calendar in some ways, a book of days in others, but this book is not meant to represent any particular season, location, or time. Instead, our intent is to give you a year's worth of day-by-day lessons that invigorate your creative flow, allow the creative juices to continue flowing, or even restart a process that may have stagnated, drifted off course, or just stalled.

Some words of caution are necessary, however. This isn't a book of feel-good quotations, or a compilation of uplifting scripture, though you will find many positive affirmations and spiritual mediations in these pages. Instead, it's more a book about life, and the wide, almost endless sources of creative inspiration, from sadness and grief to joy, ecstasy, and beyond. If you're looking for pithiness, you may want to look elsewhere. If you need a well of inspiration to revisit every day, a week from now, or even a few years from now, you've arrived at the right place.

Enjoy, create, and ride the wave of inspiration—it will set you free in innumerable ways.

—BARBARA R. CALL

How to Use This Book

THERE ARE 365 DAYS IN A YEAR, but this book does not contain 365 individual entries. Fifty-two weeks' worth of inspiration lies within the book's covers. Each week features six entries: one for each weekday and one entry for the weekend (Saturday and Sunday). The weekend entries are designed to accommodate exploration that takes more time, such as collaborating with another person, taking a class to learn new technique, or visiting and exploring nature. Throughout the book, each day will be centered on the following categories:

 MONDAY / **JOURNALING**

 TUESDAY / **RECYCLE, REUSE, OR REVIVE**

 WEDNESDAY / **COLLECTION, STASH, AND MATERIALS**

 THURSDAY / **PERSONAL HISTORY**

 FRIDAY / **NONCRAFT INSPIRATION**

 SATURDAY + SUNDAY / **COLLABORATE, GATHER, AND EXPERIMENT**

Each weekend of the month explores one of the following categories:
- · Collaborating
- · Exploring nature
- · Shopping, hunting, and gathering
- · Researching, learning, and/or trying new techniques

There are hundreds of craft categories, and thousands of crafters who call those crafts their passion. In this book we opted for the larger islands of activity, to connect with more of you and possibly to inspire crossover techniques. That said, this book includes paper crafts, textiles (fabric), fiber (knitting, yarn, embroidery), mixed media, and beading. We have not included fine art, and we have steered clear of commercial art such as graphic design, but should those artists find us, we welcome you, too.

Throughout the book you'll also find miscellaneous bits, including quotes, how-to tips or techniques, stories, exercises, brainstorming prompts, visuals, and more. We've also included a few examples of creative or artistic rituals that may provide inspiration or encourage you to seek out (or create) your own customs surrounding your work.

Why Journal?

A BETTER QUESTION MIGHT BE, why *not* journal? Writing, sketching, or even just taking notes in a day book lets you capture your hopes, dreams, wishes, fears, aspirations, or creative ideas. A journal can also serve as a special, private place to record your grief, sadness, or random thoughts, using just two very basic tools: a writing instrument and something (usually paper) to write on.

Journaling is one of the first tools used to teach aspiring writers how to tap into the creative flow, but you needn't be a writer to harness the power behind capturing your thoughts, visions, or favorite quotes, and that's just for starters.

A basic definition of a journal involves a pen and paper, but the possibilities for journaling are virtually endless, from paper and fabric to wood and more. Journals, books, or collections of pages themselves can even become works of art.

Journaling needn't be expensive—peruse your local office supply shop, drugstore, warehouse, or stationery store for a notebook that can serve as your first journal. Choose the book that you're drawn to instinctively, whether it's a miniature notepad or a leather-bound book.

...

JUST WRITE. Don't judge your output or even reread your writing at first. The goal is to let yourself go and get comfortable with recording whatever it is that you want to keep track of, from happy moments to sad ones, and everything in between.

"How truly does this journal contain my real and undisguised thoughts—I always write it according to the humor I am in, and if a stranger was to think it worth reading, how capricious—insolent and whimsical I must appear!—one moment flighty and half mad,—the next sad and melancholy. No matter! Its truth and simplicity are its sole recommendations."

—FRANCES BURNEY (1752–1840),
British author

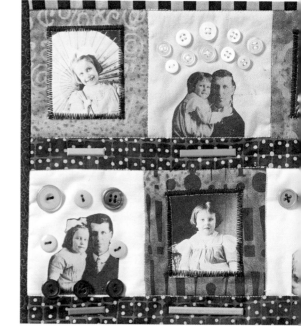

Reusing Old Photos

HOME SCANNERS CAN CREATE electronic versions of childhood, vintage, or print photos you've taken (but lost the negatives), or photos sent to you by friends, colleagues, or other family members.

If you don't have a scanner, the photos can be scanned at a copy shop or office supply store. These digital versions can be printed on demand, and the files can be manipulated, tweaked, stretched, cropped, tinted, and toyed with in a photo-manipulation program.

Even black-and-white copies can be made for pennies apiece (color copies are more expensive). Playing with the size, shade, or angle of the original photos during the copying process often creates unexpected, fun results.

All these techniques allow you to reuse a photo in your creative work without ruining the original. This is especially important with vintage photos, as there may be no way to ever re-create the original. Scanning older photos also gives you a more permanent means of storing them (electronically, such as on a CD or hard drive) or sharing them with other people (via email or other online connections.)

OLD PHOTOS CAN INSPIRE many creative endeavors—use them as you would any random image, but remember (and be respectful of) the potential power of any emotions attached to those photos (in yourself or in others).

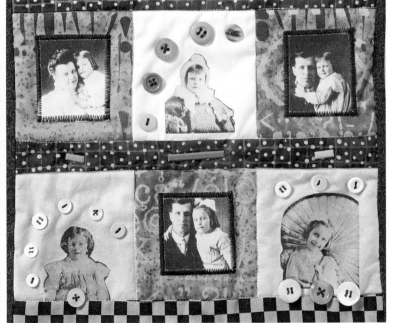

To make the base for this art quilt, the artist used a combination of photo fabric and iron-on transfer sheets; and embellishments include buttons and decorative stitching.

ARTIST / Pam Sussman

For instructions on how to use photo fabric and/ or iron-on transfer sheets, see page 230–231.

Crayon Therapy

TODAY'S EXERCISE IS SIMPLE—pull out (or better yet, buy a new box!) of crayons and color to your heart's content. Color in a coloring book, or just color on plain white paper. Don't judge, don't hold back, and just have fun.

SOMETIMES, the simple task of returning to the activities of our childhood can serve as inspiration.

THURSDAY day 4

Your Creative DNA

EACH OF US HAS A UNIQUE SET of DNA in our genes that determines, among other things, our body shape, our hair color, and the size of our feet. Consider this concept, borrowed from Twyla Tharp, one of America's greatest choreographers: Each of us also has a unique creative DNA. Writes Tharp:

"I believe that we all have strands of creative code hardwired into our imaginations . . . these strands are as solidly imprinted in us as the genetic code that determines our height and eye color, except that they govern our creative impulses. They determine the forms we work in, the stories we tell, and how we tell them. I'm not Watson and Crick; I can't prove this. But perhaps you also suspect it when you try to understand why you're a photographer, not a writer . . . or why your canvases gather the most interesting material at the edges, not the center.

In many ways, that's why art historians and literature professors and critics of all kinds have jobs: to pinpoint the artist's DNA and explain to the rest of us whether the artist is being true to it in his or her work."

(From The Creative Habit: Learn It and Use It for Life *[Simon & Schuster, 2003])*

Tharp illustrates this theory by pointing to Ansel Adams, best known for his expansive black-and-white landscape photographs. Adams's creative DNA compelled him to carry his camera high atop mountains to capture the widest view of nature, and this view of the world became his signature, she explains.

..

TAKE TIME TO REFLECT on your own artistic DNA, perhaps using these questions as a starting point. If you were born to produce just one type of work, what would it be? What is your unique view of the world, and how does it manifest in your artwork? What medium lets you best express your creativity?

The Power of Sacred Places

HAVE YOU EVER BEEN INSPIRED while in a house of worship? Sometimes the music moves you, other times it may be the sermon, prayers, or meditation, and other days just the edifice itself—stained glass, the soaring ceilings, austere décor, or familiar icons.

For those who attend church, temple, or other houses of worship and prayer on a regular basis, here are some ways to tap your experience for later use:

- Pretend you are visiting your place of worship for the first time: Look upward at the edifice itself, noting the building materials, or stop and read the historical plaque on the outside.

- Explore the focal point of your place of worship—the altar, bimah, or the like—and beyond. How is it decorated, and why? What do you like about it? What would you change if you were in charge?

- As you worship, sing, or reflect, be aware of (and note) any feelings or words that resonate. Jot down any associations you make after hearing a certain hymn or realizations you have after the sermon.

...

SACRED PLACES, such as temples, churches, and even outdoor amphitheaters, can serve two purposes—as a place to worship and reflect, but also as a potential source of inspiration for art, projects, or other creative output.

13

ARTIST / Jennifer Hardy Williams

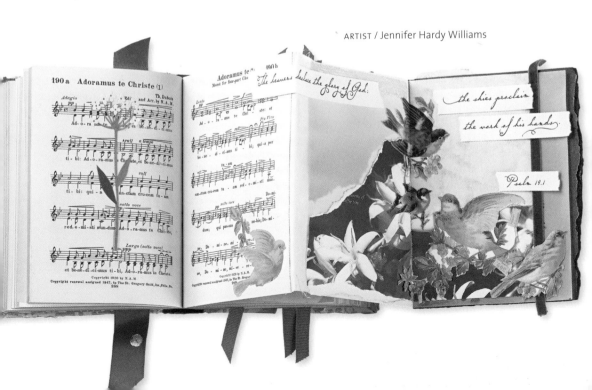

What Is Folk Art?

WHAT IS FOLK ART, and what could it mean for you? According to the International Museum of Folk Art in Santa Fe, New Mexico, folk art can be defined as follows:

- Folk art is the art of the everyday.

- Folk art is rooted in traditions that come from community and culture.

- Folk art expresses cultural identity by conveying shared community values and aesthetics.

- Folk art encompasses many mediums, including cloth, wood, paper, clay, metal, and more. If traditional materials are inaccessible, new materials are often substituted, resulting in contemporary expressions of traditional folk art forms.

- Folk art reflects traditional art forms of diverse community groups—ethnic, tribal, religious, occupational, geographical, age- or gender-based—who identify with one another and society at large.

- Folk art is made by individuals whose creative skills convey their community's authentic cultural identity, rather than an individual or idiosyncratic artistic identity.

- Folk artists traditionally learn skills and techniques through apprenticeships in informal community settings, although they may also be formally educated.

- Master folk artists demonstrate superior levels of craftsmanship and creativity, often introducing new materials and innovations that express both traditional and contemporary imagery and values. In this way, traditional folk art forms evolve as dynamic living traditions.

- Folk art fosters connections between art and people with a creative spirit that unites all the cultures of the world.

...

STUDYING OTHER forms of art is a classic way to inspire your own creativity. If folk art or its style doesn't resonate with you right away, give it time—assimilation of a new art may come gradually.

Make Your Own Folk Art

Try applying one of the above definitions to your own folk art. This could mean remaking a project in another style or designing a new piece entirely. Folk art as the art of the everyday could translate to a beaded pillow, a decoupaged vase, a decorative lampshade, or the stamped folk art–style boxes shown at right. (Look online for local folk art museums, galleries, or exhibitions.)

Rubber-Stamping Air-Dry Clay

This technique creates the effect of hand-carved clay but it's as simple as rubber stamping.

SUPPLIES

AIR-DRY CLAY, ROLLER, ART STAMP AND INK, ACRYLIC PAINT, SPONGE, VARNISH BRUSH, WATER-BASED VARNISH

Start with a clean, flat surface. Pinch off a chunk of air-dry clay, and use a roller to flatten it to a shape about ¼ inch (6 mm) thick. Stamp the piece with the rubber stamp, then let the ink dry completely. To decorate the stamped image, rub acrylic paint on the surface, into crevices, or around the stamped object.

Remove paint from any indented areas with a damp sponge. Repeat the process with other colors or gold-toned paint. Let the paints dry completely, then coat with water-based varnish to finish.

The rubber-stamping technique used to make these folk art–style stamped boxes can be applied to just about anything, from picture frames or flowerpots to the lid of a wooden box or the outside of a jewelry box.

ARTIST / Kathy Cano-Murillo

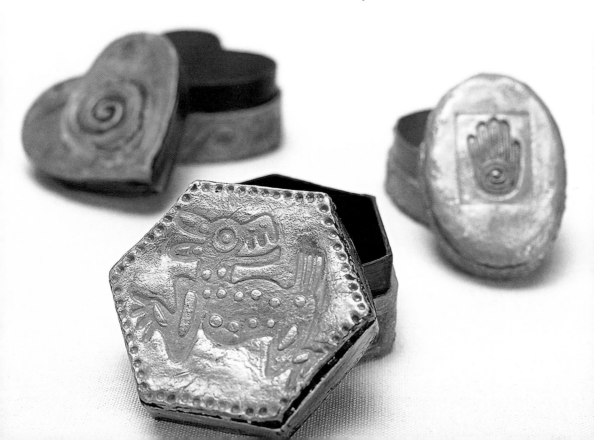

Personalizing a Journal

IF YOU'VE ALWAYS BEEN a crafty type, you've probably been inspired to personalize a store-bought journal or spiral-bound notebook. It can be as simple as adding a monogram, bumper stickers, or doodling to your heart's content. The blank journal cover is a blank slate, so to speak, for original artwork. (Advanced crafters can create a bound book or journal from the ground up, from handmade paper to hand-stitched binding, complete with a cover, spine, and dedication.)

A journal can be embellished in thousands of different ways; create a diary for a young girl using a horse, princess, or fairy theme, or just make a one-of-a-kind bookplate to identify the owner of a leather-bound sketchbook.

16

A CUSTOM JOURNAL is a lovely gift, but don't forget to create art for yourself sometimes. Surrounding yourself with your own creations (rather than giving them away) can inspire new ideas, and remind you how creative you really are.

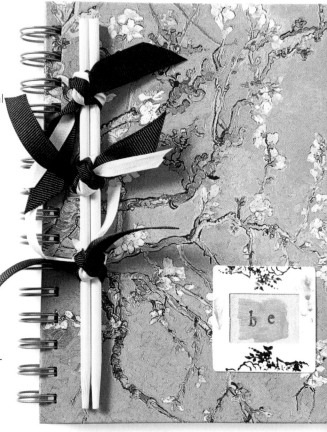

This piece began as a simple spiral-bound notebook. Deborah played up the journal's Asian look and feel by adding key decorative elements: chopsticks wrapped with black and beige ribbons. The white-painted slide mount was stamped with black ink and accents of gold. The word "be" was stamped, and a thin layer of pearl turquoise paint softened the look.

ARTIST / Deborah Fay D'Onofrio

When affixing items to a journal, be sure to use an adhesive suitable for the materials being used. Using hot glue on a pair of chopsticks, for example, might not be strong enough for a journal that is handled frequently. A stronger adhesive, such as epoxy, is critical.

Theme and Scheme

FOR SOME ARTISTS, the creative process is *itself* inspiring.

Consider the words of Olivia Thomas, a collage artist: "The best thing that works for me is that the more I create, the more I create. Making and creating things generates endless ideas for me to try." Thomas keeps notebooks of ideas and then refers back to them if she needs a jump start.

Another tried and true technique for Thomas is something she calls "Theme and Scheme." She chooses a theme, such as love, angst, or chaos, then selects a color scheme (anywhere from three to five colors) to match the theme.

She gathers images from magazines, roots through her stash, or even visualizes a finished piece that integrates the theme and scheme. She advises, "Let a piece mutate often, changing as it goes, until it has a life of its own."

..

"THEME AND SCHEME" is a simple tool for starting a new project: Pick a theme, pick a color scheme that reflects that theme, and begin creating.

Sample Color Schemes

VINTAGE

This trio, which combines "Big Apple" printed vinyl fabric by Oilcloth International with red and blue paint, could evoke a cheerful, upbeat feeling or work with a nostalgic or "days gone by" theme.

MODERN

This trio combines Spacer, a blueberry-tinted 100 percent polyester fabric from Jhane Barnes Textiles, with orange and red paint. The resulting combination could be viewed as chaotic, fresh, or highly charged.

NATURAL

The texture of this Paperwork paper bag deisgned by Larsen contrasts with the burgundy and green paint tints. The theme could be cool and detached, open and receptive, or nature inspired.

ROMANTIC

This silk fabric by Scalamandré, called Jour de Juin, works beautifully with the red and periwinkle paint tones. This combination evokes joyful and carefree feelings.

Your Unique Living Space

CONSIDER YOUR REFRIGERATOR—the enormous, whirring appliance in a corner of your kitchen. It is probably an evolving collage of your daily life for all to see, its surface covered with magnets, artwork, phone numbers, to-do lists, quotations, and photos, and the contents change over time. There's no fixed composition (although some elements stay put), but the pieces morph, change, and move around as your life changes.

What we choose to display in our homes are usually our favorite things, from antique tea cups or botanical photographs. Take a fresh look at your living space and ask yourself these questions:

- What are the items that show up over and over?

- What are the themes that repeat themselves from room to room?

- What are the colors that you use to reflect your personality?

- What does your living space say about you, your life, where you are in your journey, or how you approach the world?

- How can you relate the items you collect in your home to your clothing choices, your friends, or your relationships?

..

JUST AS YOUR CHOICE of clothes, jewelry, or shoes can give a stranger insight into your personality or character, your living space offers deeper reflection about who you are and what you convey to the world.

18

Purse Ephemera

A WOMAN'S CHOICE of handbag may vary by the season, occasion, outfit, or the color of her shoes. Unless you're a complete neat freak, purses become repositories for forgotten receipts, scraps of paper, spare change, and more.

Today's exercise: Empty your unused purses and examine the contents. Use these quotidian castoffs as inspiration for new work, new directions, or simply new materials. Try this exercise with other vessels or places that accumulate ephemera, such as suitcases, backpacks, glove compartments, and junk drawers.

THINK OF THESE COLLECTIONS as forgotten fragments of your life that can be reassembled, reorganized, or reused as art, as inspiration for new projects, or as craft materials. Alternatively, you can simply clean house, throw it all out, and start with a clean slate—a process that can take your creative process in a completely different direction.

Buttonwork, Part I

ONE MAGNIFICENT BUTTON, from a fabric store or flea market, can be the centerpiece of a unique and beautiful project. Buttons can embellish or enhance, or they can play their intended role—as closures.

Start a button collection by gathering the extra button envelopes that come with store-bought clothing. (Use the buttons for one project and reserve their tiny envelopes for another.)

Watch your collection grow: Cut buttons off discarded clothing, buy vintage button collections at flea markets, or scour yard sales for used clothing or sewing supplies. Consider altering their surfaces, attaching them to a piece with unusual materials (such as embroidery thread, fishing line, or wire), or hand-stitching them in place to form a motif.

The buttons on this artist trading card help complete the flower motif.

ARTIST / Lauren Teubner

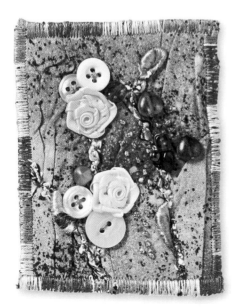

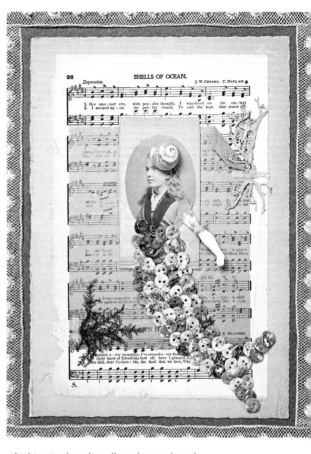

In this mixed-media collage, buttons form the mermaid's tail.

ARTISTS / Maryjo and Sunny Koch

BUTTONS ARE quintessentially versatile: they are a tool (or an analogy) for closure, but can also be used as embellishments for fabric, paper, or even beaded projects.

For more on buttons, see pages 39, 102, 108, and 196.

Ocean Jewels

THE SOFT, MUTED COLORS of seashells can inspire a color scheme in your next project, while the gentle spiral of a conch shell may inspire a painted, embroidered, or beaded form, outline, or pattern.

There are as many different shells as there are beaches on which to find them, and they come in many shapes, sizes, and forms, from miniature shells used as embellishments to fragments used for tiling. You can incorporate shells into your pieces, or construct an entire piece from shells.

You may simply be satisfied to incorporate their textures, shapes, and colors into your work.

..

FRESH OUT OF IDEAS? Consider using seashells (or other sea-buffed natural artifacts) to augment or inspire new elements in your work.

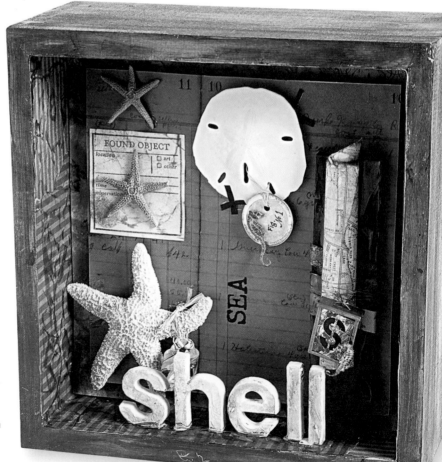

This shadow box collage, titled Shell, includes several starfish and a beautiful sand dollar.

ARTIST / Jenn Mason

Wordless Journaling

NOT EVERY JOURNAL must be filled with writing.

Try this exercise: Make a clipping journal. The form isn't important—a blank journal, a sheaf of folded papers stapled at the edge, a recycled paperback—what's more important is what you fill it with: clippings. These can be:

- Color palettes or color combinations clipped (or color copied) from home decorating books, magazines, and catalogs

- Images, icons, or symbols you want to re-create, feature, mimic, or alter

- Diagrams or line drawings

- Maps, brochures, or other collateral material

- Fabric swatches, fibers, or yarn scraps

- Postcards, photos, or other snapshots

- Artwork, paintings, or images of other artists' works

- Mementos, such as ticket stubs or foreign coins

- Paper scraps, such as post-marked stamps or receipts

- Labels, stickers, or stamps

- Stitching, either done by hand or machine

- Paint swatches, experiments with paint, or brushstrokes

- Cut up and recycled artwork (your own or others)

- Copies of anything, from money to packaging, stuffed animals, or body parts

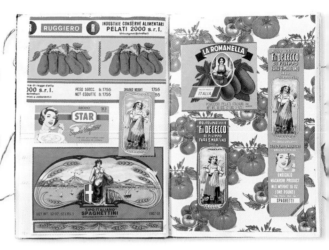

This travel journal of Italy features bold, beautiful food labels.

ARTIST / Jill Littlewood

21

- Stamped, printed, or typeset images, letters, or numbers

- Clip art or other electronic output or printouts

- Buttons, snaps, or other sewing materials

- Dried flowers, leaves, or other natural elements (items that are not flat may require a boxlike field journal; see page 36 for more information)

ALTHOUGH MANY JOURNALS are filled with words, just as many are not. Consider a journal as a collection of items, a place to store whatever it is that awakens your creative instincts.

Move Things Around

"INSPIRATION IS SLIPPERY," says mixed-media artist Shirley Ende-Saxe. However:

> "... When the burning desire to create or express is absent, sitting down with images and moving them around in little groups is enough to help get a grip on what needs to be done. Put one with another, and pretty soon they're asking for another to join them. The images themselves can create the inspiration, but cutting and pushing things together helps, too."

How can you put Ende-Saxe's ideas into action? It can be as simple as assembling a handful of your favorite materials, then playing with them until they start to form a composition. Sometimes, as was the case with *Map of a Minute* at right, the final crowning element comes into your hands later on, after you thought the piece was done.

22

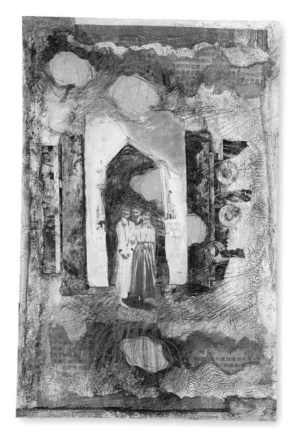

SOMETIMES the elements you collect will fall into place quite naturally, but other times they require a push or two. Keep this in mind, however: if the process feels forced or unfruitful, don't consider it a failure—simply walk away, give it a rest, and try again another time.

To create this collage, Shirley Ende-Saxe layered paper, paint, a brochure, hole reinforcements, and Asian-style papers. There was a large, mysterious negative space in the center but she felt it was complete. Two weeks later, the photograph of friends and cutout house found their way into the clutter on Shirley's table and she added them to the collage. Those two finishing touches reminded her of her trip: two friends in the shelter of a house.

Steered in the Right Direction

ALTHOUGH I'VE MADE lots of paper-based (and mixed-media) collages before, I had a new experience while creating the miniature collage shown here. I started the project by selecting several scrapbook papers I liked, then tore them and layered them on the surface of the box lid. Next I added a quote from Henry David Thoreau in the corner—"Heaven is under our feet as well as over our heads"—and started layering my critters— a hawk and a butterfly in one corner; trees and horse in the middle; and dragonfly, frog, and tiny flowers in the bottom corner. After I was done, I sanded the edges of the lid and sealed the entire collage with acrylic medium.

When I went back to look at the lid the next day, I was slightly startled—although I had not set out with this composition in mind—the papers, elements, and animals had naturally formed into sky, land, and water.

It was as if something or someone—call it creative spirits, if you will—had guided my hands to assemble the items in this way. I felt that I was steered in the right direction to make this piece.

..

SOMETIMES, CREATIVE ENERGY works all by itself. Let your hands lead the process (instead of your brain). You may be surprised by the results.

23

This multilayer collage was created using paper scraps, stamps, and stickers.

ARTIST / Barbara R. Call

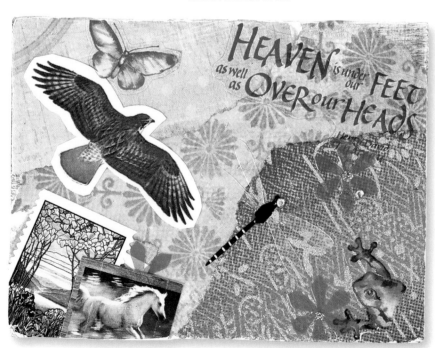

Finding Her Artistic Voice

WHILE COMPLETING HER MASTER'S in art, Corinne D'Onofrio finally and truly connected with the concept of art "as a powerful tool to reveal one's voice." The mixed-media work shown here, titled *Beyond Consumerism*, was inspired by her own personal life (and situation) as well as the work of several Southern artists. In this edited excerpt from her thesis, she tells the story of what inspired this piece, and how it reflects her personal feelings about consumerism.

"My epiphany came when I learned that many of the Southern artists, such as Ruby Williams and Mose Tolliver, have found recognition in the mainstream art world but chose not to be part of it," she writes. "They create art for their own fulfillment and on their own terms. These thoughts are what propelled me to look at myself as an artist and an individual who resides in an upper class community where consumerism and prestige reign. While married I lived in a wealthy community where the value of life was earmarked by the number of possessions one could attain, and those possessions were displayed whenever and wherever possible. After sixteen years of consumption, the marriage and collection of valuables ceased. My artistic response has provided me with a powerful opportunity to voice my exclusion from the wealthy community where I live and reveal it to the public. Revealing this work to colleagues and fellow students truly made this self-imposed exclusion authentic and real, both personally and emotionally."

To create this mixed-media work Corinne sought out materials she already had on hand. "In the spirit and respect of the self-taught artist's recycling method, I deliberately selected wood, canvas, and art materials such as paint, pastels and compound. I used a scavenger's eye around my home to seek out my art resources," she writes.

"The work reveals an enormous contemporary home that swells throughout the canvas and threatens to expand beyond. The color palette for the picture was influenced by the vivid hues used by artists such as Nellie Mae Rowe, Bernice Sims and Ruby Williams. Their use of bright color led me to use the bright blue Tiffany's box as the starting point for my color palette. The home itself was constructed with great detail, precision and consideration by stockpiling various materialistic icons such as Tiffany boxes, BMW and Coach insignias, and $100- and $1,000-dollar bills. The accumulation of these small collage pieces represents the effort, calculation, and energy spent in creating this ostentatious lifestyle.

"To create the lush landscape collage surrounding the home I used a society article from a local newspaper that featured a tasting event for local businesses to advertise their goods. The images and icons reveal the materialistic value in the composition, whereas the newspaper article reveals community events that focus on feeding the middle and upper class while the city adjacent to where I live, with one of the highest poverty levels in the state, has populations surviving on food stamps.

"The fence was incorporated for many reasons. Southern Outsider artist Thornton Dial used fences in his artwork and referred to 'the fences of the United States' as representations of the hardships of being born black into a certain social class in the deep South. In contrast the fence in my artwork surrounds the contemporary home and all its inhabitants in order to reveal the materialistic emotional frenzy that lies within. The materialistic lifestyle is so hunted, persevered, and valued within the fenced area, it is a virtual prison that is hard to see or remove oneself beyond. A place exists here where frenetic emotions and buying are perpetuated in order to keep up with the Joneses.

24

"The fence contains the frenzy in order for it to grow and perpetuate within the property bounds.

"The smallest and most symbolic object is the chair, which offers an authentic place beyond the world of consumerism and Catholicism which is unadorned, simple, welcoming, and sturdy. Here is the place where I reconsider the paths of life. Here is the place where life values such as impartiality, individuality, economy, frugality, authenticity, austerity, and generosity are valued more than elitism, discrimination, materialism, consumerism, and exclusivity. When you live outside the fence, freedom and choices can be made."

CORINNE FOUND that art is a powerful expressive tool for sharing thoughts, emotions, and personal statements about life and the world around us. Try creating a piece of work that expresses your opinion on a situation, your community, or the greater world.

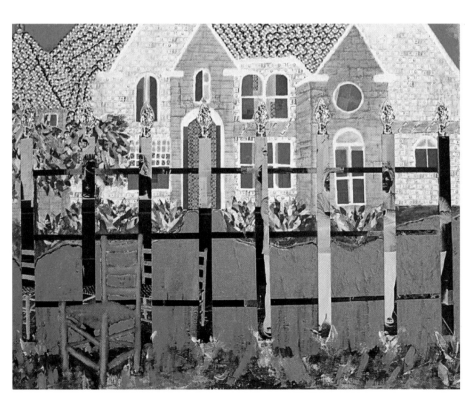

ARTIST / Corinne D'Onofrio

Gravestone Symbolism

GRAVESTONES, LIKE OTHER MARKERS of life's major passages, have a language all their own. These symbols and their meanings, many of them timeless, can be applied to other creative pursuits, used as a source of inspiration, or just admired for their beauty and craft. Here are some commonly accepted meanings associated with gravestone markers:

SYMBOLS REPLACE WORDS with an image or icon that often stands the test of time and sometimes becomes universal. Think about your own work, and consider what symbols, icons, or motifs you're drawn to over and over. What are the possible interpretations for those symbols?

SYMBOL	POSSIBLE MEANING
Hourglass	Inevitable passing of time
Winged hourglass	Time flies, swift passage
Hourglass on its side	Time has stopped
Tree	Life
Broken tree	Life cut short
Sprouting tree	Life everlasting
Willow tree	Life, mourning
Broken flower	Life cut short
Flying angel	Rebirth
Weeping angel	Grief
Bird in flight	Flight of the soul
Gourds or pomegranates	Nourishment of the soul
Candle flame	Life
Fig, pineapple, other fruit	Prosperity, eternal life
Heart	Love, love of God
Rooster	Awakening, resurrection
Shell	Life everlasting, life's pilgrimage
Sun shining or rising	Renewed life
Vine with grapes	The sacraments

Source: The Association for Gravestone Studies (www.gravestonestudies.org) and the American Antiquarian Society (www.americanantiquarian.org)

Sensory Exploration: Vision

NATURE'S PALETTE IS A RICH, constant source of inspiration, and the colors are intuitively sooth-ing. Mother Nature may have intended just that—offering our eyes pleasing combinations of tints, hues, and shades that are unique to our place in the world.

This exercise invites you to capture the colors of the season. Here, we've chosen the vibrant greens, soft browns, and tinges of soft red of spring. Depending on where you are in spring, the colors will differ, but this is incidental. More important is capturing those colors in your mind, your sketchbook, or your journal, or even using a camera.

Many other animals do not see the same colors as humans do. According to information published by the School of Biological Science at the University of Bristol in the United Kingdom, "Colour is not an inherent property of the object; it is a property of the nervous system of the animal perceiving the light." Humans have three-dimensional color vision because we have three main photoreceptors, or cones, which produce the sensation of color: red, green, and blue.

Birds and other animals such as turtles and fish, however, have more complex vision. Birds can see ultraviolet light, meaning they have four-dimensional color vision.

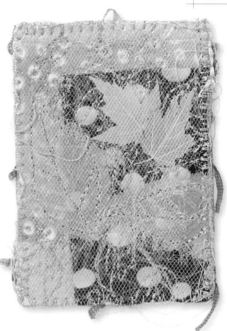

This artist trading card, which includes stitched leaves and maple leaf forms, uses the bright greens and soft browns of a spring palette.

ARTIST / Linda C. Gillespie

The bright, vibrant bird feathers we see may be even more colorful, even psychedelic, to other birds. (This lends new meaning to the phrase "bird's-eye view"!)

TAKE A WALK in your yard, neighborhood, or local park and observe the colors around you. Capture those colors in your journal or sketch-book, using markers or paints, torn images, or even with words. Start a new knitting or sewing project using those palettes as inspiration. However you are inspired, try to re-create those colors in your own work.

27

The Colors of a New Destination

THE NEXT TIME YOU TRAVEL somewhere, whether it's as exotic as Italy or as close as the local nature preserve, try to capture the colors of the region in the pages of your journal.

The artists featured here, Linda Blinn and Jill Littlewood, traveled separately to Italy and captured the colors of the region in their sketch-books or travel journals, each with different techniques.

...

THE COLORS of a region—whether found in the local materials or the items you collect through-out your journey—can be used to capture the feel of a place in ways that words or images alone may not express.

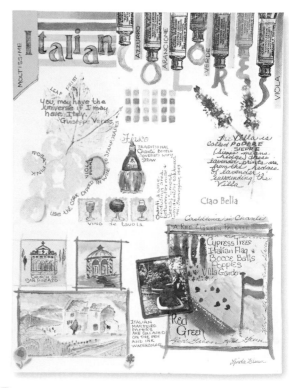

28

Artist Linda Blinn captured the colors of Italy by imprint-ing her pages with objects such as grape vine leaves, plants, wine corks, and cut fruits dipped into paint or ink pads. This variation on the old-fashioned technique of block printing allowed her to capture the true feel of the region: she dipped the cork in wine, then printed circles to create grapes to accompany the leaf print above.

Jill Littlewood captured the colors of Italy by collecting stamps, labels, tickets, and other scraps of paper, then gluing the items directly into the pages of her travel journal.

Sand, Scrape, and Mark Your Photos

YOU'RE LONG ON PHOTOS, but they're not the right images you need for your project. Have no fear—there are several simple ways to alter photos to create an image that looks totally different from the original snapshot.

Dip a photo into a pan of lukewarm water for about 60 seconds. Place the image on a flat surface, and use fine-grit sandpaper or marking tools such as a book-binding awl, sharp needles, or screwdrivers to alter the image.

...

ALTERING PHOTOS is as simple as scratching away the portion of the image that you no longer want or need. Look around your junk drawer, your workshop, or your garage for other marking tools.

> "The goal is not to change your subjects, but for the subject to change the photographer."
>
> —Anonymous

Artist Karen Michel altered this photo was altered with an awl and a sewing needle. Notice how outlining certain areas of the photo accentuates those areas. You can also use the awl to add your own text or phrases.

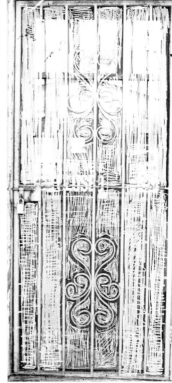

In the picture (above), notice how the area inside the door's filigree is very busy (one might even say distracting). To remove the background, Karen scratched away the background, using the sharp point of a book-binding awl (right).

Raid the Sewing Basket

BUTTONS AREN'T THE ONLY sewing supply that can be used as embellishments: consider this trio of artist trading cards, which uses snaps, hooks, an old zipper pull, and even a scrap of a measuring tape as embellishments.

WHEN MAKING ART, there are no rules: virtually any material can be used to embellish original crafts.

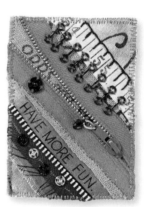

ARTIST / Wendy Richardson

Visual Biography

TODAY'S STARTING POINT: Write your own biography. Don't panic—it doesn't mean write a book! Instead, make a list of all the important milestones, favorite memories, important meetings, defining moments, or colorful experiences that you've ever had. If necessary, ask your parents, siblings, or friends to share their thoughts about each moment.

Arrange them in order, either in a journal or in list form, then try to create a piece of work that reflects each item. At the end of this process you'll have created a visual biography of your life to date. Note: Composing this biography may take more than one day!

MANY WRITERS base their characters on their own personal experience or people they've come into contact with; in the same way, you can create art based on the important moments of your life.

Words and Phrases

EVER NOTICE HOW certain words seem to show up in craft projects, no matter what the medium? Who hasn't seen a work of art, an artist trading card, or a soul collage with the word *dream, believe,* or *love* on it?

Why is it that certain words appear over and over? One theory: Certain words carry more weight than others. The word *dream*, for example, is rich with meaning, in part because it is both a noun and a verb—you can have a dream, or you can dream in color, dream of a different job, or dream the hours away. From the word dream comes many well-known combinations of words, such as *dream team, dream catcher, pipe dream,* or *dream weaver,* plus you can use the word *dream* in any number of languages: Spanish (*sonar*; to dream about), French (*rever*; to dream), or the Chinese character for *dream*.

WORDS CAN INSPIRE your art in many different ways: Start with a single word, and design from there, or design from the ground up, then add the phrase that complements your work.

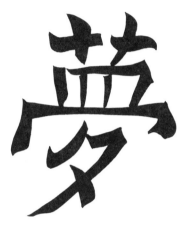

Chinese character for dream

31

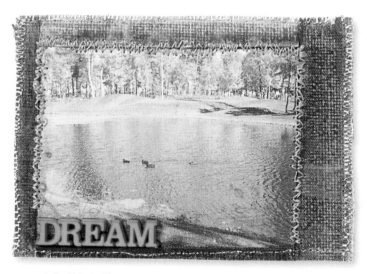

ARTIST / Cynthia A. Oberg

Creating with Other Artist's Materials

SOONER OR LATER, all creative types are asked to create a project for someone else. Sometimes it's a paying job, such as assembling a wedding scrapbook for a married couple, whereas other times, it involves using materials or photos provided by someone else, then interpreting them as you see fit (or to match the other person's vision). Commercial artists, designers, and creative types are more than familiar with this type of work, as it represents the very nature of their business, but for crafters it may be a new experience.

In most cases the more information you have for this type of work, the better. It is worth your while to ask your client or recipient a number of important questions, such as:

- Do you have a vision, sketch, or idea you'd like me to work from?

- Do you have strong preferences in terms of materials, colors, forms, or techniques that you like (or don't like)?

- What is the purpose or goal of this project, where will it end up, and who will see it?

- Can you tell me about the feelings you have surrounding this project, and how you'd like to capture those feelings?

- What is the budget, time frame, and form of delivery? (It's always important to understand the limits of your creative interpretation when working with other people).

- Do you want me to show you sketches, color swatches, or working designs along the way?

COLLABORATION can take many forms, and one of these involves receiving materials or goods with which you will create a project. This type of work may be easier for crafters with more experience, as you will have a richer wellspring of previous work to draw from and more knowledge of techniques or materials to use in your creative process.

> "If I create from the heart, nearly everything works; if from the head, almost nothing."
>
> —MARC CHAGALL (1887–1985),
> *French painter*

32

Story: **Honoring History**

Professional calligrapher Jan Boyd knows first-hand what it's like to create a project for someone else—and to come face to face with sadness as inspiration.

In 2008, Jan was asked by a social worker to help with a project: The Archdiocese of Boston was looking for a way to honor the victims of the clergy abuse scandal. The social worker told Jan there were 1,476 names they wanted represented, but they didn't know how to do it.

"This has never happened to me before," remembers Jan, "but I had a full-blown vision of what I could do. It just sort of came to me, how it could be done, how it could be displayed. So I did a four-page spread of a paste paper book with the names in calligraphy for the social worker, and when she saw it she cried."

What the social worker didn't tell Jan was that the book was eventually going to be presented to the Pope, and become the property of the Vatican.

In retrospect, Jan is glad she didn't know those facts up front. "I'm so glad ... the social worker deliberately did not tell me that. This way, it was totally focused on the victims."

Jan believes that when it comes to inspiration, there are some things that cannot be explained. "At the same time I was working on the book I was doing Kundalini yoga, and I really used those meditations to center myself. I believe things come to you when you need them, and all those things came together for this book."

Jan created the pages of the thirty-page book from paste paper, then added the first names (or initials) of the victims with calligraphy. Of the 1,476 names, 52 had small gold crosses next to them; those represented the victims that had died of drug overdose or suicide.

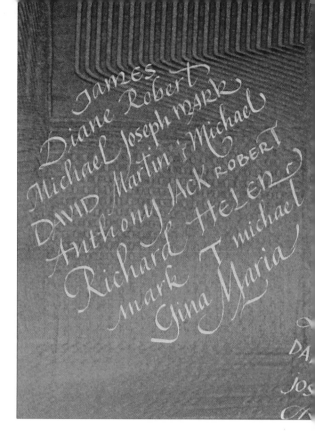

Jan Boyd is more than a professional calligraphy artist—she also creates individually designed books, paper designs (using paste paper, marbleizing, and photo techniques) and assorted bindings.

Creating the book wasn't easy, but Jan liked that about the project. "Do you know the feeling just before you're going to cry? That's what I felt like for an entire month. All of those names, those were real people with real lives and real connections. I felt like I knew them."

For more information about Jan, visit www.janboyd.com.

For instructions on how to make paste paper pages, see page 129.

House Journals

THERE'S NO REASON a journal must be in book form. This artist has moved off the written page and taken her journals to a three-dimensional form—the house.

Artist Terry Garrett offers these additional tips for getting started:

- Choose a theme for your house journal, such as creativity or adventure.

- Paint your journal house to match your real home.

- Make a travel journal—the box will protect your journal while you're traveling and keep thoughts of home in mind at the same time.

- Make a house journal as a housewarming gift for someone who's just bought a home.

- Drill holes in the edges of the roof for hanging beads or charms.

- Look for home-oriented items for collaging the outside.

Imagine a whole collection of house journals, much like the village scenes displayed around the holidays; you could create a series of houses, each marking particular milestones or events, or just create one house journal for each year of your life.

...

A BOOK is not the only form for a journal. **Imagine the possibilities for converting two dimensions into three dimensions.**

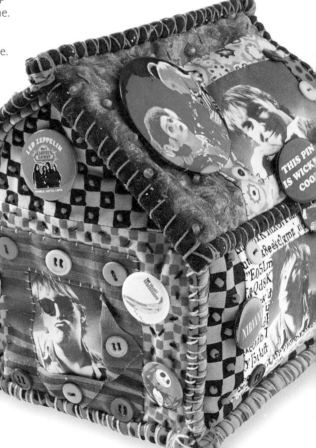

What if all the pages of a journal were displayed on the outside, rather than the inside? Behold the house art journal, a fabric box structure with an interior compartment, and six exterior "pages" bound together with hand stitching.

ARTIST / Pam Sussman

34

Tilework

THE NEXT TIME YOU VISIT the home improvement store, be on the lookout for Formica or faux wood samples—they're the perfect size for recycling into craft projects such as the beautiful key chains by Anne Sagor shown here.

Alternatively, turn them into miniature collages or jewelry, or decorate them and glue them together to miniature houses.

Formica Tile Key Chain

SUPPLIES

FORMICA SAMPLES, DECORATIVE PAPER AND EPHEMERA, ACRYLIC MATTE MEDIUM, GOLD AND SILVER WASHERS OR COINS WITH CENTER HOLE, CHARMS, BEADS, OR THREE-DIMENSIONAL EMBELLISHMENTS AS DESIRED, KEY CHAIN, LARGE JUMP RING, SANDPAPER, ART STAMPS, INK, SCISSORS, GOLD-LEAFING PEN.

1. Remove the label from the back of the Formica tile, and sand to remove any residue. Sand front and sides as needed.

2. Stamp images directly onto both sides of the tile, or stamp onto decorative paper, then adhere the paper to both sides of the tile with acrylic medium. Let dry.

3. Trim the edges of the paper as needed, and check to make sure all edges and corners are secure. Trim the paper covering the hole in the tile. If necessary, add more acrylic medium to the edges to seal. Let dry.

4. Decorate the edges of the tile using the gold-leafing pen. Coat with a thin layer of acrylic matte medium, let dry, then coat the entire piece two times to seal.

5. Glue a washer or coin to each side of the tile, centering over the hole. Let dry. Attach embellishments as desired.

6. Finish by attaching the key chain to the tile using the large jump ring.

..

FORMICA TILE SAMPLES, like their fabric artist trading card counterparts, are the perfect size for experimenting in a small format.

35

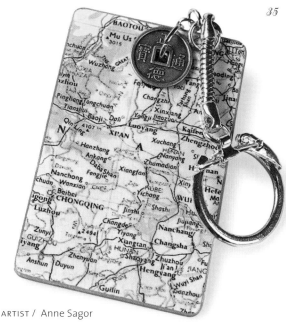

ARTIST / Anne Sagor

Shadow Boxes, Laid Flat

IN THEIR SIMPLEST FORM, boxes are shipping containers, gift enclosures, or protective shields.

On a different level, they can serve as the foundation for a project, be it transforming a cigar box into a book or purse, decorating a mint tin to serve as a tiny treasure box, or working with a shadow box.

For the project featured here, the artist started with an unfinished shadow box, but laid it flat and filled it with an assortment of simple but beautiful items. The result—a quiet, reflective centerpiece that is both visually interesting and soothing at the same time.

..

TODAY'S ADAGE: Sometimes turning a material upside down or laying it flat versus hanging it can take you in a creative direction.

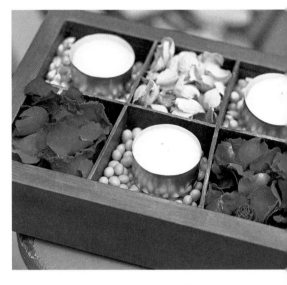

To create this petal potpourri tea-light holder, the artist started with an unfinished shadow box, then added balsa wood dividers. The open sections are filled with dried petals and grains.

ARTIST / Sandra Salamony

Reread a Childhood Favorite

ONE OF MY FAVORITE childhood books is *Season of Ponies,* by Zilpha Keatley Snyder. It's a quick read—only about 130 pages—but the book is filled with a magical world of mist, ponies, and nighttime adventure. It reads like a dream; the imaginary world the main character Pamela creates helps her cope with a summer spent trapped in the home of two old spinster aunts. The names of the ponies Pamela meets on her adventures— Cirro, Aurora, and Nimbus—make me nostalgic. As a child, I named many of my own model horses after those in the book.

Today's task: Reread one of your favorite books from your childhood. Take notes, draw sketches, or just journal as you read; your intent is not just to re-experience the words but also to capture the feelings of nostalgia that may arise. Listen to the memories and enjoy a fresh perspective on what makes the story so wonderful.

..

JUST AS OLD PHOTOGRAPHS can evoke nostalgia, so can rereading our favorite childhood books. Tap these feelings for new directions, colors, or even forms for your creative endeavors.

Tap into Your Endorphins

THIS WON'T COME as a surprise to some people—exercise is good for your brain. Along with eating healthfully, eliminating (or reducing) stress, and engaging in mental exercises, physical activity is considered one of the four pillars of good brain health, and a healthy brain is a creative brain.

Exercise reduces stress hormones such as cortisol and increases feel-good hormones such as endorphins. And anything that makes you feel good can inspire creativity!

So if you've been stuck in rut, regaining that fresh outlook may be as simple as taking a brisk walk around the block, going for a quick run, biking to the grocery store, or visiting your local fitness center for a yoga, Pilates, or weight-training class.

..

CHANCES ARE, once your body is moving and you've got fresh oxygen circulating through your blood, so will your new ideas!

Your BFF's Stash

YOU KNOW YOUR Best Friend Forever (BFF), the one that's totally into mixed media while you're into jewelry? Or maybe she's into fabric and you're into knitting; no matter what the two of you share (or don't share) in terms of your love of crafting, it's time to mix things up (with her permission, of course).

Beg, borrow, or steal (not really!) assorted materials or tools from your BFF's stash or learn techniques from your BFF's arsenal.

The key to success is to get organized ahead of time: Sort through your stash first, setting aside items that you wouldn't mind parting with. Ask your friend to do the same, then swap.

The result: a slew of new materials at no cost, and the new inspiration that comes with using different materials. Consider making the swap process a recurring event or create a swap circle with other crafty friends!

..

NEW INSPIRATION might be as close as your best friend's house—or her stash.

"Your friends will know you better in the first minute you meet than your acquaintances will know you in a thousand years."

—RICHARD BACH,
American writer

Field Journals

A FIELD JOURNAL is a three-dimensional collection of items, rather than two-dimensional writing. Collecting 3-D objects for your journal means finding some kind of container for holding those items. Imagine an old type tray, laid flat and filled with specimens from the field, whether you've collected stones, feathers, shells, or nuts.

The beauty of a boxlike field journal is threefold: it serves as a container for your collection, it can be used to display a large number of individual items, and it's an easy way to organize your materials for quick selection.

If you can visualize colonial explorers' collecting samples of novel flora, tiny fauna, or interesting shells or stones, and you can imagine old-fashioned wooden boxes, separated into small, individual compartments filled with found objects. Your field journal needn't be complicated, however: a discarded cigar box, a broken dresser drawer, even a shadow box laid on its side can all contain your finds.

...

THINK OUTSIDE the box—or, in this case, inside the box instead of inside a bound book. Field journals are a wonderful place to assemble three-dimensional objects, whether you collect beads, old jewelry, stones, samples of bark, or bottle caps.

Retracing Your Steps

THE DESIRE TO REVISIT particular images, marks, or subject matter is common among many artists; think of Monet's lily pads and haystacks, which he painted many, many times. Traveling the same ground over and over again can yield intimate, expert knowledge of that path, a map by which one can reach new territory just by the act of reconsidering materials and ideas.

Today's exercise is simple, but it will need repetition: Choose an icon, an image, or a subject matter that you can revisit ten to twelve times in the coming months. The subjects of love, sorrow, or friendship, for example, are rich wells for mining; similarly, a personal symbol, such as a horse, a dancing woman, or an egg cracking open may hold the key for your repetitive work.

The point here is to capture that icon, image, or subject matter just as Monet captured his famous lily pads or haystacks: in different light, at different times of day, at various points in his life. In many of Monet's paintings, the subject matter (and even composition) remains the same, but the colors would change, depending on such things as the weather, the time of day, or the season. Consider that your particular icon or subject may be something you approach once a year or once a week; try touching on the same subject every day for a week, or once a month for five years. The choice is up to you.

...

THE GOAL, over time, is to explore the inner workings of both your image and your creative output; The result may be an entire body of work or a study in light and shadow.

Buttonwork, Part II

BUTTONS ARE EMINENTLY VERSATILE in their application, but also in their design. Just looking at the assortment of ready-made buttons shown here can inspire many a project.

Keep these tips in mind for using ready-made buttons in new and creative ways:

- One great button: This fabulous button is so compelling, and so perfect, that it's the only button needed on the page, the project, or the piece at hand. You'll know it right away when you find it.

- Repeat pattern buttons: Many buttons of the same size, shape, or color can fill an area quickly with pattern, texture, and color.

- Buttons as body parts: Buttons make great body parts, from fingernails and rings on large hands to heads on dolls, eyes on animals, or scales on fish.

- Buttons as frames: Surround an image with a button border.

READY-MADE BUTTONS may be all you need to kick-start your creativity—so always be on the lookout for interesting closures, charms, and findings.

Tips for Attaching Buttons

- Sew on buttons with strong craft and button thread, going through the holes at least five or six times. Buttons receive a lot of handling, so attach them firmly.

- Never sew a button to a single layer of fabric. Add additional reinforcement such as batting or interfacing behind the decorative fabric layer to support the button.

- If the button will be used functionally, as in a buttonhole or other closure, add a thread shank or small additional button spacer between the button and the background fabric.

- Try variety in attaching your buttons. Just because there are holes in the center of the button doesn't mean the thread must be sewn between the holes—try looping the thread around the outside edges for a different look.

- Never iron buttons. They can melt, crack, or discolor from the heat, steam, or weight of the iron. Just ask anyone who's had his or her suit buttons ruined at the dry cleaners!

For more on buttonwork, see pages 19, 102, 108 and 196.

Catalog Clippings

MAIL-ORDER CATALOGS are ever-replenishing visual resources, not just junk mail! They reflect the latest trends, colors, or technology; they also invite you into the lives and lifestyles of others, especially if you borrow catalogs from people who are older or younger than you, or who pursue novel hobbies.

Try this: Instead of flagging items to buy, try clipping items you like, items that trigger memories, or colors, designs and even textures and patterns that resonate with you. Use scissors for a clean edge, or tear them out freehand. Store them in a box of clippings, display them on your fridge with magnets, or tape them into a journal. Incorporate them into your everyday paper art, or allow them to guide you to other modes of expression.

THINK OF A mail-order catalog as a trigger— a thing, place, person, event, or item that elicits certain emotions, actions, or behavior, in the same way the smell of chocolate can trigger feelings of hunger.

For paper-based collage, acrylic medium can serve as both an adhesive and a finishing coat. Between coats, cover your collage with a sheet of waxed paper and let it dry under a pile of heavy books.

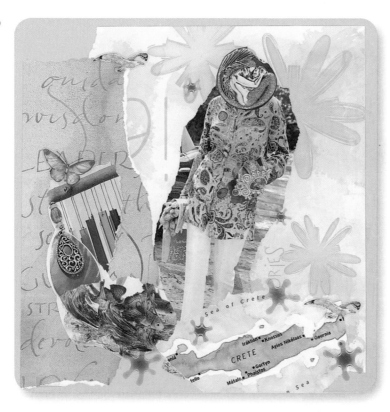

This mixed-media collage, called Greek Princess, uses clothing and images torn from catalogs and magazines.

This collage is one of a series of 8-inch (20 cm) square mixed-media pieces titled The Many Facets of Barb. In one I am a gypsy, in another a Celtic goddess, and in a third a Greek princess. Some of the collages came together quickly, like dressing a paper doll, while others took more work (and more searching) to assemble the right mix. These cards leave me feeling empowered by my multifaceted personality.

ARTIST / Barbara R. Call

The Sound of Horse's Hooves

THE HORSE SYMBOLIZES FREEDOM and the power that comes with being free. Like many other symbols, it can be a powerful source of inspiration.

If you have horses in your life, consider these words of wisdom concerning the horse totem. People who love horses can be fiercely independent—they want to run free (literally) and have little tolerance for anyone who holds them back. If a horse has come into (or keeps reappearing in) your life, ask yourself: Are there challenges in front of you that you don't want to deal with? If the answer is yes, the horse asks you to awaken your inner strength, move forward with courage, and breath in the smell of freedom.

HORSES REPRESENT FREEDOM, strength, movement, courage, and wildness. Consider watching a herd of horses gallop across a field, the smooth feel of a horse's muzzle, or riding a horse bareback, for new inspiration.

"A thousand horse and none to ride!—
With flowing tail, and flying mane,
Wide nostrils never stretched by pain,
Mouths bloodless to the bit or rein,
And feet that iron never shod,
And flanks unscarred by spur or rod,
A thousand horse, the wild, the free,
Like waves that follow o'er the sea,
Came thickly thundering on . . ."

—LORD BYRON, "MAZEPPA," XVII, 1818

41

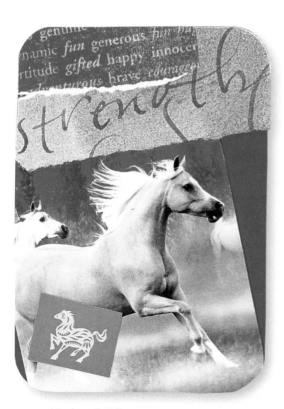

ARTIST / Barbara R. Call

Playing Hooky: Crafty Field Trip

WHEN WAS THE LAST TIME you stashed your kids (or called in sick for a mental health day) and headed out to explore a place, a town, or a location you've never been? This is a treat many artistic types engage in on a regular basis, not only for the wealth of new ideas it can inspire but also to give themselves a break from the studio, the office, or the confines of wherever they spend their days.

- Not sure where to go? Ask your friends, neighbors, or creative types in your community where they shop, hunt, or gather materials. You're sure to gather more than one response along these lines: "You've never been to XXX? You've got to go!"

- Pick at least one destination in the town or location to make sure the trip is worth your time (and gas money).

- Once you've arrived, ask the locals about other places you shouldn't miss. Many times the best finds are located off the beaten track, perhaps down an alley or just off the main drag.

- If money is tight, set a budget, and don't spend it all in the first shop you visit! If you're drawn to multiple items but only have the money for purchasing one of them, ask the salesperson if he or she can hold each item for you (just for a few hours). That way if you tour the entire location and find nothing else more fabulous, you know your special item is waiting for you.

- Don't be afraid to bargain, especially in shops with used or gently worn items. You never know how long something has been sitting out, and the shop owner may be willing to take a lower price to move the item along. Always be polite, and if they say no, be gracious.

- Have fun, take notes, and don't forget to treat yourself to a fabulous meal, a special cup of coffee, or a taste of something sweet from the local chocolatier.

..

MAKE THESE excursions a regular part of your creative life and you're certain to have a rich and complex source of inspiration on many levels. They don't have to be complicated or expensive, either—sometimes a visit to the town next door or a spot you've driven by a hundred times is all it takes.

A Magical Bead Shop

It helped that I'd been to Amesbury, Massachusetts, an up-and-coming creative town with a rich mill history, briefly before for another reason, so I knew the area was burgeoning with creative potential. It also helped that we could park behind a large and beautiful bead shop (the Riverwalk Bead Shop and Gallery) that I'd flagged on my previous trip, so this trip had at least one focal point.

The bead shop was so magnificent that it made the drive from my home worthwhile. The assortment of beads, trinkets, and findings was unique and beautiful; it was difficult to hold myself back and purchase only a few items. The beads filled the entire center part of the store, and the outer perimeter of this beautifully restored train station was filled with finished jewelry, crafts, ceramics, even medicine bags, all created by local artists and available for purchase.

This was a treasure trove in the true sense of the word—a magical place, filled with creative energy begging to be used in the materials for sale, but also with the wisps of creative energy that are left behind when artists display their work. I was as equally drawn to the handcrafted, felted medicine bags hanging on the wall as I was to the finished jewelry and the list of classes.

As is often the case in these kinds of stores, the owner was sitting down, addressing postcards, and I struck up a conversation with her. She was friendly, outgoing, and a wonderful source of knowledge about the town and its potential for creative inspiration. After wandering back and forth several times, taking it all in, I made two small purchases: a dragonfly bead and a small handmade clay pendant signed "Nancy" on the back. At the register I inquired about the artist, Nancy ... and the friendly saleswomen informed me I'd been talking to her.

I was naturally drawn to Nancy, her artwork, and her bead shop, and although I'd never met her before, she and her magical store inspired me on several different levels for many days to come.

—BARBARA R. CALL

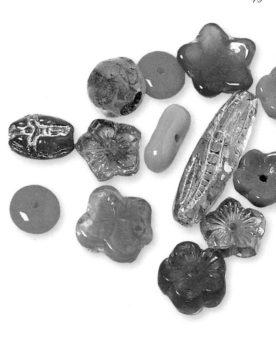

Journal Necklace

WHO SAYS YOU CAN'T wear your journal? This updated version of a locket features a tiny accordion journal that folds neatly into a miniature brass picture frame.

Miniature Journal

SUPPLIES

DECORATIVE PAPER (FOR BOOKLET AND MATTING), BRASS PICTURE FRAME, SMALL PHOTOGRAPHS, EMBELLISHMENTS (E.G., RUB-ON LETTERS, OLD POSTAGE STAMPS, RHINESTONE STICKERS, ETC.), AND RUBBER STAMPS.

1. Cut a piece of sturdy decorative paper to fit the brass locket; the journal shown here measures 1½ x 8⅜ inches (3.8 x 21.3 cm). Fold this strip into eight equal panels to create an accordion-folded booklet.

2. Close the booklet and orient it so the first page opens like a book. This first page is the cover, and it's what will show through the brass locket. Decorate as desired.

3. Open the rest of the book so you can see all the panels; decorate as desired, using decorative-edge scissors to cut mats for the photos. Fold up the journal and insert it into the brass locket.

..

THESE TINY BOOKLETS can be used in many different ways—tuck them into pockets, tag sleeves, or envelopes attached to larger journal pages (see below), or roll them gently to fit inside a tiny glass vial.

The brass locket opens at the top to remove the journal; to use the locket as a necklace, add a jump ring to the top and string it onto cotton or leather cord.

ARTIST / Jenn Mason

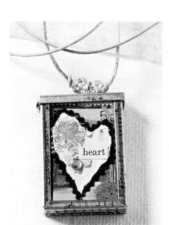

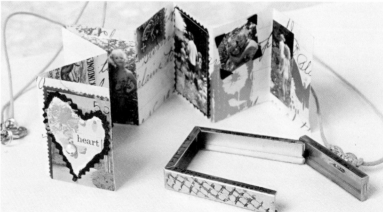

Distressing Photos and Paper

IF YOU FIND SOMETHING NEW but want it to look old, you need a technique for distressing. Here's the good news: It's easy to give new items a used look with just three basic tools—ink, sponge, and sanding block or sandpaper.

To distress paper, trim it as needed. Crumple it up, then flatten it out again. Rub the ink pad or sponge over the paper to transfer the ink to the raised areas. To make the paper look even more distressed, sand the edges and the surface of the paper to break up some of the fibers; this works especially well with dark paper that has a lighter core.

..

SOMETIMES YOU FIND the perfect object, but it's not quite right. That's the beauty of recycling, reusing, and reviving—you can paint it, sand it, add glitter, remove certain pieces, or alter it in any way you like. The possibilities are endless.

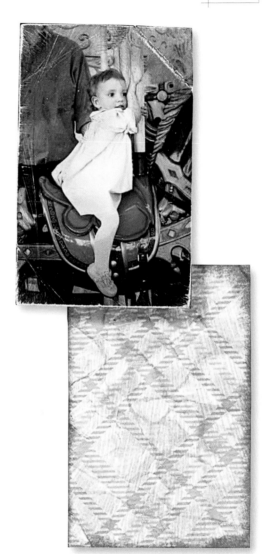

To distress a photo, start by trimming the photo as needed. Next, lightly ink the edges, using a sponge. Last, crumple the photo and sand the edges as desired.

ARTIST / Jenn Mason

45

Jewelry Box Stash

WHEN WAS THE LAST TIME you emptied out your jewelry box or dresser drawers, looking for jewelry bits and pieces you can reuse, recycle, or revive? Let's face it—most of us only wear a small percentage of our jewelry, such as our favorite pieces, matching sets, or items with special significance. That leaves a treasure trove, of sorts, for recycling into other uses.

Today's exercise: Empty your jewelry box (or wherever you store your personal adornments) and set aside any jewelry you no longer wear. Once you've gathered a pile of materials, take out some pliers, wire cutters, or the like, and start taking pieces apart.

Imagine how beads or charms could be reused to decorate greeting cards, how cords or ribbon could be stitched onto fabric, or how a special pendant could take center stage in a mixed-media collage. Alternatively, think about reusing strung beads in new jewelry or restringing items on fresh ribbons, trims, or cords.

..

SOMETIMES THE BEST materials—and the inspiration for how to use them—can be found right under our noses.

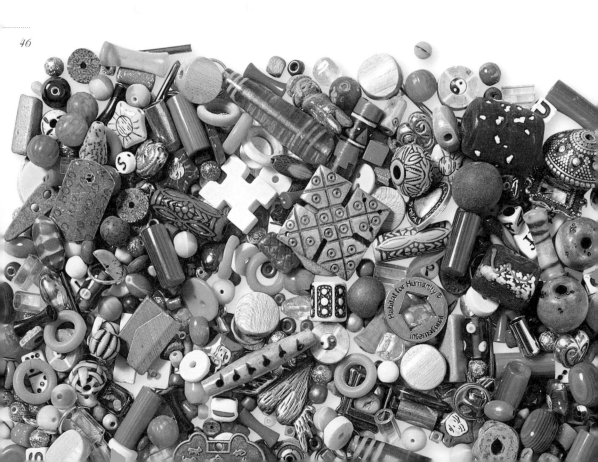

Revealing Your Creative DNA

YOUR CREATIVE DNA is the artistic part of you that's permanently imbedded in your being. If you're not sure what this means, ask yourself these questions:

- What materials and tools are you drawn to over and over again? How do you best express your creativity (e.g., on paper, in clay, with paint, etc.)?

- Where are you on the journey of unearthing your unique creativeness? Have you found your ideal outlet, or are you still searching for your perfect material technique?

- What is your signature look, color, or style?

- When you work, which do you enjoy more: the process or the end result?

YOUR CREATIVE DNA may be hardwired, but that doesn't mean you can't experiment, or try on someone else's DNA for size.

"If you understand the strands of your creative DNA, you begin to see how they mutate into common threads in your work. You begin to see the story that you're trying to tell; why you do the things you do (both positive and self-destructive); where you are strong and where you are weak (which prevents a lot of false starts); and how you see the world and function in it."

—TWYLA THARP,
American dancer, director, and choreographer

Borrowing from Other Cultures

CULTURES OTHER THAN YOU OWN are a rich and endless source of inspiration for many artists, and thankfully, material suppliers have kept up with the trend. Nowadays, Asian-inspired embellishments such as coins, mah-jongg tiles, and images such as bamboo and irises are widely available for use; search a little further and you'll find global inspiration somewhere in most craft and hobby stores.

Borrowing can mean using images and icons, as with the artist trading card shown here, or borrowing familiar shapes and forms.

TAPPING INTO other parts of the world can also be as simple as reflecting on the customs, language, or clothing from other countries and cultures, past or present.

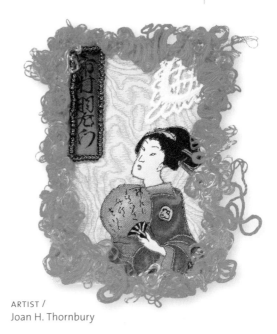

ARTIST /
Joan H. Thornbury

Frida Kahlo

ICONIC FIGURES, SUCH AS Martin Luther King Jr., Jesus Christ, Buddha, even musicians and painters, have often inspired works of art.

One intriguing example of this is Frida Kahlo, the well-known Mexican painter (1907–1954). Perhaps she inspires other artists because she faced so many challenges as an artist, or perhaps it's her work, her unique face, or her hauntingly personal paintings that ignites the spark in other artists.

In celebration of the hundredth anniversary of her birth and to recognize her powerful influence on artists working today, in 2007 the Walker Art Center in Minneapolis (in association with the San Francisco Museum of Modern Art) organized a major exhibition of Kahlo's paintings. The show, which featured approximately fifty paintings, included her "hauntingly seductive and often brutal self-portraits' as well as other portraits and still life paintings, according to information from the Walker Art Center.

It is said that the artist painted her own reality, and it was a reality fraught with pain and sorrow—she contracted polio as a child, then survived a near fatal car accident around the age of eighteen that affected her health throughout her life. "Her insistence on being strong and joyful in the face of pain sustained her, and many of her paintings are testimony to her passion for life and her indomitable will," the curators wrote.

IS IT ANY WONDER that an artistic spirit as strong as Frida's would inspire artists throughout the world? Consider the iconic figures that you admire, then research their lives, their art, and their struggles and think of how your own work could reflect your findings.

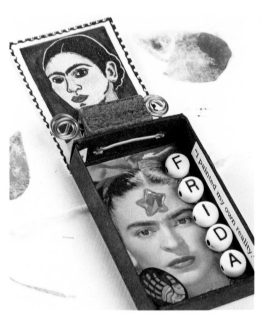

This tiny matchbox shrine, which is part of a larger doll, opens to reveal the familiar face of Frida.

ARTIST / Anne Sagor

48

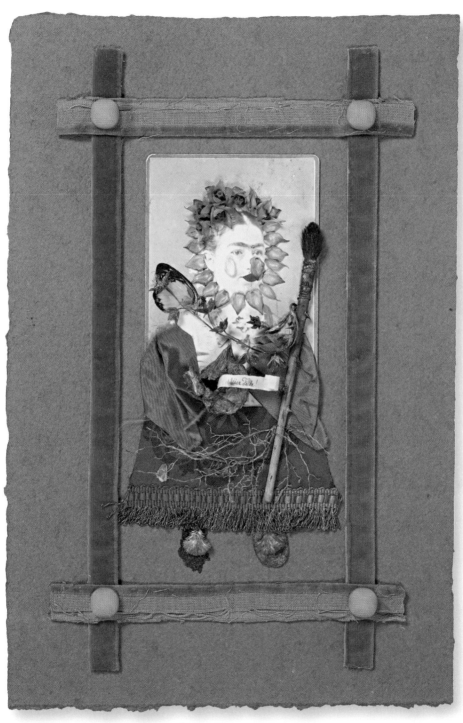

Artists Maryjo and Sunny Koch turned this photograph of Frida into a
portrait of the artist as a nature goddess interpreted in botanicals.

Women's 7 Senses

BEST-SELLING AUTHOR Sarah Ban Breathnach, author of *Romancing the Ordinary* and *Simple Abundance: A Yearbook of Comfort and Joy*, believes that women have seven senses, not just five. Beyond our everyday senses of sight, sound, scent, taste and touch, Breathnach believes every woman also has an intuitive sense, which she calls "knowing," and a sense of rapture and reverence that she calls "wonder."

Today's exercise is to apply this broader view of our senses to your journaling experience. There are several ways this can take form, including your own interpretation, but here are two ideas to consider:

Option 1: One day at a time, record what each sense experiences. On Monday, for example, try taking note of all the interesting things you've seen that day, on Tuesday what you've heard, Wednesday what you've smelled, and so on.

Option 2: Alternatively, try recording something for each sense every day, however small. This type of journal entry might read as follows:

FRIDAY

Sight: The rain has made the leaves and foliage in my yard look greener than ever.

Sound: The red squirrels were particularly chatty this morning when I opened the window.

Scent: I baked a chocolate cake for the party tomorrow and the boys commented on it as soon as they walked in the door.

Taste: I tried a new flavor combination for lunch: baked sweet potato topped with peach salsa and vanilla yogurt.

Touch: It's cool and rainy today, so I pulled on my favorite fleece socks. I love the feel of fleece against my skin, so warm and comfy.

Intuition: I sense that my friend Courtney is angry with me, but she doesn't express it directly.

Wonder: It's raining today, which leads a lot of people to complain about the weather, but it occurred to me that the trees, grass, and flowers are happy because they're getting a drink. They don't have a choice whether they want to stay wet or dry—they just endure whatever the Heavens deliver. Maybe I should take a lesson from them.

BY TAKING NOTE of all your senses, rather than just your "primary" senses of sight and sound, you're automatically opening yourself up to deeper daily experiences and, by extension, new material to work with.

Altering Used Books, Part I

IF YOU'VE NEVER ALTERED an existing book, you're missing an exciting opportunity to create unique and beautiful artwork, using a prepackaged form. What's more, if you were told as a child not to color in your books, here's your chance to break those rules!

There are other advantages to altering used books, of course: They're portable, meaning it's easy to bring your project with you on vacation or to a friend's house; they're already complete with binding, cover, and printed text, which eliminates the need to make your own book or face an empty page; they give you something to react to, such as words to highlight or images to work off; and last, but not least, altering a book creates an entire body of work, versus just creating one piece at a time.

ALTERING OLD BOOKS is a fun (and frugal!) means of creating new artwork. Scour yard sales, flea markets, and used book stores for your new art supplies.

See "Altering Used Books," Parts II and III, pages 80 and 95.

To create these altered dictionary pages artist Melissa McCobb Hubbell started with a simple action: circling the word dwelling.

Piling It On

HERE'S A TECHNIQUE that can be useful for getting started on a new project: piling. It's simple: Start pulling out items from your stash and putting them into piles. Very quickly you can see how colors, themes, or materials start working together, on their own.

PICK A THEME and pile your materials. Don't let your brain do any thinking, but just pull things together instinctively. Sometimes, those piles beget amazing creations.

Story: Piling It On

I used the piling technique when making the animal totem cards shown here. I started by making a list of all the animals and birds I see on a regular basis outside my window; the original list had about ten animals as well as three types of trees.

This next step is one of my favorites: I sat down with the list and started assembling piles of materials that I felt represented (literally or otherwise) each animal or bird. For the most part I used materials from my own personal stash, such as papers, images, stickers, flowers, and the like, but I also bought some postage stamps, and I raided my sons' collection of *Ranger Rick* and *ZooBook* magazines to look for animal images.

The "piling" process further narrowed my list. I see a lot of red squirrels in my yard, but I couldn't find an image of one that I liked. For other animals, such as horses, dragonflies, hummingbirds, and butterflies, each of the individual piles was fat with materials. I took this as a sign that these animals were my totems, but perhaps the red squirrel is totem for my son, Alex (which is why the card didn't come together as easily).

If you're new to collage, the small form of a playing card is perfect for experimenting. Try moving things around, playing with your materials and/or composition, before you adhere anything permanently.

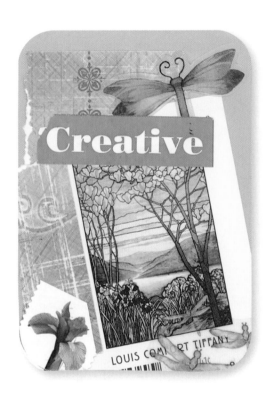

ARTIST / Barbara R. Call

Making an Altar

IF YOU LOOK AROUND your home, chances are you already have altarlike groupings of favorite objects, meaningful talismans, or special found objects. You may even collect them on altarlike surfaces, such as dressers, mantels, side tables, desktops, and the like.

If you already have these spontaneous altars in your home, consider using them for prayer, reflection, or meditation. If you don't, consider making an altar either as a creative project or for use with creative inspiration. Keep these guidelines in mind:

- The objects on your alter should have meaning, whether they evoke certain emotions, help you remember past memories, or hold special significance .

- The list can include anything, but here are some ideas: keepsakes, souvenirs, charms, stones, shells, candles, postcards, or photos.

- Think about what you will use the altar for—Healing? Protecting? Prayer? Honoring? All of the above?

- Consider the location of your altar; it can be created inside or out. If you're working outside, consider your garden, a tree stump, a shaded corner of your yard, or other somewhat private or protected areas. If you prefer an indoor location, look around for a bookcase, dresser top, or even a shelf to assemble your items.

- Once the altar is complete—and this could take a few minutes or a few months—many people like to purify the area by burning incense or sage. You can also dedicate your altar, alter it (an altered altar), or share it with others as time goes by.

THE ACT OF CREATING a personal altar is an exercise in assembling personal items of significance. This principle can carry over to journaling, collage, and other "collective" creations.

"Any object, intensely regarded, may be a gate of access to the incorruptible eon of the gods."

—JAMES JOYCE (1882–1941),
Irish writer

53

Universal Symbols

TODAY'S LESSON: Take inspiration from universal symbols that stand the test of time. These include, but are not limited to, such things as eyes, hearts, hands, arrows, circles, and the like. Is there a culture that you're drawn to, such as the Celtic culture of Ireland, Scotland, and England, the Mayan culture of Mexico, or the ancient symbols of Greek mythology?

Research your chosen culture and reflect on the symbols and characters associated with that time, location, or period in history. If possible, research what those symbols mean. When creating your art, select an item after considering what message your symbol may be sending, intentionally or unintentionally.

..

THINK OF SYMBOLS as shorthand for words, phrases, quotes, or feelings. This can be especially useful if space is limited, and you don't have room for much more than a tiny symbol that's rich in meaning.

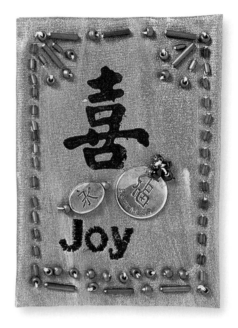

This artist trading card uses the classic Chinese character for joy as its central motif. The artist added beads and decorative elements as accents.

ARTIST / Joy Osterland

Artist Interview: Linda Frahm

LINDA FRAHM WAS in the midst of a challenging five-year period that included a seemingly endless job search and a failed relationship. To keep her spirit strong Linda dove into art, taking classes in ceramics, silversmithing, rock carving, and fiber arts. One night, she had a powerful dream—about sheep —that lead her out of the dark.

Q: Tell me about your dream.

A: I dreamed about a beautiful white sheep that was comfortably curled in my lap. I told a friend in my dream that I wanted to keep this sheep. She said, "Linda, a sheep is not like a dog. You can't keep a sheep in your apartment!" I told her that maybe I'd buy my sheep a pasture. She said, "Oh, that's silly. You won't buy a pasture."

To persuade me to come to my senses, she introduced me to a family who owned a farm. When I met with the owners and they mentioned their deep green pasture, my sheep's ears perked up, and I felt bad. I was being so selfish. And yet, my heart wouldn't let me part with something so special. I wrapped my arms around my sheep and held on tightly. Then I woke up.

Q: Did the entire vision for your trademark sheep rattles come from one dream?

A: Yes. I had been working in clay and I was toying with rattles when I had the dream. I wanted to create something that would help me hold onto the dream longer. One night at the studio, I set out to make a sheep rattle. It was a surprisingly effortless creation in my hands— from construction to glaze—like I had been making them all my life.

Q: Can you tell me a little more about what was going on in your life at that time?

A: The dream came during a really bad time in my life when I felt I had lost "me"—my identity and everything that had been making me happy or content in life.

The dream about the sheep was so real. I woke up with a feeling of comfort. The choice was mine on whether to give up on everything or not. I began making sheep a few days later. Right from the start, I found the process of making the sheep rattles soothing and meditative. The repetitive process of making these creatures helps me stay quiet, allowing me time to think and dream even after a rough day.

I still think about the dream every time I make a sheep rattle. How life has its ups and downs, and how the bad times can pave the way for maybe a better future with new adventures, new talents, better jobs, and new friends. I am grateful for that dream about the sheep and its message at a time when I was very low. And I'm happy that I decided to be selfish enough not to give up.

...

THE TRUTH IS, none of us really knows why we dream or what, if anything, our dreams mean. One interpretation is that dreams are subconscious messages—and that these hints can lead us in new and/or unexplored directions. Today's message: Be open to new ideas, whenever they come to you (day or night) and in whatever form.

For more information about Linda Frahm, visit www.sheeprattles.com.

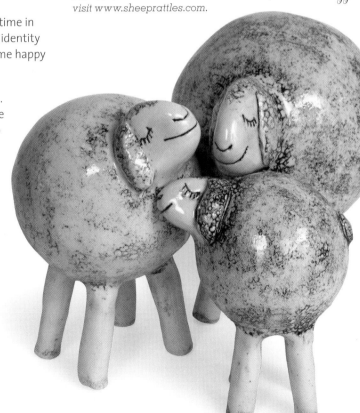

Nature-Speak

WHAT IS NATURE-SPEAK? Some define it as the language of the birds, animals, and plants that speaks directly to the soul, whereas others say it's the universal language of Mother Nature, sending us messages in a special language that we can't receive any other way. Whatever you believe, creating a nature-speak journal can be a rich source of new material for creative endeavors.

Start by creating your journal, whether you plan to use an empty notebook or customize a sketchbook especially for this purpose. Day by day, take notes of the elements of nature all around you, from the trees and flowers in your yard to the locations that you're drawn to over and over, whether that's a beach, a lakeside cottage, or the deepest forest. Leave room on each entry page for interpreting the special meaning behind the chickadee at your feeder, the foxglove in your garden, or the shells that always seem to find their way into your bag after a day at the beach.

Last but not least, consult a book such as *Nature-Speak: Signs, Omens and Messages in Nature* by Ted Andrews, to interpret what nature is trying to tell you.

NATURE SPEAKS . . . and if you listen and learn to understand what she's saying, you may find a rich source of new material.

56

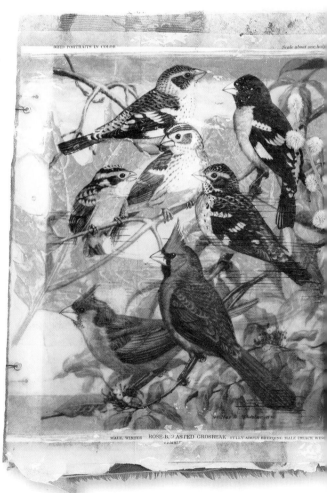

ARTIST / L.K. Ludwig

Paint and Mark

MAYBE THE COMPOSITION or subject matter of your photograph is just right, but the colors aren't quite vibrant enough, or the effect isn't quite what you're looking for. No worries—just pull out your markers or your watercolor paints and you can create an entirely different look and feel in just minutes.

Water-based markers are great for filling in specific areas—such as transforming a light blue sky into an evening sky or making green grass even greener—or they can be used for other completely different effects. Imagine a hot pink version of your dog, new colors for the flowers in your garden, or even a vivid sunset on that old beach photo.

For finer details and/or more refined edges, try gel or pigment pens.

DULL OR LIFELESS photos can be revived in minutes, using water-based markers or water-color paints. Try these techniques on color or black and white images for different effects.

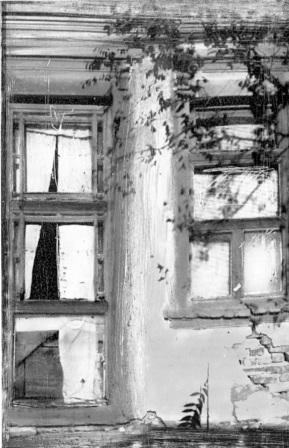

The original photo had plenty of white area and very little pigment. Artist Karen Michel started by sanding down the edges of the photo (to create your own border) and damp-ening the photo slightly. Then she filled in the pale areas using water-based markers or liquid watercolors.

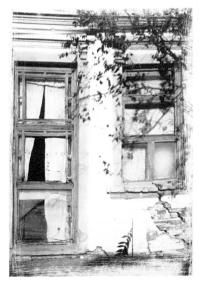

Words to Inspire: Find Your Outlet

"You must find a creative outlet for yourself. You see, where people go wrong when they set out in life is not exploring that part of themselves that feeds their spirit. Without that food, the spirit dies, and it's a large part of our responsibility to ourselves not to allow that to happen. In fact, consider how few psychiatric problems there might be if every individual actually knew what to do to keep alive in himself something that could affirm the very essence of who he is. That's what the creative act does."

—AUTHOR ELIZABETH GEORGE,
in *What Came Before He Shot Her*

Self-Portraits

58

QUICK—NAME A FAMOUS ARTIST who's well known for his or her self-portraits. Who came to mind—van Gogh? Rembrandt? Someone else?

There's a reason this classic type of portrait has stood the test of time: It can reveal as much (or as little) about the artist as the artist desires. What's more, it's an intensely personal exercise that involves reflecting back to the outside world how you think the world sees you, or how you want the world to see you. Self-portraits are not just a reflection of what the artists look like, but also how the artists interpret themselves, their immediate environment, and the world around them. In short, it may be one of the most personal projects you will ever create.

Today's exercise: Compose your own self-portrait. This can be done any way you want, whether that involves taking or painting your own image, sketching yourself in the mirror, creating a collage or sewing, beading, or otherwise embellishing an existing image.

• How are you trying to present yourself: as you see yourself, as others see you, something else?

• How does your chosen medium, materials, tools, or technique reflect you and your personality?

• How would your self-portrait be different if you had created it five years ago versus now? What about five years from now?

• What is the overriding message of your self-portrait?

CREATING a self-portrait is a true exercise in looking inside *and* out.

Labyrinth Lore

THE LABYRINTH IS AN ANCIENT circular pattern that leads the walker on a path to its center. It's not a maze, as there is only one way in and one way out, and there are no dead ends that would make the seeker choose directions. Labyrinths have been documented throughout history as far back as the Bronze Age, in almost every religious tradition, and in areas from Egypt and Greece to Italy, France, England, Peru, and North America. Labyrinths are found in many different sizes, and in many different forms, and they are located at churches, schools, parks, hospitals, and community centers.

Many people see labyrinths as a metaphor for life's journeys, offering lessons as we walk their path. Walking, or even tracing the path of a handheld labyrinth, has been said to help with addressing life's challenges, allowing the walkers to find peace through meditation and prayer.

Interested in drawing your own labyrinth? It's not as hard as it might seem. Follow these simple instructions for creating a classical seven-circuit labyrinth.

1. Begin by drawing the seed pattern seen in the upper left-hand corner of this illustration. Always start at the top of the cross, and either go clockwise or counterclockwise. In this case, a line is drawn clockwise to the first available dot or line-end that you can hook on to: the top of the L shape in the upper right-hand corner.

2. From the top of the L in the upper right-hand corner, lift your pencil and go to its mirror on the left-hand side of the seed pattern—the top of the mirrored L in the upper left-hand corner, and then draw around to the dot in the upper right-hand quadrant, and so on.

MANY ARTISTS FIND that walking a labyrinth is inspirational. Drawing a labyrinth—a timeless symbol that's found all over the world—may inspire new works of art, or the labyrinth can serve as the artwork itself.

> "Stand at the crossroads and look;
> ask for the ancient paths,
> ask where the good way is, and walk in it,
> and you will find rest for your souls."
>
> —JEREMIAH 6:16

Start with the seed pattern, located in the upper left-hand corner.

Sisterly Creations

OUR SIBLINGS CAN BE a source of inspiration, awe, or frustration. Luckily for many of us, we view our sister(s) as a blessing (and possibly as the person/people most like us in all the world.) You can use that relationship in many creative ways—to celebrate my familial bond, for example, I've created many original crafts for my sisters, nieces, and mom over the years. (Recently, I started making collage cards for my brother and father with outdoorsy or fishing themes, in part because they felt neglected!)

The bond of sisterhood—among true siblings, close friends, or even cousins—can also serve as a source of collaborative inspiration. One idea my younger sister and I have been working on for years is a two-person photography exhibit called "Two Sisters, Two Views." To be honest, I'm not sure if it will ever happen, in part because our lives are so busy and we live so far apart, so instead we tried to collaborate on a line of cards to sell together. To that end, we looked at all our individual photos and tried to find a pair of images that work well together as a set, despite the fact that both photos were taken at different times and with different cameras. One of the goals of any collaboration is to create an entity—in this case, a pair of greeting cards—that is larger than what you can create individually.

Two Views of the Same World

Find a crafty friend (sister, soul sister, or otherwise) and try these exercises together:

1. Start with the same three to five materials, but create your own individual pieces (see page 161).

2. Start with the same three to five materials, but each of you designs half of the finished piece.

3. Agree to each design half of the finished piece, but use coordinating materials.

4. Pick an idea or theme (e.g., summer day, dog-eat-dog world, life is good) but let your own design sense lead the way.

5. Each of you starts a design, then hands it over halfway through the process for the other person to finish.

60

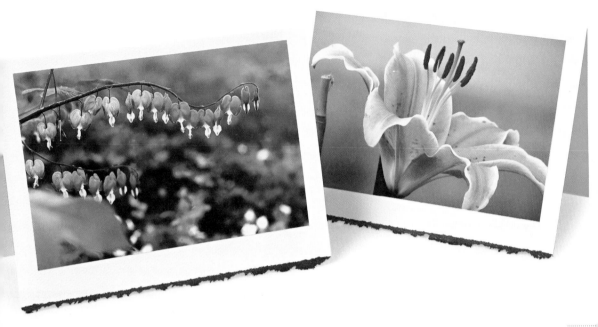

Although these photos of bleeding heart (left) and Asian lily (right) were taken at different times, in different gardens, and by different cameras, they're united by their color, composition, and subject matter.

ARTISTS / Barbara R. Call and Carolyne Mary Call

COLLABORATION IS, by its very definition, an opportunity for learning. Rather than judging the output from the abovementioned exercises, take time to reflect on what you can learn from the process, whether that means trying a new technique, experimenting with a new material, or just appreciating another perspective on the same idea.

Journalwear

THERE'S ABSOLUTELY NO REASON why your journal has to take the form of a book, or why your entries need to be written by hand. A journal skirt is a beautiful and unique example of how journaling can translate onto a skirt made from an old pair of jeans.

THERE'S NO NEED to limit your journal entries to written pages, as this example shows. If a skirt feels like too large a project, start with the back of a jean jacket or a simple denim wrist cuff cut from an old pair of jeans and tied with a strip of leather.

This journal skirt was created with art stamps, fabric paint, embroidery thread, and beads. This technique will also work on an old jumper, jean jacket, work shirt, or overalls. You can transcribe actual journal entries from your journal onto your clothing, or just stamp or write whatever comes to mind while you're working.

ARTIST / Rice Freeman-Zachery

Tea-Dyeing Fabrics

IF YOU LOVE VINTAGE FABRICS, antique lace, or old-time postcards and clip art, you'll want to learn this technique for tea-dyeing fabric. Tea-dyeing ages fabric instantly, and is best suited for plain muslin or cotton fabric. No special chemicals are required, and all the work can be done right on your kitchen counter.

As you might expect, the type of tea you use, as well as the strength of the brew, will affect your results. (See samples, right). The more tea bags you use, and the longer they're allowed to steep, the more intense the color will be. Keep in mind that tea-dyed fabrics dry much lighter than they appear when wet.

If you want less uniform coloring, take a page from the age-old technique of tie-dyeng and twist or fold your fabric, then secure with rubber bands.

1. Wash and dry the fabric. Cut the fabric into 1-yard (0.9 m) or ½-yard (0.45 m) -long pieces.

2. Place about twelve tea bags in a large container and cover with 6 to 8 cups (1.4 to 1.8 ml) boiling water. Let the tea brew for at least 8 to 10 minutes.

3. Remove the tea bags and add your cloth to the solution. Turn or dip the fabric frequently to saturate fully. Let it soak for 10 to 15 minutes, then check the color.

4. Once you've achieved the desired color, squeeze out any excess tea, rinse briefly under tap water, and place the fabric in your dryer with an old towel. The cloth should be dry in about 15 or 20 minutes. Note: Some of the tea color may transfer to the towel during drying.

5. Remove the fabric from the dryer, press, and cut to size for your project.

TEA-DYEING IS A natural and fun way to add color, tone, or texture to plain or everyday fabric. It's especially well suited for use with antique or vintage photos, papers, or embellishments.

ORANGE AND BLACK PEKOE BLEND

BLUEBERRY TEA

PEACH TEA

GREEN TEA

PLAIN MUSLIN

ARTIST / Pam Sussman

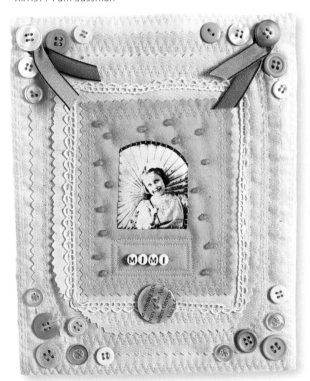

63

Step Outside Your Comfort Zone

NO DOUBT YOU'VE GOT A PILE of materials, tools, or techniques that you return to time and time again when creating new work. But sometimes the familiarity of playing it safe, working with the same materials over and over (otherwise known as "staying in your comfort zone"), can limit your creative output. Today's exercise is about taking risks, whether that means trying something totally different, tackling a technique you've been resisting, or forcing yourself to work with materials you've never handled before.

Nothing is intrinsically wrong with *safe*. There is comfort in predictability, and many people even fear change. On the flip side, a great deal can be learned from taking risks, doing things differently, trying new paths, or even using new materials.

SOME PEOPLE believe that playing it *safe* is really taking the biggest risk of all: the risk that we will never learn or grow in that particular area. And those may be the areas where life's most precious and important lessons await.

"Behold the turtle. He makes progress only when he sticks his neck out."

—JAMES BRYANT CONANT (1893–1978), *American chemist and educator*

Going Back in Time

WHAT ARE YOUR ROOTS? Did your relatives immigrate from Ireland or Scotland? Or perhaps your ancestors lived in China, Brazil, or Greece? Whatever your genealogy, researching your family history or origins can be a rich source of inspiration.

Once you've done basic research about where your ancestors came from, reflect on what you're naturally drawn to in the images or writings you've found. Consider these questions about your ancestors' origins as well as other places/periods of the past to which you feel some special association:

• Are you inspired by the local culture, heritage, traditions, or customs of their native land(s)?

• Are you drawn to the art, costumes, or literature of another time?

• Are you inspired by historic locales, natural or man-made, such as canyons or castles?

• Are you fascinated by certain historical figures or events?

• If you had lived during another time, what would you have been? How would you have lived, and what would you have done?

SOMETIMES JUST imagining what life was like in another time, another culture, or another time zone is the fuel you need to move in new directions with your projects or artwork.

A Taste of Contemporary Art

I'LL ADMIT IT—although I was an art history minor in college, I'm not a big fan of contemporary art. But when my friend Lisa came into town from Colorado and suggested a visit to the Institute of Contemporary Art in Boston, I was intrigued by my resistance to the idea. Instead of seeking out the kind of art that I was familiar with, even fascinated by, why not challenge myself to explore an unknown venue?

Long story short: I went, I saw, and I was blown away. I had never seen art like that of Anish Kapoor before, and it challenged all my preconceived notions of how an artist can interact with the viewer, even long after he's created his piece.

Today's task: Find a museum, gallery, book, or even online collection of art that you're not familiar with (or not even particularly interested in). Devote an hour or two to exploring what this type of art has to offer, whether it's form, technique, perspective, or style. Then ask yourself what you can take away from that experience, and how you can apply it to your own work, even if it just means imagining your world in an entirely different color palette, expressing yourself in a much larger format, or trying something completely different.

AS ARTISTS, it's important to move outside our familiar world from time to time to consider different perspectives and points of view. If nothing else, visiting a museum offers quiet time for reflection.

Ask Questions

Although museum guards may look like passive observers, they are often great sources of information. Be sure to ask a question or two, to drill a little deeper during your visit—I did this at the Kapoor exhibition and learned a great deal about the artist and what he was trying to achieve.

The Art of Collage

PAULA GRASDAL, an accomplished author and artist, defines collage as "an intuitive process of concealing and revealing, adding and sub-tracting, until the desired result emerges from the layers."

On a more technical level, collage is the process of creating a composition or artwork by adher-ing many elements together on a background or substrate. Often this involves paper, but it can also include fabric, original artwork, or found items, to name just a few.

If you've never tried collage, it's a wonderful technique for several reasons. First, you don't have to be good at drawing or painting to create a collage; instead, it's more like putting together a puzzle with unlimited pieces. Second, collage is adaptable to a variety of surfaces; you can create one-dimensional paper-based collages, add in mixed media for two-dimensional effects, or use collage to decorate a three-dimensional object, such as a wooden birdhouse, a box, or a triptych.

Basics of Collage

Assemble the following basic collage supplies before getting started:

SUPPLIES

DESIRED IMAGES AND OBJECTS, NEWSPAPERS TO PROTECT YOUR WORK SURFACE, SCISSORS, CRAFT KNIFE AND SELF-HEALING CUTTING MAT, BRAYER, METAL RULER, PENCIL AND ERASER, ARTIST'S AND FOAM PAINTBRUSHES (ASSORTED SIZES), WATER JAR, PAINT PALETTE, ADHESIVE

Note: If you are following directions for a spe-cific project, you may need other materials in addition to the items on this list.

Start by arranging your images and objects into a loose composition before attaching them. Move them around as you see fit to create a cohesive unit, statement, or theme.

When working with paper, it's important to use the right adhesive. Avoid rubber cement (it dries out over time); instead select an acid-free glue such as polyvinyl acetate (PVA) or acrylic medium. When adhering heavy objects, metal, or nonporous surfaces, use industrial-strength craft glue, or think outside the box and attach your items with pins, staples, string, thread, wire, tacks, grommets, or brads.

MAKING A COLLAGE can be as simple as tearing up a catalog or magazine and aligning the images (or words) in a new way, or can be taken to the highest form of art, as reflected in pieces from well-known collage artist Joseph Cornell. Try the action of layering to create something new and see where it takes you.

The Origins of Collage

THE TERM COLLAGE may have originated with the French word *coller*, which means "to paste or stick," but it took Cubist artists such as Picasso to bring collage to an art form.

According to the online glossary from the Tate Collection (www.tate.org.uk), "Cubism was a new way of representing reality in art invented by Picasso and Braque from 1907–1908. The name seems to have derived from the comment of the critic Louis Vauxcelles that some of Braque's paintings exhibited in Paris in 1908 showed everything reduced to 'geometric outlines, to cubes'. 'A head,' said Picasso, 'is a matter of eyes, nose, mouth, which can be distributed in any way you like. The head remains a head.' In practice however, the object became increasingly fragmented and the paintings became increasingly abstract. They countered this by incorporating words, and then real elements, such as newspapers, to represent themselves. This was Cubist collage, soon extended into three dimensions in Cubist constructions. This was the start of one of the most important ideas in modern art, that you can use real things directly in art."

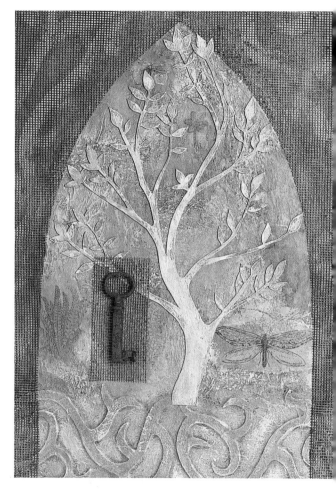

This nature collage combines rice paper, mesh, and cutout paper shapes to create the effect of looking through a doorway into a light-filled garden. The key hanging from the branch of a single tree could symbolize the Tree of Knowledge, the key to a secret world, or a locked garden gate.

ARTIST / Paula Grasdal

Quick-Bound Journals

LOOKING FOR FAST AND EASY ways to create simple but unique journals? Consider these ideas:

1. Want a quick fabric journal cover? Fold an old place mat in half and stitch muslin pages inside.

2. Take apart a mint tin, drill small holes as needed, and wire pages inside.

3. Carry a stack of your favorite handmade or collected papers to a commercial copy center and ask them to spiral bind them together.

4. Check book publishers and printers for leftover binding samples; these bound (but usually empty) books are ready for filling with artwork, writing, or both.

A BOUND BOOK for writing is but one definition of a journal. The possibility for creating unique and personal journals is only limited by your imagination.

"Write down the thoughts of the moment. Those that come unsought for are commonly the most valuable."

—FRANCIS BACON (1561–1626), *British philosopher*

Artist Lesley Jacobs created this pocket-size metal journal using candy tins for pages. She also needed a heavy-duty hole punch, copper foil tape for wrapping the edges of each page, and metal eyelets for attaching items. The book is bound with leather cording.

Recycled Gift Bags

SHOPPING BAGS, which many stores so readily hand out these days, needn't go in the recycle pile—instead, decorate them with simple embellishments such as yarn scraps, gift tags, or snips of ribbon for unique gift packaging. For specific ideas, consider these altered bags for inspiration.

...

ANY BLANK PAPER is suitable for recycling and reuse, whether it's shopping bags, manila envelopes, or file folders.

Artist Kitty Foster embellished this plain brown bag using strips of decorative paper. She started by cutting the paper scraps to fit the bag's dimensions, then inked the paper's edges to add depth. Although the patterns are not the same (polka dots, plaid, and stripes), the colors coordinate with the scraps of ribbon tied to the handle and the matching gift card.

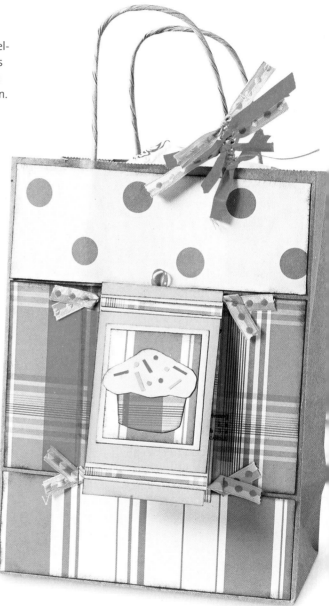

Chronicle Your Daily Walks

ARTIST JOCELYN CURRY captured the essence of her daily walks during the month of December 2002 by creating thirty-one watercolor paper tags. Each tag is notated with writings, observations, quick sketches of objects collected along the way, letters, and numbers. After completing the tags the artist suspended them from a 5-foot (1.5 m) -long tree branch.

This unique artwork relies on thirty-one days of the artist's personal history.

ARTIST / Jocelyn Curry

..

YOU CAN ALWAYS record your thoughts and observations in a written journal: Instead use these rough musings in art or as the basis for any new work.

Re-Name Yourself

IF YOU COULD PICK a new name, what would it be? The purpose of this exercise is to explore the facets of your personality.

With all due respect, your parents probably named you, and most of us are completely happy with our given names. But every year, thousands of people change their names, for a variety of reasons; think of Madonna (originally named Madonna Louise Ciccone) or Cat Stevens (now known as Yusuf Islam after converting to Islam in 1977). Writers also play the name game all the time when they ghostwrite using a second identity.

Today's exercise: Pick a new name for your creative self. It can be a combination of words that sound good together, a name that includes personal meaning, or words that reflect an aspect of yourself. You can name your creative self after someone you admire, or chose a name that projects a certain image to the world.

Consult baby-naming books for still more ideas, or flip through the dictionary for names such as Silence or Echo. Look at a list of locations for names like Arizona, or look to other languages, cultures, or geographic regions for more ideas.

..

SELECTING A new name is a very personal exercise, and it's an activity that may take more than one day. It's not necessarily a process you want (or need) to share with anyone else, as it is, by its very nature, deeply personal. The process of finding the right name for your creative self, however, may take you, literally, in many new creative directions.

Explore Bookstores

A VISIT TO YOUR local bookstore can often stir up the creative juices. Here are some ideas for making the most out of your visit:

- Instead of looking for books to read, take a survey of the book jacket art throughout the store. The children's book section is always rich in this regard.

- Visit the bargain bin and rummage for low-cost supplies to cut up and reuse.

- Wander through the children's and gift book sections, and take a visual survey of the latest forms that books are taking: mixed-media covers, pop-up and three-dimensional cutouts, ones that come with stuffed animals or kits, etc.

- Peruse the racks of greeting cards, journals, bookmarks, and other small gift items to survey their use of embellishments or creative ideas.

- If you can't visit a bookstore without buying a book, stop at the information desk and ask three questions: What's the most requested book or author? What's the most inspiring book you've read lately? Who is your all-time favorite author and why?

- Visit the art section and look through books about artists you love, admire, or want to know more about; alternatively, open a book about an artist you've never heard of. Do the same with the architecture, craft, art, photography, design, or home decorating sections.

- Visit the magazine rack and flip through art, craft, design, even home decorating and fashion magazines for ideas, inspiration, or color palettes.

..

TODAY'S BOOKSTORES sell much more than books, and they're an amazingly bountiful source of art, design, color, and creative packaging. Even if you don't buy anything, you should come away with a treasure trove of visual images for later use. Bring a sketchbook or journal to record your visual impressions.

Right Outside Your Window

CONNECTING WITH NATURE can be as simple as looking outside your window. The animal totem/personal meditation card shown here, for instance, was inspired by the critters and birds that visit the feeders in my yard.

Over the years, I've always had a feeder in my yard, and I've been fascinated by the number and variety of birds and animals that show up. Certain birds, though, seemed to show up over and over, and some people believe that's a sign of one's personal animal totem.

Hummingbirds, for example, are always showing up in my life, either in my yard (after my son asked me to buy a hummingbird feeder), or on correspondence, in magazines, and the like. I researched the hummingbird as a totem and found the text really resonated with me, so I researched other birds and animals and ended up with a list of critters that appear over and over again in my life.

To honor those birds, bugs, and animals, I designed a deck of twelve playing card–size miniature collages, each one featuring an animal, bird, or butterfly with significance to me. The collage appears on the front of the card, while the text about what that critter signifies is on the back.

When I researched hummingbirds, I learned that ruby-throated hummingbirds migrate from North America every fall to spend the winter in Central America, a trip of more than 1,800 miles. We can use this example of stamina to inspire us to persevere in meeting our goals, following our dreams, or simply finishing the task at hand.

MANY PEOPLE BELIEVE that animal totems are messengers. Take a look at the animals or birds that appear in your life and use them (or their messages) as inspiration.

EVERYDAY ANIMAL TOTEMS

OTTER
Otters are playful creatures. As such, you may need to be more playful in your life, artwork, and creative pursuits.

SNAKE
Snakes indicate change (as in shedding old skin) and the need to let go of your old self.

WHALES
This animal totem encourages you to look to the past, listen to old stories, and heal old wounds.

DOLPHIN
Dolphins are beautiful, playful animals that live in water but breath air, meaning they move back and forth between two worlds. Dolphins encourage you to do the same, whether that means breaking emotional barriers or speaking the truth versus lying.

FOX
Foxes are masterful at camouflaging themselves; this animal totem can mean that you need to take a step back and observe things from a quiet vantage point.

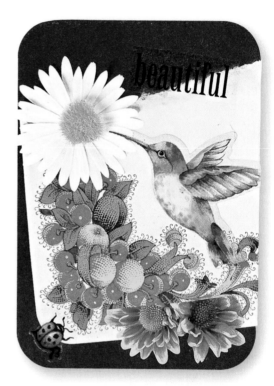

This multilayered hummingbird collage uses paper, stickers, and found images.

ARTIST / Barbara R. Call

For more information on animal totems, see page 77.

"Play" the Accordion File

As we explored on day 29, journals needn't be bound books—their pages can also take a three-dimensional form. One easy venue for creating this type of journal is the handy accordion file, an expandable collection of files or folders (made from paper, plastic, or other materials).

The beauty of the accordion file is that it's already complete and ready for decoration, and it lets you slip anything you like into the pockets, such as letters, school papers, photos, maps, brochures, and the like. You can add your own images to the cover or tabs, finish off the file with a decorative ribbon to tie it closed, or group them together to create a series.

Accordion files are available in a variety of places—office supply stores sell basic, brown files for as little as seventy-five cents (£0.5); paper supply stores sell more decorative, heavier stock files that do double duty as totes, wedding organizers, and the like. Oversize accordion files (available at artist supply stores) are perfect for large pieces of artwork.

..

ACCORDION FILES provide the organizing principle, and you add the contents. How simple is that?

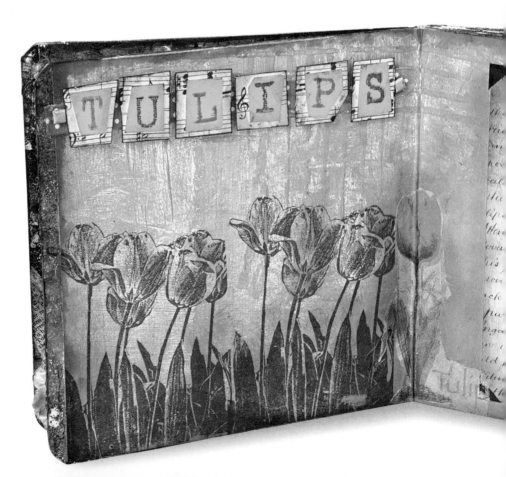

Altered Board Books

USED CHILDREN'S BOOKS are a great starting point for many creative projects—imagine the possibilities when starting with a book of fairy tales, a prebound board book, fabric or foam books, or even pop-up books, which feature three-dimensional paper forms that appear as you turn the pages.

Board books are an especially easy format to start with—most are just eight pages long, and they can be altered as is or taken apart and rebound, using book ring binders or ties. They replace the need for locating, cutting, and prepping chipboard, but they do need some preparation, as most will have a finished surface.

How to Alter Board Books

1. Prepare the cover and individual pages by coating them with several coats of gesso. This creates a solid undercoat for any added paint or decorative elements.

2. To cover the cover completely with decorative paper, trace the book onto the paper, cut out, and glue in place.

3. Embellish the cover with metal charms on the corners, a child's photo in a metal frame, die-cut letters, and ribbon scraps.

4. Decorate the inside pages with paint, decorative paper, and assorted embellishments.

...

BOARD BOOKS are a good choice if you're just learning to experiment with altered books— they're already bound, and the pages are heavy enough to handle just about any decorative elements.

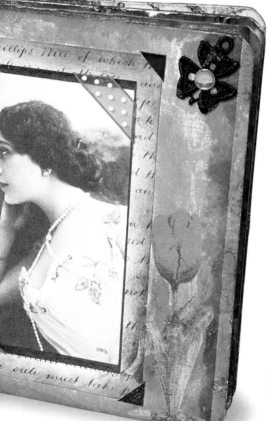

Artist Lori Roberts used elements and tools such as trim, silk flowers, brads, images, paint, foam stamps, and alphabet stickers to decorate the pages of this altered board book.

Paint Your Own Paper

SOMETIMES, YOU DON'T want to create a project—you want to create the materials for future projects. Artist Elizabeth Beck satisfies this need by painting her own papers, then organizing them on clipboards (arranged by color).

This is a simple and expressive exercise: Simply gather your paper of choice, assemble your paints and your instrument of choice, and create away. Mix colors, apply layers, create patterns, or just let the paint dictate the direction.

...

HAND-PAINTED PAPER is a wonderful creative exercise in its own right, but it also gives you an endless supply of unique material for use in collage, decoupage, card making, and the like.

Elizabeth Beck adds paint to dictionary pages, maps, and other papers, then files them away for later use.

Your Signature Motif

CONSIDER THESE DEFINITIONS of the word motif:

- A unit repeated to create visual rhythm

- A recurrent image, word, phrase, represented object or action that tends to unify the literary work or that may be elaborated into a more general theme

- A situation, incident, idea, image, or character type that is found in many different literary works, folktales, or myths

- The recurring design or subject matter of a wallpaper pattern

- Any single form or integrated group of forms that make up part of the overall design of a homemade rug

- An element that recurs in a literary work, or across literary works

- The shortest musical idea of rhythmic or melodic identity that retains its identity when elaborated or transformed

- An element that stays the same within a tradition

...

REFLECT ON whether your projects include motifs. Do you use the same motifs but give them different forms? Do you return to the same motifs over and over? What is the meaning, purpose, or construction of your motif? If you don't use motifs, consider adding them to your work in one form or another—this could be as simple as buying a rubber stamp that you use in many different ways.

Finding Your Animal Totem

SOME PEOPLE BELIEVE that animals, birds, insects, or objects (such as trees) that appear over and over in your life have meaning. Native Americans, in particular, have a rich history of associating certain qualities with particular animals, such as bears, buffalo, and eagles, which appear on many of their objects and in their lore and literature. (Information on interpreting the meaning of various animal totems can be found in books or online.) If you don't know what your animal totem is, ask yourself these questions:

1. What animals are you drawn to instinctively?

2. If you visit the woods, beach, zoo, or other outdoor area, what types of animals are you most interested in seeing?

3. If you could take a class or course in any one animal and its life, which would it be?

4. Do any animals frequently appear in your dreams?

5. Do you have artwork, home decorating items, or clothing with animals, and if so, which ones?

ANIMALS CAN BE turned into personal symbols for certain characteristics or qualities. Once you've identified your animal totems, study their species and habitat, learn more about their behavior, and research how they have been used as emblems historically and artistically. Then consider how to incorporate them into your own creative work.

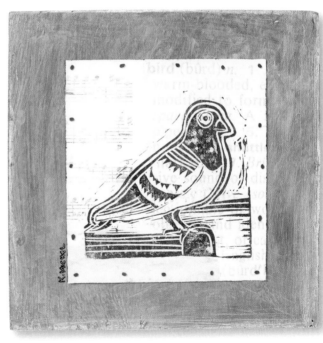

Here, a simple pigeon inspires a hand-carved linoleum printing block (left). Artist Karen Michel first prepared the paper with a series of ink-jet transfers, then printed the bird image. The finished piece (above) was mounted on wood using carpet tacks.

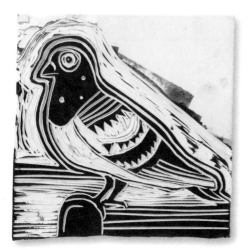

Guided Meditation

IF YOU ARE working with other artists this weekend, try using a guided meditation to inspire your work.

Just what does this mean, and what does it entail? Although there's no textbook definition for guided meditation, most people agree it's an exercise in which one person's voice is used to guide a group meditative process. Typically one person serves as the "guide" (and the voice) while the other participants relax and meditate (see pags 105 and 122). Many creative types swear by this technique for generating wonderful images, visions, or other ideas for creative output.

Why use guided meditation? Many people believe that by entering a truly relaxed, meditative state, we're able to access parts of our brain that we don't typically access unless we're dreaming. Guided meditations can produce images, visions, feelings, ideas, or even just objects that are worth exploring or using creatively.

"The art after a guided meditation comes straight from the heart, straight from the soul," says artist Lynn McLoughlin, who uses guided meditations in many of the art classes she teaches. "After my father passed away, guided meditation let me tap into my father's spirit and use my art to heal from the grief," she adds.

...

GUIDED MEDITATIONS are just another tool for accessing feelings, thoughts, or images that feel "just out of reach" in our everyday, awakened state. The process is similar to keeping a dream journal and using the content of your nighttime adventures as inspiration.

Story: **The Moss Maiden**

I attended a guided meditation where I recently received a beautiful image of a princess surrounded by forest and mossy stones. Looking for the meaning of this image, I took the following notes after consulting *Nature-Speak* by Ted Andrews:

Moss maidens: Group of spirits found beneath trees

Wood nymphs: Other spirits who live around trees (also known as dryads [Greek])

Lady of the woods: Along with the wood nymphs there is usually a mistress or lady of the woods; she is the guardian to entire forested areas or even small groves of trees

The resulting ceramic wall plaque, titled "Moss Maiden," came directly from three influences: the images I received during my meditation, an interpretation of those images from *Nature-Speak*, and my own creative hand.

Making this ceramic wall plaque involved several steps: rolling out and cutting a flat circle of clay, using leaves and other flora to make impressions in the clay, firing the clay, coloring the impressions, firing once again, and finally adding the mixed media elements such as yarn, real moss, and colored glass pebbles.

ARTIST / Barbara R. Call

Camera Capture

WHEN WAS THE LAST TIME you bought five or six rolls of film and photographed whatever you wanted? This week, try this exercise: Buy a week's worth of film (or free up a week's worth of memory on your digital camera), and try to record your life in pictures.

Each day, try to take photos that reflect your feelings—a bright sunny shot of your garden to indicate happiness, a sink full of dirty dishes to signify chaos, a neatly organized linen closet to represent clarity.

Shoot the photos as you move around your world, whether that means one photo per day or twelve; you can use analogies, like those mentioned above, or just create a catalog of your everyday life. Try to take photos unique to each day and the activities, emotions, or feelings that you experience.

This is an exercise that is creative on its own, or you can use the photos for later projects. You can turn them into a book, journal, or other visual representation of your life; print out the photos and use them as pages; bind the photos together at the edge to create a flip book; or arrange the photos in a linear fashion under the headings Monday, Tuesday, and so on.

THINKING VISUALLY—and using a camera to capture those thoughts—can be stimulating in many ways. Relax and go with the process— don't judge your photos; rather, let them lead you in new and creative directions.

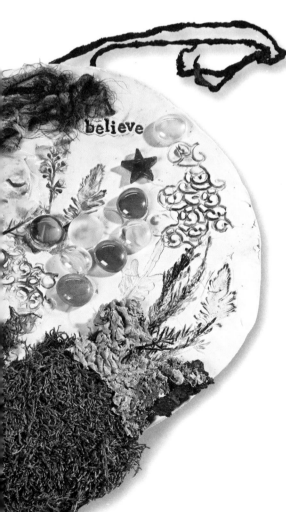

Altering Used Books, Part II

USED BOOKS ARE natural starting points for many paper art projects, and not just because of their prefabricated form. The sheer variety of their contents, dimensions, colors, or original purpose may lead you in many creative directions.

Consider using a discarded address book, for example, with its alphabetical tabs, to catalog lists of favorites, create a personal dictionary, or note significant events. History textbooks could be used to house a family tree while atlases might inspire a visual travel diary. Even aged, yellowing books found stacked in any antique or second-hand store are blank canvases ready to receive your crafty, creative ideas.

The next time you visit a used book store, flea market, or yard sale, keep these ideas in mind:

- **Address books:** Instead of throwing out your old address books, decorate, paint, or collage the pages. Consider highlighting favorite names, creating images of actual locations, or embellishing the pages that serve as dividers.

- **Cookbooks:** Use the images of food or meals as a springboard for creating your own projects, or transform a small cookbook into a book of spells, recipes for love, or the like.

- **Poetry books:** What better place to find inspiration than among the words of a poet—imagine creating images that work alongside the poems, alter the words to make them your own, or just highlight the phrases you like best.

- **Reference books:** Dictionaries, guides, or compilations are a great jumping-off point. Highlight words, quotes, or phrases with paint, colored pencils, or markers.

- **Old atlases:** There's nothing more nostalgic than a volume of old maps; consider mapping your own journey or life history on the pages of an old atlas or book of maps.

...

OLD BOOKS are everywhere, and they offer a complete form that's ready for customization, personalization, or your own interpretation, as witnessed in the artwork shown on page 51.

See "Altering Used Books," Parts I and III pages 51 and 95.

Burned Pages

BURNING OR CHARRING the edges of any paper creates an aged, nostalgic look, or it can be used to create a sense of mystery.

How to Burn Pages

• To burn the edges of a page or window, dip a brush in water and draw a wiggly line just past your planned burn line. This way the whole page won't catch on fire!

• Always keep a damp cloth handy in case the fire-wall fails, and work over a sink to catch the burned material and to keep a water source nearby.

• You can also use a candle to add smoke marks to paper; set the marks in place with fixative spray.

...

BURNING THE EDGES of paper is a simple technique for making your project look aged or worn or to impart an antique effect. Always use care when working with paper around an open flame.

Revisit Childhood Crafts

TODAY'S TASK SHOULD be a fun trip down memory lane: Visit your favorite craft, toy, or art store and buy a kit for a craft you used to do as a kid. It could be bead looming, a miniature potter's wheel, paper dolls, or sequin art. It may not look exactly like you remember, and the materials may have changed, but try to find a kit that resembles something you liked as a little child.

Buy the kit, take it home, and do the craft. Take your time and savor the process; jot down any feelings or emotions that come up, or just enjoy creating something while following someone else's directions.

SOMETIMES rekindling creativity is as simple as revisiting the things, places, or activities that we loved as children.

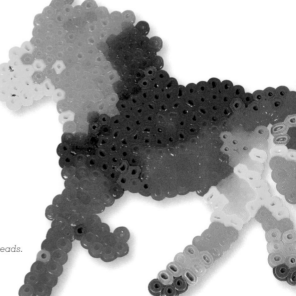

This rainbow pony was made with fuse beads.

Inspired by Dragonflies

THE INSPIRATION FOR this stunning dragonfly pin, made by artist Michela Verani with precious metal clay, came directly from her garden.

"When I first put my pond in my garden, there was nothing in it, no fish or anything. But the dragonflies showed up and laid their eggs like crazy, and when they hatched there were dragonfly nymphs all over the place," she says. "Have you ever seen a dragonfly nymph? They are very ugly, brown things, and they're carnivorous, so they were crawling all over the pond eating each other!"

Within a few months, however, the scene changed. "Within a few months there were dragonflies everywhere," she says. "Powder blue ones, iridescent ones . . . it was just wonderful. They would follow me around while I worked in the garden, because they eat mosquitoes. I really appreciated that that ugly little thing in the bottom of the pond turned into something so beautiful."

In fact, Michela gets most of her inspiration from the outdoors. "I take a one-hour walk in the woods every day with my dog and look for odd little flowers. I collect them, put them in a vase, and then sketch them for use later on. Or I take photos if they're flowers that can't be picked."

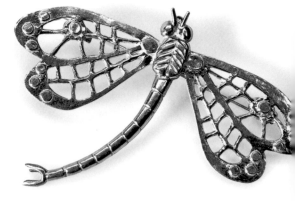

ARTIST / Michela Verani

And what does Michela do when she's fresh out of ideas? "I have reference books on the history of jewelry, and I look at what other people have done over the years. I do have dry spells, and I just try to work through it. Soon enough it will flow again."

The Art of a Cemetery

THERE'S A WHOLE WORLD OF LIFE in a graveyard—birds, squirrels, trees, and other flora are oblivious to the irony of where they have chosen to live. The old-growth trees in expansive cemeteries are allowed to grow into wide, sprawling natural shapes, and the landscape encourages wandering and pensive reflection.

The meditative quiet of cemeteries is perfect for writing, sketching, or meditation. Gravestones themselves offer design inspiration, too, with their cornucopia of historical embellishments. (Some cemeteries allow rubbings to be taken.)

Cemeteries by their nature are also very spiritual places, and many people find peace and calm there unlike anywhere else. They are a place for mourning, but they are also a place to witness the circle of life, the contrast of life and death, or the play between shadow and sunlight that can renew and uplift.

Gravestone Rubbing 101

Gravestone rubbings are a wonderful way to collect unique and beautiful artwork, but the practice is banned in some areas to prevent damage to delicate (and/or historically significant) markers. Anyone who wants to make gravestone rubbings should follow these guidelines from the Association for Gravestone Studies:

- Check (with cemetery superintendent, cemetery commissioners, town clerk, historical society, or whoever is in charge) to see if rubbing is allowed in the cemetery.

- Get permission and/or a permit as required.

- Rub only solid stones in good condition, as the rubbing process can cause damage to fragile grave markers.

- Follow established guidelines for proper rubbing technique, including the following:

- Cover the entire surface of the stone with paper and secure with masking tape.

- Use wax or ink to make the rubbing; never use felt-tip pens or other permanent ink.

- Rub gently and carefully.

When you are done, be sure to replace any gravesite materials you may have moved, remove all trash, and leave the stone in better condition than when you found it.

Haiku: A Powerful, But Simple Outlet

POETRY CAN BE read to inspire new works, or it can serve as a unique creative expression in of itself, as it does for artist Chrissy Grant Steenstra.

This week's task: Write a poem every day. Chrissy suggests trying haiku, in part because the form is so simple to learn. "In the Japanese tradition, haiku was always three lines, with 5 syllables in the first line, 7 in the second, and 5 in the third," she explains. "But now it's more open— it's always 3 lines, under 17 syllables total, and it should include some kind of nature-related word, such as snow or sun."

Chrissy, who teaches haiku to elementary school students and who has written more than two hundred such poems of her own, finds it a "powerful outlet for strong feelings, personal issues, emotions, or just observations of everyday life."

Chrissy often assembles handmade books, such as this one, that include her poetry as well as segments of original watercolor paintings or simple decorations to match the poem's theme. This fast and easy book was made with precut chipboard pages; Chrissy punched holes in each page, added artwork and poetry, then "bound" the book together with binding rings colored black with a felt-tip pen.

...

WRITING HAIKU is a simple way to express your thoughts, feelings, or observations in a beautifully simple and time-honored form.

A dedication

To true teachers everywhere

Flashlights in the dark

Chrissy's collection of haiku features a section of one of her original watercolor paintings on the cover.

HAIKU ∼ 2008

Image Editing 101

IF YOU'RE INTO scanning photos, or even just working with digital versions of your photos at different websites, you may already know the power of Edit. You can create a wide variety of altered images, using such settings as Brightness, Contrast, Crop, Hue, Saturation, Rotate, Reverse, and Mirror.

Keep these general guidelines in mind when using image-editing programs on your computer, scanner, or online photo storage provider:

- **Brightness and Contrast:** These controls can darken or lighten a photo. For dramatic effects, max out the contrast.

- **Color Variations:** These can change the overall color of the photo, converting it to green, blue, or red.

- **Crop:** Cropping a photo—meaning focusing on a certain area of the image—can bring certain objects to the forefront.

- **Hue and Saturation:** These controls can be used to alter or adjust the color of an image. Changing the hue alters the global color palette, whereas changing the saturation adjusts how much of the hue is used. The higher the saturation, the more exaggerated the results.

- **Rotate, Reverse, and Mirror:** Use Rotate or Reverse to change the orientation of the image or use Mirror to create an identical secondary image.

..

THANKS TO TECHNOLOGY, no photo need ever be printed out the same way more than once— image editing tools let you alter your photos in a variety of fun and interesting ways.

The somber, dreamy feeling of this photo was created by adding blue tones.

To bring out the details more dramatically in this photo, the contrast was increased. This lightens the lightest colors to white and darkens the darkest colors to black.

To create the exaggerated effect shown in this photo the saturation of the color hues was increased.

Paper-Painting Techniques

DECORATING YOUR OWN PAPER can be as simple as buying a large roll of brown wrapping paper and letting your kids rubber-stamp or adhere stickers to their heart's content, or buying yourself a large pad of watercolor paper and paints and taking an afternoon to play with color, texture, or materials.

Visit the paint aisle of your local craft or art supply store. Take some time to explore the wide variety of offerings, including (but not limited to) glazes, faux painting products, gesso, spray paint, acrylic paint, and gel. Craft divas Jennifer Francis Bitto, Jenn Mason, and Linda Blinn offer these ideas for decorating your own paper with such mediums:

- **Gesso:** Traditionally used to prepare canvas for painting, gesso comes in black and white. Add any acrylic paint to white gesso to create a custom color. Gesso (or custom-colored gesso) makes a great undercoat if you're planning to apply multiple layers of paint. To create a shabby-chic look, apply a coat of white gesso, then wipe it off with a paper towel.

- **Spray paint:** Spraying a light mist of black matte spray paint over colored paper results in interesting texture. For sparkle and shine, spatter silver or gold metallic spray paint in a light mist.

- **Glaze:** A thin coat of glaze painted over dark or light colors can create a whole assortment of effects.

- **Ink:** Use ink to add depth or interest to your papers; dilute with water for a lighter, more subtle effect. Create the look of aged paper with brown or sepia ink.

- **Acrylic paint:** Standard artist acrylic paints come in tubes and are opaque; fluid acrylics, on the other hand, are transparent and can be used to tint gesso, glazes, or gels. Try applying your paints with a wide variety of materials, such as sponges, rubber stamps, fabric scraps, or combs.

- **Gel:** Soft gel in matte, gloss, or semigloss can be used as an effective medium for decoupage, or tint the gels with fluid acrylics to add a soft glow.

ALTHOUGH specialty, craft, and scrapbook stores offer a huge (and growing!) assortment of decorative papers, there's nothing quite like experimenting with paint to make the perfect shade, texture, or design.

Collage Portraits

IF YOU'RE INTERESTED IN creating a portrait or self-portrait (see day 60), consider using a technique called magazine collage. Your hair and skin can be created from several different textures and colors, and the background (as well as your clothing) can be harvested from any number of clippings. Use markers, paints, and other materials to outline the face, features, clothing, and other elements to further personalize the portrait.

› Magazine Collage

Fashion magazines and mail-order catalogs offer a variety of close-ups of eyes, noses, lips, skin tone, hair, and even clothing that can be used in many interesting ways to create your self-portrait.

1. Canvas board makes a good, solid base for a collage.

2. Start by applying a thin, even coat of gel medium to the surface of the board, then start building the collage by layering the images on top.

3. Once you've completed the design, add one or two layers of gel medium to seal all the papers and adhere any loose corners or edges.

...

PORTRAITS CAN TAKE many different forms: Try working with paint, beads, paper, fabric, or just rubber stamps.

87

Long Ago and Far Away...

THE STUDY OF YOUR ANCESTORS—known as genealogy—can be a rich source of inspiration for many creative types. Thanks to technology, it's now possible to research your ancestors via a wide assortment of websites, compile your family history with software designed specifically for this task, or even post a greeting on an online genealogical message board to connect with others that share your family name, history, or heritage.

Here are three ways to explore your heritage:

- Historical context will establish a timeline of events paralleling the eras of your relatives. This can help you understand some of the challenges and events that influenced and molded their lives.

- Artistic transformation of family photographs and heirlooms will create more memories to share. Displaying your family history makes a connection through time and helps children (and others!) to build a sense of continuity and belonging.

- Storytelling gives you the opportunity to perpetuate family lore as told by living relatives and create an audio component to go with historical records or other forms of information.

...

YOUR APPROACH to genealogy will likely reflect something about your personality, how you see the world, or what's important to you. Take time to research your ancestors in any way that interests you, then personalize your approach to what you've found based on your passions, interests, or areas of expertise.

Working in Grids

GRIDS ARE A CLASSIC FORM of organization in many artistic media. Graphic designers often rely on grids for unifying disparate elements on the page; crafts such as knitting and cross-stitch embroidery are rendered on a grid as well.

Working on a grid gives you balance and uniformity; for some artists this will be pleasing, while for others it will be too restrictive. A grid, by its very nature, is the opposite of free-form design. As such, it's a useful tool for exploration, especially if you're not sure where to start, you have a number of different elements to work with, or your piece is calling out for organization.

Consider these three pieces of work; while they all employ the grid format, they are different in terms of application and material. Notice the similarities, however, in the end result.

88

FOUND OBJECTS, images, scraps of paper, or beaded elements may appear insignificant by themselves or arranged haphazardly, but giving these objects a natural composition unites them and makes them more powerful as a unit. The grid layout is a simple way to visually organize disparate elements, and can be used to create everything from original artwork to journal entries.

If chips of dried paint appeal to you, think of other ways to reclaim discarded artwork and form them into a grid. Failed collages can be cut up into tiny squares and reassembled, or glue squares of scrapbook paper scraps onto a premade journal for a tiled effect.

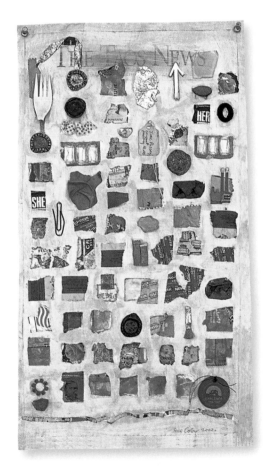

This work, called Taos News Diary, *is a testament to the beauty of overlooked things. Artist Sas Colby collected streetside debris from her daily walks, then sewed, glued, and painted them onto a background in grid format.*

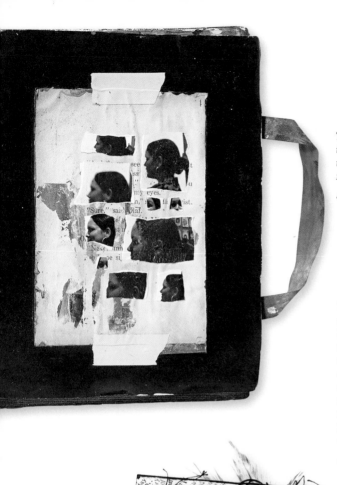

The artist created a grid of images by tearing up old photographs, then adhering them to an old book, using gel medium. The resulting composition is simple but effective.

ARTIST / Karen Michel

The cover of this journal combines interesting texture and vibrant colors. The distorted background print was made by crumpling the morning newspaper and placing it on a copier; the ultracolorful grid elements are swatches of dried paints peeled from an innovative palette: a plastic Frisbee! To finish the piece, the artist added lines of machine stitching to outline and define the paint chips, then left long, uncut thread ends for additional texture.

ARTIST / Monica Riffe

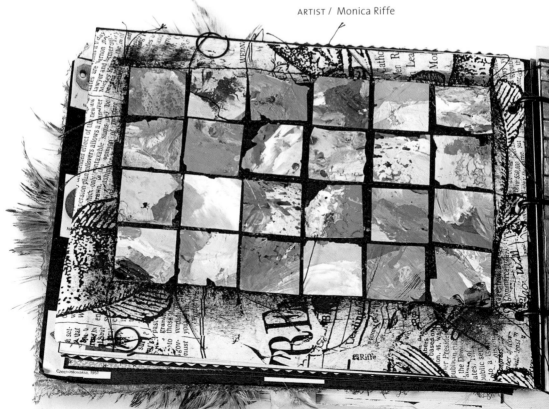

Czechoslovakia, 1951

Seasonal Journaling

WINTER, SPRING, SUMMER, and fall—no matter where you live, your world changes as the seasons change. The seasons present a wide variety of ideas for journaling, including:

- Explore a location through all four seasons.

- Follow a tree, bird, or flower through the seasons.

- Examine the season of your birthday and use images of yourself across time.

- Compare and contrast seasons on facing pages or alternating spreads of a journal.

- Choose a theme and use the seasons as a way to structure a journal.

THE CHANGING SEASONS present a natural structure for journaling; at its most simple level, a seasonal journal is automatically divided into four chapters, sections, or themes. Alternatively, consider the change of seasons as another set of headers, and you've created an eight-section journal without even trying.

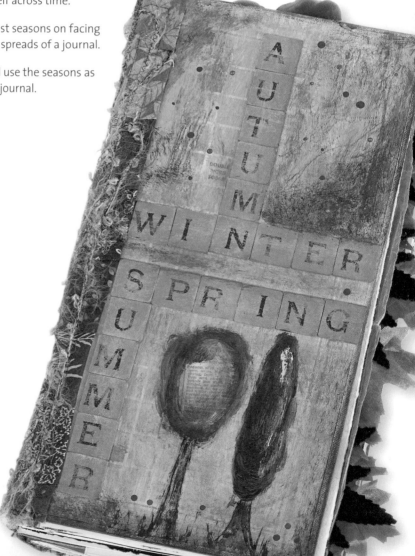

Artist L. K. Ludwig used an old game board and playing pieces to create the cover for her Seasons Journal.

The Glitter of Chandelier Crystals

CHANDELIERS WERE ORIGINALLY early lighting devices that often held candles and hung from the ceiling to illuminate an entire room. Their faceted and cut designs and shapes are designed, in part, to reflect their light source, making them magical and beautiful at the same time.

As with so many objects, crystals (vintage or modern) are a wonderful starting point for decoration and alteration. You can use them as jewelry, such as pendants or brooches, or just decorate them to hang in your windows or shadow boxes.

...

CHANDELIER CRYSTALS can be found at antique fairs or flea markets, or you can buy new crystals in hobby and craft stores.

Start with crystals that have flat backs. Remove the top bead (you will replace it once you're done). Next, decoupage flowers, flora, paper, or transparencies on the backside, then finish by painting or foiling the edges and adding a ribbon or other finishing touch.

ARTIST / Jenn Mason

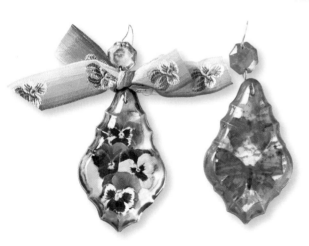

Revisiting Shrink Plastic

SHRINK PLASTIC (also known as shrink film), a classic children's craft material, can be rubber-stamped or colored with permanent markers, colored pencils, acrylic paint, or heat-set inks. After it is decorated, it is baked in the oven, where it reduces in size and hardens. Children can use it for tags for backpacks or magnets, but you can use it to make jewelry, luggage or gift tags, key chains, bookmarks, holiday ornaments, or miniature tiles for decorating picture frames, wooden boxes, or greeting cards. (See the results of artist Jenn Mason's shrink-plastic experiments on page 262.)

Consider collaging, stamping, assembling multiple shrink-plastic shapes, coating them with resin, and adding beads and other dimensional embellishment to further transform this medium.

..

REMEMBER the materials of childhood crafting … and make them grow up!

Personal Inspiration: Artistic Archaeology

BOLD, NEW ARTISTIC IDEAS are usually the exception rather than the rule. More often than not, ideas are born from familiar musings, variations on a past theme, or a new execution of a previous idea. If you feel stuck today, make a list of the things you love. Oftentimes just assembling the list will spark a new idea, a memory, or a jumping-off point for new artwork. If you need further inspiration, examine your stash, wander around your living space, and take in what you see with fresh eyes. See if you can find common themes among your personal items.

When I conducted this exercise I noticed several personal themes among my belongings. For starters, I have many images—watercolors, photographs, etchings, or prints—of trees in my home. When I thought about it later, I realized that trees—and their branches, twigs, leaves, and acorns—show up in my artwork as well. Some of my mixed-media collages have acorn caps in them, a calendar I made hangs from a small branch, and I use rubber stamp images of leaves everywhere. Even when I doodle I often draw leaves, vines, and flowers.

I also have a large collection of green-blue ceramic vessels. Over the years I assembled them one by one—I was drawn to the same color over and over, but the form, shape, and size varies. I never saw them as a collection until I happened to clean out some boxes and cupboards and saw all my vases, bowls, and vessels in one place. I was struck by how many similar items I'd collected over time. I now display them together on the mantle, but the green-blue color palette is one I return to over and over in my artwork.

..

INSPIRATION can be found in our personal collections and mementos to the icons or symbols of modern or ancient culture. Sometimes, new inspiration is as close as opening your eyes afresh on the things you love.

Words to Inspire: The Power of Dreaming

"Dreaming is an act of pure imagination, attesting in all men a creative power, which if it were available in waking, would make every man a Dante or Shakespeare."

—FREDERICK HENRY HEDGE (1805–1890),
American theologian

Shopping by Instinct

RICH, BEAUTIFUL FABRICS; a global assembly of yarn; unfinished wooden objects waiting for a creative touch—we shop for what we are visually drawn to. It's natural to seek out the things we like, the colors we love, or the materials we're familiar with, and those are often the items that end up in our hands, ready for the journey back to our home.

The next time you shop, hunt, or gather, however, try this technique: Shop by instinct. Try to find the items that seem to call out to you. As your eyes scan, taking in the variety of items available, tune into which of these objects, if they could talk, would be whispering to you. (Note: Sometimes objects scream at you instead. Those items are much easier to find!)

Once you've located an item or two that you're instinctively drawn to, continue exploring, but then circle back. Pick it up (handling it gently, of course!) and turn it upside down, side to side, or inside out. Your goal: Look for clues. Why is this object calling to you?

If possible, ask the owner or salesperson about the artist, the history of the item, or the materials used in the making of it. If you are at an antique store, ask, "Where did this object come from?

What kind of material is it made from? Do you know the history of this item? What was it used for?"

Any of these kinds of questions—as well as any others you can think of—may lead you to clues about why this item is special for you. And those clues, as we all know, can lead to new inspiration, new projects, and even new chapters in our lives.

GATHERING OR SHOPPING by instinct may take some practice, especially if you're not in tune with listening to your gut. As with any skill, however, once you've done it a few times you'll find it comes more easily, and it often gets easier the more you practice.

"Good instincts usually tell you what to do long before your head has figured it out."

—MICHAEL BURKE,
American baseball coach

Mining for Personal Content

NEWCOMERS TO JOURNALING often ask the same question: What should I write about? If you're struggling with content for your journals, ask yourself these questions:

1. What is on my mind today?

2. What am I feeling today, and why?

3. What's the best thing that happened to me today? This month? This year?

4. What's the saddest thing that happened to me today, this month, or this year?

5. If there is a lesson for today, what is it?

6. If there is a theme for today, what is it?

7. If there was a movie made about my life today, what pieces would stay, and which pieces would end up on the cutting-room floor?

8. What five words best represent what I'm feeling today?

..

TAPPING INTO THE FLOW of personal content may be difficult at first, especially if you're not used to it. With time and practice, however, it becomes easier and easier to access your feelings—and get them down on paper.

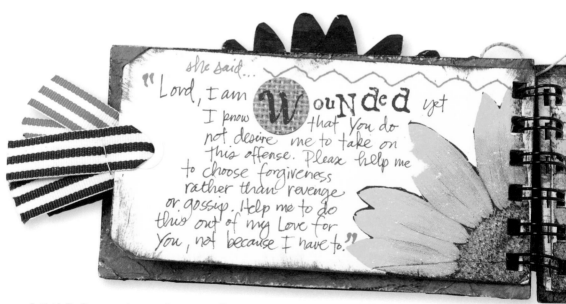

Artist Julie Scattaregia uses the pages of her mixed-media journal to express her feelings, starting with the words, "She said . . ."

Altering Used Books, Part III

IF YOU'RE CONSIDERING altering an old book, you may be searching for techniques. Keep these ideas in mind as you begin your project (or search for your used book):

- **Highlight:** Highlight words, quotes, or images to create a narrative, tell a story, or inspire emotions.

- **Hide:** Attach envelopes, pockets, or other paper-based catch-alls and tuck tiny cut-outs, journal pages, or images inside. To take it a step further, create a book within a book.

- **Cut:** Cut windows to emphasize certain images or create a frame for your own images.

- **Glue:** Glue pages together to thicken them, glue images in place to alter them, or glue the entire book shut and cut out an opening for found objects.

- **Rip and tear:** Rip or tear pages, papers, or images to alter their edges, or add torn papers to existing pages.

- **Punch:** This is a great technique for attaching found objects, charms, or stones; punch in grommets or punch out holes with shaped craft punches.

- **Sew:** Sew on buttons, fabric, fringe, or other fibers.

- **Stamp:** Stamp images, words, or quotes onto the pages, to other papers, or on the covers.

- **Drill:** Drill into the cover and attach fibers, yarn, charms, or other dangling items.

...

MANY OF THESE techniques can be applied to other craft projects; imagine a journal that hides certain elements, a beaded box that opens to reveal a personal icon, or an altered shrine that reveals a secret message.

See "Altering Used Books," Parts I and II, pages 51 and 80.

95

Twigs and Branches

TWIGS, BRANCHES, AND BARK are a wonderful natural material that's widely available (and often as close as your yard). Here are some creative uses for these materials:

- Create a miniature fairy or troll's house by painting an unfinished birdhouse, then attaching twigs, moss, and bark.

- Assemble your own bird's nests or sitting branches for clip-art eggs or birds.

- Attach a tiny twig to the top of a decorative box to serve as embellishment or as the means for opening the box.

- Tie twigs to the covers of nature-inspired boxes, bags, and books.

- Use branches or sticks as the support structure for three-dimensional projects or collages.

- Impress twigs or branches into clay to create natural impressions.

...

BRANCHES, STICKS, and twigs—as well as bark, moss, and flowers—can serve as materials, tools, or just a source of inspiration.

The Power of Tears

SADNESS AND GRIEF have led to many a work of art. The top ten songs on any radio station offers stories of heartache, lost love, and loneliness. Inspiration comes not just from the happy moments. Many psychological experts and spiritual leaders say that truly experiencing all emotions, in their entirety—including loneliness and grief—is one of the healthiest ways to move beyond them.

When a friend's mother died, I created the mixed-media collage cigar box titled *Helen's Heaven*, (see page 200), giving my friend Kim some reassurance that her mother is in a bright, happier place.

In the case of my own divorce, *Splitsville* (see right) is neither pretty nor pleasing; the colors are not soothing, the images are torn and tattered, and the piece feels unsettling. Although the title of the piece implies a wry sense of humor, the piece reflects only raw emotion.

Visit any craft store or read any magazine and you'll be fed a steady diet of happy, colorful images, from bright and cheery flower stickers to magazine images of happy-go-lucky moms and kids living in "blissville." Life, of course, is not always that picture perfect, so I had to find words, phrases, and images that could be interpreted two ways. This exercise in expressing sadness, which society sometimes portrays as a negative emotion, was a powerful catalyst for me.

...

WHAT YOU CREATE from tapping into sadness (or other difficult emotions) can be cathartic. Be forewarned—the results might upset others: They might turn away from sad feelings and pain or they may elicit a sadness of their own.

Visualization Exercise

Create a mental image of the strong waves of sadness or grief you are feeling. Ask yourself:

What color is your sadness? Is it a soothing color, a repulsive color, a combination of both, or a color you're not naturally drawn to?

What icons do you associate with your sadness—a broken heart? A tear-lined face? How can you use those icons as jumping off points? Tears can turn into raindrops, a flowing stream, or a raging river.

What words do you associate with your sadness? Use those words to find other words, or find images or associations that reflect those words.

What materials reflect your feelings of sadness? Torn paper? Broken or crushed beads? Fiber or fabric that's been randomly cut (or left unfinished)?

How can your feelings of sadness affect the design of your project? Instead of logical or symmetrical placement, your piece may be jumbled, skewed, purposely random, or completely upside down.

Splitsville

Nonstop "Why"

happy mother's day

Take a Deep Breath

Pain

Each OF US IS THE accumulation OF OUR memories.

curad® fle
"ouchless"
CURITY®

2122
5-7017/2110
749

75. 00

FEING TO DISAGREE "I'm not against, in princip...al, having the same color, but I don't think I have...the yellow half of this Cambridge two-family. Twen...al effort," says Richard de Neufville, owner of...eparate ways with exterior color choices. ...ago, he and his neighbor decided to go their s...

Marriage resemble... pair of shears — so join... that they cannot be ...d, often moving in ...rections, yet

Why should being a good parent mean being tired all the time?

This collage, titled Splitsville, creates a two-dimensional collage
of the feelings, words, and confusion created by divorce.

ARTIST / Barbara R. Call

Words to Inspire: Voyage of Discovery

"The only real voyage of discovery consists not in seeking new landscapes but in having new eyes."

—MARCEL PROUST (1871–1922),
French novelist

The Meaning of Color

COLOR MEANS DIFFERENT things to different people, depending on the culture, the context, and the application. As such, color can be a powerful tool for sending messages, expressing emotions, or evoking particular feelings in or through your artwork.

Just what do certain colors mean? The answers to that question are as varied as their sources, but what follows is two lists of "color meanings" that demonstrate how different colors mean different things to different people. Notice the similarities—as well as the differences—between the two lists.

I. What Is Your Color?

Many people believe colors, like people, have distinct personalities. Ask yourself, what color are you?

- **Red:** You crave excitement, are passionate about life, and like to live in the moment. You are easily bored and like to get things done quickly.

- **Pink:** You are sweet, sensitive and kind, and you crave romance in your life.

- **Yellow:** You are generally happy, playful, and optimistic. If something isn't working in your life, you quickly seek to change it. You are spontaneous and energetic.

- **Blue:** You like a sense of calm and order in your life. You are also trustworthy and value loyalty. Sky blue indicates a pleasure seeker and daydreamer, while navy blue is more serious and conservative.

- **Gray:** You're a watcher rather than a participator and are reserved in social situations. You don't like to firm up plans until the last moment.

- **Green:** You long to feel safe and make the world a better place for others. You are generous with your time and goodwill, but can also be stubborn about issues of importance.

- **Brown:** You are down to earth and a dependable, loyal friend. Your home and family are very important to you, and comfort is a key issue in life.

II. The Color of Auras

This interpretation is based on reading the colors of auras, or the field of energy that surrounds all living things.

- **Red:** Vibrancy or anger

- **Pink:** Sensitivity or healing

- **Orange:** Healthy sexuality, self-indulgence, or slyness

- **Yellow:** Warmth and compassion

- **Silver:** Erratic mental energy

- **Green:** Balance and growth, envy, or depression

- **Blue:** Independence or protective

- **Indigo/violet:** Truth and spirituality

COLOR IS a powerful tool in your craft arsenal, and it may serve as both a starting point and the basis for a variety of projects. Take a close look at the colors in your closet, on your walls, and in your previous artwork and reflect on what that says about you, your feelings, or your artistic statement.

- **Purple:** You're known as a negotiator and have a strong desire to please. Though well liked, you don't confide easily in others and enjoy a sense of mystery.

- **Orange:** You are gregarious, dynamic, and fun to be with. You may be flamboyant by nature, and as such, don't mind standing out in a crowd. You have a great appetite for life and food.

Source: The Complete Color Harmony (Tina Sutton and Bride Whelan, Rockport, 2004)

Write for 100 Years from Now

WHEN WRITING IN YOUR JOURNAL or creating a scrapbook, don't forget to write about those around you, namely your family, your friends, your neighbors, your co-workers, even your pets. You may think now that a short visit by a distant relative isn't something to write about, but one hundred years from now, your descendents may think differently.

Today's exercise: Think about what you would find interesting if you could read your great-grandmother's journal, your mother's childhood journal, or the journal of your long-lost cousin, then imagine that a future relative is reading your journal. Try answering these questions:

• What is a typical day like in your life?

• How much does a loaf of bread or a postage stamp cost?

• What does your home look like?

• What are your favorite books, music, movies, or objects?

• What is going on in your own personal world, or the world at large?

..

MOST OF US don't imagine someone else reading our private journal. Imagining that a relative in the future will be someday reading your journal can spur new ideas for your writing.

100

ARTIST / Judy Serebrin

Knitting + Hot Water = Felt

IF YOU'VE GOT an old wool sweater or a hand-knit woolen scarf that no longer suits you, you can transform either piece into felt for use in other projects.

The easiest way to felt a large number of items or larger pieces is to use your washing machine. Be sure to felt each piece in a separate mesh laundry bag, and set the machine to the highest water temperature, the lowest water level, and the highest agitation setting. Add 2 to 3 table-spoons (30 to 45 ml) of mild liquid detergent to the water and set the wash time to the longest setting.

Stop the washing machine before the drain-and-rinse cycle to check the felting process. Your items should have a firm, spongelike texture. If not, repeat the washing and agitation cycle. Once the pieces are done felting, allow the ma-chine to complete a warm rinse-and-spin cycle, then let the felted items air dry.

You can also felt small items by hand in a bowl of hot water; rubbing the knitted item all over replaces the agitation that a washing machine offers. This technique takes more elbow grease than using the machine, but is more effective for small pieces.

..

FIND A NEW USE for that knitted sweater or scarf—turn it into felt!

101

The three stages of felting (left to right): Prefelted sample, partially felted item, and fully felted end product.

Customized Buttons

Sometimes a project calls for a one-of-a-kind button; thankfully, there are many tried-and-true techniques for creating your own. Here are two easy methods that take just minutes to master:

Acrylic buttons

Clear acrylic buttons come in many shapes and sizes, and can serve as the ideal surface for layered collage or rubber stamping. Be sure to use solvent-based inks that are specially formulated for nonporous materials. Once you've stamped your image or words, you can glue decorative paper to the back of the button to add depth and color.

Fabric-covered buttons

You can find kits for covering buttons with fabric in most fabric or craft stores. Some self-covering button forms have a rounded, domelike surface, whereas others are flat. Look for colorful fabric scraps, novelty fabrics, or printed fabrics featuring a specific design, depending on the button's intended use. The fabric-covered buttons shown here are used as faces, but you could use your custom-made buttons in a wide variety of ways.

..

MAKING YOUR OWN buttons can be a creative process in itself, or just one step in a multi-faceted project. Either way, customizing your own buttons is a fun and worthwhile endeavor that can launch other creative ideas.

Researching Your Ancestors

SO YOU'RE INTERESTED in understanding more about your ancestors, but you're not sure where to start. Here are some tips for digging into your family tree.

Step one for many people is to contact other family members, especially if you have a large, extended family. Chances are someone else has been bitten by the genealogy bug, and you can save yourself months and perhaps years of work by joining forces and sharing your research.

Talking to your family is also an excellent way to gather information, especially from older relatives and family members. You can conduct interviews on the phone, in person, by written letters, or through email to gather important dates, facts, or family stories; be sure to keep a written record of everything you gather (and where it came from) to stay organized.

Staying organized is key: Decide early on in the process whether you're going to record your information with a pen and paper and traditional forms (e.g., charts and forms) or use one of the many computer software programs available, such as Family Tree Maker or RootsMagic.

..

RESEARCHING your ancestors can provide a rich source of information for creating new projects. Even recording the story of your immediate family may be enough to inspire pieces of new work, large or small.

103

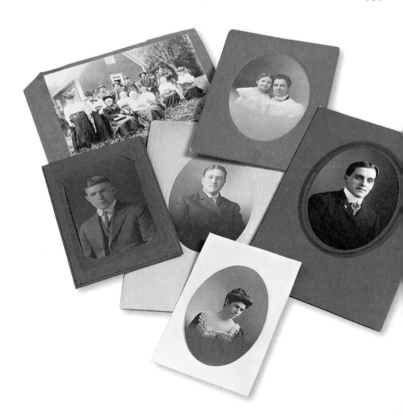

Visual Candy

SOMETIMES, ALL YOU NEED for inspiration is to look at other artwork: the result of another artist's personal creative journey. This pair of artist trading cards inspired me in several ways—both because of what they share and how they differ.

Both depict a garden scene. The artists used a variety of media, such as fibers, beads, and ribbon, to create their design, and they both worked on a solid, dark background, which causes the design to "pop."

They are different, however, in several ways. Laura Bailey's flowers grow in perfect rows, and her butterflies hover quietly nearby. This is an orderly garden, and the feeling is quiet and peaceful. I'm inspired to try embroidering with silk ribbon and beads because I love the texture the artist has created.

ARTIST / Mary L. Eischen

ARTIST / Laura Bailey

Mary Eischen's piece, on the other hand, is wilder—the piece is a jumble of flowers and foliage, and the airy blue fiber framing the piece contributes to its organic feel. This card inspired me, in part, on my Shelter project (see page 161).

LOOKING AT beautiful examples of other artists' work—and considering how to use the same materials, techniques, or composition in your own work—is sometimes all the creative guidance you need.

Color Wheels

YOU KNOW ALL those fabric, fiber, felt, or yarn scraps you just can't part with? Use them to create a color wheel. Seeing new combinations can open creative doors that were rusted shut just moments before! (You can also do this exercise with scrapbook papers, found objects, beads, or other craft materials.)

1. Cut shapes (or scraps) of predominantly red, yellow, blue, orange, green and purple fabric, felt, or fibers.

2. Choose a fabric for your backing; cut it to roughly 8 x 10 inches (20.3 x 25.5 cm).

3. Lay your scraps on the backing fabric so they resemble a wheel with the colors arranged in rainbow form; sew or glue the scraps in place, then embellish as desired.

...

NOT ONLY IS a fabric wheel beautiful to look at, but the juxtaposition of fabrics or fibers may inspire new creative direction.

107

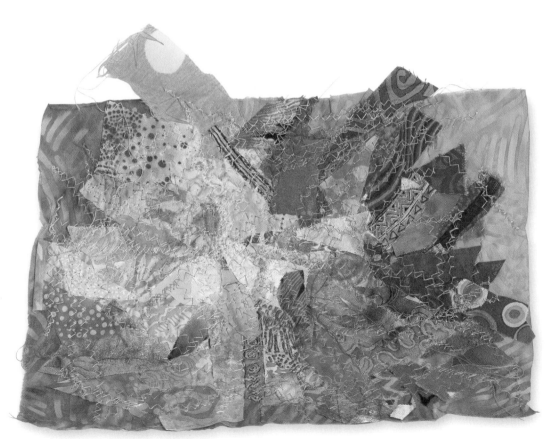

This fabric-scrap color wheel was sewn by Lisa Li Hertzi.

Hand-Painted Buttons

HAND-PAINTING YOUR own buttons is as simple as finding flat wooden shapes, using a hand drill to create holes, and painting to your heart's delight. Follow these simple instructions for using paint to create one-of-a-kind, signature buttons.

1. Start in the woodcraft section of your local craft store; you're looking for any flat, blank wooden shape, be it a round disk, heart, stars, or even letters.

2. Use a hand drill with a 1/16-inch (1.6 mm) or 1/32-inch (2.4 mm) bit to make holes in the wood for sewing. If you are going to add letters to the buttons, as shown here, be sure to drill the holes near the edge of the button.

3. Lightly sand the surface of the wood blank to prepare it for painting. Apply two base coats of acrylic paint to all sides of the button—don't forget the sides!—and let dry. Add your shading, painted designs, or symbols to the surface of the button as desired. Use rubber-stamp alphabets for letter buttons, or other small rubber stamps for a repeated motif.

4. When the paint is completely dry, apply one or two coats of clear acrylic sealant, then use very fine steel wool to give the button a smooth surface.

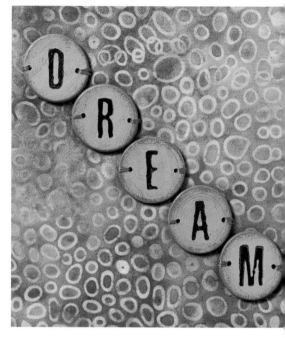

These hand-painted letter buttons have holes drilled near the edge, rather than the center, so the thread does not distract from their visual impact or obscure the letters.

HAND PAINTING your own buttons can serve as a project in itself, or as one step in the process of creating your project. Either way, the possibilities are endless for customizing your closures.

For more on buttons, see pages 102, 108, and 196.

Home Sources

Do you find yourself drawn to actual items that relate to your family's history? If so, consider tapping these "home sources" of information for inspiration or materials.

What is a home source? Anything from the bundle of family letters your mom tucked away in her dresser drawer to the quilt that was sewn by your great-grandmother; these items give you insight into the personalities of your family members as well as facts you may never have known about them. They may also provide clues about other family members, such as the names of distant cousins or long-lost uncles. Examples include:

- Announcements for births, weddings, and deaths
- Bibles
- Books with inscriptions
- Certificates
- Church records
- Journals and diaries
- Employment and pension documents
- Estate papers, probate records, and wills
- Family heirlooms, such as jewelry and furniture
- Family histories
- Funeral cards
- Insurance and loan papers

- Land records and deeds
- Letters and postcards
- Medical records
- Memoirs
- Military awards, medals, uniforms, and war memorabilia
- Newspaper or magazine clippings
- Oral histories
- Passports, visas, and immigration papers
- Photographs or albums
- School papers, diplomas, report cards, and yearbooks
- Old theatrical programs, LPs, collections of objects, and hobby materials
- Tax records

109

BY TAPPING INTO home sources, you may find that you and your grandmother shared a love of gardening—or that an old collection of her silk embroidery threads is perfect for use in your projects.

Stones for Healing

SOMETIMES, THE MATERIALS pick you, rather than the other way around. At least that's what happened when I made my first Beaded Chakra Meditation Fob in a recent beading class. The idea was simple—to select stones to represent each of the seven chakras, or energy centers, in the body.

I knew that many stones have healing properties, but we were advised not to read about the stones before selecting them; rather, to let ourselves gravitate to the stones that we felt naturally drawn to. It was only after our beaded fobs were strung and assembled that we learned the meaning of the stones and the healing properties associated with each. As it turns out the stones were exactly what my body and mind needed when I made the fob.

Each of the body's seven chakras, which correlate to major nerve centers on the spinal column, is associated with a different color: red (base or root chakra); orange (sacral chakra); yellow (gut and intuition chakra); green (or pink; heart chakra); blue (throat chakra); indigo (3rd eye, or brow, chakra); and violet (crown chakra).

...

CONSIDER SELECTING STONES and crystals based on the healing properties associated with those objects, or use the colors of those stones and crystals in your art.

110

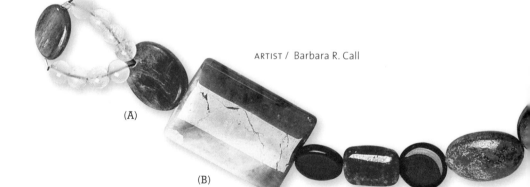

ARTIST / Barbara R. Call

(A)

(B)

(C)

(D)

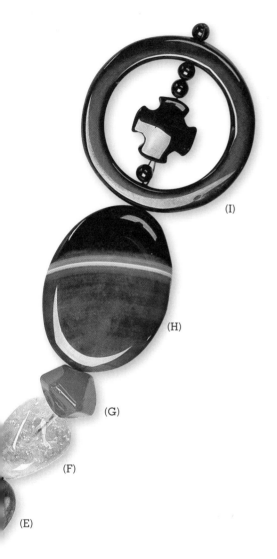

(I)

(H)

(G)

(F)

(E)

(A) Kyanite (top; for completion):
Develops telepathy and boosts the immune system.

(B) Amethyst (crown chakra):
Facilitates communication with angels and spiritual guides.

(C) Lapis lazuli (brow chakra):
Prevents negative thoughts from becoming karmic patterns; changes negative views of reality to positive outlooks; facilitates all healing.

(D) Chrysocolla (throat chakra):
Connects the thymus and throat for releasing grief and sadness; aids in the entrance of joy and universal love.

(E) Ruby fuchsite (heart chakra):
Collects emotions and soothes the release process.

(F) Citrine (naval/intuition chakra):
Stimulates the intellect, regenerates tissue, and clears, expands and aligns aura bodies.

(G) Carnelian (sacral chakra):
Aids creativity, raises moods, aids inflammation; promotes responsible sexuality, holds attention to the now; represents the wild feminine energy.

(H) Red and black sardonyx (base/root chakra):
A combination of onyx and carnelian (see properties, above and below).

(I) Black onyx (for grounding):
Black onyx absorbs and transforms negativity without storing it; it also aids inspiration, balancing, and has protective qualities.

///

Artist Trading Cards, Part I

ARTIST TRADING CARDS are everywhere—you might find them traded at mixed-media retreats, swapped at art parties, exchanged through the Internet—any place that mixed-media, fabric, and collage artists congregate.

Just what is an artist trading card, otherwise known as an ATC? In a word, it is a tiny (2.5 x 3.5 inch [6.4 x 8.9 cm]) mini collage, using fabric, fiber, paper, beads, buttons, and the like. There are no rules in ATC—except the size—and no constraints on materials. Typically the artwork is featured on one side, while the backside contains the artist's contact information and the date the ATC was made.

In short, an ATC is a terrific little platform on which to try new techniques or experiment with different media without the pressure of filling a large space, using yards and yards of fabric, or creating a masterpiece. ATCs are especially well suited to crossover artists, such as paper artists who've never worked with fabric and fiber, or bead jewelers who've never worked on fabric.

Check out the ATCs on this page, scattered throughout this book, or follow the directions for making ATCs on page 138.

ARTIST TRADING CARDS, a.k.a. ATCs, are the perfect platform for experimentation with new materials, found objects, and everything in between. They all measure 2.5 x 3.5 inches (6.4 x 8.9 cm), but other than that, the sky's the limit for design, technique, or materials.

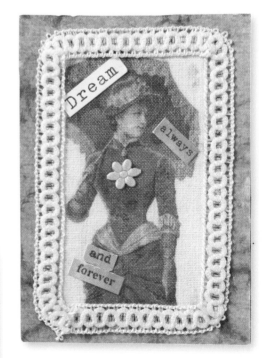

ARTIST / Mary Ann Richardson

These ATCs both feature the word dream, but each uses varying materials, color schemes, and embellishments to create different feelings associated with the same word.

112

ARTIST / Dorothy Debosik

Writing in Petroglyphs

TODAY'S TASK: Write (or just add) petroglyphs to your journal.

Petroglyphs are images carved in rock, usually by prehistoric peoples. They were an important form of communication in the days before writing. As such, they can be used as substitutes for words, creative embellishment in your projects, or just to create a secret code for sending messages to your lover.

Here are an assortment of petroglyphs to inspire your writing or your projects.

..

USE THESE SYMBOLS as icons in your creative work, shortcuts in your journal writing, or as your personal motifs.

Petroglyph key:

1. Warrior, honest
2. Regenerate
3. Friendship
4. Moon, night
5. Lightning, storm
6. Stars
7. Clouds
8. Solstice, woman, water
9. Rain, storm
10. Home
11. Running water, constant life
12. Sun, new life
13. Shaman, wise, watchful
14. Rainbow
15. Bird's feet
16. Sun, awake
17. Go this way
18. Man, self
19. North star
20. Found
21. Strong medicine
22. Discussion
23. Hill, mountain
24. Here, this place
25. Look this way
26. Sacred site
27. Waves, river
28. Trail

Recycling Clothing

TODAY'S TASK: Find an article of clothing and recycle it for a craft project. This could mean cutting apart that old bridesmaid dress that's been taking up room in your closet, stealing the buttons off a old dress shirt, or cutting mixed fabrics into strips, then braiding them as artists do for coil rugs.

The point is to look around your world and seek out a second use for some piece of clothing.

If you can't bring yourself to cut the fabric, consider scanning it, making color copies, or recreating the pattern, texture, or colors, using other craft materials.

..

GETTING IN the habit of reusing old items, or reinventing them in new ways, is a practical and frugal exercise that may take your art in totally new directions.

Pressed Flowers

FLOWERS, WHILE CERTAINLY inspiring in three-dimensional form, are easier to use in craft projects when rendered to two-dimensional form, whether that means photographing them, pressing them, or even scanning them directly.

Learning how to press flowers is one technique that is easy to learn and can yield material for dozens of uses. They can be affixed to projects using a fine paintbrush and acrylic medium or thinned craft glue.

There are two accepted techniques for pressing flowers: the beginner's way (paper and heavy books) and the more advanced method (using a flower press). For beginners, just press the flowers between two sheets of blotting paper, then place the sheets between several heavy books and weight with several additional books. Alternatively, place the objects in an old phone book, identify the plant by writing right on the page, and pile heavy materials on top. Using a flower press, while slightly more involved, does have its advantages: It is orderly, portable, and relatively inexpensive.

Using a Flower Press

1. Collect flowers, leaves, seaweed, or other botanicals. If they are damp, set them aside to let the surfaces dry before pressing.

2. Use two pieces of matte board (about $1/8$-inch [3 mm] thick) and white construction paper (cut to fit) for pressing. Avoid corrugated or ribbed cardboard, as this will leave line marks on your flowers.

3. Place a piece of matte board on the bottom of the press, followed by a piece of white construction paper. Position the botanical or flower on the paper, then top with a second sheet of paper followed by a second piece of matte board.

4. Close the press and leave for 24 hours. If the items are not dry when you open the press, change the papers and press again until completely dry.

5. Coat and protect the pressed item with acrylic matte varnish for protection.

...

CERTAIN FLOWERS are better suited for pressing than others. Botanical items such as leaves and ferns, as well as flowers with thin petals, such as pansies, clematis, violas, delphiniums, and petunias, work best.

See projects using pressed flowers on page 132.

114

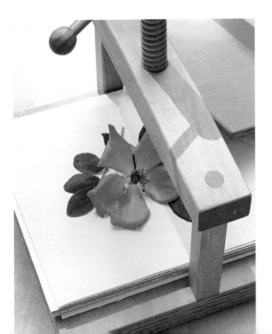

Reflecting on Relationships

THIS EXERCISE IN REMEMBRANCE and reflection is adapted from a seminar offered by my sister, Carolyne Call. It is designed to help you to rethink, reconsider, and reflect on your relationships (healthy or otherwise), and perhaps even to see beauty in emotional chaos.

The process is simple but the results can be transformative. To begin, reflect on a relationship and write free-form about your experience. Next, pull out key words, phrases, or events that represent your current feelings on that relationship. Highlight them, circle them, or write them on a separate piece of paper. Finally, rearrange those words or phrases or introduce new art elements in a creative way.

You can perform a similar exercise with poetry: Write a poem about a relationship. Type the poem into a computer file and place ample space between all the words and lines. Print the poem. (You can also transcribe the poem by hand on another piece of paper, leaving ample space as well.) Cut the poem apart, word by word. Place all the words into a bag or bowl and pick them out, one by one, to rewrite the poem. The rewritten poem can give you a new perspective on the relationship or your feelings, or it may tell a completely different version of your story.

Both of these techniques remind us that we have the power to reframe our thoughts, and that beautiful works of art can spring from the words we use to narrate our memories and experiences.

1. Find a quiet place to write, for about twenty minutes straight. Write about the end of the relationship (whenever that occurred). Start your writing with the single word *when* and move on from there. It should be stream of consciousness, without any breaks; everything is acceptable and no one will read the finished product.

2. When you are done writing, go back through it very slowly, and circle or underline any words or short phrases that stand out to you as having emotional power, that seem especially important, or that simply you like the sound of. They do not have to be connected to other words and they do not have to make any sense.

3. Assemble a stack of different colored papers, different textures, and so on. Take several pieces of paper and tear them into strips or pieces of varying sizes.

4. With the torn pieces of paper beside you, go back through the writing sample and choose pieces of paper on which to write each of your circled words or phrases. When you are done, you will have a stack of phrases and/or words on small slips of paper.

5. Take a large sheet of scrapbook paper and use it as your canvas. Arrange the words and phrases in any order you choose—move them around to see how sounds mix up or connect with one another. The end product is meant to be a poem or prose poem constructed from your torn pieces. Use other paper (vellum, tissue, and so on) to add dimensionality, cover up, or add further expression to your piece.

6. Use your journal to explore and/or record what you've learned from the experience or any new insights you may have gathered about the relationship or your reaction to it, role in it, remembrance of it, and so forth.

115

..

SOMETIMES, the act of remembering painful moments, but then re-creating them in the way we want, can be a powerful healing tool.

Words to Inspire: *Begin*

"Whatever you can do, or dream you can, begin it!
Boldness has genius, power and magic in it."

—Johann Wolfgang von Goethe (1749–1832),
German poet and dramatist

Global Collaboration

YOU MIGHT CALL it global collaboration: asking the world for help with your pet project. Only this project was bigger than most: Jennifer Marsh wanted to completely cover an abandoned gas station and its pumps with fabric. She set out in March 2007 with two goals: to draw attention (some might say protest) to the world's dependency on oil and to "connect with viewers and artists from all other cultures and parts of the world."

It took more than a year to spark interest in the World Reclamation Art Project (WRAP), but she succeeded, using word of mouth, the Internet, email, workshops, presentations, media interviews, and advertising. All told, she received more than 400 3-foot (91.4 cm) square panels from artists all over the world, and more than 2,500 12-inch (30.5 cm) square panels from students. Once stitched together with upholstery thread, she had gathered more than 5,000 square feet of handmade panels—stitched, crocheted, sewn, knitted, collaged, and more—that she used to cover the abandoned gas station.

"As an artist you make these objects alone, but you feel like you want to connect with people," she says. "After years of making sculpture with the door shut in my studio, I wanted a springboard to connect with my audience and other artists."

The second part of the project involved "finding something that we could all relate to," she continues. "I wanted to reuse, recycle, and reclaim the materials and the building. I had passed by that gas station all the time, so it was the perfect location."

This might have been Jennifer's first large-scale, outdoor art installation, but it certainly won't be her last. She was able to salvage about 50 percent of the panels, and she hopes to reuse them in a new installation. Since graduating from Syracuse University in May 2008 with a MFA in sculpture, she has taken a job in Huntsville, Alabama. While she hasn't found many abandoned gas stations, she has a theme in mind: "our worldview." What direction that will take remains to be seen.

For more information on Jennifer and her work, visit www.internationalfibercollaborative.com.

These photos show the gas station before and after the WRAP installation.

ARTIST / Jennifer Marsh

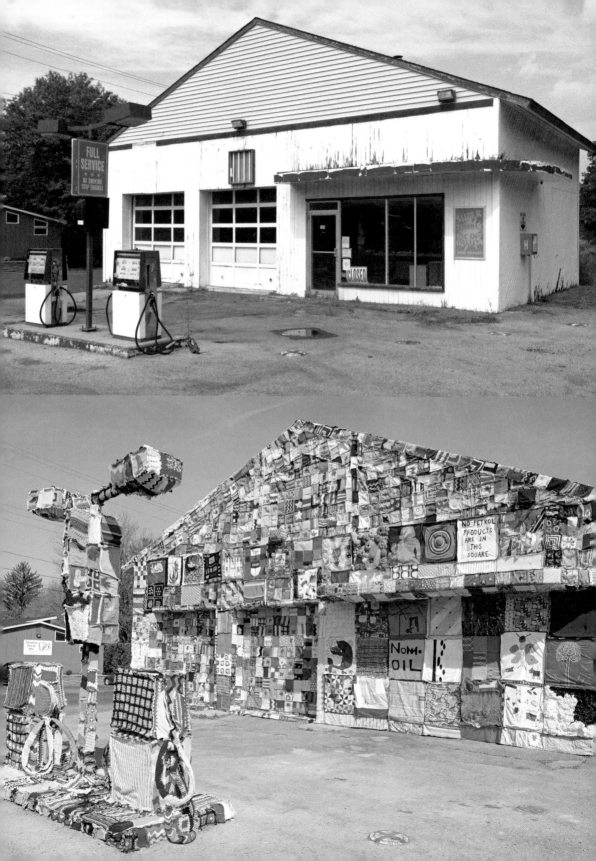

Writing as Art

ALTHOUGH MANY ARTISTS like to keep their journal entries private, keep in mind that your entries can also be made into projects or works of art.

Consider these ideas for reusing your written thoughts:

- Decorate a series of small, flat photo frames with journal entries or key words.

- Stitch a set of sachets, then add journal entries, using fabric ink.

- Create a week's worth of miniature boxes, each with a tiny journal entry or miniature book inside.

- Paint words or key phrases on stones or bricks for use in your garden.

- Embellish a set of candles with your favorite quotes or musings.

...

SOMETIMES your most personal thoughts and feelings make the most meaningful art. Other times, those entries need to stay private. The choice is always up to you.

> "Feelings are much like waves, we can't stop them from coming but we can choose which one to surf."
>
> —JONATHAN MÅRTENSSON,
> *motivational speaker*

Recycled Pockets

POCKETS, SUCH AS fabric ones found on the back of a pair of jeans or paper ones found in the front or back of a library book, can be recycled in several ways. You can remove the pockets and add them to other projects or clothing, embellish them to give them new life, or create your own pockets from paper or fabric scraps and add them to projects, clothing, and the like.

Pockets make great hiding places, either for unexpected treasures or secondary elements; most scrapbookers are well versed in creating, attaching, and filling paper pockets with pullouts, tags, and the like, but you can also think of pockets as metaphors.

Natasha Bedingfield's 2008 hit, *Pocketful of Sunshine*, brings to mind happy, carefree times, and the phrase, "got you in my back pocket" may remind you of your best friend.

...

POCKETS, whether new, used, or reinvented, can be used as hiding places for secrets, treasures, and hidden messages.

> "A book is like a garden carried in the pocket."
>
> —CHINESE PROVERB

Bandana-O-Rama

REMEMBER THOSE RED bandanas that every cowboy Halloween costume had to include? They've come of age—bandanas are now available in a wide range of colors, from hot pink to sizzling lime green, and many can be bought with pocket change. What's more, they're a versatile and timeless craft material. Consider these uses for your collection of bandanas:

- Color photocopy or scan your bandanas and print them for use in paper projects.

- Tie them into letters and create your own alphabet; scan or color photocopy the letters, then reduce them to the appropriate size.

- Stitch together a rainbow of bandanas for a quick fabric journal.

- Cut them up and use them for embellishing fabric projects or altered clothing.

- Cut them into thin strips, then use them to create your own yarn, fiber, or tassels.

- Use them as building blocks for three-dimensional pillows or fabric sculptures.

- Add beads, charms, or feathers and turn them into unique necklaces, headbands, or wristbands.

- Embellish the printed designs with seed beads, then use them to cover a store-bought journal.

- Sew them together to make a lap quilt, wall hanging, or pillows.

- Copy the swirling motifs and/or designs, using ink, stitching, beading, or paint to create your own unique embellishments.

BANDANAS—that quintessential symbol of the American Wild West—can be a colorful source of inspiration or an inexpensive, precut square of fabric that's fun and and easy to work with.

119

This ATC uses a second pocket to hide a fiber-embellished paper tag.

ARTIST / Normajean Brevik

Symbols for Transformation

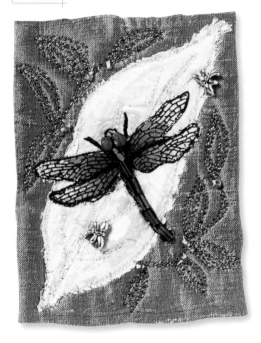

IF YOU'RE GOING THROUGH A TRANSITION, change, or new stage of life, you'll find that Mother Nature offers a wide assortment of symbols that can be used to represent change: an unfolding flower, the growth of a tree, a baby bird leaving its nest, geese flying south, even the changing seasons.

Two insects in particular are often used as symbols for change (and freedom): butterflies and dragonflies. The process of metamorphosis, where a caterpillar turns into a butterfly or moth, is a classic analogy for change and awakening. In a similar vein, the transformation of a dragonfly nymph into a beautiful winged insect can serve as another symbol for new life, new growth, or enlightenment.

..

120

This stitched dragonfly makes a beautiful embellishment to this artist trading card.

ARTIST / Melanie Borne

SYMBOLS—which are shorthand for meaningful messages, words, or phrases—can be inspirational on their own, used to communicate in a "secret" language, or just used as beautiful embellishments.

The Language of Flowers

IN THE KORAN IT IS SAID, "Bread feeds the body, indeed, but flowers feed also the soul." It's easy to understand why flowers have been a part of every culture for thousands of years; not only are they fleeting and unique works of art in themselves, they can be used as a source of design, as a harbinger of thoughts or messages, or as dots of color in an otherwise gray world.

Researching and understanding the secret language of flowers is an ancient art, and throughout the ages flowers have been infused with symbolism and meaning. Blue flowers, for example, have several different meanings:

> "In its dark, regal tones, blue can express trustworthiness, confidence, intelligence and unity, which explains why it's frequently the color of police uniforms, why the blue "power suit" is an icon of the business world and why winners of competitions receive blue ribbons. And yet, in its softer hues, blue can embody the uplifting spirit of a sunny sky or soothing ocean— perhaps explaining why so many of us choose blue flowers when we want to send a message of calming beauty, tranquility, and peace."

CONSIDER STUDYING the language of flowers, examining the intricate design of flowers, taking photographs of blossoms, stopping to smell the roses (literally), or just buying flowers and creating a beautiful arrangement for your workspace.

Photographs by Barbara R. Call.

Receiving a Guided Meditation

IF YOU'RE READY to experience a guided meditation, keep these tips in mind for accessing your innermost thoughts, feelings, and emotions.

First, and foremost, remember not to try too hard. There is no right or wrong way to experience a guided meditation, and you may have one kind of experience one day, but something completely different on another day. Also, your experience may be completely different from that of your neighbor or friend.

- Cover your eyes to block out all light; this may help you relax more quickly. (This can be as easy as tying an opaque scarf around your head).

- Wear comfortable clothes and sit (or lie) in a comfortable position.

- Don't try to force the process; just relax and let it happen.

- Let go of expectations—let yourself be surprised.

- Let your spirit lead you in the ways that are best for you. (Some people are visual, meaning they experience beautiful images, while others capture pure feeling, emotions, or thoughts. Don't judge your way or envy another—it's different for everyone, and it's all good!)

- If you have trouble quieting your mind, focus on the natural rhythm of your breath or the background music.

- Keep a pen and paper close by for making notes. As soon as the meditation is over, and before you're fully "present" again, be sure to jot down any images, feelings, or messages you received during your relaxed state. These can be a rich source of inspiration for many creative endeavors.

- If you plan to try it again, consider keeping a meditation journal in which you can record your thoughts or images—this may reveal patterns or reoccurring themes over time.

- Have fun! Let it be an adventure in exploring yourself like no other.

...

DON'T BE SURPRISED if every guided meditation is different—I've had beautiful, long streams of images, almost like complete dreams, in some meditations; broken, fragments of images or locations in others; and I've even fallen asleep in others. Don't judge your experience—just use it for wherever it takes you, unencumbered and without worry.

"To make the experience a conscious memory, I instruct those finishing a meditation to journal without talking, capturing all important thoughts, feelings, or images. In future meditations and/or journal writing, notice any patterns or repeated themes, images . . . these are often the main points to be considered and to work with."

—LYNN MCLOUGHLIN,
artist

Simple Felt Journal

THE BEAUTY OF working with felt (or fleece, for that matter) is that neither type of fabric needs to be hemmed. This week, try making a simple fabric journal by stitching several colorful sheets of felt together at one side, then embellishing the pages with the simple embroidery stitches shown on page 127.

Here are several ways to use embroidery on your felt pages:

- Use a blanket stitch to finish the edges of your pages.

- Add background texture with tiny stitches worked close together in an irregular pattern.

- Edge or frame fabric appliqué by embroidering around the edges of the piece.

- Add details to appliqué, such as stems on flowers, beads to represent eyes, etc.

- Outline a design or shape, then fill it in with beading or sequins.

- Add words or text to a page.

You can also decorate your felt pages with such items as beads, sequins, brads, trim, fiber, sewing notions, or machine stitching. The possibilities are endless!

You can also use the running stitch and cross stitch shown on page 127 on paper or vellum (because paper often tears or crumples during stitching, adhere the paper to cardstock with spray adhesive before stitching).

..

FELT IS AN EASY material to work with, and experimenting with embroidery thread and stitches may take you in new creative directions. Thread your needle and start stitching!

Beyond Laundry: Bleach

YOU MIGHT THINK chlorine bleach is just for getting your whitest whites even whiter, but this household chemical can also be used to alter photos, fabrics, and even yarn. Note: Always wear rubber gloves, protect your eyes, and work in a well-ventilated area when using chemicals such as bleach.

Bleaching Photos

Start by filling a shallow pan with water. Fill another pan with a fifty-fifty mixture of water and bleach. First dip the photo into the plain water, then into the bleach mixture. When the colors of the photograph begin changing, rinse immediately in a second pan of plain water. Work quickly and watch your work carefully, as the timing is critical.

To bleach out certain areas, use a paintbrush with synthetic bristles. Rinse your photo in the plain water once you've created the desired effect. Alternatively, use a bleach pen to add words, create patterns, or highlight certain areas in a photo. For this technique, apply the bleach pen directly to a dry photograph, let the bleach sit for about ten seconds, then wipe it off with a damp paper towel. Rinse the photo in plain water once you've achieved the desired results.

REMEMBER these two simple principles: (1) Bleach removes color, meaning it works best with darker photos. (2) The longer it sits, the lighter the result, starting at red, going to yellow, and finally reaching white. If your photo turns completely white, it means all of the emulsion was removed. Next time, work more quickly.

Here a bleach pen was used to write "new day" in the darker area of the bottom of this photo and to add polka dots to the two poles intersecting the horizon.

ARTIST / Karen Michel

SEP X X ENT'D

Borrowed Tools

GOT A CRAFTY FRIEND? Ask if you can borrow a few of his or her favorite tools for the weekend. Ask your friend to mark them with his/her name so they don't get absorbed into your collection (or do so yourself as soon as you receive the items), then make the most of your borrowed time—try using the tools on an assortment of materials and in a variety of ways.

Rubber stamps, for example, can be used with acrylic paint; a borrowed sewing machine can be used to add stitching to paper; and that friend's box of trinkets might just contain the perfect crowning jewel for your project.

EVERYONE NEEDS a fresh infusion of inspiration from time to time, and borrowing a tool or technique every now and again is a simple but effective way to achieve this.

"The meeting of two personalities is like the contact of two chemical substances; if there is any reaction, both are transformed."

—CARL JUNG (1875–1961),
Swiss psychologist

Words to Inspire: *Occasional Wildness*

"The healthy being craves an occasional wildness, a jolt from normality, a sharpening of the edge of appetite, his own little festival of the Saturnalia, a brief excursion from his way of life."

—ROBERT MORRISON MACIVER (1882–1970),
Scottish-born American sociologist and philosopher

The *Mona Lisa*

SHE MAY HAVE the most famous face in the world: Leonardo da Vinci's *Mona Lisa*, which hangs in the Louvre in Paris. At home amid top art icons, the *Mona Lisa* has inspired artists all over the world since its creation around 1503.

The painting is believed to be a portrait of Lisa Gherardini, the wife of a Florentine cloth merchant named Francesco del Giocondo. But even these historical details are still shrouded in mystery, which may help explain the painting's universal appeal. Even the curators of the Louvre do not know who, exactly, is shown in the painting, who commissioned the portrait, how long Leonardo worked on the painting, and, perhaps most important, how it ended up in the French royal collection.

What is known, however, is that Mona Lisa's smile has been reproduced thousands of times, in formats ranging from fabric and fiber to paint, paper, and jewelry.

ICONIC FIGURES such as Mona Lisa have a timeless appeal and myriad interpretations. Even the briefest hunt for versions of this famous portrait show the creative liberty other artists have taken. You're sure to find inspiration somewhere along the way.

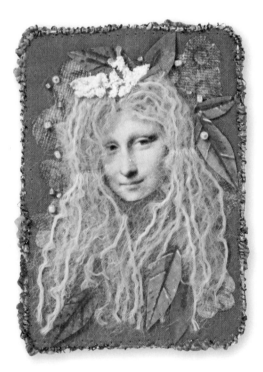

These pieces demonstrate just how versatile—and endearing—the image of Mona Lisa can be. For the charm bracelet, artist Anne Sagor stamped a miniature of the painting on the backside of a domino; ATC artist Sherry Boram turned her Mona Lisa into a blond woodland nymphlike creature, using fiber and fabric.

Embroidery 101

MATERIALS

EMBROIDERY THREAD, EMBROIDERY NEEDLES, SCISSORS, AND FABRIC OR PAPER

Thread your needle with about 18 inches (45 cm) of embroidery thread. Test these stitches before starting your final project.

BASIC EMBROIDERY stitches can embellish everything from curtains and lampshades to scrapbook pages—think beyond the fabric!

Blanket stitch: *Work from left to right. Bring the thread out at the position for the looped edging. Insert the needle above and a little to the left of this point as shown, and make a straight downward stitch, with the thread under the tip of the needle. Pull up the stitch to form the loop, then repeat.*

Running stitch: *Working from right to left, pass over 5 to 6 threads of the fabric (depending on the weave, ⅛ to ¼ inch [3 to 6 mm]) before inserting your needle. Bring out your needle and make the next stitch 3 or 4 threads away (⅛ inch [3 mm] or less).*

Chain stitch: *Bring the needle out to start the first stitch. Loop the thread and hold it down with your left thumb. Insert the needle where it first emerged, and bring the tip out a short distance below this point. Keep the thread under the tip of the needle and pull the needle through. For the next stitch, insert the needle into the hole from which it has just emerged.*

Double running stitch: *Work a row of running stitches, then work a second row in the same or contrasting color. The second row of stitches should fill the spaces between the stitches in the first row.*

Straight stitch: *These single, spaced stitches may vary in size. Simply insert the needle where you want the stitch to start, and exit where you want the stich to end. Take care not to make them too long or too loose.*

Cross stitch: *(1) Work one or more evenly spaced diagonal stitches in one direction; (2) cover with one or more diagonal stitches worked in the opposite direction.*

127

Make a Leather Journal Cover

IF YOU LOVE THE LOOK and feel of a leather cover for your journal but don't want to splurge on one every few months, the solution is at hand: Make your own removable, stamped or embellished leather journal cover.

Start with a blank sketchbook and three pieces of untreated, vegetable-tanned cowhide or leather. (See box, at right, for sizes). On the right side of the large piece of leather, stamp your design using permanent ink. Use leather-compatible paints to color the images, then sponge on brown permanent ink to created an aged look. Further embellish the cover as desired, using beads, charms, buttons, and the like; alternatively, punch holes in the leather to attach items or decorate with eyelets.

Turn the decorated leather cover to the wrong side and use a thin line of leather-compatible glue to attach the two sleeves to the short ends. (These will form the pockets where the cover of the blank journal will fit.) Finish the journal cover with a light rubbing of furniture wax and insert your blank journal.

Leather Sizing

For a blank journal measuring 4 x 6 inches (10 x 15 cm), cut the leather into a 7 x 10-inch (18 x 25.5 cm) rectangle for the cover and two 2 ½ x 7-inch (6.5 x 18 cm) rectangles for the sleeves.

For a blank journal measuring 6 x 9 inches (15 x 23 cm), cut the leather into a 10 x 14-inch (25.5 x 35.5 cm) rectangle for the cover and two 2 ½ x 10-inch (6.5 x 25.5 cm) rectangles for the sleeves.

128

HANDMADE LEATHER covers add a classic, timeless touch to your journal, and they make a great gift.

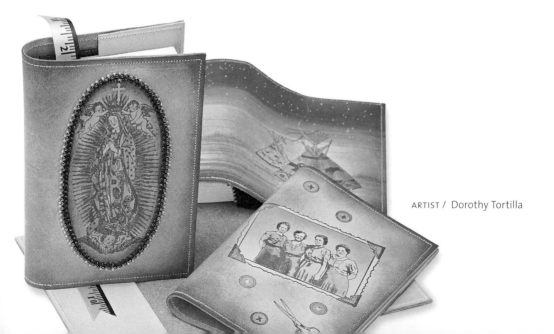

ARTIST / Dorothy Tortilla

Crafting from Trash

WHAT ARTIST HASN'T found inspiration in a used or discarded item? These days, with global warming on many people's minds, the idea of reusing trash, discarded items, or recycled goods is even more compelling.

Today, take a walk through your neighborhood or city block in search of trash that can be used in your crafts.

Be open to whatever you find, and don't reject anything right away—try to imagine it in another form, another color, or even another use.

...

IMAGINING the possibilities, and seeing the potential in a discarded item, is a skill that can be honed over a lifetime.

Make Your Own Colored Paste Paper

ARTIST JAN BOYD uses paste paper pages in her artwork (see page 33), and you can learn this technique in an afternoon. The result: beautifully colored and textured paper that's perfect for journaling or other book projects.

MATERIALS

FLOUR, WATER, COLORED ACRYLIC PAINTS, PAPER, PAINTBRUSH AND TEXTURING TOOLS, SUCH AS A STYLING COMB, FOAM BRUSH, OR OLD KITCHEN UTENSILS

1. Add 2 tablespoons (30 g) of flour to 2 cups (475 ml) of water in a small saucepan or pot. Let sit until there are no lumps.

2. Bring the flour mixture to a boil over medium heat, stirring constantly. Remove the mixture from the heat and let it thicken to a paste as it cools. Cool the paste to room temperature before continuing.

3. Mix in your desired color of acrylic paint, then brush the paste generously onto the paper surface.

4. While the paste is wet, drag the styling comb or other tool through the paste to create patterns. Set the paper aside to dry completely before using it for projects.

...

WITH PASTE PAPER, a colored flour paste is the basis for free-form designs. This simple technique can be used over and over to create beautiful and unique paper.

Two mottled colors of paste paint form rays that suggest a summer sunset. The design shown was made by jerking an adhesive spreader, but you could substitute a chopstick or other sharp device to create a similar pattern.

129

Assembling Personal Shrines

A SHRINE IS A PHYSICAL TRIBUTE built to honor the people or things we love. Gathering special objects and assembling them into a shrine is an ancient art, found across the centuries in all corners of the world. The ancient Greeks, for example, constructed the Parthenon, a temple of the goddess Athena. Other large well-known shrines or shrinelike structures include Notre Dame in France, the Taj Mahal in India, and England's Stonehenge.

Your own shrines needn't be as large or as grand, but they can be just as meaningful. Creating a personal shrine only requires an active imagination, excitement or passion for the subject, and some basic craft supplies. That said, shrines do share two basic, universal elements: They are usually elevated or positioned in an important spot, and the items featured in the shrine should have a specific symbolism or purpose.

Follow these steps as you begin building a shrine:

1. Decide on a theme (or an honoree). Think of a subject, topics, or person you're familiar and comfortable with.

2. Research and gather items that reflect your feelings, fit the theme, or relate to the project.

3. Decide how you want to display the collected items. Ideas range from framed shadow boxes to recycled objects, triptychs, boxes, and the like.

4. Select the emotion(s) you want your project to convey, such as happiness, seriousness, or quiet reflection. The colors you choose and contents you include can both help drive this process or help communicate your feelings.

5. Gather your supplies and begin assembling. Exercise your eye for design by arranging and rearranging a layout or composition until you find the right balance and structure. Don't be afraid to experiment with unusual placement or positioning, or sketch out several designs and sleep on it before you begin attaching things permanently.

..

SHRINES HAVE EXISTED for thousands of years, and as a basic art form they have many possibilities.

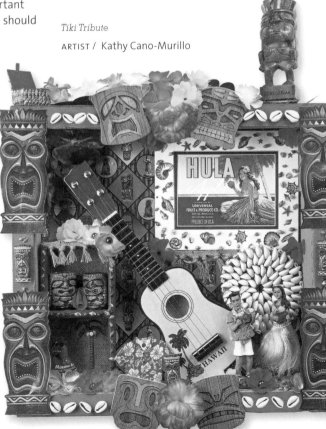

Tiki Tribute

ARTIST / Kathy Cano-Murillo

Georgia O'Keeffe

MANY AN ARTIST, naturalist, or creative type has found inspiration among the works of Georgia O'Keeffe, a feminist and well-known artist whose images grace the halls of museums and galleries worldwide. O'Keeffe is best known as an American Modernist, a loosely defined period of art that does not have one dominant style or approach. As such, it includes artists as diverse as Charles Sheeler, Elsa von Freytag Loringhoven, and Arthur Dove, among others.

O'Keeffe's works are generally organized into three periods: the Early Years (1915–1918); New York (1918–1929); and New Mexico (1929–1984). She may be best known for works from this last period, which includes her iconic flowers, bleached desert skulls, and other abstract scenes of the American Southwest.

..

GEORGIA O'KEEFFE'S unique and colorful style of expression has gained her a wide following over the years. Her artwork, her life, and even her story may serve as the spark you need to rekindle your creative fires.

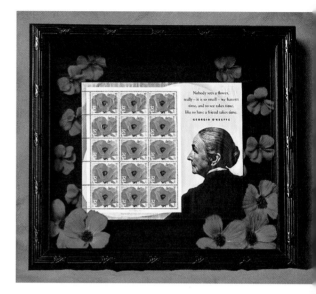

Georgia O'Keeffe shadow box of glass, black silk mat, red silk poppies, and stamps.

ARTIST / Robin Jumper

131

Using Pressed Flowers

YOU HAVE A bounty of pressed flowers, and now you're looking for ideas on how to use them. Consider these pressed flower projects for inspiration.

Use the flowers to alternatively decorate terra-cotta pots:

- Paint, decoupage, or embellish the pots.

- Drape and affix strands of seed beads along the rim.

- Distress the surface using crackle medium.

- Rubber-stamp images, words, or phrases onto the unfinished surface.

Display pressed flowers under organza:

- Capture seed beads, coins, or found objects under organza in mixed-media collage.

- Use sheer white organza pockets to add embellishments to jeans.

- Cover shadow box, book, or journal openings with sheer organza in varying colors.

- Use organza to represent netting in fish-related projects.

- Substitute sheer ribbon, and construct a runner.

To make these pressed pansy pots, seal the terra-cotta flowerpots with water-based varnish, paint as desired, then glue the pressed flowers in place. Seal the pot completely with 4 to 6 coats of water-based varnish.

ARTISTS / Sandra Salamony and Maryellen Driscoll

These simple sewn greeting cards display pressed flowers and their seeds under sheer white organza. When sewing, set your machine to a long stitch length.

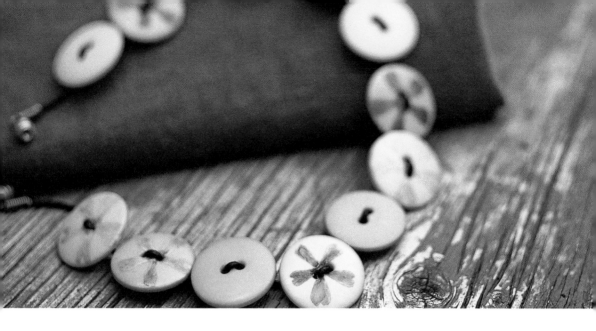

Phlox Button Necklace

SUPPLIES

MATTE ACRYLIC MEDIUM; 13 TO 18 LARGE ROUND BUTTONS IN PEACH, LAVENDER, AND GREEN; PRESSED PHLOX FLOWERS; SATIN WATER-BASED VARNISH; BLACK LEATHER CORD; FOAM BRUSHES; CRAFT KNIFE; 2 SMALL COIL CRIMPS; PLATED SCREW CLASP; JEWELRY PLIERS

1. Coat the surface of each button with acrylic medium. Place a pressed flower on the damp surface, avoiding the button holes if possible. Repeat as necessary and let dry completely.

2. Apply one coat water-based varnish to the surface of each button and let dry. Use your craft knife to trim away any material covering the button holes and seal again as needed.

3. String the flowered buttons, alternating with plain buttons, on the leather cord. Test fit the necklace against your neck to determine the correct length.

4. Fit a small coil crimp over each end of the cord, then pinch closed with pliers. Separate the screw clasp into two pieces and attach each piece to the end of the cord using the pliers.

PRESSED FLOWERS can be used in a variety of craft projects, from making decorative household objects or greeting cards to jewelry, collage, and more. Try pressing leaves, seed pods, and grasses as well.

Color Preserved

Varnishing can cause the flower colors to fade, but you can use watercolors to reinforce or change the color of your flowers.

Pet Journals

LOOKING FOR A NEW WAY to express your feelings? Why not chronicle the life of your pet by creating a pet journal?

This can take any form you like, whether you choose to write about life from your pet's perspective, fill a scrapbook with photos and pet-related mementos, or simply chronicle the milestones and events of your pet's life.

OUR PETS ARE a big part of our lives, and, like our children, can be a natural subject of our art and craft.

In the example shown here, artist Stephanie McAtee created a decorative memory file for her dog, Hogan. The journal is made from an manila envelope and a plastic sleeve containing a miniature photo book. The files contains Hogan's pedigree papers, while the book is filled with photos from his first week in their home.

Blank Slate: Cigar Boxes

WHAT WOULD CREATIVE TYPES have done without the cigar box? This elegant and durable form of packaging can be the base for many a project, from purses and guitars to memorials and beyond.

At their simplest, cigar boxes are containers; as is, unadorned, they're the perfect size for storing craft materials, photos, or trinkets. Decorate, embellish, or add paint, paper, and trinkets to their surface and it's transformed into a gift box for handmade cards, stationery, or recipe cards. They can house books (purchased or handmade), double as shrines, or just corral a collection of items.

As with many versatile materials, you can take them apart and use their cardboard or balsa wood components for journal covers, book pages, and the like.

CIGAR BOXES are available at flea markets, yard sales, online, and anywhere used or recycled items are sold. Decorated cigar boxes are the perfect vehicle for holding special items, from books and memories to lipstick, spare change, and keys.

Crackle medium is a great tool for making wooden objects appear old. The box opens to reveal a set of miniature handmade books.

ARTIST / Jenna Beegle

135

Working with Wire

HAVE YOU EVER WORKED WITH WIRE? It's a versatile material that can add a bold statement or a delicate overtone to your work. Fine wires, such as those sold at bead shops, can be crocheted into overlays or twisted into jewelry, whereas heavier-gauge wires can be made into baskets, window decorations, bowls, or napkin rings, or used in more free-form, sculptural ways.

Sample this trio of wire techniques for inspiration:

THINK BEYOND jewelry making and basket weaving. Use wire as you would a soft fiber—it can be wrapped around items, used to attach objects, or manipulated on its own.

Knitting wire: *Choose a lightweight copper wire, such as 26-gauge, and a pair of knitting needles in an appropriate (larger) size. Add beads or sequins for extra dazzle. (For basic knitting instructions, see page 154.)*

Chain mail: *Although somewhat labor intensive, handmade chain mail is a creative process in itself. You'll need pliers and jump rings, and the technique is simple: create a chain of rings, and interlock each chain of rings. This elaborate example shows an alternating pattern of a single ring linked through two rings, but there are many traditional chain mail designs to experiment with.*

Sculpted wire: *You'll need a bendable wire, such as 12-gauge, and a pair of pliers, for this technique. Some people find it easier to draw the desired shape and form on paper before bending and manipulating the wire.*

Travel with a Pocketful of Pockets

TRAVELING, ESPECIALLY WHEN it involves exploring new regions or corners of the world, is a rich source of inspiration for many craftspeople.

The next time you are planning a trip, purchase several clear plastic sleeves meant to hold slides or small photographs (available at office supply stores.) These ready-made sheets are the perfect container for collecting miniature mementos such as coins, bottle caps, paper scraps, ticket stubs, and the like.

The spoils of several trips can be stowed in a three-ring binder, full of tiny items and trinkets.

COLLECTING MEMENTOS can happen naturally—as in the assortment of paper scraps that pile up with any trip—or purposely, as in gathering coins, wrappers, postcards, and trinkets. Having a place to stash those items makes it easy to collect them.

133

Gone Fishin'

GOT LEFTOVER FISHING lures, line, or swivels? These items—as well as tackle boxes—make great materials for a wide assortment of projects.

..

REMOVE THEIR HOOKS and many fishing lures make great charms, trinkets, and metal embellishments for your paper, fabric, or wood projects. Tackle boxes, both recycled or brand new, can be transformed into memory boxes, storage devices, or shrines.

An old fishing lure is attached to a fish-themed journal page using an eyelet.

ARTIST / Lesley Jacobs

Artist Trading Cards, Part II

SO YOU'RE INTERESTED in learning how to make an artist trading card (ATC)? A great place to start is this basic technique for creating a collaged felt ATC for stitching.

You'll need the following materials:

- 9" x 12" (22.9 x 30.5 cm) piece of fusible webbing
- 9" x 12"(22.9 x 30.5 cm) sheet of felt
- 9"x 12" (22.9 x 30.5 cm) piece of white tissue paper
- Scrapbook paper scraps
- Acrylic gel medium (matte)
- Decorative tissue papers
- Embellishments
- Assorted rubber stamps
- Black rubber-stamping ink
- Coloring agents (ie., watercolors, water-soluble crayons, ink pads, etc.)
- Acrylic glaze in yellow
- Metallic paints
- Iron
- Heat gun
- Rotary cutter, ruler, and rotary mat
- Sewing machine and threads (optional)

Creating the Collaged Background:

1. Set your iron to the cotton setting and, following the manufacturer's instructions, iron the fusible webbing to the felt. When cool, peel off the paper backing.

2. Fuse the piece of white tissue paper to the fusible webbing side of the felt piece.

3. Cover the white tissue paper with torn scraps of scrapbook paper using gel medium (see sample, next page).

4. For a more complex look, tear pieces of decorative tissue paper and/or sewing patterns and place on top of the scrapbook papers (sample 2).

5. Use your rubber stamps and black ink to randomly stamp on the collaged felt.

Coloring the Background:

1. Using your coloring agents, paint the background (sample 3). When dry, paint yellow fluid acrylic glaze on top.

2. Heat-set the design with a heat gun.

3. Add other paint or stamped designs as desired.

Cutting Your ATCs:

1. Lay the collaged felt on a rotary mat.

2. Measure 2½-inch (6.4 cm) -wide increments across the collaged felt and cut using the rotary cutter.

3. Turning to the side of the mat so you can cut crosswise, measure 3½-inch (8.9 cm) -long increments. Cut into eight or nine ATCs, depending on how you orient the cutting.

Embellish and Finish:

Your ATCs are now ready for stitching and/or embellishing. You can rubber-stamp onto the ATC, stitch on other fabric or fibers, add beads or buttons, or attach found objects, words, or photos. The options are limitless!

...

YOU CAN USE this basic technique to create a wide variety of ATC forms, then embellish them in many different ways.

Sample 2: To further embellish the collage: Add torn tissue paper or sewing patterns, or stamp images in black ink.

Sample 1: To create a collaged background: Iron fusible webbing to the felt, fuse white tissue paper on top of the webbing, then add torn paper scraps on top of the tissue paper with gel medium.

ARTIST / Patricia Bolton

Sample 3: Paint the background with a coloring agent of choice, seal with acrylic glaze and heat set, then finish with other painted or stamped designs.

Fabric Journals, Paper Journals

IF YOU'RE A PAPER BOOK ARTIST who's interested in dabbling in fabric journals, or new to the entire world of fabric journals, you may be in for a few surprises.

There are several important differences between making the two types of journals:

Paper: When using paper, everything cuts neatly with a craft knife or paper trimmer. With precise measurements and careful cutting, you can produce an exact result time after time.

Fabric: Contrast that with fabric, where the edges can fray. What's more, the more the cut edges of fabric are handled, the more likely they are to fray. The best advice: Sew (or finish) a cut edge as soon as possible after cutting.

Paper: When you need a sharp crease in paper, you score the paper, fold it, and then burnish with a bone folder.

Fabric: Fabric can be folded and creased like paper, but the tools for the job (and the results) are different. Instead of a bone folder, the fabric journal artist uses a steam iron. While a single thickness of fabric will hold a crease, stitching may be necessary to hold multiple layers in place.

Paper: Paper, boards, and other pages are joined together with glue.

Fabric: Sewing replaces the glue bottle in most cases with fabric journals. It is possible, however, to construct a fabric journal without sewing a single stitch: You can work with fabric glue or fusible adhesive. Fusible adhesives, which use the heat of an iron to activate the glue, can be used to attach lining, interfacing, trim, appliqué, and edge binding, to name just a few.

...

TRY YOUR HAND at making a fabric journal, or incorporate hand-sewing, beads, and sewing notions into your paper journals.

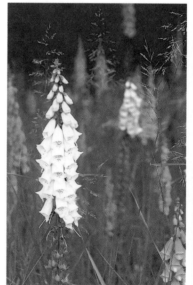
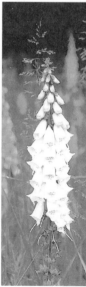

Your Digital Photo Palette

BOTH FILM AND DIGITAL PHOTOS can be developed and printed through a number of online photo management services, and many sites offer photo-editing options. At their most basic level, these sites have "instant fix" that can improve less-than-ideal cropping, poor contrast, pink eyes, or other mild defects of the original photos. The more advanced features include tints and artistic effects, such as the ones shown below. Although these don't compare to the sophisticated tools offered by professional photo editing software, they are easy to use and require little to no instruction.

ONLINE PHOTO-DEVELOPING sites offer a wide range of photo-editing effects as well as personalized books, photo-related gifts, and more.

141

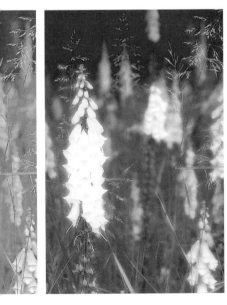
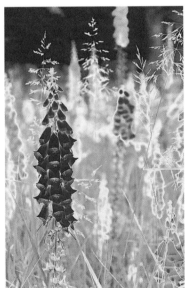
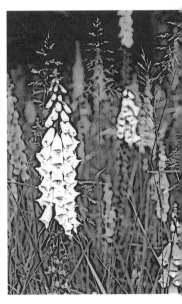

These photos show some of the editing effects available at online photo developing sites (from left to right): the original photo, grayscale, softglow, solarized, and cartoon.

PHOTOS / Barbara R. Call

Words to Inspire:
Searching for What You Need

"Ask, and it will be given you;
Search, and you will find;
Knock, and the door will be opened for you."

—MATTHEW 7:7

Tapping Current Events

THE 2008 KENTUCKY DERBY had a field of nineteen thoroughbred colts and one dark gray filly named Eight Belles. It's unusual for a filly to run in this race, in part because most colts are bigger and stronger than the female horses at this age. Eight Belles, however, was an exception: She ran with spirit and heart rivaling that of her male competitors.

Many horse-racing fans will never forget the tragic outcome of that race: Eight Belles finished second to winner Big Brown, only to stumble in the back stretch and break both front ankles. The filly was euthanized on the track but memorialized at the Kentucky Derby Museum the following September.

A meaningful event like this can inspire a shrine, a memorial, or phrases and sayings. For example, one could say of Eight Belles, "Strong fillies are never afraid to run with the colts" or "Never be afraid to reach beyond your means."

Everyday newspapers are filled with such food for thought … and creative expression.

..

IF YOU FIND yourself in want of ideas, pick up a daily newspaper or read a hefty Sunday paper. A news item, profile, obituary, or even an advertisement may strike a creative chord.

142

The Rainbow Connection

TECHNICALLY SPEAKING, a rainbow is an arc of light refracted by rain, spray, dew, mist, fog, or ice. Occasionally, rainbows can also appear in circular, striped, or flamelike shapes.

Artistically speaking, however, rainbows are sky-borne palettes, divine clues, and so much more than refracted light.

Rainbows have a long symbolic history, perhaps in part because they only occur under special circumstances. To the Greeks, the goddess of the rainbow traveled up and down the arc as if it were a stairway to Earth. More recently, rainbow flags have been used all over the world to represent peace, hope, and diversity (for this reason, in recent times, gay pride groups have picked up the rainbow as their symbol). The colors in the rainbow align with the colors of the seven chakras, a concept used in holistic healing (see page 110).

Remember the old memorization tools from childhood, "Roy G. Biv" or "Richard of York Gave Battle in Vain"? These are easy ways to correctly order the colors in the visible spectrum: Red, Orange, Yellow, Green, Blue, Indigo, and Violet.

Today's exercise: Work a rainbow theme into your work.

..

RAINBOWS ARE MYSTICAL, weighty symbols that can infuse all styles of artwork with added meaning.

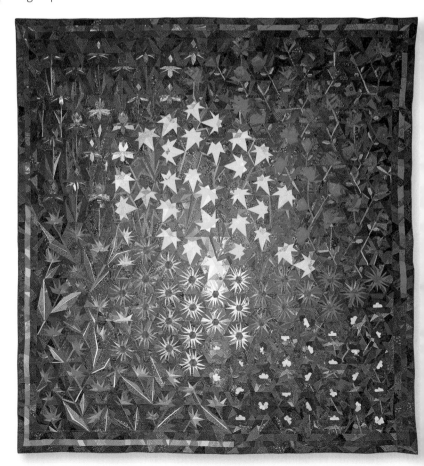

Quilt
ARTIST / Ann Trotter

The SCAMPER Concept

MANIPULATION IS THE BROTHER OF CREATIVITY, says Michael Michalko, author of *Tinkertoys: A Handbook of Creative-Thinking Techniques.* "When your imagination is as blank as a waiter's stare," he writes, turn to the concept of SCAMPER.

What, exactly, is meant by SCAMPER? It's a checklist of idea-generating questions, some of which were first suggested by Alex Osborn, a creativity pioneer. Later, they were arranged into this mnemonic by Bob Eberle:

Substitute something.

Combine it with something else.

Adapt something to it.

Modify or magnify it.

Put it to some other use.

Eliminate something.

Reverse or rearrange it.

To use SCAMPER, Michalko suggests two steps:

1. Isolate the project, challenge, or object, or subject you're working on;

2. Ask SCAMPER questions about each step of the project or subject and see what new ideas emerge.

Substitute: What can be substituted—other ingredients? Other materials? Other processes or procedures? Other approaches? Other pieces?

Combine: What ideas can be combined? Can you combine materials, processes, tools, or techniques? Can you blend something or create an assortment?

Adapt: To become an expert at adaptation, ask yourself these questions, says Michalko: What else is like this? What other idea does this suggest? What could I copy or emulate? What ideas can be adapted from other techniques, fields, nature, etc.?

Modify or magnify: Can your object be magnified, made larger, extended, exaggerated, overstated, added, duplicated or carried to dramatic extreme? Can it be altered, twisted, changed, or reformed or repackaged?

Put it to some other use: What else can this object be used for? Alternatively, what else could be made from this object?

Eliminate: Can this object be condensed, compacted, streamlined, or separated? Can it be made smaller? What parts, pieces, or areas are not necessary?

Reverse or rearrange: Creativity, Michalko says, consists largely of rearranging what we know in order to find out what we do not know. Can your object or project be rearranged into a different pattern, layout, sequence, or order? Consider it reversed, backward, or upside down.

SCAMPER IS A great technique for kick-starting just about any stalled project. Simply apply one—or all—of the questions to your object and see what happens.

"Change the way you look at things and the things you look at change."

—SUN TZU (C. 6TH CENTURY BC)
*Chinese military strategist,
author of* The Art of War

144

Visual Prompts

CREATIVE WRITERS OFTEN USE a technique called prompts to spur their imagination. Simply put, prompts involve selecting an object or thing to which they have no personal connection, then developing a story, poem, entry, essay, or other written communication about that object. (There are many other types of prompts, such as scenarios, unfinished sentences, and the like, but not all of them are adaptable to the world of journaling.)

For this week's exercise, use a new, foreign object, such as the photo at right or a thrift-store curio, as a prompt for your own journaling. (This photo was tucked inside an antique album purchased in upstate New York; see page 308). Remember, a picture may be worth a thousand words, but you don't have to write that much (or that little!).

VISUAL PROMPTS ARE powerful tools for tapping into our own feelings, thoughts, or emotions, or for creating purely fictional writing.

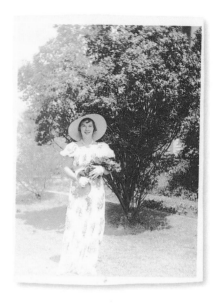

One Mememto Per Day

INSTEAD OF JUST writing in your journal this week, consider adding one memento per day, such as a ticket stub, the tag from a new pair of jeans, a photograph, a note from a friend, and so on. Tape or otherwise adhere the item to the page of your journal, and add some text about the memento (who you were with that day, where you bought the jeans, and so on).

In this way, you're less dependent on coming up with the words every single time you make a journal entry, and you're adding depth and complexity to your entries.

When you look back over your entries in years to come, the items themselves—in addition to the writing—will spark memories, nostalgia, and inspiration.

ADDING TIDBITS from your daily life—even simple items such as ticket stubs, receipts, or a newspaper clipping—can add new meaning to your journal entries.

Online Inspiration

Don't neglect the world wide web, a source of inspiration in a variety of sizes, shapes, and forms.

Many retail and catalog-based art, craft, design, mixed-media, bead, and yarn shops, for example, now have an online presence, and these can be inspiring in several ways:

- Peruse the product lines for new tools, materials, or implements.

- Visit the materials section and look for creative color combinations, interesting textures, or examples of designs you can re-create on your own.

- Browse the site's gallery to see original artwork, sample projects or project ideas, or follow the links to read more about the site's contributing artists.

- Visit the site's bookstore for the latest publications, books, and project sheets.

- Check out the sale rack or bargain bin for discontinued products or last-minute deals.

- Shop or research by theme—try entering words like ocean, winter, or friendship into the search engine and see what products come up.

- Look for classes, swaps, contests, or forums for fun and easy ways to get involved or communicate with other artists.

- Buy a kit—sometimes it's nice to just turn off your brain and follow someone else's directions for a change.

..

ONLINE RETAIL STORES offer many of the same types of inspiration as their brick-and-mortar counterparts, but it's all accessible right from your computer. What's more, there's no need to spend money if you don't want to—simply cruise around these sites for plenty of fresh ideas.

Children's Artwork

If you have children, chances are, you've got piles of their paintings, drawings, and other masterpieces. If you don't have children, or your children have grown up (to more refined artistic pursuits, of course), here's a chance to reintroduce yourself to the joy of children's arts and crafts.

There's something quintessentially innocent about artwork created by kids—in most cases, there's no judgment; rather, pure creative output. Think finger painting, crayons, pony beads, and other colorful, vibrant, crafts.

CRAFT AS IF you're in kindergarten. Tap that pure, unadulterated stream of creative energy. It's the river that flows without judgment, decision, or direction.

This paper and bead crocodile collage was created by a ten-year-old using children's craft supplies in a pure, fun format.

ARTIST / Emma Lamoureux

Borrowing from Other Artists

I FIRST SAW THE ARTWORK OF Portia Munson on display in the Albany (New York) International Airport. Although Munson also produces sculpture, paintings, and installation art, this particular exhibition showcased her flower mandalas. Her technique is intriguing: She arranges flowers directly on the bed of her scanner.

Munson describes her the flower mandalas and her technique for using the scanner as follows:

> "To make these mandala images, I use the scanner like a large-format camera. I lay flowers directly onto it, allowing pollen and other flower stuff to fall onto the glass and become part of the image. When the high-resolution scans are enlarged, amazing details and natural structures emerge. Every flower mandala is unique to a moment in time, represents what is in bloom on the day I made it."

If you have a flatbed scanner in your home office, you can apply Munson's technique with any collection of objects.

...

BORROW (but don't steal). After all, you can't be expected to reinvent the wheel every time you need inspiration—instead, consider borrowing an established technique from a well-known artist.

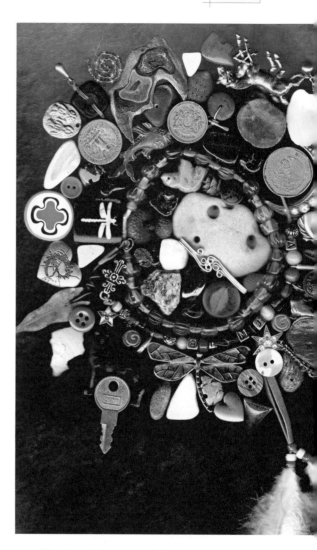

This found-object mandala was created with Munson's technique; to create a uniform colored background. I draped blue velvet over the items, closed the scanner bed, and draped another piece of dark fabric over the entire scanner to eliminate any light.

ARTIST / Barbara R. Call

A Lexicon of Symbols

SYMBOLS ARE EVERYWHERE, from our road signs to books, papers, and sports arenas. When looking for symbols to use in your artwork, one of the richest sources surrounds us: the world we live in. Often, without even realizing it, we internalize cultural interpretations of elements both natural and constructed. The red rose, for example, stands for love; the white wedding dress stands for purity.

Understanding the meaning of symbols can give you a new language to use in your artwork, and add depth and meaning to your projects. The image of a metal crown, for example, stands for king but also for kinglike attributes such as strength of character or leadership qualities.

Use this short lexicon of symbols, assembled by Holly Harrison and Paula Grasdal, as a jumping-off point for new creative endeavors or the crowning point of a nearly finished piece of art.

USING SYMBOLS in your artwork is a powerful tool for expressing your thoughts, feelings, and emotions without words or color. In addition, understanding what certain symbols stand for may give you new insight when viewing the artwork of others.

ARCHITECTURE
Doorway or gate: passage, transition
Fountain: eternal life
House: psyche, dwelling of soul
Roof: feminine, sheltering principle
Stairs: steps in spiritual development, passage of life to death
Wall: strength, containment
Window: eye of the soul, perception

HUMAN BODY
Foot: balance, freedom of movement
Footprint: leaving one's mark
Hands: open, palms up: welcome; folded: submission; raised to head: thought
Heart: love, compassion

OBJECTS
Anchor: stability, safety
Cup: symbol of feminine realm
Hourglass: mortality, passage of time
Key: power to open things, symbol of wisdom
Mirror: reflection, self-knowledge
Thread: life, human destiny

SHAPES
Circle: infinity, eternity
Spiral: vortex of energy; in dreams: growth, need for change
Square: dependability, honesty, safety
Triangle: the trinity; pointing up: ascent to heaven; pointing down: grace descending

148

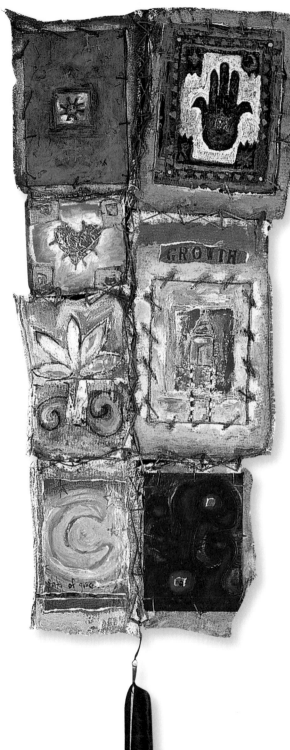

This mixed-media collage, called Prayer I, uses several well-known symbols: a home (a place of shelter and sanctuary), a hand (creativity), the moon and an ocean (for humanity's connection to nature), a lotus (offering hope for enlightenment), a heart (conduit for love and compassion), and a solitary cell (the artist's reminder that we are one among many).

ARTIST / Karen Michel

Keeping a Quote Journal

AT A LOSS FOR YOUR OWN WORDS? Consider collecting those of others by starting a quote journal (ak.a. a commonplace book). Choose your first entry from a book you've read recently (or frequently!), a song whose lyrics loop in your head, or another inspiring source.

A QUOTE JOURNAL is a fixed place to collect the phrases, sayings, and reflections of others that best reflect your own outlook on life, creativity, or living.

> "If you surrender to the wind, you
> can ride it."
>
> —TONI MORRISON,
> *American novelist*

The Meaning of *Modify*

WHAT CAN TRULY BE MODIFIED? Just about any aspect of anything, writes Michael Michalko in *Tinkertoys: A Handbook of Creative-Thinking Techniques.*

Consider these ideas for modifying your projects or objects (adapted from Michalko's book):

- How can this object be altered for the better?

- What can be modified about it? Is there a new twist to add?

- Can you change the meaning, color, motion, sound, odor, form, or shape?

- What other form can this object take? What else can this object be used for? Are there new ways to use this object?

- What else can be made from this object?

- Can it be made smaller or condensed? Can this object be divided, split up, or separated into different parts? Can it be streamlined or minimized? Can you interchange or rear range certain components?

- Can you turn it upside down, inside out, or backward?

......................................

TO MODIFY means to change, but change can take innumerable forms. Sometimes just thinking outside the box can lead you in new directions.

Experiment with Art Stamps

IF YOU'VE NEVER PLAYED WITH art stamps (or rubber stamps), then you're missing a great opportunity to experiment with a tool that's fun and versatile. If this is your first time working with art stamps, keep these pointers in mind:

Inks and paints: Although most stamped images are created with either ink or paint, you can, in theory, use just about any liquid to produce an image. Consider experimenting with food coloring, dyes, vegetable juice, or bleach, to name just a few. Inks are available in permanent, pigment, or embossing formulas; specialty inks are available for stamping on glass, metal, and fabric. Acrylic paint is well suited for stamping on paper, coated, or painted surfaces.

Inking: The simplest way to ink your rubber stamp is to press the rubber stamp onto the surface of the stamp pad, but you can also lay the stamp face up on a flat surface and pat the ink pad onto the stamp. (You move the ink pad, rather than the stamp, to cover the entire surface.) Use a rubber brayer to ink larger stamps; roll the brayer several times over the ink pad, then roll the brayer onto the stamp to transfer the ink.

Embossing: To emboss inked designs, you need embossing powder and a embossing ink, which stays wet, holding the embossing powder, until it can be melted with a heating tool.

Using stamps with other materials: Art stamps can also be used to make impressions in ceramic clay, polymer clay, or precious metal clays.

Adding color to stamped images: If you're stamping on paper, add color with pencils, chalk, markers, crayons, watercolors, paint, or ink. For fabric, use fabric paint; for metal or glass, use the same kind of ink or paint you stamped with; and for wood, use any of the tools used for paper.

Cleaning your stamps: Always clean your stamps as soon as you've finished for the day, or any time you switch from stamping with ink to stamping with paint, as dried paint or ink will clog the fine lines in the stamp. To clean ink, just stamp onto a wet paper towel; for permanent ink you'll need a special cleaner. For acrylic paint, use warm water, mild soap, and an old toothbrush for scrubbing.

...

ART STAMPS are available in innumerable sizes and designs. Because they can be expensive, consider borrowing a few from a crafty friend and spend some time experimenting.

151

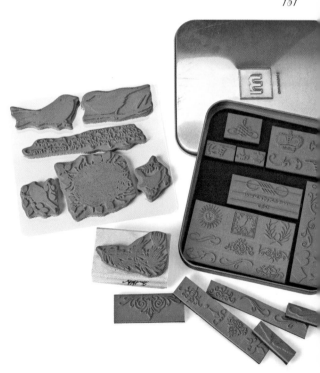

Mom-Speak

YOUR MOM HOLDS MANY special memories, tidbits, and family facts that no one else is privy to. As such, her stories, memories, and recollections are powerful inspiration for any number of artsy ideas. Today's task: Interview your mom … or interview another family member *about* your mom.

What follows is a list of questions to ask your mom (they can also be tweaked for use with dads, siblings, grandparents, aunts, uncles, cousins, or other relatives). Consider writing the answers in a journal, typing them into the computer, or otherwise creating a permanent record of her responses—it will be a treasure trove for generations to come.

- What is your full name, and do you know why your parents chose this name?

- Did you have a nickname?

- Where were your born, and where did you live as a child?

- Do you remember anything special about your house or neighborhood?

- What is your earliest childhood memory?

- What were your mother and father like? What about your grandparents, siblings, or aunts and uncles?

- Do you have any special memories of those other relatives?

- What was your favorite childhood game and why?

- What was your favorite childhood toy and why?

- Did you have a pet while growing up? What was its name and what do you remember most about it?

- Where did you go to school, college, and the like? What are your best and/or worst memories from those years?

- Did you play sports, participate in activities, or have a hobby as a child?

- What is your religious background, and did you go to church when growing up?

- Who were your best friends while growing up?

- How did your family celebrate birthdays and major holidays such as Christmas or Thanksgiving?

- What kind of traditions did you have while growing up?

- Do you know any stories about your parents, grandparents, siblings, or other relatives?

- When did you meet your husband, how did he propose, and where did you get married? Where did you honeymoon?

- How did you choose my name?

- What is your favorite memory of me as a child?

TAKE THE TIME to ask your parents or other relatives these questions—and record the answers for safe keeping—as someday it may be too late.

A Primer of Common Phrases

SOMETIMES, THE WORDS COME FIRST. Other times, you make the art, then add the appropriate words to cement the meaning. What follows are a list of timeless words, phrases, and sayings that can be used in your craft projects and artwork:

Believe

Pretty in pink

Girls will be girls

Because of you

Let your light shine

You & me

One of a kind

Remember me

Cherish

Sweet dreams

Joy

The rest of the story

Goddess

True story

Live

Happy together

Friends

Don't fence me in

Made with love

Together

Forget me not

No day but today

All boy

Reach for the stars

Follow your dreams

Peace

Mon ami (French: my friend)

La luna (Spanish: the moon)

Reflect

Create

Beauty

Carpe diem (Latin: seize the day)

Live it up

Dream in color

Spirit

Trust the universe

Faux be it

Be yourself

Freedom

Spread your wings

Speak the truth

Meant to be

Just breathe

Reinvent yourself

Love life

SOMETIMES a certain word or combination of words can serve as that much-needed spark to heat up your imagination for your next project.

153

Knitting 101

HAVE YOU ALWAYS wanted to learn to knit, but never had the time? This weekend, consider finding some knitting needles and yarn and finally learning this classic craft. It's a skill you can use over and over for years to come, and the wide assortment of fibers, yarns, and materials available for knitting, felting, and crochet has never been larger. Have no doubt: You're sure to find some inspiration among the skeins, needles, and notions.

Basic Techniques

There are four foundation techniques used in knitting: cast on, knit, purl, and bind off.

154

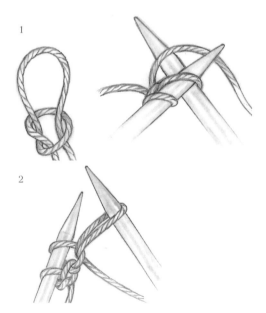

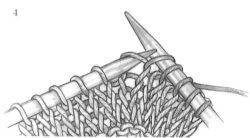

3

4

Knitting: *Once you have cast on, then you can start knitting. Hold the needle with the cast-on stitches in your left hand. Hold the empty needle in your right hand. Insert the right needle (pointing it front to back) into the front of the first stitch on the left needle and wrap the yarn around the point of the right needle* **(illustration 3).** *Using the right needle, pull the yarn through the first stitch and off the left needle* **(illustration 4).** *You will now have one completed knit stitch on the right needle. Continue in this manner until all of the stitches on the left needle have been knit and you are at the end of the row.*

5

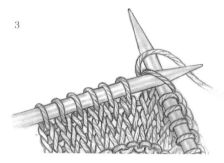

Casting on: *There are many ways to cast on, but one versatile method is the cable cast-on. Form a slipknot and place it on a knitting needle* **(illustration 1).** *Hold the needle with the slipknot in your left hand. With your right hand, slip a second needle through the first loop and pull the yarn through, making a second loop. Place the second loop back on the left needle. You now have two stitches. Continue to add on stitches by drawing the yarn through the last loop on the needle until you have the desired number of stitches* **(illustration 2).**

6

Purling: The purl stitch is the reverse of the knit stitch. Hold the needle with the stitches in your left hand. Hold the empty needle in your right hand. Insert the right needle (pointing it back to front) into the front of the first stitch on the left needle and wrap the yarn around the point of the right needle (illustration 5). Using the right needle, pull the yarn back through the first stitch and off the left needle (illustration 6). You will have one completed purl stitch on the right needle. Continue in this manner until all of the stitches on the left needle have been purled and you are at the end of the row.

7

8

Binding off: This technique is used to finish your piece and prevent the stitches from unraveling. Knit or purl the first two stitches. Using the left needle, pass the first stitch over the second stitch and completely off the point of the right needle (illustration 7). Knit or purl the next stitch and repeat, passing the previous stitch over the next stitch until one stitch remains (illustration 8). Cut the yarn, leaving a tail; thread this tail into a tapestry needle and then through the last stitch. Pull to fasten the yarn off.

ABBREVIATIONS

Most knitting patterns use abbreviations in their instructions.

Beg	begin, beginning, begins
BO	bind off
CC	contrasting color
Cm	centimeter
CO	cast on
Fwd	forward
Inc	increase, increasing, increased
K	knit
K2tog	knit two stitches together
M	meter
Mm	millimeter
P	purl
P2tog	purl two stitches together
Rep	repeat
Sk	skip
Sl	slip
St(s)	stitch(es)
WS	wrong side
YO	yarn

KNITTING IS A wonderfully relaxing and creative craft that may take your art in new directions. Pick up some needles, find some beautiful yarn, and give it a try this weekend—your art life may never be the same!

All About the Gauge

Gauge refers to the number of stitches and rows per inch, and it determines the size of your final knitted piece. There are two factors that influence gauge: needle size and yarn weight.

A Journal Entry a Day…

…KEEPS THE *THERAPIST* away. Or so the saying goes. A journal works for many people because it represents a safe haven: a place free of judgment, a place where any feeling, emotion, or thought can be expressed without worrying about the consequences. Today, and once a week going forward, try using your journal to express your innermost secrets and feelings.

This may be hard to do, as putting sensitive ideas to paper not only makes them real, it puts them out in the world, and creates something that other people can possibly read.

If you're afraid that someone else will read your words, buy a journal with a small lock and key or keep your journal in a hidden place.

..

YOUR JOURNAL can be a form of therapy, or at least therapeutic. Journal records your thoughts, feelings, and emotions chronologically, so you can reflect on and explore them over time.

An Eye for Potential

SEEING THE POTENTIAL in used objects is a skill that's worth developing. It's similar to walking into someone else's house and seeing the potential for how you could make it a home. Sometimes it's the item itself that draws your attention, like a table that wants decoration, and sometimes it's the pattern of the fabric that suits your purpose, such as the large damask tablecloth shown here that served as the perfect background for a fabric collage.

..

LOOK FOR ANALOGIES and parallels when considering used objects—in the same way that checkered fabrics mimic windowpanes, woven threads might mimic your life's experiences.

Artist Sandra Donabed layered a moiré fabric with an airy lace curtain panel to form the outside scene, then added text in the upper windows by using bias tape to form letters. The bouquet was assembled by cutting out large floral pieces from several different fabrics.

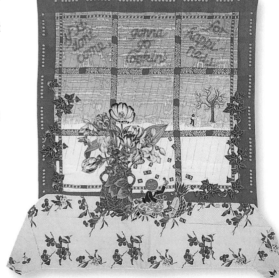

Color Tools

WHAT IS THE color wheel and how can it help inspire you? It's a useful tool for visualizing color balance and color harmony.

The twelve segments of the color wheel consist of primary, secondary, and tertiary hues and their specific tints and shades. The three primary hues are red, yellow, and blue; they form an equilateral triangle within the circle (see illustration **1**). The three secondary hues are orange, violet, and green. Located between each primary hue, they form another triangle (see illustration **2**). The six tertiary hues—red-orange, yellow-orange, yellow-green, blue-green, blue-violet, and red-violet—result from the combination of a primary and secondary hue (see illustration **3**).

AN EFFECTIVE color scheme can infuse emotion into your art, help attract attention to certain components, or set the tone in ways that other materials can't. (For examples of basic color schemes, see page 98–99.)

More Color Terms

The primary, secondary, and tertiary hues shown here are at *full saturation*, meaning there is no black, white, or gray added. The word *value* refers to the lightness or darkness of a color, or the relative amount of white or black that's been added. If you add white to a color it makes a lighter version of the hue called *tint* (pink is a tint of red). Adding black or gray to a color results in darker values known as *shades* (burgundy is a shade of red).

1: *primary;* **2:** *secondary;* **3:** *tertiary*

Craft Tools in the Workshop

DOES YOUR SPOUSE, father, or someone else you know have a handyman workshop? (Do you? Kudos!) If you've never visited it, or you're overdue for a visit, today's task is to do just that: Travel to that traditional male domain for inspiration among the nails, hammers, and tools.

Keep these tips in mind while you hunt around the workshop:

- Sandpaper is useful for creating aged or worn effects.

- Nails, screws, and eyelets make great devices for hanging items.

- Hinges can be used to add doors or other items that open and close.

- Bang a hammer or poke with a screwdriver to add weathered effects.

- Clamps are great for holding glued items in place.

- Don't forget the scrap pile for wood, findings, or trims.

- Borrow the wire clippers, pliers, or other handheld tools for manipulating wire, bead findings, or other found objects.

- Use the saw to remove items, cut things in half, or just create openings.

- Dip into that leftover room or house paint for new ideas, or mix your own.

- Borrow the paintbrushes, rollers, or brayer for applying liquid materials.

- Savor the smell of sawdust—that alone may inspire new projects.

ALTHOUGH A WORKSHOP has a traditional male feel to it, there's plenty of room for all modes of inspiration among the wood shavings and power tools.

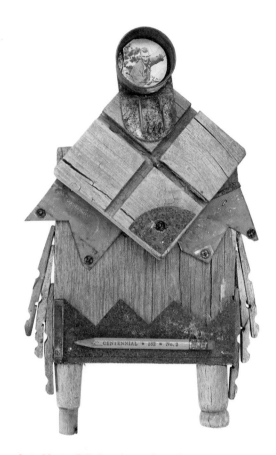

Artist Monica Riffe found everything she needed to create this homage to her grandfather, Andy Hansen, in the family's woodshed. Odd bits from the shed, such as an old #2 pencil that may have spent time tucked behind her grandfather's ear, are glued, stapled, and taped together.

Household Inspiration

THE CENTERPIECE FOR this found object necklace is an everyday object as close as your kitchen drawers: a spoon. The next time you need new inspiration, pull open the kitchen drawers, cabinets, and closet doors and look for unused objects that can find new life as jewelry, home decorations, or embellishment. Sometimes the item can be used as is, and in other cases, the end result is radically different from the original item.

..

THE BOWL OF A SPOON, the saucer without a teacup, or even a colorful food package can have new life as part of your creative process.

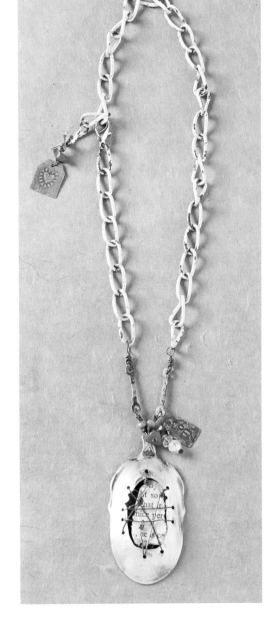

Artist Stephanie Lee sawed out the center of a vintage silver spoon and removed the handle, then drilled holes in it. Like a seamstress sewing with wire, she laced copper wire back and forth through the holes and attached an embellished piece of mica. She also used copper wire to attach the vintage chain to the spoon and add dangles of crystal, coral, and glass beads.

One Birdhouse, Two Artists

WHAT WOULD HAPPEN if two mixed-media artists started with the same materials and theme, but were given free rein to interpret, design, and experiment with those materials on their own? To answer this question, I bought two sets of supplies, including an unfinished bird house and an assortment of fiber, scrapbook papers, acrylic paint, and charms (one set for myself and one for friend and fellow artist Deborah D'Onofrio), picked a theme (Shelter), and handed off Deb's supplies.

A few weeks later we compared the results: two different views of the same room, so to speak. Two sides of a coin, two creative interpretations, and two different artistic visions of what the world shelter means to each of us.

CONSIDER EXPERIMENTING and collaborating with the same set of materials, theme, or tools with your artistic friends.

Deb's Story

I knew right away that I was thinking about what brings me shelter—and I came up with three houses: soul (the tallest house), family (medium-size house), and friends (the smallest house). I could have added a fourth house—nature—but instead I used natural items to encircle all three homes. I call this piece *A Woman's Shelter*, and I soldered a sign with those words on it for the side of the house.

I gathered a wide assortment of natural materials for this project (moss, sticks, pinecones, shells, and bark) as well as beads, fiber, and other assorted supplies. I started by painting and scraping the roofs, then layered them with gel medium and added soldering on the peaks. I also soldered a bottle with cut glass glitter for the top of the "soul" house and used rub-on letters to spell the words magic, friends, family, and soul on the individual houses.

I'm a storyteller, and my stories always come out in tactile ways. I always have a theme for my projects, and I believe that the story is how you interact with what's inside you. Stories are really expressions of your soul and your essence.

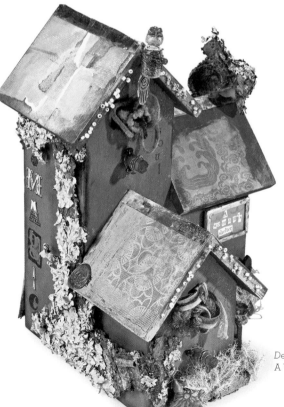

Deb D'Onofrio's finished version of the project, titled A Woman's Shelter.

Barbara's Story

As soon as I looked at the unfinished birdhouse, I headed into the wood shop to cut the houses apart. I'm not really sure why, but as it turns out I needed two separate houses to represent my view of shelter: water and woods.

The *Water House* represents the beauty and freedom I find around water; the quote on the roof reads, "Live the life you love," a personal mantra for me. I painted the entire house with shades of blue acrylic paint, then layered on scrapbook papers and tags. I love the feel that fiber adds, so I cut apart a crocheted scarf and used it to wrap and drape the roofline with yarn. I broke apart a dollhouse sideboard to create a door, which I painted and backed with deep blue velvet. I finished the piece by adding embellishments—old pieces of jewelry, keys, and charms—to the door and the roof, and attached miniature paper Chinese lanterns on the sides.

I'm as happy in the woods as on the water, so *Wood House* represents the security and peacefulness I find in the forest. I completed this house in much the same way: I started by painting the entire house with shades of green, then layered on decorative paper all over, including the roofs. I embellished the sides with a variety of glass pebbles, charms, old bits of jewelry and tiny stones; the grill windows are scavenged from a plastic pirate ship that belonged to my boys; the door is a metal charm that I painted brown and decorated with fiber, lichens, and old jewelry. I used a fiber and yarn to create a mossy, woodsy feel for the roofs and eaves.

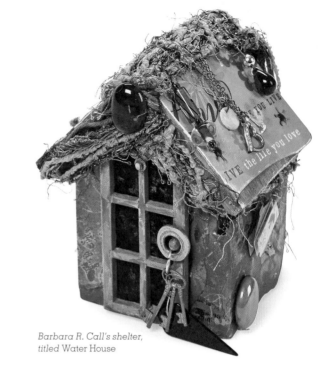

Barbara R. Call's shelter, *titled* Water House

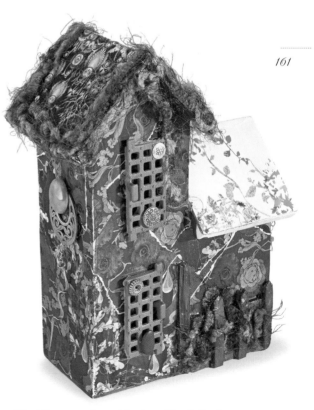

Wood House, *version number two of the shelter theme*

ARTIST / Barbara R. Call

Words to Inspire: *Dare to Take Risks*

"Risk more than others think is safe.

Care than others think is wise.

Dream more than others think is practical.

Expect more than others think is possible."

—CADET MAXIM,
U.S. Military Academy, West Point

Yard Sale Finds

So you want to be good at finding treasures at local yard sales? Keep these tips in mind, gathered from experienced "trash pickers:"

- Visit sales in affluent areas. Let's be realistic: High-quality items may be found at the sales in higher-income neighborhoods.

- Imagine items in a new form. Old linens, tablecloths, quilts, and napkins can be turned into pillows, curtains, or throws, and vice versa. Old clothing can be cut up and sewn into new projects; old boxes can be decoupaged or decorated; old jewelry can always be taken apart and put back together, used as trinkets or charms, or simply restrung.

- Be on the lookout for craft supplies and tools. If you see some, ask if the sellers have any yarn, embroidery thread, unused kits, fabric, silk flowers, paper, and the like that they might consider selling, too.

- Practice your negotiation skills. Some people start by asking if the prices are negotiable, whereas others assume all prices are and simply throw out a number.

- You can suggest the amount you're willing to pay, or suggest a lower amount and move up from there. Always be respectful and friendly; that approach goes a lot further than being intimidating or angry.

- Always carry cash in small amounts. Here's a tried-and-true technique: Stash most of your money somewhere else, then open your wallet and say, "I only have two dollars. Will you take that?"

- Yard sale shopping can be addictive— while watching for bargains, watch out for overspending and stockpiling items that you'll be unloading in a year's time, too.

SOMETIMES, other people's cast-offs are just the starting point you've been waiting for.

Move It Outside

SPRING, SUMMER, AND FALL can be great seasons for taking your crafts outside. Here are a few activities that really should be done outside, as well as a few suggestions for trying your creative hand in the fresh air.

- **Painting, sketching and journaling:** All three of these activities can be done outside, whether you carry your watercolors, sketchbook, or pen and paper into the woods, onto the beach, or just out into the countryside.

- **Painting large (or small) pieces of furniture.** Pick a day that's dry (versus humid) and not too windy, then set up a drop cloth and get to work.

- **Dye.** Outdoors is one of the best places to dye, in part to avoid the mess.

- **Tap the foliage.** Make sun prints (see page 198); press leaves, flowers, and other foliage; or take photos of trees, locations, or outdoor venues.

- **Collect materials.** Scour the woods, beach, park, or even sidewalks for interesting found objects or specimens. After a storm or particularly windy days, be on the lookout for blown natural items, such as sticks, bird's nests, leaves, or pine needles.

- **Try your hand at letterboxing**—a unique combination of crafting and outdoor adventure. (See page 182 for details).

..

SOMETIMES, WE SHOULD move ourselves outdoors instead of bringing the great outdoors in.

163

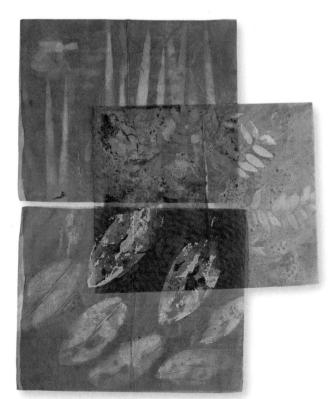

Mesh nature print
ARTIST / L. K. Ludwig

Birthstones and Birth Flowers

No doubt you've heard of birthstones, or the gems associated with each month of the year. Each month also has specific flowers associated with it, and if you're in need of personal (or personalized) inspiration, birthstones or birth flowers may be just the ticket.

I was born in January, so my jewelry box is filled with garnets (signifying purity, truth, faithfulness, and friendship) and my birth flower is the carnation (representing pride, beauty, admiration, and gratitude).

If you were born in October, your birthstone would be opal (signifying hope, purity, and innocence) and your birth flower marigold, which represents affection and grace.

..

BIRTHSTONES and birth flowers can cleverly celebrate your own personal history. Alternatively, consider adding special touch to gifts and projects for others by working in the colors, shapes, or look of their birthstone or birth flower.

Words to Inspire: *Butterfly*

"The butterfly's attractiveness derives not only from colors and symmetry: deeper motives contribute to it. We would not think them so beautiful if they did not fly, or if they flew straight and briskly like bees, or if they stung, or above all if they did not enact the perturbing mystery of metamorphosis: the latter assumes in our eyes the value of a badly decoded message, a symbol, a sign."

—Primo Levi (1919–1987),
chemist and Auschwitz survivor

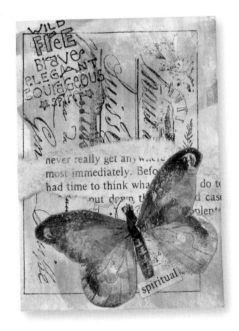

ARTIST / Catherine J. Wegner

Carving Your Own Stamps

IF YOU CAN'T FIND what you want among the aisles and aisles of ready-made art stamps, have no fear—it's possible to carve your own stamp. What's more, no drawing is required.

› Stamp Carving

MATERIALS

CARVING BLOCK, MAT MEDIUM, CARVING TOOLS, AND A SOFT CLOTH

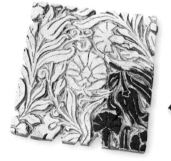

Begin cutting away all the black areas of the design, using your carving tools. Alternatively, carve out the white areas.

165

Start with a copyright-free design (or create one of your own). Make a photocopy of the artwork. To transfer the image to the carving block, coat the surface of the carving block with acrylic medium, then place the artwork face down. Burnish lightly with a soft cloth, and let dry. Once dry, run the block under water to lift off the copy paper and expose the design.

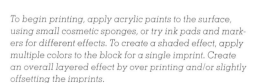

ARTIST / Anne Bagby

Can't Find Carving Blocks?

You can carve rubber erasers; many artists have created tiny alphabets on the erasers of standard #2 pencils! See page 192 for further instructions.

To begin printing, apply acrylic paints to the surface, using small cosmetic sponges, or try ink pads and markers for different effects. To create a shaded effect, apply multiple colors to the block for a single imprint. Create an overall layered effect by over printing and/or slightly offsetting the imprints.

A HAND-CARVED stamp adds a unique and completely personal touch to any project at hand, and you'll never see another one like it in any craft store!

What Are Your Life Goals?

YOU MAY HAVE heard of the book *1,000 Places to See Before You Die: A Traveler's Life List*, by Patricia Schultz or the movie *The Bucket List*, starring Jack Nicholson and Morgan Freeman.

The premise of both the book and the movie is roughly the same: Compile a list of things you want to do in this lifetime. In the case of *1,000 Places*, the book contains a list of a thousand locations worth seeing in a lifetime; in the movie, the two characters devise a list of things to do before they "kick the bucket."

This week's journaling task: To compile your own life goals. This can be as simple as "learn more about Buddhism" to as complex as "visit the Taj Mahal" or "get a master's degree in education." You can make a simple list with five to ten items on it; attach a time frame ("within five years I want to ...", "by the year 2015 I intend to ...", and so forth); involve your spouse, family, friends, or children; or just keep it simple, and limit the goals to the coming days, weeks, or months.

...

THE ACT OF writing down our goals, dreams, desires, and wishes can help make them real. And the journey of moving forward will inspire new art or projects, even if those pieces are only designed to document our lives.

Candles as Art Canvas

PILLAR CANDLES ARE a wonderful place to use those scraps of fabric or paper, extra charms and trinkets, or leftover stickers. They're easy to decorate, can be inexpensive to purchase, and their flat, smooth surface is the perfect canvas for a number of media.

In the decorated candle set and matching tray shown here, artist Michelle Hill wrapped her 5-inch (13 cm) and 3-inch (7.5 cm) candles in scrapbook paper, then added ribbon, silk flowers, beads, and seed beads.

Other ideas include:

- Adding one letter per candle to spell JOY or other holiday greetings

- Wrapping or layering fiber, fabric, trims, or yarn

- Creating a collage of stickers, paper, and art-stamped images

- Using old jewelry, wire, and charms to create candle collars

- Pinning or gluing silk flowers, foliage, or other natural materials

...

DECORATING pillar candles is a quick, simple craft that can showcase leftover crafting supplies. What other blank canvases can be used in a similar way?

Using Copyright-Free Designs

IN NEED OF new material? There's a whole world out there, just waiting to be tapped: It's called copyright-free designs, and it's much more than clip art. Today's copyright-free designs can be modern, fresh, and innovative, and many books are available that even include CDs with printable, copyright-free designs. Name your desired time period, style, or aesthetic and a design, template, border, or piece of art is available with little or no charge.

...

FROM ART NOUVEAU and Art Deco to Celtic alphabets and bird illustrations, copyright-free designs free you up from doing all the work.

163

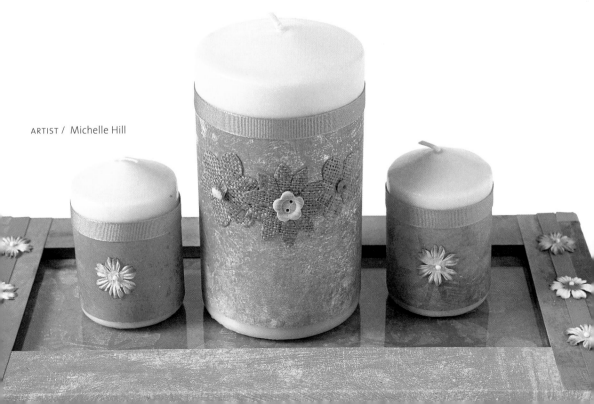

ARTIST / Michelle Hill

Embellished Like a Princess

WHAT DOES IT MEAN TO CELEBRATE your inner princess? It depends on who you ask.

There is no canonical list of behaviors, actions, or thoughts that are uniquely feminine or masculine. The definition of what it means to be masculine or feminine changes with time, geography, and culture, and everyone's interpretation is a personal one.

When it comes to creating art, celebrating your feminine side could mean selecting colors or materials that are "girly" in nature, such as lace, sheer fabric, or frilly accents. For others, it could mean dabbling in goddess art and rituals.

Some artists associate emotions or personality traits with their feminine side, such as grace, compassion, strength, beauty, and poise. For others, artwork that celebrates the feminine side is more soulful, intuitive, thoughtful, emotionally engaging, personal, or complex.

Celebrating your feminine side might mean choosing iconic or historical female figures for your art; dabbling in icons such as fairies, mermaids, angels, or witches; or just celebrating all the unique things about being female.

..

WHAT DOES IT MEAN to celebrate the feminine? The answer is both personal and revealing. Take the time to explore your own unique feminine qualities, or what feminine energy means to you, and reflect on how your artwork can express, incorporate, or highlight those qualities.

Molded Faces

IF YOU'RE LOOKING for a way to add depth and personality to your artwork, consider capturing a three-dimensional or molded face in your work. A molded face can represent a celestial body, such as the moon or sun, or bring to life an imaginary being, such as Mother Nature or Father Time.

It's easy to create lifelike faces using a flexible push mold and a soft moldable material such as paper clay, polymer clay, candle wax, hot glue, even icing. The resulting flat-backed face can be mounted to make jewelry, or used in a mixed-media collage to represent actual people, fairies, spirit guides, or mythical creatures. If you type the term "flexible push mold" into your Internet search engine you're sure to find a wide range of molds in a variety of styles.

...

MOLDED FACES can be used in many different ways, and they're an easy tool for adding personality and presence in your works.

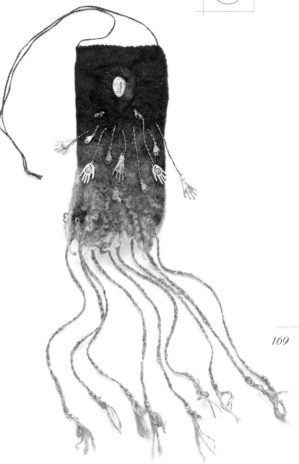

169

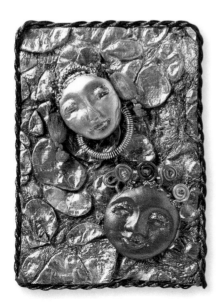

This handmade felted bag by Carole Presberg, titled Sedna 3, features a handmade face pendant by Melanie Lukass of Earthenwood Studios. The face peeks out from a collar like border, a clear reflection of the Presberg's love of Arctic culture. Tiny pewter hands, attached with tiny wool braids, and an assortment of handspun wool and silver beads complete the feeling that there's a spirit or presence captured in the wool.

The pair of faces shown in the ATC here, designed by Patricia Smith, gives the piece contrast and depth; the faces could represent the sun and moon, summer and winter, daytime and night, or any other pair of opposing concepts.

Beading 101, Part I

THIS WEEKEND, TRY your hand (and needle!) at beading. It's a craft that requires just a few tools and materials but leads to infinite design potential. Beading adds color, flair, and drama to any fabric project or paper piece.

MATERIALS

BEADS, SEQUINS, OR STONES (SEE "BEADS, SEQUINS, AND STONES," PAGE 213), THREAD, FABRIC, SCISSORS, AND BEADING NEEDLES

You'll also need a design or a plan, which can be as simple as adding a beaded fringe to the pockets of your favorite jeans or an elaborate border for the edge of a shawl or scarf.

Basic Guidelines:

- In general, match your thread to the background fabric; exceptions include places where you want the thread to show either on the fabric or between the beads.

- Select a size 12 beading needle for the most versatility; beading needle sizes range from 10 (thickest) to 13 (thinnest).

- Polyester or cotton-wrapped polyester thread is ideal for most work, but use Nymo thread (very strong nylon thread that resembles dental floss) for the bouclé and dangle stitches on pages 171 and 207 to prevent the stitches from being caught and broken.

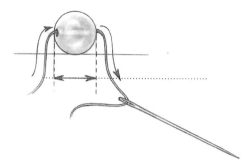

Running stitch: *Basic running stitch is used for stitching beads either closely in a line or widely spaced. Working from left to right, bring the needle in and out of the fabric at regular intervals, picking up the beads as you go. The stitch length should be at least as long as the bead, or slightly longer, to make the bead sit square on the fabric. Do not make the stitch shorter than the bead.*

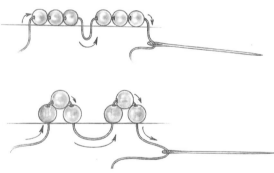

Multiple beads on a running stitch: *This stitch uses a number of beads on one stitch—the number is variable to taste. The stitch length can be the same length as the total number of beads on the stitch, or it can be shorter.*

When the stitch length *is the same as* the total number of beads, the bead sits flat against the fabric. This is a good way to sew a line of beads quickly.

If the stitch length *is shorter than* the total number of beads, the stitch will stand up from the fabric. This makes a textured line that is good for edging sections within a design.

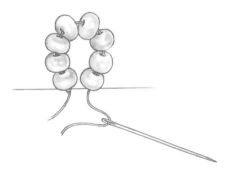

Bouclé stitch: *This is a variation of multiple beads on a running stitch. For bouclé stitch, the object is to make a long strand of beads and stitch it down with a very short stitch so it buckles. The buckling forms a loop. The loops can be short or long, closely or sparsely spaced. After three to five stitches, knot off the thread without breaking it.*

BEADING IS A SIMPLE and inexpensive way to add color, texture, or shine to fabric projects. And once you've learned the stitches shown here and on pages 206 and 207, you can use these techniques with stones or sequins.

Sequins on a Running Stitch

Stitching sequins on a running stitch is a beautiful way to create a line of uniform sequins (as shown here); the working thread is hidden under the overlapping sequins.

1. Start by drawing an outline of design. Bring the thread up through the fabric, and slide the first sequin down the thread onto the fabric.

2. Insert the needle into the fabric, just to the right of the design line where it meets the edge of the sequin. Pull the stitch closed.

3. Bring the needle up from below the fabric, just to the left of the design line. Pull the stitch closed. Slide another sequin down onto the fabric.

4. Insert the needle into the fabric, just to the right of the design line where it meets the edge of the sequin. Pull the stitch closed. Repeat steps 3 and 4 until finished.

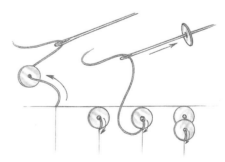

Something Borrowed, Something Blue

IF YOU'RE STRUGGLING with where to take your art, or wondering what techniques will best suit the project you've got in mind, take heart. There's no need to reinvent the wheel. Studying the artwork of others can give you a list of fresh starting points.

To demonstrate, consider this fabric journal spread by Lesley Riley:

Interpret literally: The poem contains the words "blue moon," so the artist creates blue moons on the pages. The main character holds a blue moon—which may be assembled from separate parts. Start with a photo of a girl, then layer a moon image, and finally position a set of hands so it appears that she's holding the moon.

Use contrasting colors and/or geometric shapes: Notice how the series of brown fabric rectangles contrast with the blue circles that represent the moons. Contrast can give a piece energy and movement, or it can be used as an organizing principle.

Embellish freely: Add miniature buttons, dangling beaded items, or suspended charms to give a piece movement and/or three-dimensionality.

Try new materials: The words for this poem are printed on fabric, not paper.

Extend the theme: The face of this young girl, looking upward, reinforces the gazing at the moon.

Consider composition: The artist creates a balanced composition by creating similar—but not symmetrical—elements on each page.

...

IF YOU'RE DRAWN to a piece of art instinctively, take the time to examine it, break it down, and separate out the individual elements that make it successful in your view. Then, borrow, reinterpret, or reuse those ideas, materials, or elements in your own work.

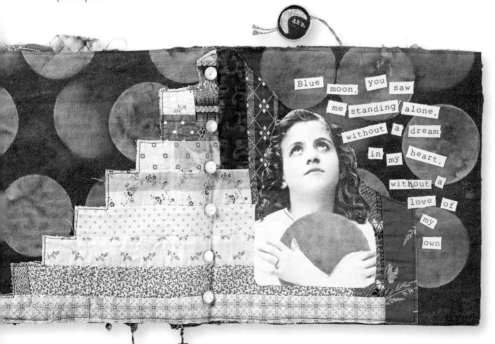

Blue moon, you saw me standing alone, without a dream in my heart, without a love of my own

This journal spread was designed by Lesley Riley; the Paper Moon fabric journal also contains pages from several other contributing artists, as it was a traveling collaborative work of art.

Bleaching Fabrics

CONSIDER USING CHLORINE BLEACH to alter the color or pattern of fabric. (See page 124 for altering photos with bleach.) The techniques shown here work best on natural-fiber fabric (not synthetic). Always create a test swatch before starting your final work. Always wear protective eyewear and rubber gloves when working with bleach, and work in a well-ventilated space. To temper the strength of bleach, dilute it with a small amount of water. The longer it sits, the lighter the result, so keep a bucket of water on hand for rinsing your fabric to curb the bleach.

..

SOME HOUSEHOLD STAPLES are tried-and-true craft mediums. Bleach removes color, rendering the most dramatic results with darker fabrics.

This fabric started out pale blue, but then was dyed an even deeper shade of blue. To strip the color to white, the bleach was applied with a small paintbrush.

173

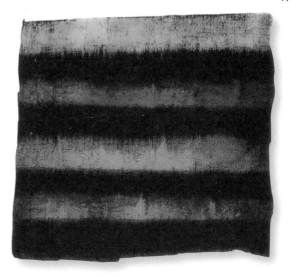

To create a gradation effect on fabric, apply bleach solution with a paintbrush. You can also use squirt bottles, spray misters, or eyedroppers. Let the bleach sit on the fabric until the color is removed to your liking, then rinse the fabric in water.

Leaf Printing, Part I

GATHER SOME EYE-CATCHING LEAVES on your next trip outdoors, whether it's to walk the dog or hike a mountain. Leaf printing is a craft technique that transfers leaves' natural color to fabric (or paper).

LEAF PRINTING allows you to admire nature's materials and use them as tools.

MATERIALS
ASSORTED LEAVES, SCRAP PAPER, FABRIC, TRACING PAPER, A HAMMER, AND A PROTECTED FLAT SURFACE

1. Cover the work surface with some clean scrap paper. Lay the fabric you are decorating on top of the paper.

2. Arrange the leaves over the fabric in the desired pattern.

3. Place a sheet of tracing paper over the leaves, then hammer the entire surface to release the natural dyes in the leaves. Discard the papers.

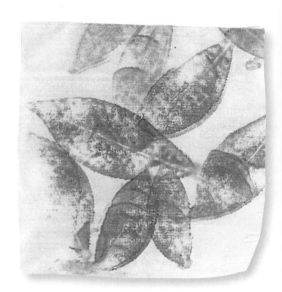

Celebrate *Uniqueness*

"At bottom every man knows well enough that he is a unique being, only once on this earth; and by no extraordinary chance will such a marvelously picturesque piece of diversity in unity as he is, ever be put together a second time."

—FRIEDRICH NIETZSCHE (1844–1900),
German philosopher

Artist Interview: Helga Strauss

WELL-KNOWN ARTIST and creative entre-preneur Helga Strauss is owner of ARTchix Studio (www.ARTchixStudio.com) and blogs at www.MyARTisticLife.typepad.com. In this interview she shares some insight into her own creative process.

Q: Where do you normally find inspiration?

A: Everywhere! In my house, on my daily walks, in my email box from my customers, shopping online or in local stores, traveling around the world. Life inspires me.

Q: What is the one tool (or material) you couldn't live without?

A: Watercolor crayons. I use them in all of my artwork.

Q: If you are ever "fresh out" of ideas, what do you do?

A: I don't think I've ever been out of ideas. But if I need to find inspiration, I usu-ally go for a walk or go shopping. I like going to book stores in particular, where you can find books on art, pattern and design, and so on, along with inspiring artwork on book covers, great magazines, and interesting greeting cards.

Q: Whose work (artist, other crafter, painter, etc.) do you admire most and why?

A: I have always admired Frida Kahlo because she was able to express her emotions so vividly through her art-work. Creating art can be such a healing experience and she seemed to be able to use her art as a way to work through her problems, desires, and emotions.

Q: What is your favorite medium (jewelry, mixed media, sewing, and so on) and how does it reflect your unique artistic personality?

A: Mixed-media collage is my absolute favorite. I have dabbled in all kinds of art: painting (acrylic and oils), jewelry making, handicrafts like cross stitch and embroidery . . . and I find that I can combine all of the techniques I've learned over the years into one medium: mixed media. This fits my personality very well because in owning my own business, I need to wear so many hats every day. I have to be creative in making and de-signing new products, numbers smart in doing accounting and figuring out costs, manager in taking care of my employees, social and support-ive in dealing directly with my customers. I enjoy doing it all!

171

ARTIST / Helga Strauss

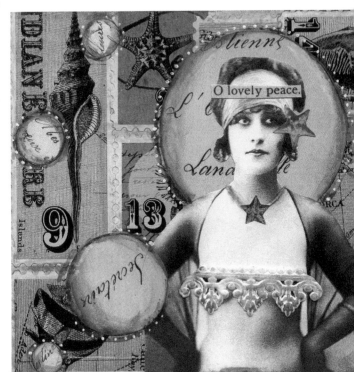

Handmade Journals 101

A HANDMADE JOURNAL SPEAKS VOLUMES: Not only is it a place to express your innermost feelings, ideas, and confessions, but it's a tactile and visually creative form to house those expressions.

One of the simplest journals to create by hand is a one-signature journal. (A signature is a printer's term that refers to a set of sixteen pages.)

MATERIALS

ACID-FREE PAPER (FOR PAGES) AND HEAVIER DECORATIVE STOCK (FOR THE COVER); BEADS, TRINKETS, OR CHARMS; STURDY THREAD OR EMBROIDERY FLOSS; BONE FOLDER; AWL; NEEDLE

2. Sew the single signature: Use the awl to pre-punch two holes into the crease, or spine, of your book. Begin sewing through the spine from the top and outside of the book down to the bottom hole, then sew back up again to the top hole. Tie the two loose ends together tightly.

1. Fold the signature and cover material: Begin by folding four or five pieces of paper in half, smooth the crease of each with the bone folder, and stack the pages together to form a signature. Fold the decorative paper in half to make the cover.

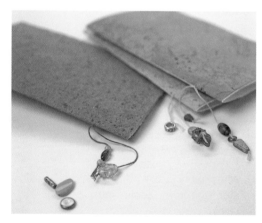

3. Embellish the spine: tie beads, charms, or trinkets in place. Grab a pen and start writing!

"There are thousands of thoughts lying within a man that he does not know till he takes up the pen and writes."

—**WILLIAM MAKEPEACE THACKERAY (1811–1863)**,
British author

What Should I Write?

What are your dreams? Not the ones you have when you're asleep, but your desires for yourself, your family, and your future? Write down who it is you want to be, who you wish you were, your successes, and your failures. Write about your joys and personal achievements. Your journal is a quiet place where you can say what doesn't get said in everyday life. Be as honest as you can. If it's hard to open up in your daily journal, create a private one. You are who you are, and an honest journal will be more important to you in years to come than a censored one.

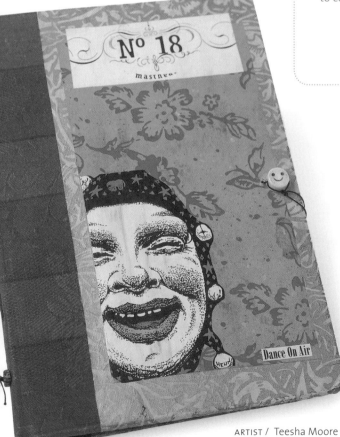

No 18
mastnea

Dance On Air

ARTIST / Teesha Moore

Keeping a Recipe Journal

A RECIPE JOURNAL CAN BE as simple as hijacking an old cookbook and taping, gluing, or stapling favorite borrowed, clipped, or handwritten recipes in its pages. Or it can be as elaborate as a family heirloom album, complete with photos, stories, and mementos. A recipe journal can document the cooking process; contain photos of meals with friends or family; or incorporate wine and food labels, menus, food terms, handwritten notes, other people's written comments, or serving suggestions.

Handwriting, typesetting, or designing the layout of the recipes can be a creative process in itself. For standard formatting, consult your favorite cookbooks for guidance. If you want to think outside the (recipe) box, your journal can be more art driven than food oriented.

178

Here's how to *really* think outside the box: Use an actual recipe box as the basis for a three-dimensional journal! Decorate the outside of the box and use it to contain a small, hand-bound recipe journal.

COLLECTING RECIPES—especially those that have been handed down for generations—is a wonderful activity for the entire family. Creating a recipe journal is both creative *and* practical—store it in the kitchen and think of those little drips and drabs from your culinary adventures as adding a touch of realism!

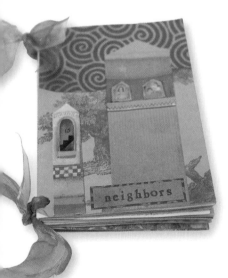

Artist Anne Woods created this hand-bound recipe journal for her friends and neighbors before moving out of the country. She included recipes as well as thoughts, impressions, photos, and drawings of her neighbors.

Before and After: Altered Clothing

TRANSFORMATION IS A MAJOR THEME fueling many styles of crafting. Altering store-bought clothing and accessories into new styles of wearable clothing is a field rich with experimental possibilities.

ALTERING CLOTHING can be so much more than hemming pant legs and changing the buttons. Imagine ways to transform garments from one wearable form into another.

Designer Kathleen Maggio transformed a pair of cargo jeans into a sassy pocket tote with just a few snips, folds, and stitches.

179

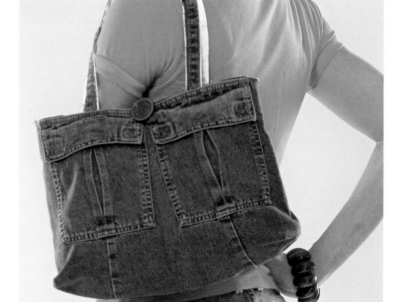

New Regions and Influences

SOMETIMES, ALL YOU NEED is to see a beautiful example of jewelry or artwork from another part of the country to inspire your own creations.

Think about your geographic region: What is it known for, and what motifs have cultural relevance outside of your region? Lighthouses, mountains, shuttered factories, Mardi Gras . . . use the colors and textures (literal and symbolic) of your native region and play with them in your artwork.

IS THERE A PART of the country you've always wanted to visit? Consider finding a way to get a taste of that region on a regular basis, such as by subscribing to a regional magazine. Absorb its images, let them resonate and percolate, and then reflect on what can be implemented in your own creations.

Artist Interview: Carole Presberg

CAROLE PRESBERG HAS BEEN WORKING with yarn—first as a spinner and weaver, and now as a felter—for more than thirty years. To say that she loves fiber is an understatement, of sorts . . . it might be more accurate to say that fiber is in her blood, and her creation of felted spirit bags and pouches is just the latest incarnation of her creative energy.

Q: Where do you find inspiration?

A: From the materials I work with. I get very involved with the fleece [wool that's been shorn from a sheep]. I feel it and look at it for a very long time. To make one of my bags I use fleece and batting. I lay out the batting and the raw wool on top, roll it up and put it in an old piece of pantyhose. I use the washing machine [for agitation] because it gives it a sense of mystery. After it comes out I spend time with it, figuring out a design.

I really like long-wooled fleeces. Different sheep have different fleeces. With Merino sheep the fibers are very short, fine, and curly. With the long-wool breeds such as Border Leicester, the fibers are four to twelve inches (10.2 to 30.5 cm) long and very shiny, and there's less crimping.

Q: What is the one tool you couldn't live without?

A: The washing machine! I have felting needles but I don't use them frequently . . . I do need one knitting needle that I use to pull the fibers forward. Once the bags are felted, the fibers are very compacted and it takes a lot of effort to pull out the fibers. I want it to look like fleece in the end—I'm inspired by the fiber [itself].

Q: What do you do if you're ever fresh out of ideas?

A: I read fiber magazines, I might go look at things like sheep, or cultural museums. I'm very heavily influenced by Artic cultures. I really like the look of old garments and costumes, skins, the outerwear of the Inuit people. I visited Finmark, Norway, and saw some beautiful old costumes. I also spend time online looking at other people's websites.

Q: What other artists do you admire?

A: I had a friend in Scotland who I used to collaborate with. She's no longer with us but she was a weaver and I really admired her work. I admire Frida [Kahlo] more for what she wore than what she painted! I also really enjoy movies with a lot of historical costumes, like Lord of the Rings.

Q: How does fiber or felting reflect your unique artistic personality?

A: I started as a spinner and a weaver; I have a degree in fine art. I moved to Massachusetts after I got married, and I felt very isolated from my friends in New York City, so I went to school in Cambridge and studied spinning and weaving. I joined a group of local spinners and weavers. I had always thought about being a farmer—I had an aunt who was married to a farmer, and I admired my cousins who could drive a tractor. I bought an old barn loom and set it up in my house. I still really consider myself a weaver because that's how it started out. There's more room for expression in weaving because you can chose the fibers. I went to a workshop on machine felting about twenty-five years ago.

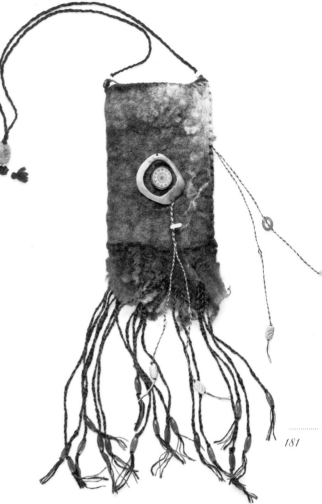

181

Carole Presberg made this bag from wool gathered from her own Border Leicester sheep. After felting the wool and forming the bag she added wood and antique horn focals; horn, bone and felt beads; wool yarn; and waxed cord.

At one time I had 4 ½ acres and a herd of 35 sheep, but usually it was just 20 or 25 sheep. I have tons of wool left over from that farm which I'm still working with, and I have a llama who gets shorn every two years.

For more information about Carole and her spirit bags, visit www.thistlewoolworks.com.

Flora, Fauna, and Fresh Air

WHETHER YOU'RE DRAWN TO SHELLS, flowers, leaves, insects, birds, or animals, the natural world provides an endless source of inspiration for capturing the feel of the outdoors indoors. Consider these ideas:

- Are you attracted to trees, leaves, and forests? Consider using these materials in your artwork in new ways. Leaves, rocks, and bark can be pressed into clay to make impressions, leaves can be used for simple block printing, and pine needles, lichen, and twigs can be used to decorate nature-themed mixed-media pieces.

- If you love the beach, sand, and shells, consider using these materials in new ways. Use shells or driftwood as the basis of a project, such as a mobile or piece of jewelry. Add sand to your painted works to create texture, or use beach glass, shell fragments, or tiny pebbles to accent boxes and frames.

- Re-create or reproduce your favorite insects, birds, or animals in the form you like best: paint on paper, modeled clay or ceramics, multi-media collage, decoupage, even altered photography.

...

THERE ARE several easy ways to tap into nature and its many themes: Use natural items in your artwork, create your pieces using natural forms as a base, or reproduce your favorite objects in your work.

Letterboxing 101

LETTERBOXING IS THE SCAVENGER HUNT reinvented, with a little hiking, rubber stamping, journaling, exploration, and navigation thrown in. As a crafter, if you like being outdoors, searching for hidden treasure, and being creative in how you leave your mark, you'll like letterboxing. Letterboxing has a community of participants that network and organize online and through word of mouth.

Here's how it works: Participants hide small, weatherproof boxes in public places (such as nature preserves or other outdoor settings), then post clues online to let others find the box. The letterbox usually contains a log book, a rubber stamp and sometimes an ink pad. You bring a book, your own stamp, and an ink pad on the hunt, and once you find the box, you make an imprint of the box stamp in your book and an imprint of your stamp in the box book.

To letterbox, you need:

- **Trail name:** This is your letterboxing name or identity. You can use your own name, devise a fictional name, or create a team name for your family.

- **Rubber stamp:** You'll need a store-bought or hand-carved stamp. (See instructions at right.) Most letterboxers chose a stamp that has personal or family significance.

- **Writing instrument:** This is used to add your trail name and date next to your stamp in the logbook. You can also add comments, notes, or messages to other letterboxers.

- **Sketchbook or journal:** This is your logbook, and this is where you stamp imprints from the letterbox stamps you locate.

- **Ink pad:** Always carry at least one ink pad.

- **Compass and/or trail maps (optional):** Many letterbox clues don't require a compass, but some do. If your clues lead you to a specific park or preserve, you may also want to pick up a trail map.

- **Clues:** This is the most important piece of the puzzle! You can find clues online.

..

LETTERBOXING CAN BE an addictive hobby that integrates crafting with outdoor adventure and treasure hunting. Even a quick online search will lead you to several local letterboxing inroads.

› How to Carve Cork Stamps
(for letterboxing or for every day)

1. Locate a cork with a flat surface; if you can't find one, slice off the top of the cork to create a flat surface. Draw your image directly on the cork, then cut the cork, using a sharp blade.

2. Once you've finished carving, practice stamping a few times, and modify the design if necessary. The print from a cork stamp will leave a more distressed image than that from a carving block (see page 165) or eraser (see page 192).

183

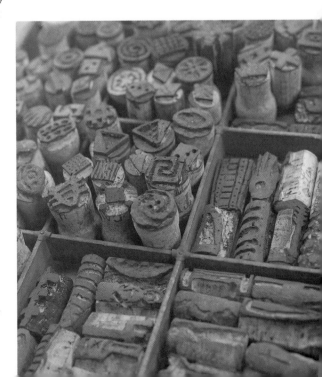

Hand-carved cork stamps

ARTIST / Peter Madden

Doodle Journal

FOR SOME ARTISTS, doodles are like a good, long stretch or a nice, wide yawn: They let you take a break from producing and instead just express yourself naturally.

Artist Elizabeth Beck keeps a doodle journal that contains her favorite marks, her signature designs, and her favorite shapes. They include hearts, swirls, stars, and geometric shapes; my own doodles often take the form of arrows, flowers, and twirling vines.

Today's task: Start a doodle journal, or consciously add doodles to your existing journal pages. This is often easier to do when another part of your brain is engaged; while talking on the phone, for example, or watching television. Track your doodles in the same way you might track your entries, your reflections, or your accomplishments, and don't be surprised if they show up in other parts of your life, such as your artwork.

..

DOODLING ALLOWS your mind to relax, and it's often an unfiltered expression of something inside you.

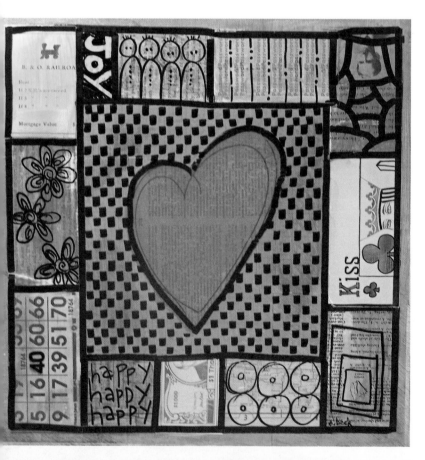

Artist Elizabeth Beck writes, "At the height of my doodle awakening, the loose mark making of the doodle-icious Sharpie made it onto lots of my canvases. One part of my artsy self was distinctly influencing the 'real' art."

Trims and Tassels

Have you visited the notion department of your local craft or fabric store lately? There are literally hundreds of choices, in a wide variety of colors, textures, and designs, all of which can be incorporated in any style of craft. You can also recycle trim or tassels from other projects or garments, or make your own trim from existing fabric, remnants, or fiber scraps.

How to Attach Trims

- **Machine or straight stitch:** Use this stitch to attach ribbons, flat cords, braids, rickrack, and flat embroidered tapes. Straight-stitch lace trim or fringe with sewing tapes attached.

- **Machine stitch zigzag:** Use this to secure ribbon, flat cord, and rickrack while adding visual interest at the same time.

- **Tacking:** Use this hand stitch when you need a few critical stitches to hold items such as ribbon flowers in place.

- **Wiring:** If sewing thread seems to fragile, you can use fine-gauge (24- or 28-gauge) wire. Simply push the wire through the fabric (leaving a small tail), wrap the wire around the object, and push it back through. Twist the ends of the wire together on the back of the fabric and clip off any excess.

USE TRIMS AND TASSELS to embellish fabric projects, such as clothing, fabric journals, pillows, curtains, hand towels, or hand-sewn dolls, as well as paper, mixed-media, and beaded work.

185

Appliqué 101

APPLIQUÉ IS A CLASSIC sewing technique used to attach a surface decoration (often sewn or embroidered, but not always) to a background piece of fabric or base.

A century ago, appliqué needlework was highly prized for its neat, tiny stitches that were barely visible. Today, fiber artists appliqué in any way they choose, using exposed, frayed edges; uneven, irregular, or meandering stitches; or nontraditional materials in place of fabric.

Appliqué can be done by hand or machine; machine appliqué is faster and gives consistent results, whereas hand appliqué is portable and variable. You can use machine blanket, zigzag, or satin stitch on raw edges, for example, or multiple rows of machine straight stitching with contrasting thread. Traditionally the thread is matched to the color of the appliqué piece, but you can use any color thread you want, to give your work more visual punch or make the stitching more visible.

APPLIQUÉ, the French word for "applied," is technique for attaching layers of fabric, embroidery, or other materials to a background fabric.

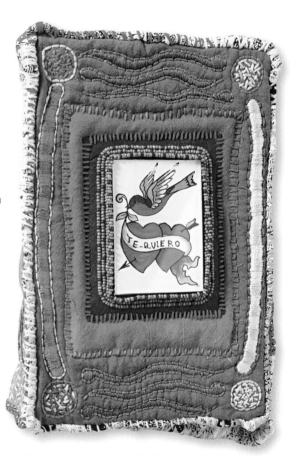

This colorful fabric journal with paper pages by artist Jennifer Whitten features colorful embroidery, beading, and hand-appliqué stitching on the cover.

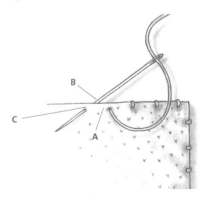

Basic hand-appliqué stitch: *Begin on the back of the fabric. Insert the needle into the smaller fabric piece approximately ⅛-inch (3.2 mm) away from the edge (point A). Reinsert the needle into the background fabric only (point B), directly opposite point A, then bring the tip of the needle out on the small fabric piece (point C), just to the left of point A. Continue stitching this way; try to make all the stitches the same length and distance apart.*

Happy Birthday!

ONE DAY A YEAR, it's your birthday, and there's no reason why you can't start your own creative rituals, celebrations, or events to mark the passage of your life.

- Transcribe the "Born Today" text from a daily horoscope to your journal. Use this text as a guide for the year to come!

- Make yourself a birthday card, but let it reflect where you are in your creative, spiritual, or life journey. (Alternatively, make a birthday card for your parents, thanking them for bringing you into this world and letting you be "you.")

- Give yourself a present, whether it's that set of rubber stamps you've been eyeing, a workshop or class, or a long-awaited manicure or massage.

- Create a ritual to honor yourself, your body, and your strengths. This could mean taking a special class, cooking your favorite foods, or just meditating on all your blessings.

..

ON YOUR BIRTHDAY, take time to appreciate yourself, your beauty, and all the gifts you offer the world.

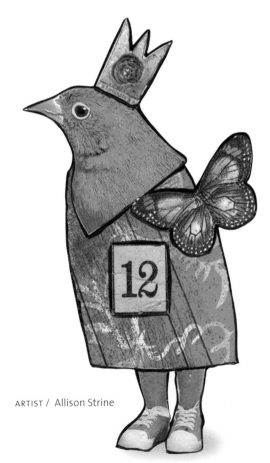

187

ARTIST / Allison Strine

Art to Inspire: Signature Motifs

ARTIST ALLISON STRINE's signature motif is her LadyBirds. Here she tells more about where they came from.

Story: The Origin of LadyBirds

LadyBirds were born from a desire to bring joy and some healing feelings to my little world, all on an artist's canvas. First, I make a colorful, textured, layered background, the kind that you have to look at closely to see everything that is there. Kind of like me! Using patterned tissue papers, transparencies, specialty papers, paint, and whatever else I can get my hands on, the background comes to life. When that dries, it's time for the next step.

I like to let each LadyBird evolve of her own volition. There are so many negative messages sent to women about our bodies, and it is important to me that they are made of all shapes, from massive silhouettes to pencil-thin bodies, and their skin and feathers come in every color imaginable. The whole process is so random that I marvel every time a finished canvas looks right to my eye. I've been known to blindly reach for paint colors, thumb through odd catalogs, and play a game to see if I can use something from the mail of that day in each piece. I am big on recycling, and this makes me feel better about all that junk mail!

Each piece is a tiny world of detail, colors, sizes, and shapes that emphasize inner beauty and individuality. When the LadyBird is finished, I look to see what she's saying. I'm listening for that quirky, sometimes irreverent, sometimes touching, but upbeat message that most of us think but never think to say about ourselves. I want to make art that sends a positive message to my daughter about what it means to be a girl, to help her to understand that she is much more than what others see on the outside.

DEVELOPING A PERSONAL MOTIF or signature design can provide a strong framework or foundation for new works of art. Knowing that all your work is going to take on a similar form can release you from having to reinvent the wheel every time, thus freeing up precious creative brain cells!

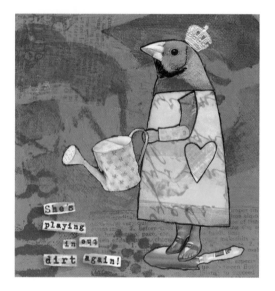

Round Robins, Collaborative Art

ONE POPULAR FORM OF COLLABORATING among artists and crafters is a round robin, or the creation of a project through joint efforts. This is an oft-used technique among fabric artists and quilters, who solicit stitched or quilted squares from individuals; the crop of squares or panels are then sewn together into a finished quilt.

In the altered book world, the round robin concept works like this: Once the players are established (such as by personal contact or signing up via an Internet site), each starts a book with an established theme. Each month, the players receive a new book in which they alter pages or spreads, then they send the book they've worked in to the next person on the list. Once a book has completed the circuit, it contains original and unique artwork from each of the players.

If you're inspired by the idea of a round robin, consider joining one via the Internet—you'll find a wide assortment of groups working in many different mediums, or browse the groups listed under "hobbies and crafts" on any community or discussion site.

Alternatively, you can host a round robin yourself. Start by asking yourself these questions, then finding a way to communicate the ground rules to all the players:

- How many players do you want involved?
- When and how will the books be exchanged?
- Will there be a general theme, or is the theme up to each individual artist?
- How many pages or spreads should each artist complete?
- How will you find the players?
- What is the project's order of procedure and the timeline?
- Does everyone have everyone else's contact information?
- Does everyone know how to mail the books to the next person?

THE COLLABORATIVE round robin offers artists an ever-replenishing source of novelty and inspiration. Try one with a small group of friends or a larger online crafting network.

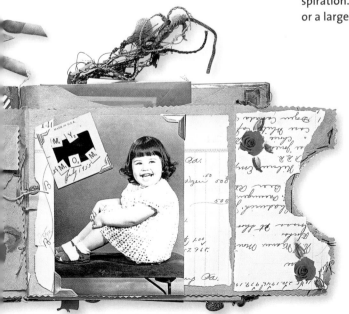

This collaborative book started when artist Sarah Fishburn found an old record album at a yard sale. She chose a theme—What My Mother Played—then signed up her players, who included Suz Simanaitis, Jill Haddaway, and Helga Strauss, among others. The She Plays spread shown here honored the artist's mother's love of sewing by using such materials as sewing notions, fabric, vintage tinsel, and a hook closure (left). The artwork shown at right was designed by Helga Strauss.

Writing with a Breath of Fresh Air

I'LL ADMIT IT—this entry was written while sitting outdoors on a Sunday morning in late August. I am struck by many things—the ongoing cheep, cheep, cheep of the crickets in the background, the breeze that stirs the wind chimes above my head, the mosquitoes that buzz around my bare arms, and then, suddenly, the loud and declarative churrrrrllll that announces the arrival of the red squirrel at my bird feeder.

Coincidentally, that morning's horoscope was marvelously appropriate. It reminded me that life isn't meant to be lived entirely indoors—spending time outdoors, whether you're pursuing a creative endeavor or not—has the power to make us feel connected to a larger world, providing us with much-needed perspective. It can also allow us to access the part of ourselves that, like the animals and birds around us, is wild, free, and pure.

...

SITTING OUTDOORS, listening to the sounds of nature around you, can give you food for thought, refreshed ideas, and the quiet realization that affirms your place in this world. We should all do this more often.

Recycling Jewelry

JEWELRY DESIGNER ELISABETH PEREZ often starts with a jewelry castoff, then builds a necklace from there. At the core of this beautiful necklace: a discarded piece of glass, complete with metal edges and built-in loops.

To make the central pendant, Elisabeth adhered the blue butterfly, beads, crystals, and the chains in what she calls a "cluster style," then added glass pearls on the sides and beaded the necklace to match the central colors.

Although Elisabeth also knits, and she has painted on shells and stones, she finds beading the most satisfying creative outlet. "As you work with beads, you find that there are no limits. You can thread it on silk or ribbon, add knitted and crocheted flowers, I've even added shells and other natural objects to necklaces. Beads bring out my best artistic expression."

...

AS YOU HUNT for jewelry or metalwork to recycle, do not overlook plain, unadorned pieces as elegant bases for your new creations.

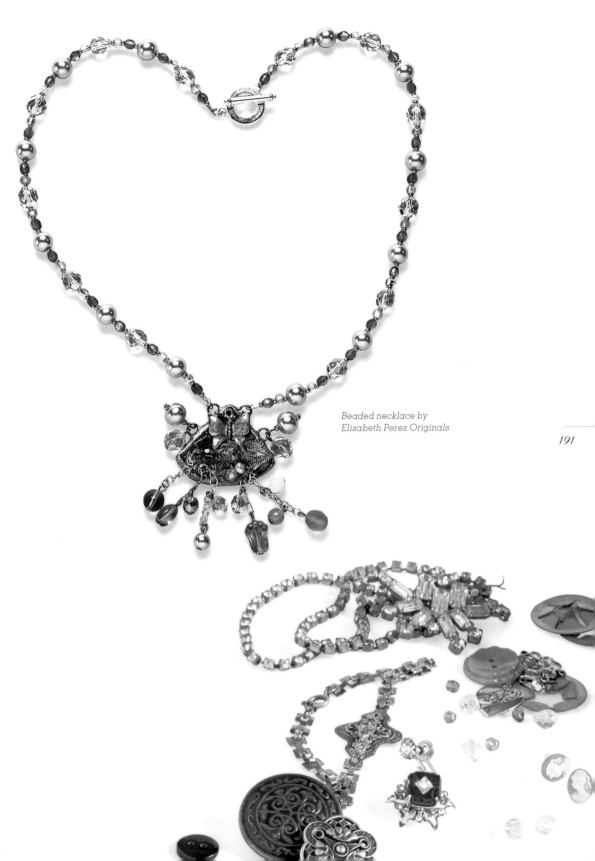

Beaded necklace by
Elisabeth Perez Originals

191

Carving Eraser Stamps

YOU CAN CREATE your own unique art stamps by carving an eraser. (See pages 165 and 183 for carving art stamps from cork or carving blocks.) This is a forgiving process that yields unique stamps for your journal pages, letterboxing adventures, or handmade cards and tags.

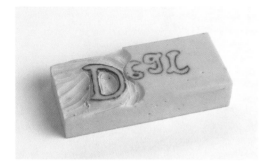

Draw an outline of the image you want to create on the eraser. Try simple forms if you're just starting out; more advanced carvers can transfer computer-generated text or images, using a blender pen. (Note: Words or images should always be carved in reverse.) Use a small, sharp blade to cut away the design; always cut outward from the image to avoid removing too much eraser. When you're done, practice stamping on scrap paper before moving to your final project.

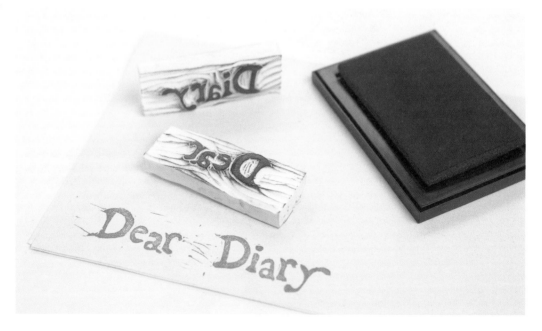

Interview Your Sibling

WHEN I WAS SEVEN, I suffered a ruptured appendix. I will never forget the first time I asked my older sister, Laurie, about that day. Up until then, I had only heard the story from my mother (and I had my own recollections). When my sister told me her memories of that day, it totally changed my perspective on the event, the day, and the resulting hospital event.

For starters, her memories gave me a fresh perspective about how my ruptured appendix affected the rest of the family. My sister shared that I was screaming for hours from the pain—a fact that made me feel slightly ill. Because I was so sick, my siblings had to spend the night at my aunt and uncle's house. I realize now how scary it must have been for my siblings—my sister was 13, my brother 10, and my younger sister just 5—as well as my parents.

As an adult with my own children, I also have new appreciation for how my parents handled the situation, and the depth of fear and anxiety they must have felt as their 7-year-old daughter was admitted to the emergency room in extreme pain, and then rushed into emergency surgery. I was in the hospital for two weeks (unheard of now, but also a reflection of just how sick I was). Imagine the upheaval for the entire family!

When it comes to our childhood, our own memories and reflections can be a powerful source of information and inspiration. But just as every story has two sides, consider that the events of our childhood did not take place in a vacuum—chances are there were other people present, such as our siblings.

This week's task: Interview your sibling (or cousin, aunt, uncle, parents, grandparents, or even close childhood friend) about a specific event, time, or place from your childhood. The goal here is not to revise your own story, but to add depth, perspective, and color to your own memories. Consider these ideas for getting the conversation started:

- Pull out some old photographs, and ask your sibling what he or she remembers about the time, the place, or the events that are shown.

- Pick an important date, place, or time in your life and ask what the sibling remembers.

- Gather old family heirlooms, such as toys, linens, ornaments, or special-occasion dishes and ask for the sibling's impressions and reflections.

- If you've saved yearbooks, school materials, artwork, or papers from your early school years, reflect on them together.

- Gather your photos from childhood and compare notes. (When my younger sister and I collaborated on a fiftieth wedding anniversary photo album for my parents, I saw childhood photos of myself that I had never seen before!)

SOMETIMES, just having another point of view—or refreshed perspective—on the important events, places, or time of your childhood can stir up creative energy.

193

Your Personal Weather Forecast

WE ARE IN TUNE with the weather—who hasn't snuggled in bed on a rainy day, headed straight for the garden on a sunny day, or romped through the season's first snowfall?

Perhaps we feel lighter and more creative in warmer months, or the natural elements (wind, rain, snow, sun) are reflected in our craft materials or medium. The day's weather or a seasonal climate can inform your creative work in many ways:

- Use the weather for analogies in your life, such as sunny days (happy times), sad times (dark clouds), or major transitions (the calm before a storm).

- Use the seasons as inspiration for your color palette or materials.

- Incorporate natural elements into the act of creating artwork, such as sun printing (see page 198) and sun tea (for dyeing).

- Consider global weather systems or events as large-scale symbols, from the force of hurricanes and wildfires to the jet stream or global warming.

- Explore the smallest details of weather, such as snowflake patterns, raindrops, or a slice of sunshine on the rug beside you.

...

WEATHER INFLUENCES the tone of the world around us—temperature, quality of light, and good hair days, to name a few—and its nuances can work its way into our creative work.

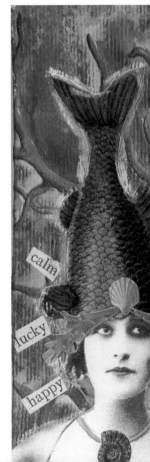

ARTIST / Helga Strauss

Artist Interview: Art Swaps 101

THIS WEEKEND'S ARTIST INTERVIEW with designer Helga Strauss offers insight into art swaps, which are group art-making events.

Q: What is an art swap, and what is the purpose (besides having fun, being creative, and so on!)?

A: An art swap is when a group of artists agree to send a certain type of artwork (usually there is a theme and/or a particular size) to one person (the hostess) and in return, the hostess divides up the swap artwork and everyone receives artwork from the other artists in the swap.

Its purpose is to help one create (a deadline and theme always help), gather inspiration (the artwork one receives back can fuel new ideas in your creativity), make new friends (I've made so many close friends from art swaps), and, let's face it, it's wonderful receiving a colorful package of art in the mail.

Q: Can anyone participate? Are any special materials required?

A: Yes, anyone can participate. Usually there is a sign-up process, though. Yes, special materials are often required, but they're always spelled out in the swap announcement.

Q: What are the ground rules?

A: Hmmm, the only rules are to follow the swap guidelines (whatever they are). You also want to make sure to put your name and email address on all of your swap artwork.

Q: Are there any big "no-nos" to be aware of?

A: Copying someone's art and calling it your own is a big no-no. Other than that, it's all pretty straightforward and everyone is usually extremely nice and supportive, so don't hesitate to ask questions if you're confused about anything. Also, pay close attention to the deadlines and email the swap hostess if you're behind schedule at all. Some hostesses accept late artwork, others do not.

Q: How can you find an art swap and get involved?

A: We (www.artchixstudio.com) host the best swaps on the planet. Other places to find swaps are: art-e-zine.co.uk or search online for "art swaps" and you're sure to find lots.

195

Words to Inspire: *Explore Your Intuition*

"You have to leave the city of your comfort and go into the wilderness of your intuition. What you'll discover will be wonderful. What you'll discover is yourself."

—ALAN ALDA,
actor

Buttons in Jewelry

BUTTONS ARE MORE THAN JUST CLOSURES— buttons can also be used as embellishments in the same way that beads, charms, and trinkets are. All of these jewelry pieces use buttons, but notice how different each application is.

In the necklace shown at right, the artist strung various colored buttons onto thin fiber. The shape, size, and color of the buttons all complement the mint green color of the fiber; in the end, the buttons hardly look like buttons anymore, but rather fuse with the thread to create a unique and beautiful necklace. Phaedra Torres attaches buttons and shells using thin leather cord for her necklace shown on facing page. The resulting design is cohesive and textural, and the buttons begin to resemble shells when they are used this way.

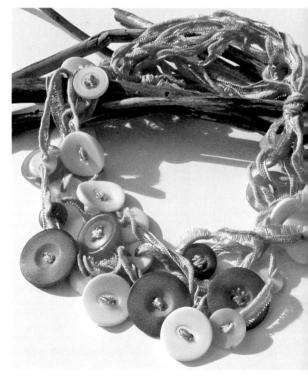

Button and ribbon necklace
ARTIST / Heloise

196

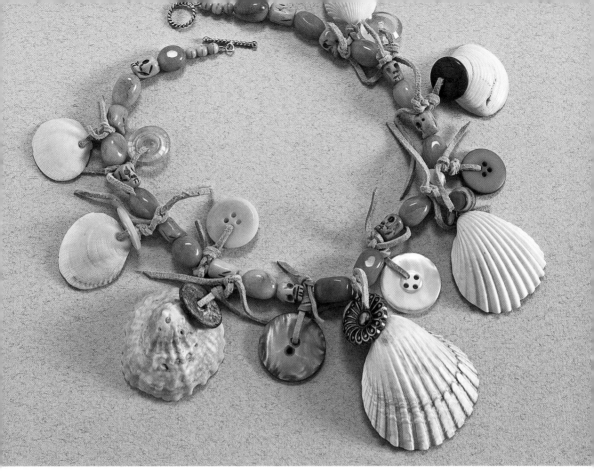

Shell, button, and bead necklace

ARTIST / Phaedra A. Torres, Lluvia Designs

Button and mixed-media ring

ARTIST / Laura Santone, SheSha

The rings, on the other hand, use the button as the centerpiece, and the effect is graphic, modern, and bold. A single, beautiful button could be the focal point of a bracelet or necklace. Moving away from the realm of jewelry, one single button could be the crowning element for a fabric, paper, or mixed-media project.

Two button and wire ring

ARTIST / Andreia Cunha Martins

Sun Printing

SUN PRINTING INVOLVES USING the sun's light to create beautiful and delicate images. Sun prints, also called *cyanotypes,* require three basic ingredients: light-sensitive paper or fabric (also known as sun-print paper or fabric), direct sunlight, and water.

Here's how it works: Sun-print paper is coated with light-sensitive chemicals that react to the light waves in sunlight. The objects placed on the paper block the light, thereby turning the paper white, while the unblocked areas stay blue. Immersing the paper in water stops the process.

To make sun prints, place your chosen object on the sheet of paper, then expose it to direct sun for 3 to 5 minutes. Immerse the paper in water, then dry the resulting print overnight in a darkened area. The paper can be used with a wide variety of objects, from foliage (shown here), to lace, household objects, kitchen utensils, office supplies, and feathers, to name just a few.

...

EXPERIMENT with sun printing and an assortment of natural foliage. Delicate stems, such as the ferns shown here, work especially well.

The top sun print image was made with ferns, but other delicate foliage will create the same effect, such as wheat, evergreens, or skeleton leaves. The lower image was made with dried bean pods, but you could substitute coins, stones, charms, or shells.

Make History Modern

MONA LISA IS A FAMILIAR ICON throughout the world—nowadays she's so famous that not many of us stop to consider her beauty, her mysterious smile, or the skill involved in painting her portrait. She's everywhere, from T-shirts to spaghetti jars.

Consider experimenting with artist Elizabeth Beck's technique for new inspiration. Beck gives the Mona Lisa a modern story, and you can do this with any famous historical icon or image, from Benjamin Franklin to Venus de Milo or ancient Greek gods and goddesses.

"I love giving [Mona Lisa] comfortable shoes, fairy wings, a stylish haircut and great accessories," she says. "I like making her whimsical and fun. She still smiles at us with her mysterious look, but in my art she is flying through the sky, walking pigs, or wearing her newest Lands' End shoes. Mona was extraordinary, then she became so prevalent she was ordinary, and now I hope I am making her extraordinary once again. How could a Bingo Mona ever be considered ordinary?"

CHOOSE A FAVORITE figure or icon from the past and make a modern version. Alternatively, take a modern figure (or a picture of yourself) and create a historical version. Imagine yourself as Joan of Arc, a famous queen, or a powerful goddess. Either process may inspire a whole catalog of new artwork!

199

Paper collages by Elizabeth Beck

Commemorate Life's Passages

SOMETIMES A PIECE OF ART, a project, or an expression of feeling comes together in pieces, like a mosaic. A word here, a snippet of conversation there, and suddenly you're inspired. Add a few materials, time for ideas to gel, and in the end you have a beautiful creation that took its own time in coming to life. Such was the case with *Helen's Heaven*, a decorative keepsake box I created in honor of my friend Kim's mother, Helen.

Story: Helen's Heaven

Four of us drove to the funeral for Helen; Tracy Anne offered her car for the two-hour ride to Rhode Island in the driving rain. We made it just in time to sneak into the church for the service, but the rain kept coming, and the graveside ceremony was held indoors. Afterward we all gathered at a local restaurant, where Kim told me about a dream her cousin had had the night before. In the dream, Helen, who had suffered from arthritis, was dancing on the lawn of her home on Cape Cod. Her husband sat and watched while Helen danced next to her treasured garden, full of beautiful flowers. It was a striking image, and we reveled in an image of Helen at peace, surrounded by the flowers she loved so much. It wasn't long after I got home that I made the collage—*Helen's Heaven*—using images torn from magazines, scrapbook papers, stickers, and the like. I tucked it away, however, and forgot about it for the entire summer.

When I stumbled on a cache of cigar boxes, however, the collage resurfaced in my mind, and I had the idea of transferring it to a box and making a keepsake for my friend. A few days later I took a "Prima Clear Paintables Class" at my local scrapbooking store. I followed the instructions for the project, but when I got home I saw many new possibilities—I wanted to cut up the painted transparency and use the paper flowers and stick-on crystals to decorate Helen's box. And that's how it is sometimes—creations come together over a few months, a little bit at a time. The end result, as it turns out, is usually exactly what it's meant to be.

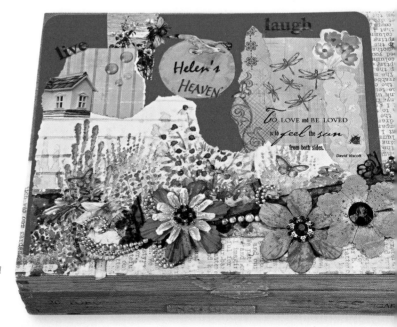

Decorative cigar box, titled Helen's Heaven

ARTIST / Barbara R. Call

Experimenting with Alcohol Ink

I SIGNED UP FOR SCRAPBOOKING CLASS at the local scrapbook supply store on a whim, not even realizing what it was all about; rather, just looking for a new source of creative inspiration. Little did I know that I would discover a whole new world: the world of alcohol inks.

As with many craft classes, the format was very straightforward: Re-create the beautiful layouts the designer, Diane DiTullio, had made; Diane provided each participant with a kit and brought out an assortment of inks to use. The kit included clear transparencies (to which we applied the ink), paper flowers, and some stick-on crystals, among other things.

Several people in the class wanted nothing more than to re-create what Diane had created: two beautiful scrapbook layouts. I found myself straying from the format almost immediately as I discovered the fun of painting the alcohol ink on a transparency. By the time I got to the second project, I was working completely on my own—I no longer needed Diane's directive; instead, the creative process took over completely and I let myself go.

When I was done, and I presented my layout to the class, Diane asked me if I was a painter, and another person asked me if I was an art student. My reply—no, just creative—made me smile. All I needed to tap into my inner artist was the tools, and it flowed from there.

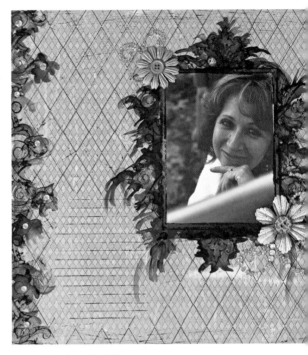

ARTIST / Barbara R. Call

Working with Alcohol Ink

Alcohol inks are vibrant transparent dye inks that come in an alcohol base. They can be used on glossy paper, transparencies, or other slick surfaces such as resin, plastic, metal, and glass. You'll also need alcohol blending solution, which is used to dilute or blend the ink (as well as clean the ink off your hands and tools).

Rereading Old Journals

IF YOU'RE AN AVID JOURNAL KEEPER, chances are you've reread your journal entries, an entire journal, or even a series of journals.

Revisit your personal journals to remember how you felt about a certain event or what you were experiencing at a certain time, and then reflect on whether you're still feeling that way or not, and why. Rereading entries from the past invite you into intimate personal spaces from the past. Look for:

- Repeating motifs or patterns of behavior

- Contrasting feelings or perspectives over time

- Unique moments, decisions, or emotional turning points

When you step back and take a look at the wider perspective, you can see the ebbs and flows of your life, year by year, and see the patterns of changes, shifts, or movement in your personal life. When do we ever see the details of our lives—as well as the bigger picture—stretched out over time for review?

IF YOU'RE A regular journal keeper, take some alone time to reread your entries, and consider if they spark new ideas for creative output. (If you're new to journal keeping, this is what you have to look forward to!)

Revisiting Your Travel Journals

Rereading your travel journals may trigger a flood of sensory memories. The details jotted down each day of a trip may transport you to where you went and what you did. Over time, you may forget the minute details—the names of towns, brief encounters with various people, or the feelings that a location evoked—and rereading those entries can bring them alive again.

202

B-o-a-r-d G-a-m-e T-i-l-e-s

ALPHABET TILES FROM CLASSIC BOARD GAMES have spawned many a creative project. (And it's still fun to play—consider a quick game if you need a break from crafting!) Consider these innovative uses for these individual letter squares.

LOOK FOR old board games, game pieces, playing cards, and other castoff childhood kits or games at yard sales, flea markets, and the like. The boards are a great starting surface for collage or mixed media, and the game pieces make wonderful three-dimensional additions.

Cuff Links
ARTIST / Adjowah Brodie

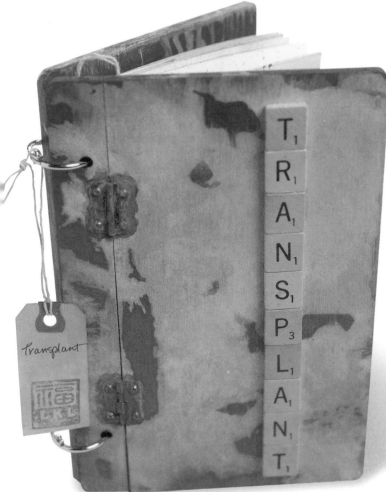

203

The cover of this handmade journal by L. K. Ludwig spells out transplant in Scrabble letters.

Water Webbing Technique

IF YOU LIKE THE PAINTERLY EFFECTS shown here, you'll want to try your hand at water webbing, a technique that can be used with water-based paint or ink and art stamps. For the best results, select a soft watercolor paper that is 120 pounds or heavier (glossy paper won't work), and select art stamps with bold images (not fine detail).

MATERIALS

WATERCOLOR PAPER, WATER-BASED INK, ART BOARD OR STURDY CHIPBOARD, ARTIST TAPE, ART STAMP, AND SPRAY BOTTLE WITH WATER

Start by taping the watercolor paper to art board or chipboard to prevent it from curling. Lightly mist the paper with water and wipe off any excess moisture. Press the stamp firmly into the ink to pick up as much ink as possible, then stamp onto the paper. Remove the stamp, position the bottle about 8 inches (20 cm) away from the image, and squirt once, using the spray bottle. The pressure from spraying the water will move the paint into the webbing patterns.

WATER WEBBING creates a delicate effect with your art stamped or hand-painted images; blot the image with a paper towel for a more subtle effect.

ARTIST / Julia Andrus

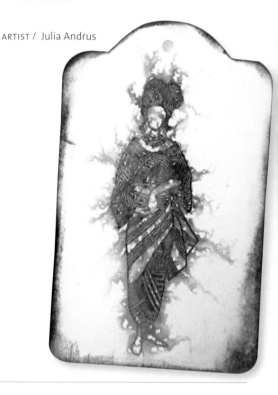

204

What's in a Name?

HAVE YOU EVER LOOKED UP your own name to find out what it means? Common names you hear spoken on the street, read in the media, or even see pop up in your email inbox have origins in far-flung regions: Irish, Portuguese, French, Korean, and beyond. The nuances of meaning can be literal (such as flower names or other natural elements) or metaphoric ("one who gives life").

Consider asking your parents why they named you what they did—there may be an interesting story or colorful character behind your name!

UNDERSTANDING the meanings of your name can illuminate your own personality, likes and dislikes, or habits.

Finding an Old French Journal

ARTIST HELGA STRAUSS recounts the story of how an old French journal inspired an original collage:

Story: Un Vieux Journal

For my birthday, my Mom gave me a gorgeous old French journal from the late 1800s. It's gorgeous! It is filled with beautiful pressed flowers that are all labeled and dated, along with poems and little pieces of ephemera. Some of the pressed flowers can be found in tiny envelopes. I was so inspired by this book that I decided to add little envelopes to my current art project: chunky book pages (4-inch [10.2 cm] square collages).

Before I added the envelopes to my pages, first, I had to design my collage. I knew I wanted to use my muse (the "spoil me" chick image) and that I had to somehow make her oceanlike (the theme was "By the Sea"). I found myself drawn to seahorses, so I started playing with them. It wasn't long before I chopped off their heads and made a funky hat with them. What fun! When all was complete, I created the tiny envelopes. I found a punch from the craft store that makes creating these tiny envelopes easy! Then I popped a lucky penny from the Bahamas (which has a starfish on them) inside each tiny envelope.

..

WALK ALONG the artist's path from original inspiration (the old French journal) to new artwork (a collage), enjoying the sights along the way.

This page from an old French journal was given to artist Helga Strauss by her mother. Let the imagery and techniques used here light a spark. Decorate a moon-shaped image, incorporate tiny envelopes into your projects, or even try to replicate an antique, aged effect.

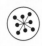

Beading 101, Part II

THIS WEEKEND THE beading lesson that started on page 170 continues. If you don't already have these items on hand, assemble the following materials: beads, sequins, or stones (see "Beads, Sequins, and Stones," page 213), thread, fabric, scissors, and beading needles. You'll also need a design or a plan, which can be as simple as adding a beaded fringe to the pockets of your favorite jeans or an elaborate border for the edge of a shawl or scarf.

Three New Basic Beading Stitches:

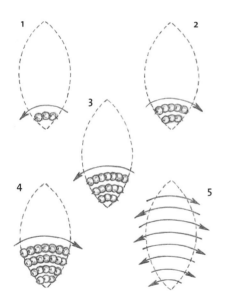

For the flat version, thread enough beads onto a stitch to take it across the design and cover it. Use a zigzag motion to stitch back and forth across the design, increasing or decreasing the number of beads at each stitch as the pattern widens, narrows, or changes. (If the design is very large, consider couching the beads in the center: Knot a length of thread and stitch between every third to fifth bead.)

For the padded version, cut a pad of felt, 1/16 inch (2 mm) smaller than the design, preferably in the same color as the beads or the background fabric. Hand-tack the felt pad in place, then work the beads over the pad. Padding can help keep beads from sinking into the nap of the fabric or create a design with high relief.

Satin stitch: *Satin stitch, also known as zigzag stitch, is great for covering large areas of a motif with beads. There are two ways to do this stitch: with padding or without.*

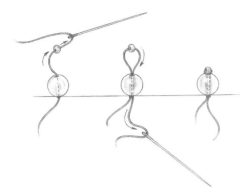

Basic stop stitch: *The stop stitch is a very useful stitch and used frequently in beading. There's one key step: When inserting the needle back into a bead (or beads) to close a stitch, make sure to scrape the point of the needle against the inside of the beads when passing it through. This prevents stitching through the thread and creating a snarl.*

1. Bring the needle up through the fabric and slide the bead down onto the fabric. Next, pick up the "stop" bead, such as a seed bead.

2. Insert the needle back through the first bead and into the fabric, then pull the stitch closed.

3. When the stitch is closed, the stop bead will sit on top of the main bead.

Dangle stitch: *This is an elongated stop stitch with multiple beads. Use as many beads as you like; if you space the beads in a row close together they make a fringe. Be sure to knot and tie off after every two or three stitches; this way, if a thread breaks, you don't create a chain reaction of unraveling.*

1. Bring the needle up through the fabric and thread on the desired beads; pick up a seed bead for the stop bead.

2. Pass the needle backward through all the beads and directly into the fabric, then pull the stitch closed.

USE THESE beaded stitches to add texture or color to your paper or fabric projects, or just use the effects shown here for inspiration in other media.

3-D Journals

As you surely know by now, journals don't have to take the form of written text and book format—they're as open to interpretation as any sculpture or three-dimensional object. Nearly any structure can be used to house a journal, and journals can take any form you can imagine. The key is that the form allows you to express yourself completely, as desired.

THERE'S ONLY ONE RULE to remember: There are no rules when it comes to journaling! Play with theme, content, and style, with regard to the form of the journal, itself.

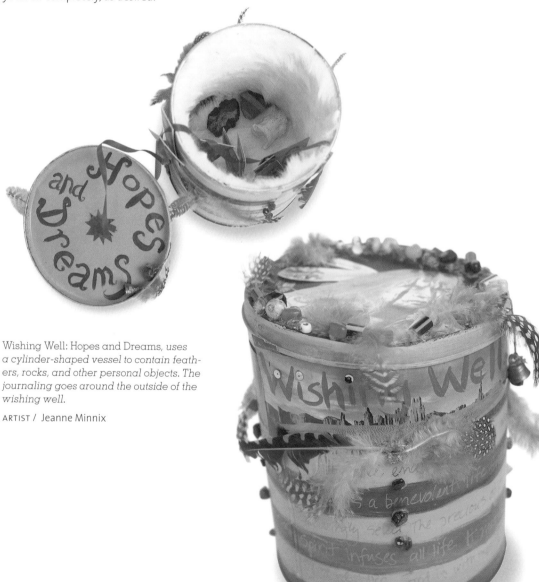

Wishing Well: Hopes and Dreams, uses a cylinder-shaped vessel to contain feathers, rocks, and other personal objects. The journaling goes around the outside of the wishing well.

ARTIST / Jeanne Minnix

Out of the Woods: Bark and Lichen

BARK, LICHEN, MOSS, and other natural objects are wonderful materials for paper or mixed-media collage projects. The "palette" of objects available outdoors depends on the current season. The shapes you unearth can be used strategically to evoke other forms.

The elaborate collage shown here, for example, re-creates the familiar boot shape of Italy in bark. Artists MaryJo and Sunny Koch then added lichen, dried leaves, seeds, and garden book clippings to emphasize the botanical family roots. The finishing touch: pasta letters that spell "Italy."

BE ON THE LOOKOUT for naturally occurring shapes that can serve another purpose: a round leaf to represent a pond or lake, a piece of driftwood to represent an island in that water, and so forth.

ARTISTS / Maryjo and Sunny Koch

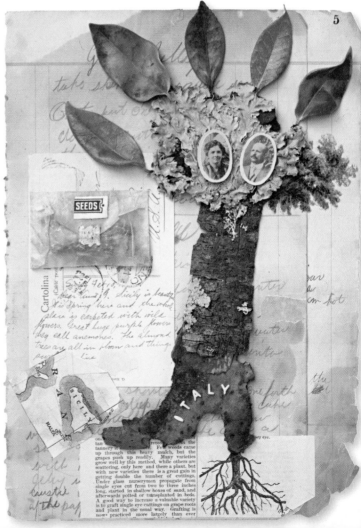

Block Printing

TODAY'S EXERCISE—to re-create an activity you may remember from your childhood: Block printing. Although you may have used potatoes then, today the materials for printing blocks are as varied as fresh fruit, leaves, flowers, or any object with a flat, smooth surface. Apples, mushrooms, or other firm fruits and vegetables with a distinctive shape will work, as will collected foliage and stems from your garden.

MATERIALS

MATERIAL TO PRINT OR PAINT ON; PAINT OR INK (FABRIC PAINT FOR THE FABRIC PLACEMATS SHOWN HERE, ACRYLIC PAINT OR INK FOR PAPER, AND SO ON); COSMETIC SPONGES AND/OR PAINTBRUSHES; SPRAY BOTTLE; AND OBJECTS TO PRINT WITH

To create the pear prints shown here, use a lightly dampened cosmetic sponge to load the flat cut surface of a pear with paint. Begin by covering the entire surface with yellow paint, then sponge gold, green, and red paint on to add shading and detail. (Apply the paint fairly heavily.) Color the edge of the pair, the stem, and the inner seed with brown paint. Spray the painted surface lightly with water to blend the colors, then print. Add further details with the paintbrush, if desired. Let dry completely and if using fabric, heat set the paint following the manufacturer's instructions.

..

BLOCK PRINTING is a simple technique for adding natural images to your artwork.

210

ARTISTS / Sandra Salamony and Maryellen Driscoll

The Endless Energy of Children

IF YOU HAVE KIDS, you already know they can inspire infinite types of new art and projects, especially if you document special events and milestones. But capturing your kid's everyday moments and events can also fuel your creativity—try thinking beyond just the first day of school, the big soccer trophy, or their tenth birthday.

CHILDREN ARE an endless source of energy, new experiences, and fresh outlooks on life. Consider how children approach the world, or how you approached the world when you were a child, and incorporate those insights into your work.

Making the Folio

To make this folio, start by cutting and covering four mat boards (see page 216). Decorate the four boards with photos and stickers, then punch holes and set eyelets in all four corners of each board. Use jute to tie the folio together, then finish the ends with assorted beads.

211

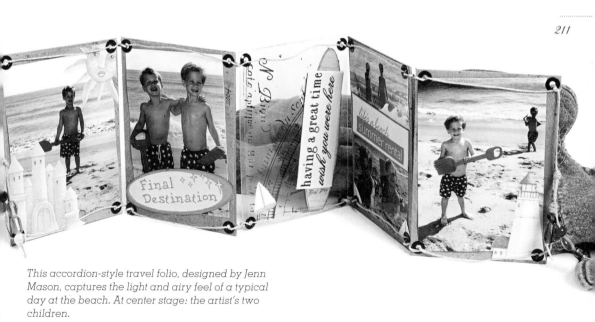

This accordion-style travel folio, designed by Jenn Mason, captures the light and airy feel of a typical day at the beach. At center stage: the artist's two children.

Artist Interview: Jennifer Mason

ARTIST AND AUTHOR Jennifer Mason, who is regularly published in paper and memory art magazines and books, has a degree in fine arts from the University of Michigan. Although paper art is her first love, she also dabbles in painting, sewing, watercolor, knitting, jewelry design, calligraphy, crochet, and flower arranging. (For examples of Jennifer's work, see the Directory of Contributors, page 316)

Q: Where do you find inspiration for most of your work?

A: I love the challenge of finding an inspiration. I like one-word prompts; they can get my mind racing. I also like the challenge of trying to incorporate a new item I've never used before into my work.

Q: If you're ""fresh out of ideas," what do you do?

A: I look at my supplies and try playing with one and expect nothing—something great always comes of it.

Q: What is the one tool, material, or technique you couldn't live without?

A: For tools? An awl. For material? Soft gel. And for supplies? Old stuff.

Q: Can you name one or two artists (craft or otherwise) whose work you admire most and explain why?

A: Joseph Cornell—his work was ahead of its time, it tells a story, it intrigues me. Alexander Calder—his work is playful, whimsical and smart. It makes me smile.

Q: Do you have a signature look and feel, how would you describe it, and how (or why) did you arrive at that place?

A: Every piece of my work tells a story. It tells me the story as I work on it. I hardly ever know the story before it starts. It is also bright and cheerful, even the pieces with less than happy stories. My art looks on the bright side and finds the silver lining when necessary.

ARTIST / Jenn Mason

Beads, Sequins, and Stones

IF YOU LOVE BEADING, there's an endless assortment of beads, stones, and sequins available in retail stores, online catalogs, even among yard-sale finds and flea market jewelry. They come in all colors, shapes, sizes, and material—the choices are as varied as the artists who will use them, and the forms they will take. What follows is an introduction to the topic of beads, sequins, and stones for beginning beaders.

BEADS

Seed beads: Somewhat round and roughly as long as they are wide, these beads come in varying sizes, from very tiny to very large (known as crow beads).

Cut beads: Similar in size to seed beads, cut beads have flat surfaces cut or molded into the bead.

Bugle beads: Tubular in shape, in sizes ranging from ⅛- to 1½-inch (2 to 40 mm) long (called glass tubes). Less expensive bugle beds are cut to length by being broken, which makes the edges very sharp. Over time, this can result in cut threads. Higher-quality bugle beads have polished edges.

Round beads: The best example of this type of bead, which is spherical in shape, is costume pearls.

Roundel: Doughnut-shaped beads made from plastic, glass, and metal, among other materials.

Drops or pendant beads: These beads are narrow at one end and wider at the other; if the hole is drilled horizontally across the narrow end they can be strung to dangle.

Lozenge: These beads feature a diamond or elongated rectangle shape.

Faceted: These beads can come in any shape, but they have flat surfaces cut into them. Swarovski beads, made of fine lead crystal, are a good example.

SEQUINS

Sequins: Round, completely flat or slightly cup-shaped disks with a hole cut in the middle.

Paillettes: Round sequins with the hole punched at the edge.

Novelty: A catch-all category that includes fancy shapes, such as leaves, flowers, stars, animals, etc.

Findings: These are not technically sequins but rather metal stampings of assorted shapes and objects that can be sewn down.

STONES

Stones: Stones are typically either flat-backed with holes drilled through the glass, or claw-backed, which means they fit into a metal fitting.

..

WITH BEADS, SEQUINS, and stones you can create decorative effects, embellishments, or accents for your work. With beads, embroider words on book pages; incorporate texture in your scrapbook pages; frame or outline other design element; or slide the beads onto ribbon, cord, or tape.

This beaded necklace features an assortment of glass, seed, and faceted beads.

ARTIST / Elisabeth Perez

Journal Prompts

LOOKING FOR FRESH WAYS TO MINE your thoughts? Today, try these seriously introspective journal prompts. When considering your responses, do not edit or curb your thoughts.

- What was your childhood experiences with holidays?

- What is something you dislike about yourself?

- What kinds of things are you good at?

- What is your favorite room in your home and why?

- Do you have pain, and if so, what does it feel like?

- What is your most indispensable possession and why?

- If you could be any animal you wanted, what would it be?

- What is the best birthday present you ever received?

- Fill in the blank: I want to be remembered for . . .

- What is something that really makes you angry?

- What makes you feel most secure?

- What is the best advice you ever received?

WRITING PROMPTS—especially challenging ones—can be a useful tool for accessing your innermost feelings. Try a new prompt once a week to tap into your creative well.

September 11 2005

On a walk with Siri to the quarry on Deer Isle near Stonington, I tried three monochromatic "thumbnails" to try to capture values and concentrate on shape and shadow rather than color. It helped greatly with composition. Then as we walked back through the woods my attention was caught by one of those "secret places" that always fascinated me as a child—the places under roots and moss where faeries surely reside.

This Rotring pen inspires a different kind of penmans—

ARTIST / Susan Bonthron

214

Using (and Reusing) Your Own Art

As I TALKED TO DOZENS OF ARTISTS and craftspeople for this book, I was surprised by how many of them make copies, reproductions, scans, enlargements, or reductions of their own artwork for use in other projects (see the interview with Maryjean Viano Crowe, page 244.)

Some make color copies of images they've created; others cut up works of art they're not pleased with and use them for collage; still others print the same photos over and over or transfer the same images again and again.

This week, think about some of your favorite pieces and how you might copy a few for use in other projects. This could mean making a color copy of a collage, for example, and cutting out the central figure for reuse; or slicing a large watercolor painting into pieces; or scanning your favorite projects and zooming in on a particular area or image.

REINVENT, REUSE, and repurpose your own work in whatever way pleases you. It will give you a virtually endless source of material, and it may help you develop your signature style.

> "Every artist dips his brush in his own soul, and paints his own nature into his pictures."
>
> —HENRY WARD BEECHER (1813–1887),
> *American clergyman*

215

Covering Book Boards

IF YOU LIKE creating your own journals or memory book covers, these instructions for covering book boards are just what you need.

THE COVERED BOARDS you make with this basic technique can be as covers for store-bought journals or handmade memory books (see image, below) as oversized ATCs, or additions for scrapbooks and mixed-media projects.

MATERIALS
MAT BOARD (LOOK FOR MAT BOARD SCRAPS AT CRAFT OR HOBBY STORES), DECORATIVE PAPER, ADHESIVE, A BONE FOLDER, AND SCISSORS OR OTHER PAPER TRIMMING DEVICE

Step 1
Start with a piece of mat board cut to the desired size of your project. Cut a piece of decorative paper large enough that the edges can fold over.

Step 2
Glue the paper to the mat board and use the bone folder to gently smooth the paper and board together; this ensures good adhesion and no bubbles or gaps. Don't fold the edges over yet—instead, miter the four corners out of the paper, leaving a small amount of paper hanging over the edges.

Step 3
Glue and wrap each paper tab over the mat board, using the bone folder to smooth and adhere the surfaces together.

Step 4
Run the bone folder along each edge to create nice, crisp lines; work carefully to avoid ripping or tearing the paper.

Words to Inspire: *Emotions*

"The artist is a receptacle for emotions that
come from all over the place; from the sky, from
the earth, from a scrap of paper, from a passing
shape, from a spider's web."

—PABLO PICASSO (1881–1973),
Spanish painter and sculptor

Opening and Closing Doors

"When one door closes another door
opens; but we so often look so long
and so regretfully upon the closed door,
that we do not see the ones which open
for us."

—ALEXANDER GRAHAM BELL (1847–1922),
Scottish-born American inventor

TODAY'S TASK: Reflect on this metaphor in terms
of your life as a whole and your artwork. What
have your "doors" been, and how have they
opened and closed over time? When one period
ended, what was ushered in next?

When one relationship was over, what was
born from the grieving? When one project was
completed, thrown away, or recycled, what new
artwork was given life, expression, or feeling?
When one experiment failed, what tiny seed of
possibility was hatched?

THERE'S A LESSON in all beginnings and
endings, and those lessons can be applied
to your artwork. Never regret the end of a
project—simply look to the future for the
new possibilities that await you.

Shop, Hunt, Gather

Story
by *Jenn Mason*

I am an antiques junkie. I should get myself into a 12-step program but my art would suffer terribly. I'm lucky that I live in Massachusetts because, three times a year, the antiques mecca arrives in my backyard. Well, not right in my backyard but in Brimfield, Massachusetts, which is just an hour away. *Three times a year.* Now, that is music to a junker's ears. It runs from Tuesday to Sunday for one week in May, July, and September. How I make it from September to May every year is inexplicable.

I own three wagon wheels that rest along one of the walls in my carriage house turned home. I have an old desk, a dress form, a vintage stamp holder, a collection of milk glass vases and compotes (perfect for holding art supplies with panache), mirrors, and a lovely oil painting of sheep in a meadow—all from Brimfield.

But what really makes my heart sing are the little things that I can add to my art: old books, rusty knobs, broken handles, doll parts, watch faces, interesting boxes, old photographs, ancient tins, wooden molds, horse shoes, well-loved toys, stamps, old correspondences, ledger books (with and without writing) and sheet music, to name just a few.

I'd be remiss if I didn't tell you that there are plenty of other wonderful antique stores or markets in every corner of the world. I have a book that lists flea markets and antique stores in Italy alone! I would especially recommend the kind of antique stores that are filled with booths—you're bound to find a must-have item when you have so many antique collector styles to choose from.

Over the years, I have learned to read a booth or vendor very quickly. If the booth is filled with highly polished wood furniture, I skip it. I'm looking for *old* stuff, not *nice* stuff. I don't have the heart to glue, paint, and drill the nice stuff. I want something that has its own story to tell. I want something that sings to me in its own dusty, rusty, wrinkled way. Because I am a junkie, I also know what I want to spend—and that's not much. If I see a booth filled with old tools, I know that this vendor knows the value of his collection. I won't get the same deal I do for a collapsible ruler there as I would at a vendor's "everything $1" table.

These two pieces at right were both created from my collection of antique treasures. The tin once held a half pound of crystallized Canton ginger packed for the S. S. Pierce Company. I just had to have this tin when I found it—my girls go to Pierce Elementary School, named for the same Pierce family, and this tin had a story to tell. I used black gesso to prime the inside of the rusty tin and then layered acrylic paints, old stamps, and old book illustrations and charts. I used pens and embossing powder to list the possibilities of the future on the left and used soft gel gloss to seal the right-side illustration.

The other canvas piece is called *Worry*. I used a hard-to-find item—a doll hand—to hold a watch face; this represents how I worry that time is slipping away. I used a mixture of acrylic paints, Pigma pens, and soft gel to attach and embellish the canvas.

Both these pieces are unique and their parts were worth the hunt. I celebrate each found and purchased treasure for the story it will tell me.

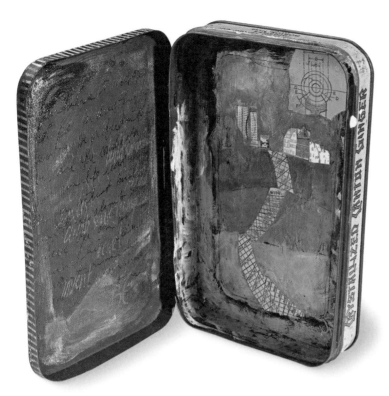

The Future Is Wide Open
ARTIST / Jenn Mason

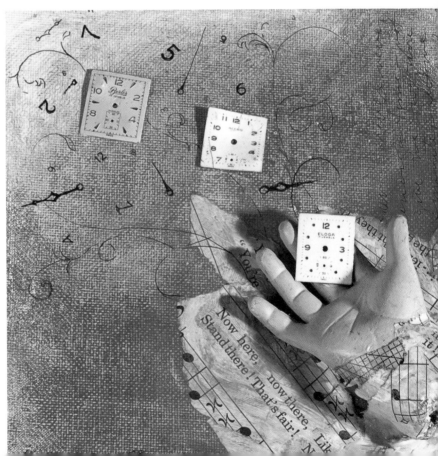

Worry
ARTIST / Jenn Mason

Novel Journal Covers

LOOKING FOR FAST AND EASY WAYS to create a cover for your store-bought journal? Consider these ideas:

- Cigar box lid
- Discarded roof shingle (or tile)
- Large scrap of leather
- Unfinished dollhouse door
- Scrap wood
- Cut-up board games
- Lightweight picture frame
- Flattened metal cans or tins

- Glued layers of cardboard
- Small, flat wooden or tin boxes
- Circuit boards
- Diskettes or CDs
- License plates
- Scrap metal

...

PERSONALIZING your journal cover need not require elaborate bookbinding skills— just decorate your chosen material and glue it in place.

Gourd Crafts

IF YOU'VE EVER BEEN INSPIRED by fruits and vegetables, then you'll understand the impetus for this unique journal by artists Linda and Opie O'Brien: a hard-shelled Lagenaria gourd.

"Gourds are 'Nature's Pottery' and one of the first plants cultivated throughout the world since prehistoric times," the artists write on their website. "Gourds have played a significant role in the origin myths of many cultures and are believed to possess sacred and mystical powers. They were functional, decorative, exchanged as money and dowry payments, and were used in both ritual and divination. Many have been excavated intact and have survived the ravages of time."

To make this book, the artists chose two thick, matching sections of the gourd to use as covers, then cut out the shapes, using a jigsaw. They sanded the edges and then applied leather cream to enrich the color. The artists also used the gourd seeds in several places—the cover features three tiny gourd seeds on a copper fixture and a tiny vial with smaller gourd seeds, while the waxed linen thread closure has leather-hard gourd seeds strung with smaller beads. Even the handmade paper pulp pages include scrapings from inside the gourd.

...

DO YOU HAVE a collection of some kind, a love of a certain object, or a fascination with a particular material? Consider finding a way to incorporate those materials into your artwork— it may open new doors that you never knew existed.

Blender Pen Transfers

THERE COMES A TIME when an artist finds an image that he or she loves and wants to use in their work. This is where image transfer comes into play. There are several different techniques for transferring images (see page 230 and 231), but one of the simplest—and easiest to master—involves using a blender pen.

ARTISTS / Linda and Opie O'Brien

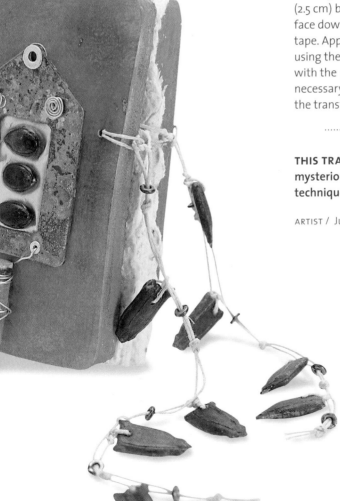

Assemble the following materials before you get started, and be sure to work in a well-ventilated room:

- a photocopy of the image to be transferred
- smooth paper surface
- solvent-based blending pen (such as Chartpak Blender)
- paper towel or bone folder
- low-tack tape

Start by trimming the image, leaving a 1-inch (2.5 cm) border all around. Position the image face down on the paper and secure it with the tape. Apply the solvent to the back of the image, using the blender pen, then burnish the image with the paper towel or bone folder. Repeat as necessary, then remove the top image to reveal the transfer.

221

THIS TRANSFER technique creates an aged and mysterious effect. For more pristine transfer techniques, see page 230 and 231.

ARTIST / Julia Andrus

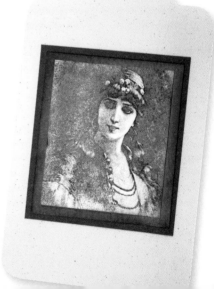

Art as Creative Healing

ART HAS BEEN USED FOR healing purposes since the beginning of time; long before Prozac, people who were labeled "troubled" were encouraged to channel their energies into artistic expression. The act of creating original artwork can be a tool for emotional release, a path to inner healing, and an outlet for negative (or positive) emotions, feelings, and impressions.

ART CAN UNLOCK areas of the subconscious, offering a way to excavate and release even deeply buried hurts. Art may also serve as a coping mechanism for everything from cancer to sexual abuse, chronic pain, and depression.

A Play on Words

Pun: A play on words, sometimes on different senses of the same word and sometimes on the similar sense or sound of different words.

SPEND AN AFTERNOON motoring around a harbor or strolling around a marina and you will be struck by the names people have given their boats. The next time you need a title for your artwork, consider a play on words, such as these nautical-inspired names:

> *Boat a Bing*
> *Reel-y Nauti*
> *License to Chill*
> *Break in Wind*
> *Clairebuoyant*
> *Sea Duced*
> *Aloan at Last*
> *Seas the Moment*
> *Endorfin*
> *Weather Oar Knot*

WORDPLAY ADDS dimension to the simplest phrases. Start with your word of choice, such as *believe*, *create*, or *girlfriend*. Then consider alternative interpretations (be-alive, be free, be and live), playful capitalization (crEate), or alternative spellings (gyrlfrnd, gyrlfrend, frendz till the end).

Artist Allison Schubert chronicles her struggles with anorexia in the pages of this journal. "Anorexia is like a shadow that follows you everywhere you go, and it is easy to slip back into that lifestyle," she writes.

Make a Swing Journal

WHAT IS A SWING JOURNAL (also known has a *fan deck*)? It's fun and fanciful design for a journal whereby the pages are attached to a central post or ring, much like the paint, tile, or flooring samplers in hardware and home improvement stores.

The beauty of this design lies in its simplicity and adaptability: You create as many pages as you want in whatever size suits your need, then choose from an assortment of ways to connect the pages together. Take inspiration from these designs, which have interpreted the swing journal in several different forms, sizes, and colors.

BORROWING FORMS or packaging ideas from other areas of life is a creative exercise in itself. The next time you need inspiration, visit the local hardware, art supply, or home improvement store to mine new ideas.

There are several ways to make a swing journal. To make the journal shown here, artist Beth Wilkinson created a cover and individual pages with heavy card stock, punched a hole in each one, and attached all the pieces to a central post. Jenn Mason covered four mat boards, then decorated them and punched a hole in each corner. She attached the pages with ball chain and tied on scraps of ribbon.

You can also connect the swinging pages with:

- a notebook binder ring
- twine or ribbon
- leather cord
- any durable material that allows for free movement

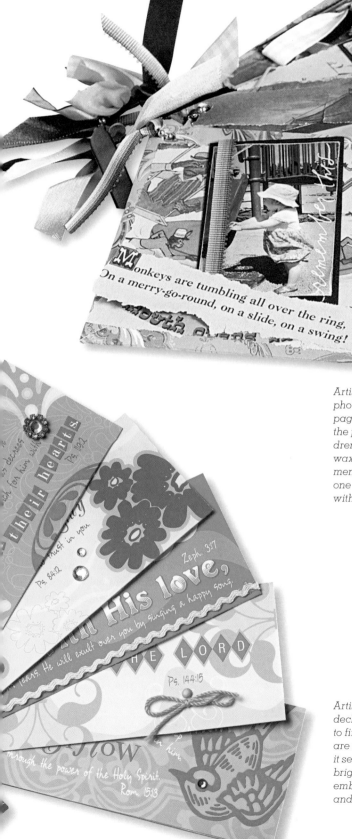

Artist Jenn Mason started this swing photo book by covering four mat board pages (see page 216). She then collaged the pages with illustrations from children's books, photos, rub-ons, ribbon, waxed twine, and other embellishments. The pages are joined together at one corner with a ball chain decorated with scraps of ribbon.

Artist Beth Wilkinson created this fan deck with a theme: scripture that speak to finding happiness. When the pages are swiveled out from the central post, it serves as a rainbow of promises in bright colors and images. The cards are embellished with crystals, rhinestones, and trim.

Dynamic Journaling

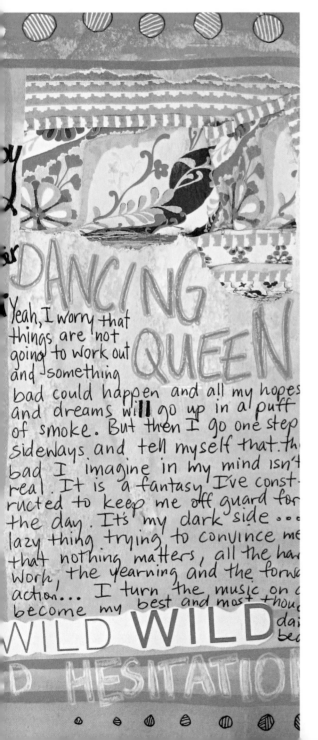

JOURNALING DOES NOT always need to be a private affair carried out at home.

- Carry a notebook (or sketchbook) with you at all times, and especially if visiting museums, galleries, or other significant locations. Make quick notes or sketches or jot down individual words to capture your feelings, emotions, or impressions.

- Follow your passions. If you love dogs, visit a shelter; if you've always admired the work of a certain artist or photographer, seek out the person's work; if you love the outdoors, set out on an outdoor adventure as often as possible.

- Enlist the help of a friend to work on a joint journal. This process can spark new ideas, inspire your creativity, and may reveal what you share in common—and what you don't.

- Don't pass up the chance to learn more about journaling: Ask your friends if they have a journal and what kinds of things they keep it in and what they write about.

..

THINK OF YOUR journal as an extension of yourself—don't leave home without it!

ARTIST / Catherine Witherell

Coloring Books

VISIT THE LOCAL craft supply or toy store and pick up some coloring books, or borrow some from your children's supply. Today's coloring books—especially those for older children—are both sophisticated and worldly, and there's a theme, subject, or collection to suit just about any interest. You can use coloring books any number of ways:

- Color in the images, then copy, transfer, or collage the results.

- Use the black-and-white drawings or illustrations as jumping-off points.

- Seek out images of favorite items for coloring with watercolor or paints.

- Create three-dimensional structures or embellishments, using torn, ripped, or crumpled images.

..

RETURNING TO the crafts of childhood can be relaxing and liberating. (Whether you color within the lines is up to you.)

Sort, Organize, and Purge

THE URGE TO PURGE is universal—it often occurs in the spring, when we're shaking off our winter coats and getting ready for plenty of fresh air. But there's no time like the present for sorting, organizing, or purging your own stash of craft materials.

There are many benefits to an organized workspace, the most obvious of which is that it lets you find what you need quickly and efficiently. But there are other benefits to sorting, organizing, and purging:

- It provides a bird's-eye view of your entire collection, which may spark a new idea or unearth a forgotten project that needs finishing;

- It may expose colors, themes, or textures that you may not have noticed while you looked for items individually;

- Cleaning, sorting, and organizing can be soothing and therapeutic, especially if your brain needs a break from creating and producing;

- There's an immediate visual impact to creating a neat and organized workspace that's very satisfying.

If you need ideas for organizing, categorizing, or purging, visit your local home goods store—the options for bins, baskets, and containers has expanded greatly in the last few years. Alternatively, borrow from the workshop and utilize woodworking cabinets designed for holding screws and nails; visit the fishing department and pick up a few tackle boxes or lure containers; or get really creative and decorate your own bins, garden pots, or cigar boxes for containing your stash.

..

ORGANIZING your materials gives you a sense of accomplishment while also letting you sit back and take in your collection from a different vantage point.

Retell Childhood Stories

No ARTIST PORTFOLIO is really ever complete without a work of art that celebrates, reinvents, or just explores the artist's childhood.

Artist Deborah D'Onofrio explains the inspiration and techniques used to create the original miniature canvas shown here, titled *Altering Ancestral Bonds*.

"As part of my healing journey at the time, I was working through being part of my matrilineal heritage [defined as relating to, based on, or tracing ancestral descent through the maternal line]," she says. "Some of the things that the women before me endured I didn't want to endure, so I envisioned myself breaking free of those bonds."

To create the work she started with a 4-inch (10.2 cm) square miniature canvas, then used acrylic paint to add color.

She altered a photo of herself as a baby, then typeset, printed out, and cut up select words from a favorite poem. Deborah fashioned the wings out of plumber tape and wire, then added charms and altered text to finish the project.

..

WHAT ARE THE STORIES that your art tells? How does your soul or spirit express itself? What are the events from your childhood that need retelling, refashioning, or even reinvention for the purpose of creative expression?

ARTIST / Deborah D'Onofrio

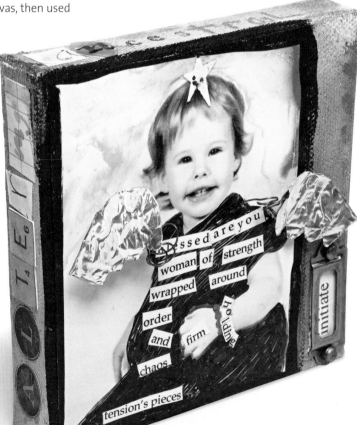

Man's Best Friend

WHO HASN'T BEEN inspired by his or her dog? Like our children, dogs can be an endless source of inspiration, based in large part on their unchanging devotion, affection, and companionship.

If you want to keep a journal about your dog, here are some ideas for how to get started:

- What was it like the first day you got your dog?

- List some of the funniest things he has ever done.

- What are his best traits, worst habits, or favorite toys?

- What is your dog's heritage? Do you know much about his parents, breeder, or siblings? What do you know about your dog's breed?

- List some of your favorite memories of your dog.

- If you could write from your dog's perspective, what would he say?

- Who are your dog's friends and playmates, and what would they say about him?

- Has your dog traveled? If so, where did he go and how was the experience?

- What one word sums up your dog's personality?

...

THAT FAITHFUL FRIEND at your feet may be all the inspiration you need for taking your artwork in a new direction.

"A dog can express more with his tail in seconds than his owner can express with his tongue in hours."
—ANONYMOUS

229

Artist Jill Beninato sums it up nicely in this artist journal spread: "Only an artist would dye their dog blue!"

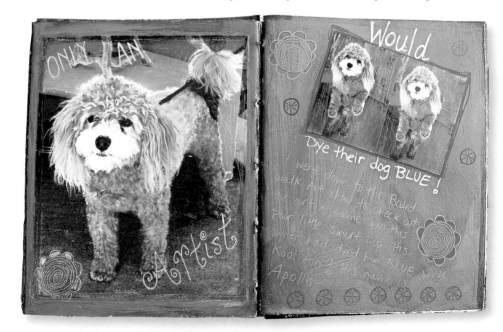

Image Transfers

ARTIST LYNNE PERRELLA has identified more than ten different techniques for transferring images. These myriad methods are an invitation to modify images to meet any artistic vision. What follows are a few of Lynne's suggestions, including samples designed by a variety of artists.

LYNNE SUMS up this topic very nicely: "Transferred artwork displays the hand of the artist rather than merely a simple collage element."

230

Gel medium ink-jet transfer from copy paper onto paper: *Make an ink-jet copy of the image on paper. Apply a generous amount of regular gel medium to the receiving paper. Lay the copy image side down, burnish and let sit for 10 seconds, and then remove the paper. Gently rub off any lingering paper fibers.*

ARTIST / Karen Michel

Ink-jet transfer from paper onto fabric with soft gel medium: *Print an image onto matte photo multiproject paper. Brush an even coating of gel medium onto the fabric and smooth the brushstrokes with your finger. Apply the medium to the image, then lay the paper ink side down on the fabric and burnish for 20 seconds.*

ARTIST / Lesley Riley

Matte medium transfer onto fabric: *Print the image onto an ink-jet transparency. Brush an even coating of matte medium onto your fabric and smooth out the brushstrokes with your finger. Place the transparency ink side down on the fabric and burnish for 20 seconds.*

ARTIST / Lesley Riley

Packing tape (or Con-Tact paper) transfer from ink-jet copy onto paper: *Apply clear packing tape over your image and burnish. Soak the tape and copy in warm water until the paper is saturated. Gently rub the paper to remove it from the tape, then let the tape dry.*

ARTIST / Karen Michel

231

Gel medium transfer from ink-jet transparency onto paper: *Print the image onto an ink-jet transparency. Brush on an even coating of gel medium onto your paper and smooth out the brushstrokes with your finger. Place the transparency ink side down and burnish for about 20 seconds.*

ARTIST / Lesley Riley

Just One Word ...

THIS IS THE REALITY OF LIVING A creative life: Some days, the well runs dry. The good news, however, is that sometimes it only takes a single word or phrase to jump-start the journaling process. The journal cards shown here are designed for that purpose. Copy the artwork onto card stock (or create your own versions), cut along the indicated lines, and keep your set of cards in a decorative tin, pouch, or bag. When you're in need of inspiration, select a card at random. Here are just a few ways the words can inspire you. After drawing a card:

- Make a list of all the feelings or emotions that you associate with that card's word. Reflect on why the word and the feelings are connected, or draw a web, diagram, grid, or chart that explains, clarifies, or builds on the connection.

- Use the word as a writing prompt about what that word means to you right now. Contrast this with what the word might have meant a month ago, a year ago, or even 10 years ago.

- Write your own definition. What does your definition reveal about yourself, your creative habits, or your personal style?

- Examine all the journal cards and select one word that you're not drawn to. Challenge yourself to explore those feelings. What is it about this word that makes you feel uncomfortable, unusual, or conflicted, and why?

A JOURNEY OF 1,000 miles (1,609 km) starts with just one step, and a journal entry for any given day starts with just one word.

232

ARTIST / Juliana Coles

Unlocking What's Within

KEYS SHOW UP IN SO MANY different pieces of artwork, perhaps because they can represent locked (or unlocked) spaces, freedom, letting go, or imprisonment, among other things. Keys can also be a symbol of wisdom or the power to open things.

Look for keys at yard sales, flea markets, or antique stores; old-style skeleton keys evoke nostalgia, whereas tiny key charms can add a lighthearted touch to your projects and artwork. You can also use key art stamps, key images cut from magazines or scrapbook papers, or clip-art images of keys to embellish your projects.

INCORPORATE KEYS as powerful symbols (or as functional elements, as in a girl's diary) into your creative work.

The Symbolism of Keys

Keys are often linked with the image of the gatekeeper, who by his or her very nature holds a certain amount of power over who moves through the gate. The gate to what? you might ask. The gates of heaven, or the afterlife; the gates to hell, or the underworld; even the gates of locked realms such as the seas or the cosmos. In some written accounts, the Greek goddess Cybele was said to hold the key to Earth, shutting her up in winter and opening her again in the spring.

233

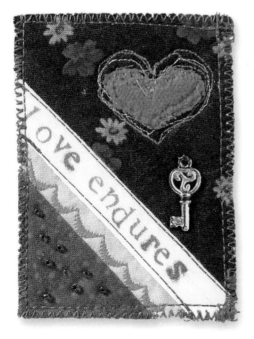

The key in this ATC (left), designed by Pam Waller, surely represents "the key to my heart," whereas Paula Grasdal's key to the secret garden (above) represents something else.

Create a Resin Shadow Box

CREATING A RESIN SHADOW BOX involves casting small items—for example, shells, pinecones, or pebbles—in a polymer compound such as resin, to create a permanent housing for the assemblage.

You can start with a miniature picture frame (remove the glass and seal the back closed), small cigar box, or breath-mint tin (spray paint it if desired); the resulting shadow box can then be used as a decorative element on items such as journals or mixed-media projects.

ARTIST / L. K. Ludwig

MATERIALS

- SMALL FRAME, CIGAR BOX, OR BREATH-MINT TIN
- DECORATIVE PAPER FOR BACKGROUND (OPTIONAL)
- ITEMS FOR SHADOW BOX (E.G. PAPERS, FEATHERS, LEAVES, BONES, SHELLS, CHARMS, BEACH GLASS, MINIATURE FIGURINES)
- GLUE
- RESIN OR ENVIROTEX LITE
- MIXING CUP
- STIR STICK
- SCISSORS
- WAXED PAPER

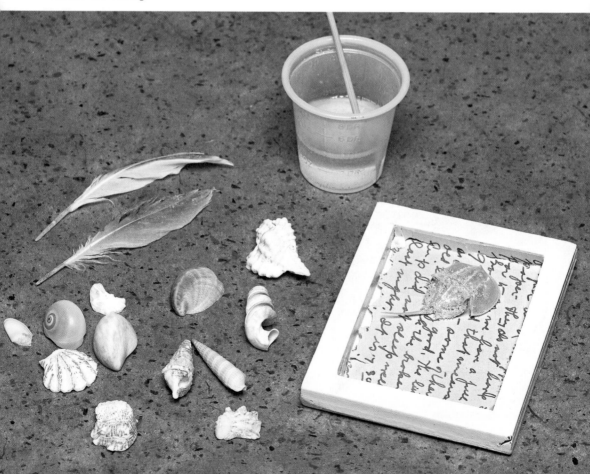

1. Glue the background paper (if using) in place. Place the items in the shadow box, adhering any lightweight items such as paper or feathers.

2. Mix the resin according to the manufacturer's instructions. Place the shadow box on the waxed paper to protect the work surface against leaks.

3. Pour the resin into the shadow box until full. Exhale onto the surface to remove any air bubbles (see box, at right). Let dry according to the manufacturer's instructions, typically 48 to 72 hours. Do not disturb until the product is completely set up.

4. Peel off the waxed paper and attach the shadow box to your journal cover or project as desired.

..

ALTHOUGH WORKING with resin is a complex process, it can yield incomparable results. Be sure to experiment with different objects, composition, and background colors or papers before casting your final design.

Working with Resin

Casting resin and EnviroTex Lite, both available in craft and hardware stores, are two-part epoxy-like polymer compounds that produce a clear, thick, and solid coating. Using these compounds, you can incorporate delicate items that might otherwise break, shatter, or crumble into mixed-media work.

The key to using these products successfully is simple: Follow the manufacturer's instructions precisely. These are two-part products, so the ingredients should be measured exactly; furthermore, when the instructions call for vigorous stirring, imagine beating a cake batter by hand. Time your stirring carefully (don't cut corners!) and measure carefully, or your resin may never harden.

Once you pour the resin, bubbles may appear. You can remove them by exhaling onto the surface, as the carbon dioxide in your breath should pop the bubbles.

What Is In the Background?

THE NEXT TIME YOU BRING OUT a stack of your childhood photos, study the small, telling details in the background.

The color of a house, the art on the walls, the look of your clothing—all of these prompts can provide a strong sense of time and place, and those feelings, emotions, and memories can be like a spark to a dry pile of tinder. Simply choose a photo and let your written reflections provide a theme.

IT'S OFTEN SAID that life is in the details, and in this case, the details may be just what you need to open a vein of creativity.

236

Music and Lyrics

MUSIC HAS INSPIRED MANY A work of art, much in the same way that art has inspired many a song or melody.

The next time you're in need of creative inspiration, try studying the lyrics of a favorite musician or artist. Transcribing lyrics into your work documents the layers of meaning you find in them. Attending a concert by a favorite performer can provide memorabilia for decorating a shrine, shadow box, or tribute journal.

Alternatively, integrate those items in other mixed-media projects; add them to three-dimensional journal entries; or copy, enlarge, or reduce them to create your own clip art.

WHY REINVENT the wheel? Sometimes the words to a favorite song are all you need, to strike you off in a new creative direction.

Repeating Yourself

THIS WEEKEND, CREATE a source file of favorite photos, images, or art stamp impressions, gather some of your own papers (if desired) for copying onto, and make a trip to the local copy store. You're sure to end up with a big pile of wonderful material for use in journal pages, collage, or paper-based projects such as cards and tags.

...

WITH A copy machine and a few of your favorite images, it's easy to see how you can easily create a pile of unique and beautiful materials for use in a wide variety of projects. Don't be afraid to experiment, even if the other patrons in the copy store are giving you funny looks!

238

1. *Try your hand at multiple copies, black-and-white copies, color copies, enlargements, reductions, or copying onto different colors and stocks of paper.*

2. *Use a photocopy as a stencil. Cut out the figure and save both parts—the portion showing the woman's body, for example, and the area surrounding the body.*

3. *Apply the stencil from step 2 to a vintage letter, sponge acrylic paint onto the surface in a variety of colors, and, once dry, embellish with Victorian scrap art and a cutout face.*

4. *Add dimensional objects such as buttons, leaves, or trim.*

5. *Use the stencil of the woman's body to create a strong silhouette shape, then add patterns using store-bought stencils and other collage elements to complete the piece.*

6. *Attach your stencils, photocopies, or altered images to a shipping tag, adhere plant material, and decorate with acrylic paint.*

7. *With just a few changes, the stenciled woman's body can be reinterpreted as an angel, a queen, or goddess.*

8. *Substitute a vintage museum postcard, scrap of paper, or other decorative elements for a portion of the photocopy.*

ARTIST / Maryjean Viano Crowe

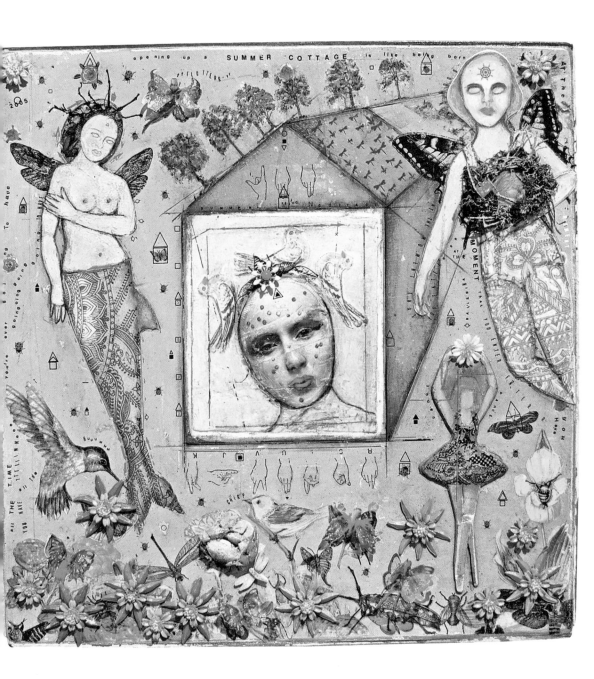

Words to Inspire: *From Thoughts to Destiny*

"Watch your thoughts, they become words.

Watch your words, they become actions.

Watch your actions, they become habits.

Watch your habits, they become character.

Watch your character, for it becomes your destiny."

—ANONYMOUS

Cut Scrap Technique

TODAY'S TASK: Turn old photos, magazine or catalog pages, scrapbook papers, vintage letters, or any other printed material into beautiful images, using a sharp blade and glue sticks.

240

The artist journal pages shown here by Ophelia Chong, for example, utilize smooth teardrop shaped fragments, but you can cut squares or triangles, using a paper trimmer, or punch out shapes with scrapbooking hole punches if you're not as confident with a craft knife.

Chong's works are compelling in part because of their composition; before you get started, decide on an image, theme, or story you want to tell. This can give the work the direction it needs to take form. Alternatively, let the art lead you in the direction you want for a free-form, contemporary look.

CUT SCRAPS allow you to be resourceful while yielding unique results. For variation, try tearing your scraps, working backward from a favorite image, or cutting scraps from actual journal pages.

ARTIST / Ophelia Chong

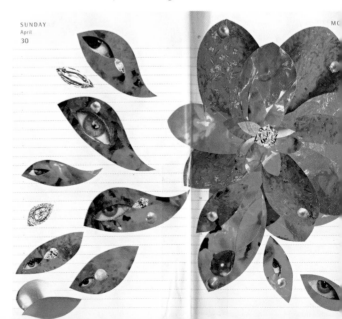

Attachment Issues

As any paper or mixed-media artist knows, there are limits to tape and glue for attaching things. Thanks, in part, to the popularity of scrapbooking, however, no crafter need worry about finding a way to attach a special object— use these ideas for attaching your favorite memorabilia, charms, tags, or papers to your projects.

GLUE IS not the only solution for connecting craft components; be clever, diverse, and multidimensional.

Gel fixative: *This brass woman charm was attached with gel fixative. The brass nameplate was attached with colored eyelets.*

Wire: *This brass starfish charm was mounted on top of amber mica using wire wrap and beads, then attached with bronze eyelets over brass washers.*

241

ARTIST /
Allison Strine

Fiber and eyelets: *This brass "secrets" charm was tied on with fiber through a punched hole; the metal-edge circular tag and metal-rimmed vellum tag were attached with eyelets.*

Take Your Family With You

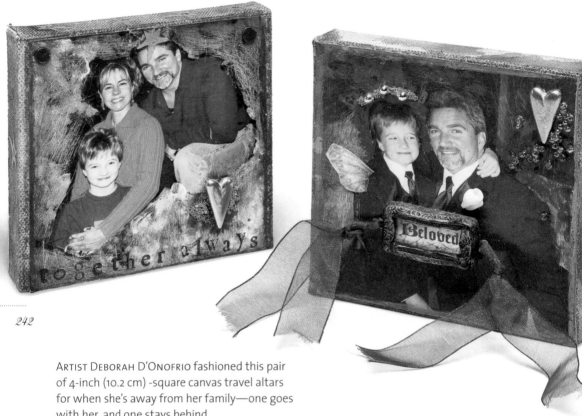

ARTIST DEBORAH D'ONOFRIO fashioned this pair of 4-inch (10.2 cm) -square canvas travel altars for when she's away from her family—one goes with her, and one stays behind.

To make the altars, Deb painted the miniature canvas, using bottled watercolors, then used water-soluble pastels on the edges. She added altered photos, then decorated the altars with charms, nails, beads, and ribbon.

The result: a decorative icon to place on her dresser or bedside table when she's away from her husband, Steve, and son, Niko, plus a complementary altar for Steve and Niko to view while she's away.

TRAVEL ALTARS are a wonderful way to keep your loved ones with you wherever you go. Even a locket with photos, a small photo album, or a collection of favorite found objects can serve as a portable altar or shrine.

Mermaids and Other Mythical Creatures

"The world is full of stories about brave heroes, magical events and fantastic beings. For thousands of years, humans everywhere—sometimes inspired by living animals or even fossils—have brought mythic creatures to life in stories, songs and works of art. Today these creatures, from the powerful dragon to the soaring phoenix, continue to thrill, terrify, entertain and inspire us. Together mythic creatures give shape to humankind's greatest hopes, fears and most passionate dreams."

—INTRODUCTION
Mythic Creatures: Dragons,
Unicorns and Mermaids exhibit,
American Museum of Natural History

THE STORY OF THE MERMAID, a creature that is half fish, half woman, is common throughout many cultures. Mermaids often represent water spirits, as seen with Mami Wata, one of the most popular and powerful African water spirits, and Lasirèn, a powerful water spirit popular in the Caribbean Islands. The name Lasirèn is drawn directly from the French word for mermaid, *la sirène*. In Greek mythology, sirens called out to sailors at sea, luring them to smash their ships against the rocks. In European stories, mermaids, like the sea, were depicted beautiful, seductive, and dangerous.

Among the Inuit people of Canada and Greenland, the mermaid is linked to the story of Sedna, a young woman who was tossed overboard by her own father, yet who survived to create the whales, seals, and walruses on which the Inuit depend for food and materials.

CONSIDER USING the shape, form, or symbolism of the mermaid (and other hybrid, human mythological creatures) in your next project.

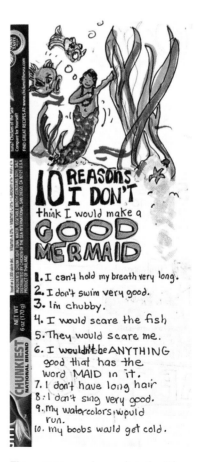

This artist journal page lists the "10 reasons I don't think I would make a good mermaid."

ARTIST / Lydia Velarde

Artist Interview: Maryjean Viano Crowe

MARYJEAN VIANO CROWE, an associate professor in studio arts at Stonehill College, is an artist with a strong voice. She uses materials in unique ways to create large-scale photographic tableaux, artist books, mixed-media constructions, and light-box shrines, and her work has been included in numerous museums, books, and exhibitions. Here she talks about what influences her art and where she finds inspiration.

Q: When were you first drawn to art?

A: When I was growing up I was so shy. I used to throw up every day before school. But I was lucky because I could draw, and people valued that.

Q: Where do you find your inspiration?

A: It usually comes from a personal space; my feelings and experience are very private but I hope that my message resonates with other women. My iconography is always female related; that doesn't change, but my materials do. I usually start with ideas from my life, and play with materials. I find it really helps when I find the title of the work. Then I muddle around with imagery from my collection.

Q: Where do you find your materials?

A: I have a lot of female images and things from nature. I also love kids' tattoos. I use them all the time—I get them at the dollar store; they have butterflies, fairies, insects—and I love them because they're cheap and transparent.

I also use my own materials over and over again, but change the form, like enlarging, reducing, or transferring. I'm a thief of my own material. I might copy my own materials and transfer it, using oil of wintergreen, which dissolves the pigment on a laser print. I also scavenge a lot, pick up things on the street, or go to flea markets.

Q: What is the one tool or material you couldn't live without?

A: It's so hard to pick just one! Do I have to pick just one? [laughs] I'd have to say Scotch tape. I do all kinds of transfers and lifts with it, like using an old coloring book and lifting off images. I couldn't live without the Xerox machine, because I copy my work and blow it up.

Q: What do you do if you're fresh out of ideas?

A: I play with images, move them around on paper. Right now I'm in a good place with ideas flowing, but it definitely ebbs and flows. My art also changes, depending on what courses I'm teaching, what I'm reading, what music I'm listening to.

Q: Which artists do you most admire and why?

A: I can still remember a day in the early 1980s when I walked into a gallery in New York City with two friends and saw the work of Frida Kahlo (see page 48). I knew nothing about her, but I have never been so profoundly affected by anyone's work since—that drive, that need to get her story out. I also really admire the work of Nancy Spero, an installation artist; Issey Miyake, a fashion designer; and Annette Messenger, another installation artist.

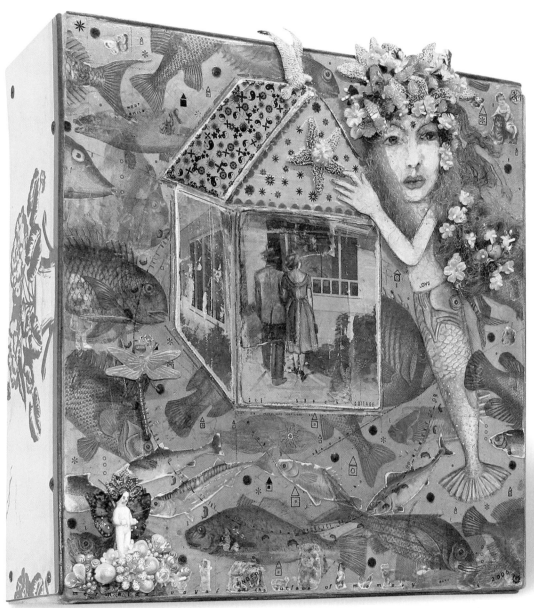

Artist Maryjean Viano Crowe started this work,
titled Mermaid's Voyage: Under the Surface of
Memory, by adding gesso to book board, which
she later inlaid into a 5-inch (12.7 cm) -deep frame.

Uniquely Yours

"There is a vitality, a life-force, an energy, a quickening that is translated through you into action, and because there is only one of you in all of time, this expression is unique. And if you block it, it will never exist through any other medium and be lost. The world will not have it. It is not your business to determine how good it is; nor how valuable it is; nor how it compares with other expressions. It is your business to keep it yours clearly and directly, to keep the channel open."

—MARTHA GRAHAM (1893–1991),
choreographer and pioneer of modern dance

THE PREMISE of this quote is simple, beautiful, and striking: If you are compelled to create something, you must let it happen, because if you don't, that unique expression will never exist. This quote is a reminder that it's not our job to judge what we create, but rather to just create.

Stones, Pebbles, and Rocks

ROCKS AND STONES can serve as your palette: When I was young, I used to paint rocks—I'd carefully copy quotes, sayings, or expressions onto the surface, then cover the top with clear nail polish. More recently I saw a beautifully collaged doorstop made from a large, smooth rock, and I was struck by the impact of finding a traditional outdoor item indoors.

Visit any craft store and you're sure to find scrapbook paper with images of stones and spray paint designed to mimic the look of stones. You can even create the look of a garden path by using alcohol inks, as artist Julia Andrus has done here. Stones, pebbles, and rocks can also be incorporated as found objects, or drilled and used for jewelry.

ROCKS, PEBBLES, and stones are symbols of gravity, weight, and being grounded. Think in multiples: Start a collection of rocks and see where the process takes you.

To create the pebble effect shown here, drip the following colors of alcohol ink—ochre, brown, olive, black, and terra-cotta—one at a time over the paper. Finish with a sprinkle of blending solution.

ARTIST / Julia Andrus

Waxed Paper Batik

THIS TECHNIQUE RE-CREATES the effect of fabric batik on paper.

MATERIALS
PAPER FOR PRINTING, SCRAP PAPER, DYE-BASED INKS, WAXED PAPER, PAPER TOWEL, FELT PRESSING CLOTH, AND AN IRON

1. Start by crumpling the waxed paper repeatedly.

2. Lay the felt pressing cloth on a table or ironing board, then place the scrap paper on the felt. Position the crumpled waxed paper on the scrap paper and place the paper for printing on top of the waxed paper.

3. Iron with a hot iron. After the paper cools, apply the ink to reveal the pattern. Wipe off any excess ink with the paper towel.

..

FOR A VARIATION on this technique, try folding the waxed paper to create lines or cutting the waxed paper into shapes or designs.

ARTIST / Julia Andrus

Created with *You* in Mind

I HARDLY EVER MAKE arts and crafts for myself. Instead, I'm more apt to make scrapbooks, collages, cards, or mixed-media pieces as gifts. One upside to creating for others: The person for whom you're making the gift can serve as your inspiration.

Every year, I make a photo calendar for my father that includes photos of all his grandchildren. When creating each year's version, I reflect on my father's love for laughter, and I try to find the pictures that will bring him a smile or a chuckle.

When my younger sister's beloved coonhound, Dela, died, I created a scrapbook that honored the family's memories and preserved her keepsakes. When I made a "sisterly shrine" for my older sister, a vast cache of shared experiences and memories of happy times fueled my creative process. And so it goes …

WHEN CREATING GIFTS for others, you can tap into the feelings of love and appreciation you have for someone. The creative energy flows like a river.

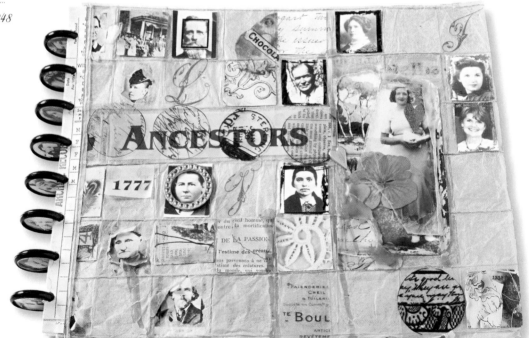

ARTIST / Linda Blinn

Crossover Crafts

ARTIST ELIZABETH BECK is an artist who paints and makes collages with the intent of selling them. Yet even artists need a break from their artwork, and Elizabeth finds relief in pottery classes, which she says is therapeutic and provides her with a social outlet. It may come as no surprise, however, that her pottery has started influencing her canvas collages, and vice versa. Some artists call this "crossover" crafting.

Elizabeth believes it is critical to creative expression. "The takeaway idea from this is most certainly that you should not stay locked into one artistic endeavor," she says. "Take classes. Try new things. The more you exercise your creativity, the more elastic it becomes."

DON'T BE AFRAID to stretch your artistic boundaries—you may discover a newfound passion or a crossover theme or technique that takes your existing work in a new direction.

249

One holiday season, Elizabeth Beck went on an angel-making binge: big, small, white clay, dark clay, smooth, textured, covered in alphabets, raku fired, clear glazed ... endless varieties. After weeks of ceramic angel making, it was no surprise that she needed to put angels on canvases. Her pottery had inspired her other artistic modes of expression, and now angels dance across her canvases in ways they never could as ceramic pieces.

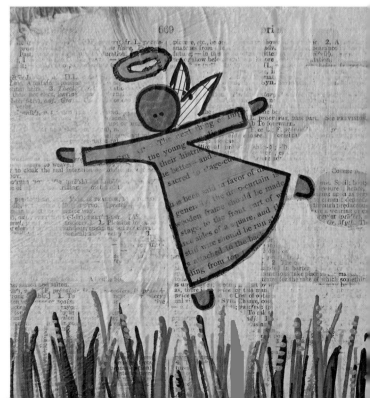

Fabric and Mixed-Media Panels

THIS WEEKEND, TAKE INSPIRATION and learn a new technique courtesy of artist Sharon McCartney.

To assemble the Fabric Fragment Shrines shown here, Sharon starts by creating a fabric-based panel using sew-through interfacing. The interfacing keeps the panels from warping and adds structure to almost any kind of paper. The resulting lightweight panels can easily be sewn or attached together to create a series of work.

MATERIALS

ASSORTED HANDMADE AND PATTERNED PAPERS; ¼-INCH (6 MM) SEW-THROUGH INTERFACING, ACID-FREE IRON-ON ADHESIVE; FOUND OR CREATED IMAGERY; EMBELLISHMENTS AND FOUND OBJECTS, PVA GLUE; MATTE OR GEL MEDIUM, EMBROIDERY NEEDLES, DRESSMAKER'S WHEEL, AND BASIC SUPPLIES. IF YOU PLAN TO MAKE MULTIPLE PANELS AND ATTACH THEM TOGETHER YOU'LL ALSO NEED FASTENERS (E.G., RIBBON, TWINE, WIRE), AN EYELET KIT, AND A ⅛-INCH (3 MM) HOLE PUNCH

1. To make the panels: Choose a paper that will serve as the background for your collage panel and cut it to the desired shape and size. To back the paper with interfacing, cut it to size and attach the interfacing with the iron-on adhesive.

2. Apply imagery and create layers: Apply the imagery with PVA, adding paper in layers if desired. Add machine or hand-sewn stitching as desired.

3. Add embellishments: Attach embellishments with thread, wire, or glue. Add three-dimensionality by sewing on borders, gluing on ribbons and chunky threads, or adding decorative stitching.

4. Finish the panels: Once the panels are complete, seal each one with an acrylic glaze or gel medium. To back the panels, attach plain or patterned paper, using iron-on adhesive and seal with glaze or gel medium; this will prevent the panel from warping and hide the stitching. Add holes at the bottom of the panels for hanging embellishments such as beads and buttons. As a final finishing step, add stitching around the entire panel.

5. If joining the panels: Attach eyelets into the corners or edges of each panel following the manufacturer's instructions and attach the panels together with twine, thread, or wire.

..

THESE BASIC fabric panels can become individual journal pages, a scroll-like mixed-media wall piece, or a series of decorative panels joined by theme, color, or embellishment. Make numerous image panels at once, then experiment with scale, shape, and composition.

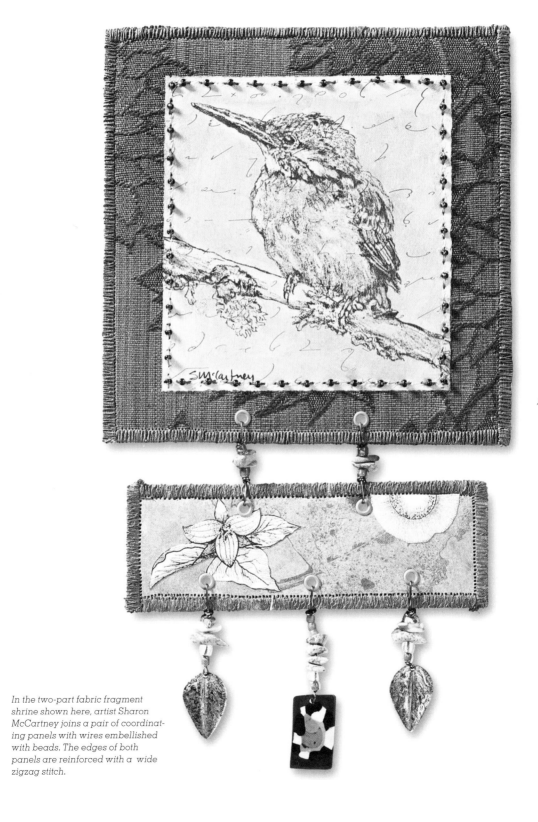

In the two-part fabric fragment shrine shown here, artist Sharon McCartney joins a pair of coordinating panels with wires embellished with beads. The edges of both panels are reinforced with a wide zigzag stitch.

Fresh Journaling Prompts

HAVE YOU EVER opened your journal to a fresh, clean page only to find that words, thoughts, or feelings escape you? That's where writing prompts can help.

What are writing prompts? Simply put, they are kindling for the writing fire. Writing prompts are a mainstay for fiction writers, poets, and even short storytellers, and they've been used for writing contests, courses, and more. The reason? They work! (For today, I will call them journaling prompts.)

Some journal prompts are lighthearted (even funny), while others are serious or more reflective in nature. Lists of journal prompts can be found in books and online, but here are a few examples:

- Retell your earliest memories from childhood.
- Write down one thing you can do today to make a difference.
- Write everything you know about a favorite sibling, cousin, or relative.
- Open a dictionary or a book, randomly select a word or a phrase, and use it to launch your writing.
- Find a photo in a magazine of a person you don't know and create a story about their life.
- Sketch out a fantasy of something you would like to see happen in your life.
- Make a diagram of the house you grew up in.
- Reflect on the things you value or enjoy in life.
- Make a list of all your favorite jewelry and why the items are special to you.
- Write about a day that was perfect.
- Fill in the blanks: In five years I'd love to be _____, People say I am _____, and so on.

EVERYBODY NEEDS a nudge now and then to get the words flowing. Try one of these ideas, or ask your friends, siblings, and journaling counterparts what they're writing about.

How to Use a Journal Prompt for Creating Artwork

After you've used a journal prompt to jump-start the writing process, you're only a few steps away from using that journal entry to create a new piece of art. Consider these prompts as further "kindling":

Do you believe in a higher power? Describe what you believe, why, and where your beliefs came from. (Use these thoughts and words to create a visual representation of what you believe.)

What's troubling you? You can answer this simply, as in what's troubling you right now, or you can answer this more deeply, as in what's troubling your soul. (Use these reflections to create a collage of your troubles, and then make a contrasting piece that shows all your blessings.)

List the important days in your life. Imagine a visual representation of those days, organized into a book, linear journal, series of individual collages, or even a collection of decorative boxes, each containing mementos from the important days.

Vintage Maps

IN THIS AGE of Internet directions and GPS devices, paper maps have fallen by the wayside. But there's another use for discarded maps: Some artists see them as the original scrapbook paper—colorful and thematic travel documents that can be used in myriad ways. Old maps can add an antique or heirloom feel, whereas modern maps can be used to show actual locations or lend depth and meaning to your projects.

USED MAPS may be as close as your glove compartment; however, finding antique or vintage maps may require a trip to a flea market or antique mall. If you're short on time, many scrapbook paper companies offer paper that features reproduction maps and maplike images.

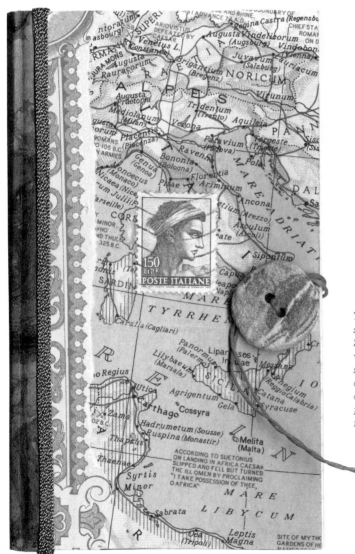

To make the mini travel journal shown here, artists Maryjo and Sunny Koch collaged the cover with an antique map, old postage stamps, and a scrap of border from an old stock certificate. The button and waxed thread closure give the journal a simple but effective finishing touch.

Hooks and Yarns

IF YOU'RE LEARNING HOW TO crochet (see pages 256–257 and 278–279) and then be sure to read up on the two items you need to get started: a crochet hook and yarn.

Crochet hooks come in different sizes and materials, ranging from fine steel hooks all the way to large hooks made from plastic or wood. Their sizes are given in a few ways: a letter, a number, or a metric diameter measurement. A skein of yarn's label will list a recommended hook size; use this as a starting point to obtain your piece's gauge (see page 155). In general, the thicker and coarser the yarn, the larger the hook you will need.

Yarn is sold by weight and/or length. If you're new to crochet, experts recommend starting with a smooth yarn in a heavy weight. There are standard terms for the most popular weights of yarn:

- **Fine weight:** Used for lacework and edgings (half or less as thick as fingering weight)

- **Fingering weight:** Used for delicate items and baby garments

- **Sport weight:** Used for sweaters, cardigans, or afghans

- **Knitting worsted:** Used for chunkier jackets or sweaters (equivalent to two strands of sport weight)

- **Fisherman weight:** Used for heavy afghans or jackets (equivalent to three strands of sport weight)

- **Bulky weight:** Used for warm outdoor garments (equivalent to four strands of sport weight or two strands of knitting worsted)

..

THE CROCHET HOOK and yarn are two variables that allow you to create fabrics that are firm, soft, and flexible or light, open, and airy, depending on the combination of materials.

Your Own Personal History

I'LL ADMIT IT: My personal memorabilia is scattered throughout assorted drawers, boxes, my desk, and several bins in the attic. I've been itching to gather these materials together into one place, tap into this well of personal data, and create my own personal history.

Use your personal memorabilia as inspiration for any one of a dozen projects. Consider all the items in your home that "document" your life:

- a birth or marriage certificate

- blessing or christening documents

- photographs of you and your family

- love letters from your spouse or partner

- old passports, driver's licenses, or student IDs

- graduation announcements

- newspaper articles

- stories told in letters and thank-you notes

- calendars and day books

- financial statements

- poems, quotes, vignettes, and favorite recipes

Consider sorting all your materials into age categories, such as childhood, adolescence, early adulthood, family/adulthood, middle age, and so on. Designate a box or folder for each category, and arrange the items in rough chronological order.

Choose a particularly engaging period of your life, and let the memorabilia lead the way. If you enjoy writing, turn what you've found into a narrative, a series of captions, or even an entire book. If you're more visual in nature, create photocopies of the actual items in a series of projects, collages, or mixed-media shadow boxes.

DOCUMENTING YOUR own personal history can be a source of inspiration or a project in itself!

> If you need more material, ask your parents, siblings, relatives, or friends for items they've kept relating to you.

Sneak Away Today

TAKE A DRIVE, GO FOR A WALK, or jump on your bike for an excursion today. Remember the old advice about soothing a crying baby by changing the scenery? The same premise can work wonders for your creative energy.

If you're driving or biking, take inspiration from the landscape, views, homes, or natural areas that you pass by. One field with a picturesque stone wall, located in the next town over, has been used in my artwork over and over again. There's a single tree in that field that I have noted or captured in all seasons.

If you're walking, take in the sights and sounds around you: Listen to the birds, the wind as it chatters the branches, or the rush of a gurgling brook. Notice the shapes and colors of foliage, trees, and flowers. Take note of how your landscape changes with the season, light, or weather; or just breathe deeply, bringing fresh oxygen (and energy) to your mind and body.

USE YOUR EYES, ears, and nose to record what you see or experience while driving, walking, or biking. The scent of fresh-cut grass, the sound of water gurgling, even the sight of rolling fields, darkened woods, or a beautiful flower garden can reboot your artistic senses.

Crochet 101, Part I

THIS WEEKEND, learn to crochet—a simple, versatile technique that can be both creative and meditative.

Start by reading "Hooks and Yarns" (page 254) and gathering your supplies, then sit down and experiment with the following basic stitches. Once you're ready to move onto an actual project, use the basic stitches shown on page 278–279.

Crochet Basics

Crochet, like its cousin knitting, is created from one continuous length of yarn. Unlike knitting, which uses two needles, in crochet a single hook is used to work one stitch at a time. You will start with a slip knot, then continue by making loops (called *chains*) to form a foundation.

Start by becoming comfortable with holding the hook. There are two main ways of holding it: In the *pencil position*, you grab the flat part of the hook between your thumb and first finger, as if you are holding a pencil. The second technique—called a *knife position*—is just what it sounds like: you hold the hook as if you were using a knife. Lay the stem against your palm and position the flat part of the hook on your palm, then grasp the hook between your thumb and fingers.

As you crochet, you also control the flow of the yarn so it moves evenly and you can create uniform chains.

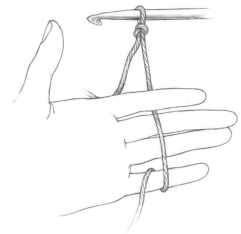

To control the tension of the yarn, pass the working yarn around the little finger, under the next two fingers, and over the forefinger. With the hook through the slip loop, and holding the slip knot between the thumb and middle finger of the left hand, prepare to make the first chain by raising your forefinger

To begin crochet, you need to make a slip knot.

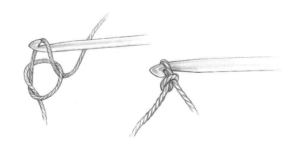

Start by making a loop about 6 inches (15 cm) from the yarn end. Insert the hook and catch the working yarn, drawing it up through the loop. Pull both ends to tighten the knot and then slide it up to the hook.

The first row of a piece of crochet is called the *foundation chain*. It is made by pulling the yarn through the slip knot and then each subsequent loop on the hook. The foundation chain should be worked loosely and evenly to ensure that the hook can enter each loop easily on the first row. The foundation chain can be short (just one or two stitches) or long; the length will be specified in the pattern instruction.

Counting Chains

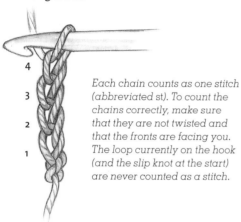

Each chain counts as one stitch (abbreviated *st*). To count the chains correctly, make sure that they are not twisted and that the fronts are facing you. The loop currently on the hook (and the slip knot at the start) are never counted as a stitch.

Making a Chain Stitch (abbreviated *ch*)

Step 1: *Hold the hook in your right hand. Keeping the working yarn taut, grasp the slip knot with your thumb and middle finger of your left hand. Push the hook forward and take the hook under, behind, and then over the yarn, so the yarn passes round the hook and is caught in it. This is called a yarn-over, or yo.*

Step 2: *Draw the hook and yarn back through the slip loop to form the first chain stitch.*

Repeat steps 1 and 2. *After making a few chains in this way, move your left hand up so that you are holding the work directly under the hook for maximum control, and continue.*

ALTHOUGH CROCHET is a traditional craft that's been around for years, the yarns, patterns, and embellishments available make it a modern creative process. You can even combine crochet with knitting, beading, or fabric work for further inspiration.

For more on crocheting, see pages 278–279.

What Are Your Writing Rituals?

WRITING, LIKE THE PROCESS OF making art, often benefits from rituals. Today's task: Consider how, when, and where you write. What setting, time of day, or location works best for channeling your inner thoughts?

Some writers swear by a set time; they get up early, perhaps when the house is quiet, and write, nonstop, for one hour every day. Others light a candle, make a cup of tea, and snuggle into a cozy chair for their reflective time in the evening, perhaps to record the day's events or make plans for tomorrow.

Ask yourself these questions about your writing habits and rituals:

- When do you do your best work—morning, afternoon, or evening? Consider doing some writing while your energy is highest.

- What are the objects or items that allow you to relax and tap into your deepest feelings? Perhaps you have a favorite sweater, a pair of slippers, or a lap quilt that makes you feel secure. Consider the ambience of the room: the lighting, the music, or even the specific chair you are sitting in.

- Do you have privacy when you write? Accessing your innermost thoughts can be emotional—make sure you can write in a place where you're free to laugh, cry, or just be quiet (and not interrupted).

RITUALS HELP EASE the transition from one task to another; writing rituals, practiced over time, will let you eventually move seamlessly in and out of journaling mode.

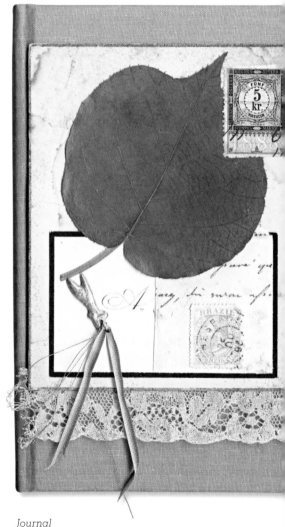

Journal
ARTISTS / Maryjo and Sunny Koch

Lace and All the Trimmings

LACE AND OTHER FILIGREE FABRICS, trims, and edgings can be reused in many ways. If you've got leftover lace lying around, consider these ideas:

- Line the edge of a pocket.

- Decorate the hem of your jeans or skirt.

- Use as a stencil for lacey designs on paper or fabric.

- String beads through it to make jewelry.

- Stitch in place to capture objects or form shallow pockets.

- Embellish journal covers, cards, and tags.

THE DELICATE see-through designs of lace add romance, nostalgia, or an antique feel to your creations.

Dyeing Yarns and Fibers

IF YOU LOVE YARN AND FIBER, you may be inspired to create your own color schemes using cold-water dyes. This process yields beautiful and unique yarns for use in crochet, knitting, or mixed-media projects.

MATERIALS
ONE HUNDRED PERCENT COTTON YARN, TRIM, OR OTHER FIBER; ASSORTED COLD-WATER DYES; BAKING SODA; SALT; WOODEN SPOON OR STICK AND RUBBER GLOVES

1. Yarn is sometimes available in hanks, but if you're working with a ball of yarn, you will have to unwind it and then rewind it into a loose hank. Tie the hank loosely with short lengths of yarn in two or three places.

2. Wash the hank of yarn in soapy water, then rinse thoroughly in several changes of clean water. Wring out the excess water and leave it damp.

3. Dissolve the dye powder and mix with water, baking soda, and salt (according to the manufacturer's instructions.) Pour each color into a separate bucket or deep bowl.

4. Wearing rubber gloves, immerse a portion of the hank into one bucket; place a wooden spoon or stick across the top of the bucket to keep the undyed yarn clear. Leave the yarn in the dye for about 1 hour.

5. Remove the yarn from the dye and squeeze out the excess. Then immerse another portion of the hank in a second color. Repeat the process as desired to finish dyeing the yarn.

6. Wash the dyed yarn in soapy water and rinse thoroughly, then leave to dry before winding into a ball.

ALTHOUGH store-bought yarns, trims, and fibers come in a large assortment of colors, experimenting with cold-water dyes can be fun and creative. Your finished yarn, and any projects you make using it, will be uniquely yours and yours alone.

She Had No Paper for Drawing *altered book pages*

ARTIST /
Sarah Fishburn

Artist Interview: Sarah Fishburn

ARTIST SARAH FISHBURN'S ARTWORK combines bright colors, photographic images, spray paint, transparencies, and words, and have been featured in numerous books and magazines. Sarah also compiles, muses over, writes, and designs art zine *Pasticcio Quartz* with fellow artist Angela Cartwright. Here she talks about where she finds inspiration.

Q: Where do you find inspiration?

A: Everywhere—urban settings or the country, reality, and my dreams. I look around in a corner hardware store and the colors, shapes, and textures are as appealing as the flamboyant orange blooms on my pumpkin plants. The mosaic "Electric Shoe Shop" sign, embedded into the sidewalk, inspires me as much as the rusted out steam engine photographed on a recent excursion into the mountains outside the town we now call home. I absorb the backgrounds in a movie, listen to a recurring riff in a piece of music, remember a passage from a well-worn book. Those images, words, and sounds may suddenly combine with the iridescence of soda sparkling in the sunlight, juxtaposed patterns in a brilliant magazine ad, the thought of fireflies sparking at dusk, and the sound of a train; with a hoot and a holler, inspiration strikes.

Inspiration? The beach, a day at the lake, a hardware store, illustrations in an old book, the contents of my closet, outfits kids wear to school, the way shadows fall across the pavement late in the afternoon, a movie that makes me laugh—I'm inspired by their beauty, colors, cool, and fun. But I give credence and a nod to the inspiration gleaned from hard times, hunger, heartbreak, the song that always makes me cry, the mystery or clarity of love gone wrong.

Q: What is the one tool or material you couldn't live without?

A: *One* tool I would *hate* to be without is my computer. I can always make do with everything else.

Q: What do you do if you're ever fresh out of ideas?

A: I'm blessed and lucky to almost *always* have ideas simmering if not crazily boiling and bubbling over. If for some reason I don't want to follow through, I might put on a movie or read a few chapters in any of several books—I usually read more than one at a time—then get back to work, ready to act upon those previous ideas, and often with new ones besides.

Q: Who are your favorite artists?

A: Among others, I would cite Chagall and Mary Blair for brilliant colors and elements of fantasy, Bouguereau and Ione Robinson for their tender realism, and Louise Nevelson for the delicacy/strength dichotomy embodied in her sculptures.

Q: How does your choice of medium fit your artistic profile?

A: As my primary medium, mixed-media narrative allows me to graciously and exquisitely reflect and render my life as a twenty-first-century magpie storyteller. It allows me to comment graphically and mysteriously on past, present, and future worlds, real and imagined. Second, photography is high on my list; it records accurately and there are means and opportunity for interpretation and manipulation. And I'm crazy about deconstructing old jewelry for artistic reassembly!

For more information about Sarah or to see more of her artwork, visit www.sarahfishburn.com.

Coloring Inside the Lines

COLORED MARKERS, the good old standby of rainy day arts and crafts or junior high art projects, can also be used by adults. In fact, a brand-new set of markers offers an easy way to add rich and vibrant color to existing paper projects, coloring pages, and everything in between.

..

COLORING, scribbling, or doodling with markers can take you back to the carefree creative days of childhood—and it gives you a chance to play with color, contrast, and composition in ways you couldn't back then!

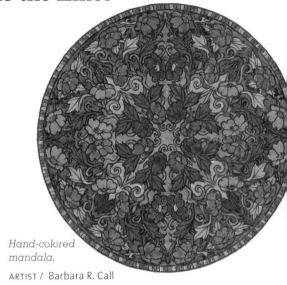

Hand-colored mandala.

ARTIST / Barbara R. Call

SATURDAY + SUNDAY days 307 + 308

Experimental Research: Shrink Plastic

By Jenn Mason

I RECENTLY SPENT A CHUNK OF TIME playing and experimenting with shrink plastic. What fun, and lucky me!

I gathered shrink plastic in black, white, and transparent sheets (translucent and inkjet printable sheets are available as well) and pens, pencils, inks, and ink pads. Then I got ready to make a mess.

I cut 2-inch (5 cm) square pieces of the plastic and then altered them with sandpaper and pens. I used rubber-stamp inks with my plastic combing tool. I stamped with the ink and without the ink. I rubbed powdered pigments into the plastic before and after heating. I pressed stamps into inked and powdered plastic that had already been shrunk to create an intaglio effect. I sanded some ink off, and added more ink.

I dripped alcohol ink onto the plastic and then removed some of the ink to lighten the color—it is important to note that the color will intensify as the item is shrunk. I punched, cut, and sanded the plastic and even started forming it into pieces that I could see making into collage elements in fine art or jewelry.

By the end I realized I had a long list of new things to try during my next experimentation. Could I create a convex and concave set of molds so that I could consistently make molded pieces of shrunk plastic? What about draping it on old brass hardware? I love the idea of playing in the studio for the pure joy of new discoveries. I hope seeing my small swatches of trials and errors encourages you to play, too!

1. A series of colored and uncolored experiments with hole punches and concave and convex forms

2. Left to right: Sanded and unsanded intaglio; inked, intaglio then sanded, inked, and combed; sanded and unsanded striae, and powdered pigment

3. Gel pen on sanded and unsanded; Sharpie marker on sanded and unsanded

4. Shrunk and pressed with flower frog; stamped with rubber-stamp ink; regular and watercolor pencils on sanded and unsanded

5. Left to right: powdered pigment applied, then shrunk and intaglio; powdered pigment on already shrunk piece; sanded and unsanded then powder pigment applied and shrunk; same on transparent piece

6. Clear plastic melted together; regular and watercolor pencils on sanded and unsanded transparent

7. Rings from left to right: large ring on transparent plastic colored with watercolor pencil then stamped on top with rubber-stamp ink (holes punched before shrinking); clear ring stamped on both sides; intaglio, inked and sanded, then colored with powdered pigment; stuck to itself (first try)

Doodling: Open-Eyed Meditation

DOODLES, ALSO KNOWN AS margin art—the little drawings you used to make in the margins of your notebook as you listened to your Physics 101 lecture in college—are considered works of art by many people. Anyone who's studied collections of artist journal pages knows the power and beauty of doodling—and author and two-time breast cancer survivor Carol Edmonston says doodling has as much power to relieve stress as meditation does.

GIVE YOURSELF permission to tap into your inner resources. If you can learn the spontaneity, to turn off the critic, and trust your innate wisdom, doodling can help you get lost in a spontaneous creative moment in time.

Story

Doodling is an open-eyed meditation, and it can help quiet a chatty mind. I stumbled into the world of doodling while journeying through a breast cancer diagnosis. I was sitting, waiting for the doctor, and I was anxious and worried, reading magazines in three seconds. I asked for a pen and paper and started aimlessly doodling, and by the time I saw the doctor there was an entire shift. From then on, through the journey of cancer, I never went without a pen and paper.

Life is uncertain, but stress is certain. I had a choice to quiet my mind and bring myself back to a place of balance. The curves, twists, and turns of doodling are not unlike the curves, twists, and turns of life.

I tell people two things about doodling. First, create an outline. Begin and end at the same point without lifting the pen; this should take about five seconds. Then come back and fill it in however you want, using flowers, dots, lines, and so forth. Doodling is very cost effective (all you need is a pen and paper), it's portable, you don't need artistic skills, there's no right or wrong, and every doodle is like a snowflake—unique and yours alone.

ARTIST / Carol Edmonston

Tiny Tin Treasure Troves

MINT TINS—those tiny metal boxes that can fit in your pocket or purse—are the perfect size for personal shrines, decorative boxes, or miniature mixed-media collages.

Start by washing and drying the tin, then sanding lightly to make paint or other materials adhere better. If you're short on time, cover the top of the tin with Con-Tact paper, stickers, or other adhesive materials. If you have time to work outdoors, spray-paint the tin with primer (paint a few at a time, for efficiency) followed by a coat of spray paint, rusting agent, or faux finish.

Then use these ideas to transform your tin into a work of art:

- Decorate with leftover scrapbook supplies.

- Use the tin to store tiny supplies, cut paper tidbits, findings, and charms.

- Use your paints and brushes to add images, color, words, or texture.

- Transform the tin into a travel poetry game using magnetic words.

- Roll out thin sheets of polymer clay and cover the box.

- Use beads, stones, or miniature cabinet pulls to add feet.

- Transform the tin into a travel tic-tac-toe game with magnetic pieces.

- Use dollhouse furniture and accessories to create a room with a view.

- Make the tin into a tiny suitcase, complete with travel stickers.

- Turn the tin into a miniature first aid or sewing kit.

- Reuse the tins for gift boxes, packaging, or three-dimensional envelopes.

- Use the tin to house a pocket-size journal, collection of tags, or journaling prompt cards cut to size.

- Stand up the open tin and make it into a personal shrine or memory box.

...

MINT TINS are the perfect size for experimenting with mixed-media collage, using up leftover craft supplies, or just working in a smaller format.

265

Learn New Collage Terms

How many of these terms are you familiar with? How many of these techniques have you tried? The next time you're short on ideas or inspiration, explore or experiment with one of these materials or techniques.

Assemblage: Sculptural or three-dimensional collage that is made by assembling diverse materials and found objects

Book board: Heavy cardboard used in making hardbound books; can be cut with a sharp utility knife.

Clayboard: Masonite board that is coated with a thin layer of clay. It supports a wide array of media and the surface can be inscribed.

Encaustic: An ancient technique of painting with pigmented hot wax.

Gesso: A mixture of plaster and glue or size that is used as a background for paintings (or in sculpture).

Impasto: The technique of applying paint thickly on a surface so that brush strokes can be seen.

Montage: The technique of assembling, overlaying, and overlapping many different materials to create an image or artwork.

Photomontage: The technique of combining several photographs or parts of photos to create a composite picture or image.

PVA glue: Polyvinyl acetate is an archival adhesive that is transparent when dry; it is excellent for working with papers of varied weight and texture.

Vellum: Translucent paper available in art supply and craft stores.

..

BOOST your artistic vocabulary! Visit your local art supply or craft store and ask the salesperson what's new, what's hot, or what material people are asking for over and over.

Words to Inspire: *Fascination with Life*

"Inspiration is everywhere: dreams, a glimpse of a stranger's face, memories. And it's all driven by a fascination with what makes us tick—the conflict of goodness and weakness that's in every one of us. The human condition. That's my wellspring."

—MARY McGARRY MORRIS,
American author

Study Your Closet

THIS WEEK, LOOK FOR INSPIRATION in your closet, your dresser, or wherever you store your clothing.

Take a look at the clothing you own and ask yourself these questions: What colors appear over and over? What textures do you like best and why? What patterns can be repeated in your art?

Then stop and consider how can you use your clothing in creative ways, such as these ideas:

- Scan fabric you like and recreate the pattern with paint or beads.

- Make color photocopies of certain patterns and use them in decoupage.

- Cut up discarded clothing and use fabric fragments, trims, or edges to decorate paper, other fabric projects, or mixed-media.

- Remove buttons, ties, or embellishments and make jewelry.

- Reuse scarves or throws for pillows or fabric journals.

- Take apart belts, buckles, or purse findings and incorporate them into mixed-media projects.

LIKE ANY collection in your house, your clothing makes a collective statement. Consider what your clothing says about you, then use that theme for following other creative pursuits.

Finding Your Groove

WHAT IS A RUT, exactly? The opposite of a groove. You know what a groove is—that easy, happy place where words are flowing, ideas are plentiful, your artwork comes together effortlessly, and all is right in the world. It's the place we all want to be when creating our projects or artwork, but the reality is sometimes we all face the opposite: the place where ideas don't flow, compositions don't fall into place, or colors don't gel.

Ruts and grooves are a creative fact of life. But recognizing a rut is step one in getting out of it, according to Twyla Tharp, American dance choreographer, writing *The Creative Habit: Learn It and Use It for Life* (Simon & Schuster, 2003). Tharp has a three-step plan for getting out of ruts:

Step One: See the rut.

Step Two: Admit you're in a rut.

Too often, creative types don't like to admit they've made a mistake or that their work is not polished, finished, or up to par. But recognizing that the creative output is not your best, not on the right track, not holding together, or just not working is critical.

Step Three: Get out of the rut.

This is the hard part, of course. Recognizing and confessing up to a problem is often easier than solving it or making a change. But this is also the light at the end of the tunnel. Here are some suggestions for breaking the cycle:

- Change your environment. Get out, see new things, mix it up, have lunch with a friend, take a walk.

- Practice luxury. Tharp likes to light a fire, take a bath, and otherwise "go blank."

- Challenge your assumptions. Identify what isn't working and turn it upside down or inside out.

- Know when to quit. Sometimes you have to start over. Know when to throw it out, trash it, or just begin again.

RUTS AND GROOVES are a part of every creative person's life. Like two sides of a coin, they are inseparable. Recognizing the pattern—and the fact that creativity ebbs and flows—is half the battle in getting your groove back.

Make a Life List

TODAY, BORROW AN IDEA from the world of birding and start a life list.

What is a life list? In the birding world, it's a list of all the birds a person has ever seen. It might include notes on each new species you discover, along with the date and place where you saw the bird. Birds are creatures of location, and because no two locations are exactly alike, it means that birders often see an assortment of new birds when they travel. As such, a birding life list chronicles much more than just birds.

Today's task: Borrow this idea and adapt it to your own world. What should you list? Try these ideas on for size, or come up with your own unique ideas for what defines a life list:

• Keep track of all the books you've ever read.

• Make a list of all the places you've ever visited.

• Take notes on all the different craft materials you've tried.

• Make note of all your favorite movies.

• Keep a list of all the historic places or locations you've visited.

• Take notes on all the wildlife you've ever seen in the wild.

• Start a list of all the important or influential people in your life.

• Make a list of all the life lessons you have learned, when they happened, and the circumstances.

AFTER A FEW YEARS, the term "life list" takes on a new meaning, because the list becomes a chronicle not only of birds or wildlife or books or movies but also of your life—travels, interests, friends, even the weather can start to read like a novel, of sorts.

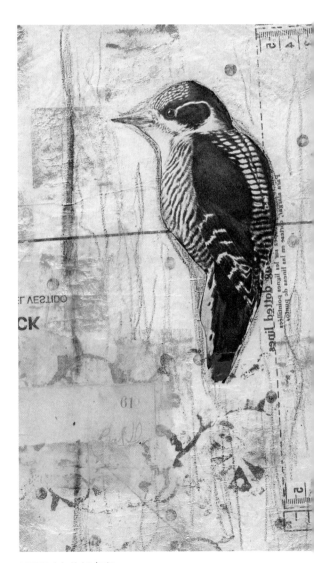

ARTIST / L. K. Ludwig

Art to Inspire: Antique Linens

WHO HASN'T SEEN THE PILES OF antique linens, tablecloths, and dresser scarves sitting at flea markets and yard sales? For many of us, these are wonderful starting points for new works of art—meshing old with new, building on something that's already beautiful, or just reinterpreting what someone else created.

Artist Sharon McCartney, for example, started with an antique cocktail napkin to create this mixed-media collage, titled *If the Seeds Are Allowed to Ripen*. To alter the napkins, she started by using fabric stiffener to create a more workable surface, then employed several of her favorite techniques—photocopy transfers, painting with watercolors, and hand stitching—to finish the piece.

AT A YARD SALE or flea market, be on the lookout for discarded linens, table runners, and the like. They may be building blocks for a new work of art, or they might just grace your table!

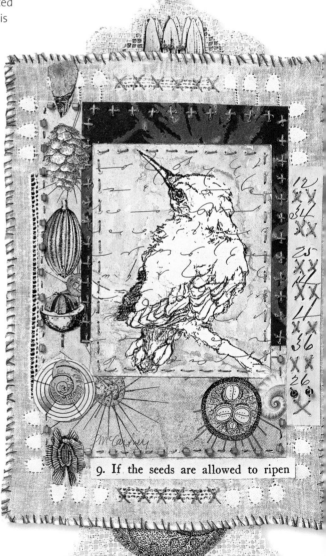

9. If the seeds are allowed to ripen

ARTIST / Sharon McCartney

270

Sharing Your Art Online

THANKS TO THE INTERNET—which connects millions of disparate individuals, and the wide popularity of digital photography, which can be used to quickly and easily capture electronic versions of your creations—a whole world of artists is out there sharing photos of their original artwork.

Many online photo management and sharing systems, for example, offer their users entry into groups, or artists who are linked by their common interest in such activities as quilting, scrapbooking, mixed-media, and the like.

Groups can either be public, invite only, or completely private, and every group has a pool for sharing photos and videos and a discussion board for talking. These are fantastic tools for inspiration:

• Talk to other artists about their favorite products, materials, and tools.

• View the work of other artists.

• Share your own work and receive feedback, critique, or advice.

• Connect with a community of people who share your passion.

• Share tips, techniques, advice, or ideas.

..

THE GREAT THING about online art or photo sharing is you can just look—it's fun to cruise around and see all the different artwork—or you can jump into the fray and start sharing your own creations.

Words to Inspire: *Know Thyself*

"When one is a stranger to oneself then one is estranged from others, too. If one is out of touch with oneself, then one cannot touch others. Only when one is connected to one's inner core is one connected to others, I am beginning to discover. And, for me, the core, the inner spring, can be refound through solitude . . . Certain springs are tapped only when we are alone. The artist knows he must be alone to create; the musician, to compose; the saint, to pray. But women need solitude in order to find again the true essence of themselves; the firm strand which will be the indispensable center of a whole web of human relationships."

—ANNE MORROW LINDBERGH,
Gift from the Sea

Art to Inspire: Feathers and Felt

THIS FELTED BAG BY CAROLE PRESBERG was created to memorialize Gremlin, a one-legged parrot that belonged to a friend. This friend of Carole's used to send her care packages with shed feathers enclosed, which she then matched to prefelt that had been dyed bright green. To finish the pouch she pulled out fibers, braided them into long strands, and added felt and glass beads.

To make felt beads, roll bits of wool or yarn into balls between your palms. Place them in a sock or hose, knot at the end, and toss the whole thing in the washing machine on the hot setting. Run the machine for one or two cycles. Remove the felt beads from the sock, reshape if necessary, then air dry.

SOMETIMES THE INSPIRATION for a new work of art starts with one tiny item—in this case, a beautiful green feather, found at the bottom of the birdcage.

272

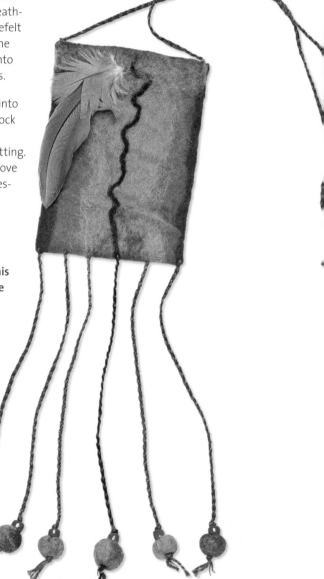

ARTIST / Carole Presberg

Listening to Other's Stories

EVERYONE HAS A STORY TO TELL. Some stories are more compelling than others—and that's why they end up on television or in magazines, newspapers, or even books—but the human experience is a rich source of inspiration on many different levels. No two people are exactly the same, and no two people experience their time on this planet the same way.

This weekend, talk to at least two artists about what inspires them. Beyond just talking to them, though, practice being an active listener. The goal is twofold: to gain new perspective on the creativity of others and to absorb as much information (and possibly creative energy) as possible.

Here are some ways to reach out:

1. If you're housebound, many artists are only a few keystrokes away via the Internet. Find artists you like, cruise around their website, then find the "contact us" link and send them an email. If you're out and about, try taking a class or visiting galleries, open studios, craft fairs, craft supply stores, or book signings.

2. Be prepared for your interaction with at least three or four questions. (No journalist goes into an interview without doing some background research and working up a list of questions, and neither should you.) Your questions may depend on what you'd like to know, but here are some ideas for how to get the conversation started:

• What is your personal favorite work of art and why?

• Where do you find inspiration for your work?

• What do you do when the idea well runs dry?

• Whose work do you admire most and why?

• What is your favorite material or tool and why?

• If you admire an artist's work, ask what inspired them.

3. Being an active listener means absorbing the words, perspective, and story of the people you're talking to without interruption or judgment. Although you may recognize common ground or shared experiences, it doesn't mean talking over them or derailing the natural flow of their thoughts. Remember, your goal is to deepen your well of information, not to tell your own story.

4. If the conversation stalls or dwindles, use either of these sets of magic words: "Tell me more" or "May I see your work?"

INSPIRATION may be as near as your next conversation, even if it's with a random stranger or someone you've just met. All you have to do is ask.

273

Exploring Metaphor

A METAPHOR IS A FIGURE OF SPEECH in which a specific word or phrase is used to suggest a similarity between two different objects or ideas. Metaphors are powerful tools for journaling and creative writing. They can add color, depth, and meaning to your writing or artwork, and they allow for interpretation. William Shakespeare was a master of metaphors, as seen in this snippet from Sonnet 18:

"Shall I compare thee to a summer's day?
 Thou art more lovely and more temperate."

Don't confuse metaphor with a simile, which is a comparison using "like" or "as." Here's an example of both:

Simile: Her face was as pale as the moon.

Metaphor: Her face is the moon, lighting up the darkened room.

..

METAPHOR IS a well that never goes dry ... once you've decided to tap it. See page 274 for more on creating artwork from a metaphor.

Today's task: Create your own metaphors for use in you artwork. Choose one concrete object, idea, or phrase, then pair it with a figurative object, idea, or phrase. Use these prompts as a starting point:

- My heart is a _____
 (flower garden, glass vase, etc.)

- My smile is a _____
 (flash of lightning, cool breeze, etc.)

- Life with you is a _____
 (sunny day, stormy sea, etc.)

- Those memories are _____
 (raindrops, musical notes, etc.)

- Your face is a _____
 (thunderhead, lit firecracker, etc.)

- She thinks love is _____
 (frozen ice, gooey syrup, etc.)

- Our home is a _____
 (sanctuary, prison, etc.)

- The day was a _____
 (never ending nightmare, carnival of delights, etc.)

Words to Inspire: *Express What's Inside*

"As an artist, what's important is to express what's
inside of you. Don't worry about it being good
enough; just do what your heart tells you. Play
and don't get stressed out."

—SARAH FISHBURN,
mixed-media artist

Crocheting with Nontraditional Materials

WHY NOT TAKE YOUR crochet repertoire beyond the standard-issue yarn? Consider these nontraditional materials the next time you pick up your crochet hook:

IF YOU CAN imagine it, you can knit or crochet with it—and wrap it around a needle or hook.

275

• Wire

• Shoelaces

• Cord

• String

• Leather lacing

• Fishing line

• Ribbon

• Novelty yarns

• Strips of fabric (cut or torn)

Crocheted wire bracelet

ARTIST / Lisa Weber,
Crystal Woman Jewelry

My Life As . . .

WHAT IS YOUR LIFE LIKE? A dresser full of drawers, some larger than others? A collection of poetry, images, or clip art? A mobile with many parts or a book with many chapters? A house with indoor and outdoor rooms? A climate map of different temperatures, growing seasons, or weather zones? A garden with flowers and stones, sun and shade, or weeds and dirt?

Create an artistic representation of your life. Artist Dorit Elisha, for example, used the analogy of a bustling circus to represent her busy lifestyle and her multiple roles as mother, wife, friend, artist, and teacher.

Her "canvas self," constructed from a photocopy of one of her original screen prints with collaged arms, juggles five ball-shaped collages representing the various roles she plays. Circus clowns, jugglers, and tandem-bike riders complete and unify the theme.

...

FINDING A metaphor for your life can be a rich creative exercise on its own (see page 274), as can re-creating that metaphor artistically. If you struggle with this exercise, start with a physical object—spice rack, collection of miniature books, and so on—and move outward from there.

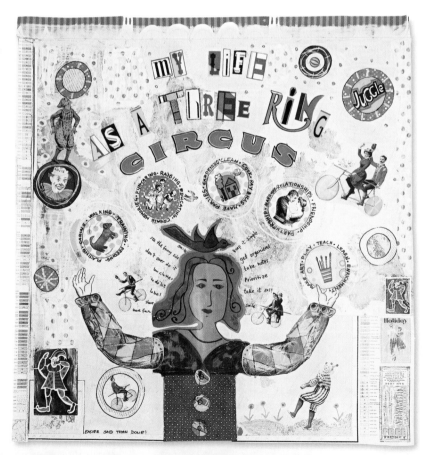

ARTIST / Dorit Elisha

The Colors of Nature

THE NATURAL WORLD IS A never-ending inspiration for color, as shown in this handspun yarn.

Consider the natural color combinations that are found outdoors: green leaves next to brown bark; soft gray sand next to the blue-green ocean; the dark, ominous color of thunderheads lit up by a bolt of lightning; or white clouds against a stunning blue sky.

MOTHER NATURE'S palette is an endless source of color inspiration. Use your sketchbook or camera to capture colors, textures, or changes in the world around you for the next time you need a fresh palette.

The hand-dyed, hand-carded wool yarn shown below, was inspired by the texture found in the brush surrounding a desert dune (left).

ARTIST / Lexi Boeger

277

Crochet 101, Part II

IF YOU'VE MASTERED THE basic chain stitch on pages 256–257, and you're ready to move onto an actual project, this is the place for you.

Making a slip stitch (abbreviated *sl st*)
This is the most basic of crochet stitches—some of the earliest crochet work found was done in continuous slip stitch. It's made by simply drawing the yarn through the work and the loop on the hook at the same time. It's commonly used to join a row into a round and for joining seams.

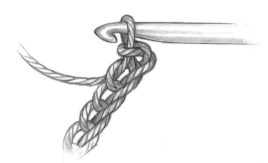

Draw the yarn through the two loops now on the hook, making a slip stitch. To continue working slip stitch, insert the hook into the next and each chain, and repeat these two steps as required.

Single crochet (abbreviated sc)

Make a foundation chain. Skip two chains and insert the hook under the top loop of the 3rd chain.

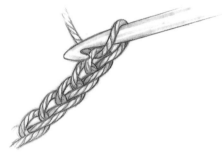

Make a length of evenly worked foundation chain (abbreviated ch).

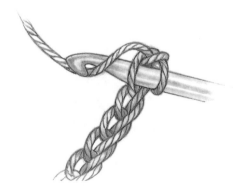

Insert the hook from front to back under the top of the second chain from the hook. Wrap the yarn around the hook to make a yarn-over (abbreviated yo).

278

Yo and draw it through the ch loop only.

To make next and following rows of sc, turn and work 1 ch. This is called the turning chain (abbreviated t-ch) and counts as first sc in a new row. Skip the first stitch (abbreviated st), at base of t-ch, work 1 sc into top 2 loops of 2nd st in previous row. Work 1 sc into next and each st to end, including top of t-ch.

..

There are two loops on the hook. Yo and draw the yarn through both loops to make a single crochet stitch.

THESE ARE just two of the basic stitches used in crochet. For more stitches and projects, consult a basic crochet book such as *Ready Set Crochet*.

Continue working sc into the next and all the following chs to the end of the row.

Building a Visual Journal

FOR SOME OF US, writing every day is simply too hard—either because the day's hours run out, the words don't flow, or other things get in the way.

This week, consider approaching the task of documenting your life, feelings, and thoughts by setting a new goal: Create one "feelings" collage per week for a year. At the end of the year, you can bind the collages together to create a visual journal. This can be especially effective if you're going through a difficult time, such as transitioning out of a relationship, battling an illness, or confronting numerous changes in your world.

One of the easiest ways to make your collages is to use old magazines and catalogs. Decide on the format for your pages; this can be as simple as buying a stack of 8-inch (20.3 cm) square scrapbook papers and building each collage on a different sheet.

Set some ground rules before you get started: Does the collage have to be created on the same day each week? Does it all have to be completed in one week, or can it be a work in progress (as long as its done by the end of the week)? Will you use any material you want, or limit it to just torn magazine pages and glue? Will the pages contain words or space for journaling, or are these only visual entries? Consider adding notes on the back to record significant events, feelings, happenings, and the like, and make sure you date each collage. Collage can also use fabric or be expressed as ATCs.

..

BUILDING A JOURNAL one week at a time lessens the pressure of producing "something" every day, but don't let a week go by without somehow translating your feelings and emotions into a visual record of your life.

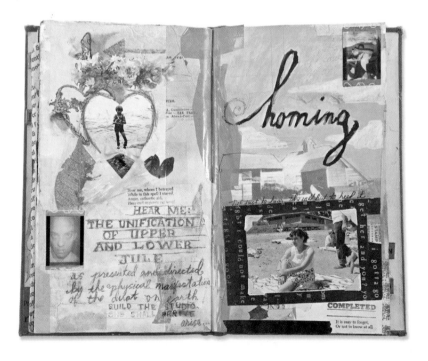

Borrowing Techniques from Others

As CREATIVE TYPES, we're familiar with borrowing techniques from various disciplines, whether it's adding stitching to a paper collage with a sewing machine or slicing paper with a craft knife and cutting mat that graphic designers use to create mockups.

Today, consider experimenting with this technique from my sweetheart, Matthew Juros, an architect.

While attending graduate school, Matt learned a model-making technique that embeds meaning and information with text. In architecture, massing models are used to study form, volume, void, and the interplay of light and shadow. As such, they are most effective if their surfaces are uniform, meaning they lack finer-grain architectural detail. While Matt was at Rice University in the early 1990s, prominent architect Daniel Libeskind published the massing models for his Jewish Museum project in Berlin. Many of the issues these models explored were informed by historical events and the legacy of the site. To convey this information, the designers cut pieces of printed text that describe salient information

into strips and affixed them to the surface of the model forms. At a glance, the surfaces have a felted, grainy appearance. When looking closer, one can read the information embedded in the models.

Nearly twenty years later, Matt made me a birthday present using the same technique: a small wooden box covered with strips of the text of our many emails. By printing his words in one font and mine in another, the lines of text read like sound bites in the voice of the speaker. The surface is a composition of poignant phrases and heartfelt hopes woven together. In some instances simple phrases are revealed, while in others full sentences run around the entire box, encouraging the reader to pick it up and turn it.

The box is like our relationship: a woven fabric of hopes, intentions, and memories bounding the rarified ether of "us." That "us" isn't really a physical thing—it has no substance—but is incredibly special and very real.

Quick Paper Embellishment

WHY PURCHASE MORE STICKERS, additional add-ons, or tiny bits of paper when you have plenty of tiny bits of paper in your stash? Cut your own designs—flowers, icons, medallions, or stand-alone images—from decorative paper, scrapbook paper, or gift wrap. If the paper is delicate, affix the design to a slighter heavier paper stock, and then cut it out using scissors or a craft knife.

To dress up the cut images, use chalk, ink the edges, add stitching, or embellish with brads.

THINK RESOURCEFULLY: Dip into your stash of scrap materials instead of buying prepackaged supplies. What are some other techniques for using up leftover scraps of decorative materials?

Blue Angel

ARTIST KATHY BUCKLEY created this shrine, titled *Blue Angel*, to honor the memory of her father, Daniel E. Buckley, who died in 2005. Here she recounts the story of how the shrine came together.

Story: My Father's Shrine

After my father's death, the sad task of sorting through and cleaning out his belongings inspired me to create a personal shrine dedicated to him. I knew I couldn't part with many of the small, familiar tokens that he carried with him or saved in his dresser drawer or collected in his garage— these objects are little reminders of my dad's everyday life.

The cigar box is painted blue, his favorite color. On both sides of the door is a copy of a photo taken when he was a young marine. On top of the box is a little angel that was part of a funeral flower arrangement sent by one of his old friends. Inside is a favorite photo of me and my dad in our yard. It seems so idyllic. Such a handsome young dad and cute chubby me and really, really green grass. The grass in our yard never looked so good with four kids trampling and digging in it every day.

The picture of a car engine is glued on the inside back panel. It is the same engine of a car my dad bought me so that I would return to New York after threatening to stay in Arizona to live with my brother in 1982. We spent many hours in the garage looking at and working on that old Volkswagen engine. Over the engine always hung a work light and so one hangs in the shrine, not only as a reminder of time spent together but also as a symbol of hope in the dark. The light is connected to a battery and is wired to a toggle switch. My father was famous for his mechanical knowledge and inventive ideas. He was constantly fixing or making something in his garage.

On the floor of the shrine is a level. My father was a stickler for making things perfectly level to the point of exasperation. Hung on a hook is a medal of Mary that is also illuminated by the little work light. My father was a devout Catholic and always wore a religious medal.

Also, in the shrine is a badge from Ford Motor Company where my dad worked for thirty years. Every day for thirty years he would have had to present his badge with ID number to get into the building. He was as fiercely loyal to Ford as he was to his family. He never drove anything but a Ford and that's why it is incredible that he bought me a Volkswagen. I believe he must have been desperate for me to come home.

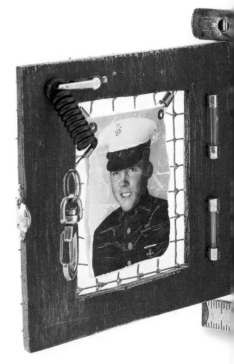

Fashion Colors

FASHION MAGAZINES (as well as boutiques and retail stores) are an endless source of color inspiration.

Want to know the hottest colors and combinations? Pick up a few of the latest fashion magazines and try this exercise. Squint your eyes and intentionally blur your vision as you flip through the pages. Ask yourself these questions:

• What colors pop up over and over again?

• What colors don't you see?

• What's your general impression of the color schemes? Dark and earthy? Bright and cheery?

• What colors are often matched together?

..

YOU CAN ALSO USE this technique with clothing catalogs or by visiting retail stores and boutiques. What's hot in fashion often extends to the world of design as well, so don't forget to consult design magazines or home furnishing catalogs or visit furniture or home decorating stores.

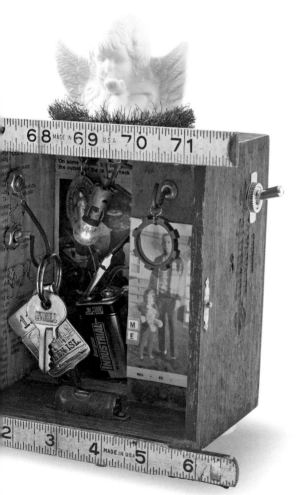

Basic Jewelry-Making Techniques, Part I

Many pieces of jewelry can be made using just a handful of basic techniques. You can purchase basic jewelry findings, but it's also easy to make your own findings, using wire and these simple instructions. (Once you've mastered findings, consult Part II, page 298–299, for additional jewelry-making techniques.)

MATERIALS
WIRE, ROUND-NOSE PLIERS, WIRE CUTTERS, FLAT-NOSE PLIERS, A JEWELER'S FILE, AND A WOODEN DOWEL OR PENCIL.

Basic Ear Hooks
Start with a 3 ½-inch (8.75 cm) -long piece of wire.

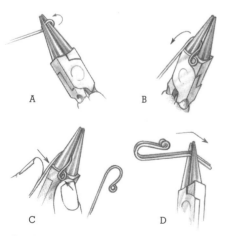

A B

C D

Cut the wire in half to yield two equal pieces measuring 1 ¾ inches (4.5 cm) long. File the ends. Create a small loop on one end, using the round-nose pliers (A). Repeat this on the second piece. Next, hold both pieces of wire together so the loops are aligned.

Grasp the straight part of your wires approximately ¼ inch (0.63 cm) past the loops with the thickest part of your pliers, and use your fingers to bend both wires 180 degrees around the nose (B). Using your pliers, position the largest part of the nose inside the bend area, approximately ¼ inch (0.63 cm) from the curl, The pliers' nose should point up, and the wire curl should be positioned horizontally toward you. Gently squeeze the curl and flat part of the ear hook toward each other about 5 degrees (C). Hold both ear hooks side by side, measure about ¼ inch (0.63 cm) away from the ends, and use the middle area on the pliers to slightly bend the ends of both wires about 25 degrees at the same time (D).

Basic Jump Ring
Jump rings are just simple wire circles but can be used several different ways when making jewelry. This technique starts with a 6-inch (15 cm) -long piece of wire.

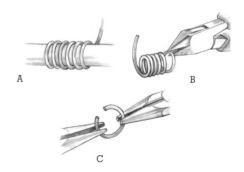

A B

C

Begin by using your fingers to wrap the wire around the dowel or pencil (A). Slide the wire off the dowel to make a coil of wire (B). Use a pair of wire cutters to cut each coil into a ring (C), then file the ends of the jump ring smooth so they can fit together.

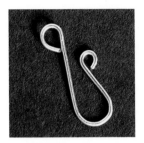

Basic Hook
Start with a 1½-inch (3.75 cm) -long piece of wire. If you have trouble with the technique outlined here, try starting with a 6-inch (15 cm) -long piece of wire.

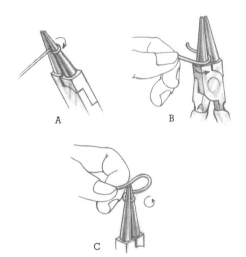

A

B

C

File the ends of the wire. Use the round-nose pliers to make a loop or curl on one end (A). Measure approximately V inch (1.25 cm) from the end of the curl, then grasp the wire with the round-nose pliers using the middle section of the pliers' nose. Holding your pliers with one hand, use the other hand to wrap the wire around the nose of the pliers to create a hook shape (B). Create a tiny curl on the end of the hook you created in the previous step (C).

Basic Eye
To make this figure-eight shaped design, start with a 1½-inch (3.75 mm) -long piece of wire.

File the ends of the wire until smooth. Use the round-nose pliers to make a large loop on one end of the wire. Repeat to form a second loop, but form the loop facing in the other direction.

MASTER THESE four basic jewelry-making techniques and you're halfway to making your own jewelry creations. Consult the basic connecting techniques on page 298–299 to complete your lesson!

Clever Fabric Journals

ANYTHING THAT'S FLAT but with structure—from vintage napkins, old gloves, and socks to quilting blocks, scraps of a fleece blanket, or cut-up, hemmed sections of clothing—can be bound together at one side with stitching to create a truly unique fabric journal.

Imagine, for example, whip stitching six vintage napkins together at one side to create a soft journal. These pages could be inserted into a contrasting journal cover, such as one made from wood or metal, or left on their own. A set of five gloves could be hand stitched together at one corner of the cuff for a loose journal, or suspended individually from a laundry line to create a linear journal.

The legs from an old pair of jeans can be cut into 5-inch (12.7 cm) square blocks to make pages; fashion a cover from the area on the seat that includes the back pocket, then machine stitch all the pages together at one edge.

...

JOURNAL PAGES needn't be run-of-the-mill or predictable—the ability to see how things can be used in other ways is a useful—and creative—skill.

Scavenging Responsibly

IF YOU LIKE TO COLLECT natural items such as feathers, twigs, shells, small rocks, or flowers for your artwork, make sure you do so responsibly. Collect bark and twigs from the ground rather than living trees, and pick flowers only where they grow in abundance (and never in a nature preserve). It's far better to grow your own flowers, buy them fresh at a florist, or invest in artificial or dried flowers than to risk picking an endangered plant.

IT MAY SEEM as though the natural world is ours for the taking, but always gather responsibly. When collecting materials, do not trespass on private property, and be sure to respect the privacy of others.

Transforming Your Photos

A PHOTO IS NO LONGER just a 4 x 6-inch (10.2 x 15.2 cm) image that you put in a frame—thanks to the evolution of digital photography, it's possible to transfer your electronic image to any number of surfaces, from T-shirts, bags, aprons, ties, mugs, and hats, to stickers, coasters, postage stamps, magnets, and even skateboards!

This week, consider what other form your photos can take, and how that might inspire new creative directions. One year, I made several sets of coasters from four different photos of flowers, but that's just one idea—you can use your photos to create custom books, decorate a set of mugs, or create unique and special clothing for friends and family.

...

YOUR OWN photos needn't just fill a frame—use them to create your own customized objects and decorative items.

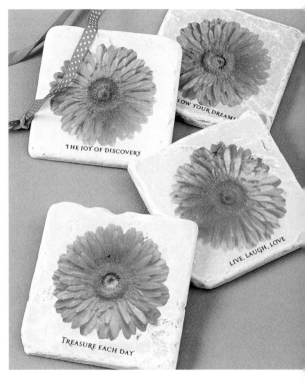

ARTIST / Michelle Hill

Holiday Traditions

THIS YEAR, CONSIDER ADDING a craft activity to the list of traditions surrounding your favorite holiday. This could involve fashioning a home-made book to commemorate holidays past, decorating your own holiday cards, or fashioning decorative packaging or wrap for gifts and cards.

Also, consider incorporating holiday icons that resonate with you (Christmas trees, holly, wreaths, dreidels, a menorah) in different media, from beads and fabric to paper, natural materials, or wood.

...

USE ANY holiday season to create new traditions of creative activities that you can treasure and enjoy for years.

Words to Inspire: *Your Hands*

"Often the hands will solve a mystery that the intellect
has struggled with in vain."

—CARL JUNG (1875–1961),
Swiss psychiatrist

Exploring Fabric Collage 101

THIS WEEKEND'S ENTRY introduces you to the basics of fabric collage.

What fabric should I use?
The best choice for beginners is a firmly woven cotton, such as broadcloth or muslin. But be sure to explore the endless assortment of fabric available, including:

- Sheer organza or netting
- Chenille (woven from plush yarns)
- Drapery velvets
- Damask (dense fabric with patterns woven in)
- Open-weave cottons
- Moirés (fabric with a rippled watermark finish)
- Lace yardage
- Raw silk
- Terry cloth
- Linen
- Corduroy
- Taffeta (shiny fabric)

- Chintz (decorator fabric; cotton finished with sizing)
- Tapestry (dense fabric used in upholstery; often woven with pictorial designs)
- Hand-decorated fabrics (e.g, batik, tie-dye)
- Utilitarian fabric (e.g., burlap bag, hair net, dishcloth, nylon stockings or tights, quilt batting, vinyl cutouts, canvas)

Where can I find fabric?
In addition to the local fabric or craft store, consider secondhand stores, yard sales, or even your own closet. Cut apart clothing, doilies, embroidered handkerchiefs, neckties, banners, table linens, and more for materials.

What tools do I need?
Find a few pairs of sharp scissors, including a small pair for trimming threads and cutting delicate fabrics, and a large pair for cutting thicker pieces of fabric. You'll also need an iron (unless you select wrinkled fabric on purpose) as well as a supply of needles, threads in several colors, sewing pins, a linen tape measure, a ruler, and tracing paper.

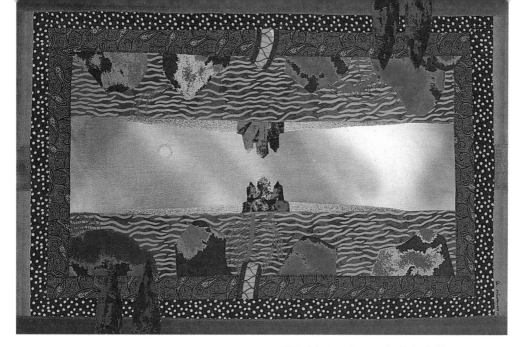

This fabric collage, titled Icbal's Vision, *uses an eclectic assortment of fabrics.*

ARTIST / Clara Wainwright

How do I develop a design?

Start out with your own sketch or reproduce a found image. Chose fabrics that correspond to the image's colors, shapes, or textures, such as blue velvet or velour for water, shiny blue satin for the sky, and so on. Next, cut out the individual shapes, using templates or working freehand. If you need to finish the edges of your fabric pieces, your choices include hemming, binding, or topstitching; torn, cut, or unfinished fabric edges create a different look. If desired, embellish your fabric pieces with fabric paint, embroidery, beads, stitching, and the like.

How do I assemble the work?

Fabric can be attached one of two ways: using glue or sewing. If you choose sewing, you can use a machine or make stitches by hand; machine-stitched zigzag stitches, for example, can connect disparate pieces while also providing a neat edge. Give some thought to the order of how you assemble the pieces; larger background pieces should be stitched in place first, and smaller pieces or details applied later or by hand.

What about finishing the collage?

After all the pieces have been secured, add the finishing touches, such as topstitching, quilting, beading, binding, or the like. You may also want to add a border or backing to your design, depending on the look and feel you want, how it's going to be displayed, and so on.

FABRIC COLLAGE offers a whole new world of materials, colors, and textures to work with. If you're an experienced paper collage artist, try incorporating pieces of fabric into your work; if you're an accomplished sewer, try moving away from patterns and strict instructions and let your inner artist speak.

Words to Inspire:
Write It Down While It's Fresh

"Every composer knows the anguish and despair occasioned by forgetting ideas which one had no time to write down."

—HECTOR BERLIOZ (1803-1869),
French composer and critic

Beyond Simple Closure

LIKE BUTTONS, HOUSEHOLD items such as safety pins, paper clips, rubber bands, and other common items have uses beyond the everyday. At the most practical level, they serve as closures, but today's exercise is a simple one: Take a moment and step away from the standard viewpoint.

Safety pins can be strung with beads and charms and used to embellish fabric journals or clothing; alternatively, they can be used to connect broken sections of jewelry chain or odd sections of trim or fiber. In the same vein, why not string beads or charms onto colorful metal paper clips and twist them into fun and funky earrings?

Rubber bands can be woven or tied, and your stapler can be used to create decorative effects on paper or fabric. Even the good old bulldog clip can be decorated and used to bind pages together for a quick and inexpensive journal.

EVERYDAY household items can often take on new and interesting use, with just a small dose of imagination.

Paper-Aging Techniques

PAPER, UNLIKE WOOD or metal, often doesn't stand the test of time. Antique papers are usually very delicate, meaning they won't stand up to everyday use in creative projects. The good news, however, is you can make new paper appear old or aged.

- Coat heavy paper with plaster, bend it when dry to create cracks, then add a wash of paint.

- Spread modeling paste or spackling on paper and stamp textures or motifs into the wet surface.

- Paint gesso onto paper, let dry, then stain with liquid acrylics or inks.

- Add dry pigments to clear polishing wax and rub it onto painted papers.

- Tear, sand, or peel papers after they've been glued in place.

- Brush varnish or crackle glazes over painted paper or images.

- Crumple paper and spray it with diluted paint to emphasize the wrinkles.

..

AGING PAPER techniques defies time and its effect on paper. Use aged paper to evoke a sense of the past.

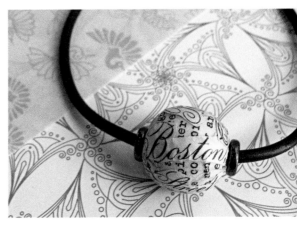

ARTIST / Jenn Mason

Aged paper can be used in a variety of ways. Artist Jenn Mason made the single-bead necklace shown above by wrapping vintage paper around a wooden bead, then coating the entire bead with gloss gel. Aged paper can also be charred, as shown at left, for an additional time-worn effect.

ARTIST / Julia Andrus

The Ebb and Flow of Inspiration

COLLAGE ARTIST Ann Baldwin offers the following suggestions for refreshing the creative flow:

- **Work on more than one project at a time:** Do more than one collage [or piece of work] at the same time. Decide that one is "real" and the other is just messing around. This relieves some of the pressure of getting it right—and you'll be surprised how often the play collage turns out well.

- **Don't fight with unresolved artwork:** If you become stumped, run an errand, have lunch, and return to your work with fresh eyes. I place my problem paintings in odd corners of the house, where I come across them unexpectedly. In that split second I can view them objectively and often see what needs fixing.

ARE YOU a single-project crafter? Try working on two, three, or even four things at once. Do you find yourself wanting to finish your artwork in one sitting? Try working on something for days, weeks, or even months. Sometimes, just altering your approach very slightly can open up new possibilities.

Artist Ann Baldwin created this collage, titled The Way We Were, *using photos, corrugated cardboard, layered paint, and paper with handwritten text.*

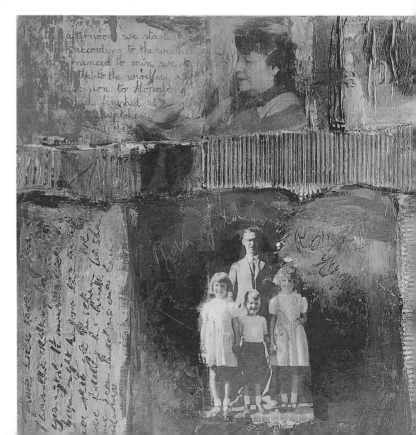

Filling the Well

Today's concept, borrowed from *The Artist's Way* by Julia Cameron, is called "filling the well." The inner well is the source from which we draw when we create.

She writes, "This inner well, an artistic reservoir, is ideally like an well stocked trout pond. We've got big fish, little fish, fat fish, skinny fish—an abundance of artistic fish to fry. As artists, we must realize that we have to maintain this artistic ecosystem."

We all need to replenish this well (nurturing the ecosystem, allowing it to flourish) to keep the stock level high. Here's how:

- Keep a supply of articles, clippings, photo graphs, postcards, or other images on hand that speak to you; flipping through these can stimulate your creativity.

- Be delighted—seek out the creative activities that intrigue you, and play with the materials that interest you.

- Any regular, repetitive actions—chopping vegetables, needlework, swimming, scrubbing—are activities that can move you from the logical side of the brain to the creative side, she says.

- Experience life firsthand. Instead of reading a book while waiting for the dentist, for example, tune into the sights and sounds all around you, each of which can elicit im ages, thoughts, or feelings that help replen ish the well.

- Ask other artists how they replenish their well. What are their tried and true ways of letting the water level rise?

...

IF YOU REFILL the well all along the way, you're less likely to run dry, or hit a spot that's devoid of creative inspiration.

Exploring Form

Artist Maryjean Viano Crowe tells the story of the inspiration behind this series of narrative dresses.

Story: Narrative Dresses

I kayak in a skirt, and have walked to work in vintage 1950s dresses and red high tops. I am hopelessly in love with, although conflicted about, fashion. Despite this, clothing, often the bridal gown and veil, has figured prominently in much of my work for more than ten years. For me clothing is a potent vehicle to convey ideas about the spirit and matter, ritual and transformation.

In *The Language of Clothing*, rather than using traditionally sized paper, I have fashioned paper dresses after one of my own. The inspiration for this work was derived from fascinating stories I discovered in the anthology Women's Indian Captivity Narratives, first- and secondhand accounts ranging from the 1500s to the late 1800s.

As white settlers moved westward, Native Americans, endlessly exploited, deceived and marginalized by the local and federal government, retaliated to survive. White women and children were sometimes kidnapped to be used as hostages or slaves; or in some tribes, taken as replacements for beloved family members who had perished in earlier battles.

In this series I use the dress form, rather than a traditional rectangle or square, as the vehicle to explore, albeit obliquely, women's stories. Patterned after a sundress of my own, the simple A-line form adds a feminine element to the lives I've imagined. Clothing is a language we employ daily to speak about ourselves, our culture, values and more.

By inscribing image, text and narrative on these garments, like tattoos, I hope the work will be seen as more than literal translations, or simply decorative outfits. Within these dresses, history, both historical and personal, coalesce.

The accounts of the women I represent are part of our nation's conflicts, and of our collective histories. In cobbling together these dresses, cutting and pasting cultures and perspectives side by side, understanding and new meaning emerges. The truths of these stories are simultaneously simple and complex, transparent and layered, reshaped through the passage of time and in the retelling, much like memory itself.

..

SOMETIMES, the form we choose helps communicate the message we're trying to deliver. The next time you set out to create a new work, consider a form beyond what's standard or expected.

294

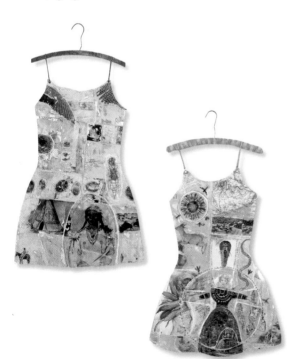

Transparent Journal Pages

TODAY'S TASK: Create journal pages from a material that adds meaning to the expression or theme. Make a fabric baby journal from cut or recycled clothing you wore as a child, or start a family album from altering your grandfather's college textbook.

To create the journal shown here, artist Maryjean Viano Crowe hand stitched private and personal items such as love letters and photos into see-through segments of shower curtain liners. "You can see them, but you can't get at them—the contents remain camouflaged and private," she says. To join the "pages" together, she used key holders threaded through the pre-formed holes in the liners.

···

IT'S ALWAYS NICE to start fresh. But next time, consider recycling treasured items and objects. Chances are, the end result will be more meaningful.

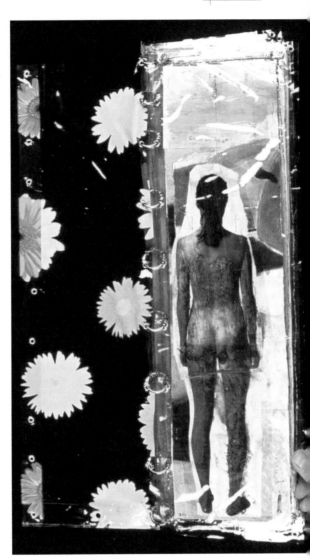

ARTIST / Maryjeane Viano Crowe

Recycled Textbooks

Do you have a stash of old textbooks collecting dust in your attic or closet? Consider riffling through these tomes to harvest evocative, naturally aged materials.

For starters, this will bring them out of the closet and into your everyday life. Second, and perhaps more important, the drawings, illustrations, notes, or even memories found in textbooks can transport you to past times and places.

Imagine transforming an elementary school workbook into a biography of your early years or turning a social studies textbook into a travel journal.

...

TEXTBOOKS needn't sit, unused, in a closet or attic. Bring them out and bring them to life, perhaps in a new form.

Adding Visual Texture

Tired of the same old tools in your toolbox? Look around your house for inspiration—in theory, almost any washable item can be used with acrylic paint to add visual texture to paper, wood, or fabric.

Consider these ideas for creating your own unique designs:

- For a batik effect, place the paper over a textured object and rub it with a wax crayon or oil pastel. Brush a wash of water-based paint over the rubbing.

- Stamp designs, using found objects such as a string-wrapped block, Bubble Wrap, doilies, fibers, or other items with texture.

- Use found objects as stencils to block out areas of paint, creating a negative shape.

- Make patterns and designs with kitchen tools such as whisks, cookie cutters, forks, and the like.

- Select several textural scraps of fabric, dip in paint, and dab a design onto your paper or wood.

- Pull out the spray bottle to alter your original designs even further.

...

CHANCES ARE, if you're creative you're also resourceful. The next time you need new tools, open the drawers, visit the basement, and look around your living space for items that can do double duty.

Emotional Cobwebs

EMOTIONS—BOTH HAPPY AND SAD—are one of the most powerful sources of inspiration for many artists. Who hasn't listened to a song chronicling a broken heart and known instinctively that the words, tune, or even the individual notes were inspired by real, raw emotion?

Many artists believe that finding an outlet for such strong feelings, whether in music, art, or writing, is critical to the healing process. Expressing those emotions can help you move beyond them to a new and clear place; giving voice to those feelings is often a critical step in letting them go.

IT'S HUMAN NATURE to move away from pain, but confronting such emotions and finding a way to channel them into artwork can often relieve the very feeling we want to move away from in a healthy and safe way.

Words to Inspire: *Trust*

IT'S A DIFFICULT CONCEPT for beginning artists to grasp: trusting their own creative voice, vision, or expression. Some new artists look for a set of instructions on how best to express themselves. But learning to trust what comes from your hands and heart is a powerful creative tool and a life skill that can be practiced and mastered.

JUDGING YOURSELF HARSHLY or trying to be perfect inhibits growth. Letting go, trusting the outcome, and believing in yourself is one route to creative empowerment.

"Trust that still, small voice that says, this might work and I'll try it."

—DIANE MARIECHILD,
author

Basic Jewelry-Making Techniques, Part II

ONCE YOU'VE LEARNED HOW TO make your own findings (see page 284–285), you can move on to learning the most common techniques for connecting the elements of your jewelry project.

MATERIALS

WIRE, HEADPIN, ROUND- AND FLAT-NOSE PLIERS, WIRE CUTTERS, JEWELER'S FILE, FOR THE CRIMPING TECHNIQUE, YOU'LL NEED TUBE-SHAPED CRIMP BEADS, BEADING WIRE, AND CRIMPING PLIERS.

Wrapped Loop

The wrapped loop technique is very useful for a variety of jewelry projects—you can use it to make earrings, add dangles to necklaces (or fabric projects), or finish off a clasp for a bracelet.

Start by using the flat- or round-nose pliers to bend the wire into a 90-degree angle to create an upside-down L shape.

Position the nose of the round-nose pliers in the bend that you created in the previous step.

Use your fingers to wrap the wire around the nose of the pliers to form a loop.

While keeping the round-nose pliers inside the loop, hold the loop against the pliers with one finger.

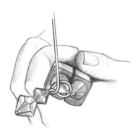

Use your other hand to start to wrap the loose wire around the straight piece of wire directly under the loop.

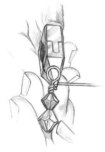

Continue to wrap as many times as you want. If necessary, trim off any excess wire with wire cutters and file the ends smooth.

Simple Loop

This is a simplified version of the wrapped loop technique; it's useful for making earrings, dangles, and pendants. You'll need a headpin for this technique.

Use the round-nose pliers to bend the headpin at a 90-degree angle. Trim the bent portion of the headpin to about ½ inch (1.3 mm) long. Position the bent part so it is facing away from you.

Using the round-nose pliers, grasp the end of the bent headpin and curl the wire slowly toward you.

Reposition the pliers as necessary and continue to curl the wire until you make a full circle.

...

PLAY WITH THESE basic jewelry-making techniques and you'll be surprised how easily your creations move from bead container to adorning your body!

Gratitude Journal

THIS WEEK, CONSIDER CREATING A Gratitude Journal, as pioneered by Sarah Ban Breathnach in her best-selling book, *Simple Abundance: A Daybook of Comfort and Joy.*

Creating a gratitude journal is simple, but it can have a powerful effect on your outlook on life. At the end of each day, list five things that you are grateful for or five positive events that happened to you that day. You can also list these things in a prayer, talk about them with your family, or add them to cards and letters.

The lesson is a powerful one: There is always something to be grateful for, even when times are hard, life gives us challenges, or things don't go exactly how we want. There are blessings everywhere if we take the time to stop and notice them. Focusing on the positives in our lives, and being grateful for the things we have (instead of lamenting what we don't), shifts you away from negative thinking. And emanating positive, happy energy often brings that same energy back to us in new ways. The more we appreciate life, the more life appreciates us.

AT THE END of the day, gratitude is the best reminder of our humanity.

"I have a beautiful blank book and each night before I go to bed, I write down five things that I can be grateful about that day. Some days my list will be filled with amazing things, most days just simple joys. Other days—rough ones—I might think that I don't have five things to be grateful for, so I'll write down my basics: my health, my husband and daughter, their health, my animals, my home, my friends, and the comfortable bed that I'm about to get into, as well as the fact that the day's over. That's okay."

—SARAH BAN BREATHNACH

ARTIST / Brenda Murray

Just take a moment.
Reflect and think.
Really think You

ABCDEFG

turn around

SHARE
THE IDEA

The Blue Velvet Album

Story: Lost and Found

I found the old photo album in an antique store, and at first my eyes moved right past it. I had zoomed in on a deck of playing cards, priced just right at a dollar. But then the blue velvet caught my eye, and I picked up the old album. I knew right then it was coming home with me.

My friends were curious—why had I bought the old book? Who was pictured in the sepia-toned photos, and what connection did I have with them? "None," I said. "I'm going to transform this into an altered book." Later, when we got home, we looked through the book, studied the photos, and hunted for clues. Tucked among the photos, most of them dated from the 1940s, were a few tidbits: a handwritten letter, an assortment of photos, and several mass or funeral cards (my funny friend Andrea calls these "Jesus trading cards"). All of these materials can be recycled and used in other projects, but what really intrigued me was the clasp on the album and the tattered blue velvet on the back cover.

What form will my adaptation take? How will I alter the book, fix the pages, and transform this into something uniquely mine? I'm still working on those questions, and still figuring out what direction to take with the blue velvet album. But I'm not worried about any of that—I've got the starting point, and that's all I need for now.

—BARBARA R. CALL

...

HUNTING FOR BARGAINS is a wonderful activity, whether you make a special trip to a large-scale antique show or just drop into a local thrift store. Be sure to look past the items on display, pick things up, and turn things over—and don't forget to bargain at the register.

Art to Inspire: A 3-D Family Tree

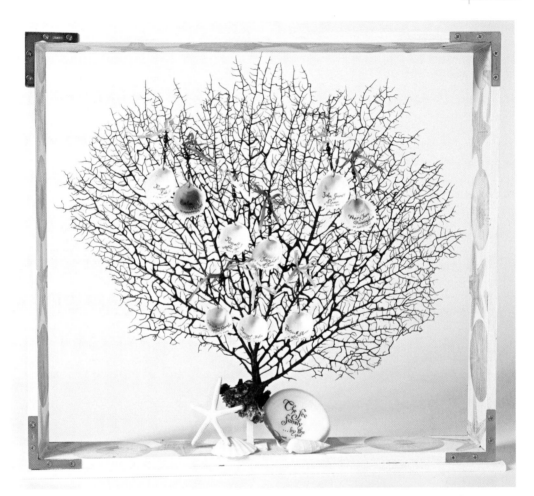

Sea fans are a type of coral that grows in the ocean, but here the plant is used to create the base for a three-dimensional family tree. Artist Jenn Mason hand lettered shells to hang from the "branches" using fishing snap swivels and silk ribbons, then encased the tree in a sturdy yet airy frame made from basswood. The ancestry of the family is written in poetic form along the edges and sides of the frame.

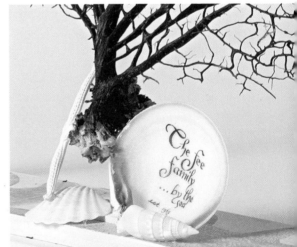

Artist Interview: Allison Strine

ALLISON STRINE is best known for her whimsical jewelry, soldered pendants, and prints. Here she fills us in on where she finds inspiration and the tools she can't live without.

Q: What do you make?

A: I make collages on thick art canvas, and then use the wonders of technology to transform the art into soldered pendants called LadyBirds (see page 188). I also make soldered pendants/charms/baubles/doodads out of vintage license plate letters and fabric.

Q: Where do you find inspiration?

A: From magazines and catalogs and sweet little birds—specifically, any magazine that has great colors and fonts. I also love sweet little birds from cool vintage books or even from new books—who knew there were so many kinds of chickadees, lovebirds, canaries, parrots, parakeets, and finches? I love them all, and they should all wear crowns!

Q: What is the one tool or material you can't live without?

A: Really, I have several. There are the basics that I need to ply my trade: soldering iron, Golden's fluid acrylics, acrylic medium, and my new favorite paintbrush (that changes every week because I always get them cruddy when I forget to wash them), and scissors, especially teeny-tiny scissors for cutting out around fingers and boots and wands and crowns. Then there are the things I need not for my art, but to be a happy artist: coffee, my dog, my iPhone, and my inspiration board.

Q: What do you do if you're ever fresh out of ideas?

A: Oh gosh, I'm out of fresh ideas all the time! When I am, I rummage around in my slightly disorganized bins looking for the pieces that I want to use *right now* in my collages. I might find arms that suit me, and build up a LadyBird around that, or a good set of striped tights from the Hanna Andersson catalog. Once I find them I just sort of wander through my bins piecing together the parts that are going to make a LadyBird. Sometimes I start with an idea first: Oh, I'm going to make an iPhone LadyBird, but sometimes I make a LadyBird first, and then figure out what she is saying. Either way, it starts with trolling through my bins (crowns, wings, things, birds, words, body parts are my best bins for finding great stuff.) Also, when I get magazines and catalogs in the mail, I cut out the good stuff and file it into the appropriate bin. Then later, when I'm actively creating a collage, I can easily rummage through and find just the perfect bit.

Q: Which artists do you admire?

A: I admire Rodney White because I love his layers and textures and colors. I also love Chris Roberts Antieau because she has lots of vowels in her name and because her work makes me swoon! My bestest inspiration (and I really do say *bestest*) comes from Elizabeth Beck, my closest art friend in the world. She inspires me and pushes me to be a better artist, and because we paint together every week, and her brushes never are as yucky as mine are!

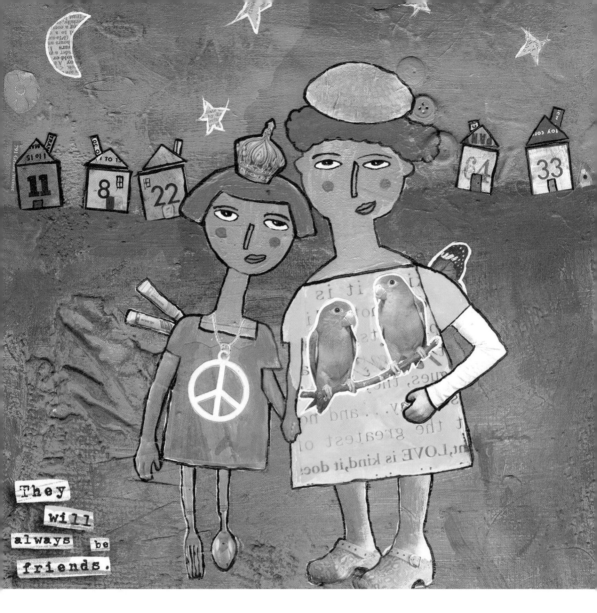

They will always be friends.

I highly recommend having an art partner, buddy, pal, compatriot; someone to work with, someone to sound ideas off, someone to help you do more than you might have done—and it doesn't hurt to have someone help you remember deadlines!

Q: What's your favorite medium?

A: I started my artistic journey with scrapbooking, then pottery, then paper arts and some quilting and fiber work. Now it's mostly collage. I'm sure there's a next thing, but I have no idea what it might be!

For more information about Allison, visit www.allisonstrine.com.

Your Colorful Heritage

WHERE DOES MIXED-MEDIA artist Kathy Cano-Murillo find inspiration? In her Mexican-American heritage and culture. Just one look at her unique Chicano folk art pieces and you can see how her style reflects the customs, colors, and historical figures of her heritage. The lamp shown here, for example, was inspired by Carmen Miranda, a Brazilian singer and dancer from the 1940s.

"No matter what aspect of Latino life lights your fire, there are ways to harness it for use as an expressive twenty-first-century art form," she says.

...

WHAT IS YOUR cultural heritage, and how can it inform your artwork? With a little bit of digging and historical research, you may find a treasure trove of new ideas.

This Latino-style lampshade was inspired by same woman who graces two of its panels: Carmen Miranda, a Brazilian icon perhaps best known for wearing fruit on her head. The artist recreated the fruit image on the remaining two panels of the shade, then accented the lamp with brightly colored beads and trims that reflect Carmen's campy, colorful style.

ARTIST / Kathy Cano-Murillo

Art to Inspire: Monthly Journal Pages

ARTIST KATHY VORENBERG created a series of 6 x 8-inch (15.2 x 20.3 cm) monthly pages, using birthstones and a variety of sources for inspiration. The August entry shown here, for example, was inspired by Shakespeare's *A Midsummer Night's Dream*:

> If we shadows have offended
> Think but this, and all is mended
> That you have but slumber'd here
> While these visions appear.

Kathy printed part of a painting by James C. Christensen onto canvas fabric with an inkjet printer, then added peridot (the birthstone for August) beads along the top border, and assorted peridot, topaz, and clear crystals along with seed beads. The largest glass piece is recycled from an antique earring.

For the November page, on the other hand, Kathy was inspired by the weather. "Fall arrives late and suddenly in southern New Mexico," she says. "On any given late November day, the air turns colder, the leaves drop all at once, and voilà! It's autumn." She used topaz crystal beads radiating from a molded sun face to represent the shortened daytime hours.

307

THESE BEADED JOURNAL pages resemble ATCs, but they're larger, and they relate to a monthly theme. Using beads and birthstones lets you express your inspiration, theme, or emotions using three-dimensional materials.

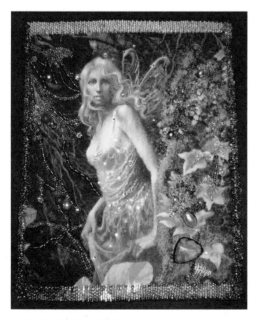

ARTIST / Kathy Vorenberg

Words to Inspire: *Creative Energy*

"Creative energy is a constant presence in our lives, but more often than not it gets drowned out by the urgency of day-to-day activity. [Artists] need to create a space for themselves that is free of interference, a space that allows them to hear their own intuition."

—PETRULA VRONTIKIS,
designer, educator, and author

ARTIST / Jane Wynn

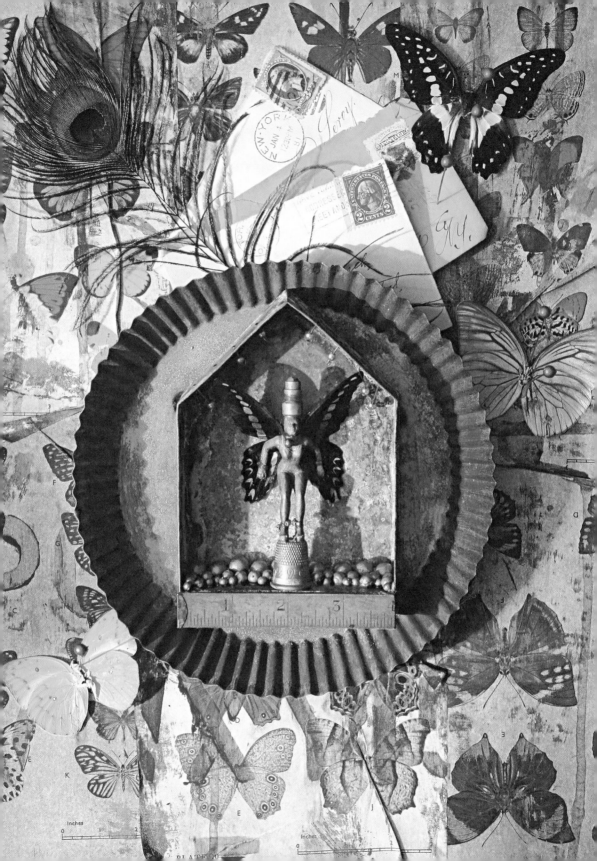

Index

Directory of Contributors

Julia Andrus
inspire@juliaandrus.com
www.juliaandrus.com
Page 204, 221, 246, 247, 291

Anne Bagby
annebagby@bellsouth.net
Page 165

Laura Bailey
Page 104

Ann Baldwin
art@annbaldwin.com
www.annbaldwin.com
Page 292

Elizabeth Beck
e.beck.artist@mac.com
Page 76, 184, 199, 249

Jenna Beegle
jbeegle@mindspring.com
Page 135

Jill Beninato
beninato@cox.net
www.sitstaysmile.com
Page 229

Linda Blinn
ljblinn@pacbell.net
Pages 28, 248

Lexi Boeger
pluckyfluff@hotmail.com
www.pluckyfluff.com
Page 277

Patricia Bolton
editorial@quiltingarts.com
www.quiltingartsllc.com
Page 139

Susan Bonthron
Page 214

Sherry Boram
Page 126

Melanie Borne
Page 120

Jan L. Boyd
jan@janboyd.com
www.janboyd.com
Page 33

Normajean Brevik
http://seasew.blogspot.com
Page 119

Adjowah Brodie
www.theweekendstore.com
Page 203

Kathleen Buckley
kbuck@nycap.rr.com
Page 282–283

Barbara R. Call
bbourassa@comcast.net
brcall@comcast.net
Pages 23, 40, 41, 52, 61, 73, 78, 97,
121, 140–141, 147, 161, 198, 199,
232, 262

Carolyne Mary Call
ccall@saintmarys.edu
Page 61

Kathy Cano-Murillo
kathy@craftychica.com
www.craftychica.com
Page 15, 130, 306

Ophelia Chong
ophelia@opheliachong.org
www.opheliachong.org
Page 240

Maura Cluthe
fragmented@earthlink.net
Page iv

Sas Colby
sas@sascolby.com
www.sascolby.com
Page 88

Juliana Coles
meandpete@msn.com
Page 232, 280

Maryjean Viano Crowe
mvcrowe@stonehill.edu
Page 238–239, 244–245, 294, 295

Jocelyn Curry
jocelyn.curry@gmail.com
www.jocelyncurry.com
Page 70

Dorothy Debosik
Page 112

Sandra Donabed
Page 156

Corrine D'Onofrio
Corinne_donofrio@msn.com
Page 24–25

Deborah Fay D'Onofrio
comebackhome@comcast.net
Page 16, 160, 228, 242

Andreia Cunha Martins
Page 197

Jenn Mason
jenn@jennmason.com
www.jennmason.com
Page 20, 44, 45, 91, 211, 212, 218,
219, 224–225, 262–263, 291, 303

Stephanie McAtee
stephmcatee@yahoo.com
http://stephmcatee.
typepad.com/her
Page 134

Sharon McCartney
lilypeek@aol.com
Page 250–251, 270

Lynn McLoughlin
lynnmcloughlin@comcast.net
http://passionart.us
Page 78, 105, 122

Karen Michel
karen@karenmichel.com
www.karenmichel.com
Pages 29, 57, 77, 89, 124, 149,
230, 231

Jeanne Minnix
jminnix@griffinassoc.com
Page 208

Teesha Moore
artgirl777@aol.com
www.teeshamoore.com
www.teeshacircus.blogspot.com
Page 177

Portia Munson
http://portiamunson.com
Page 147

Brenda Murray
bmurray@total.net
www.brendamurray.net
Page 300–301

Cynthia A. Oberg
Page 31

Linda and Opie O'Brien
gourdart@burntofferings.com
www.burntofferings.com
Page 220–221

Joy Osterland
Page 54

Elisabeth Perez
eperezoriginals@comcast.net
Pages 190–191, 213

Carole L. Presberg
shepdog@gis.net
www.ThistleWoolworks.com
Page 169, 180–181, 272

Mary Ann Richardson
Page 112

Wendy Richardson
Page 30

Lesley Riley
lrileyart@aol.com
www.lalasland.com
Page 172, 230, 231

Monica Riffe
monriffe@hotmail.com
Page 89, 158

Lori Roberts
Pages 74–75

Anne Sagor
sooie@tx.rr.com
Page 35, 48, 126

Sandra Salamony
sandanoel@aol.com
Page 36, 132, 210

Laura Santone
Shesha
www.shesha-recycling.
blogspot.com
laurashesh@hotmail.com
Page 197

Julie Scattaregia
scrappyscat@aol.com
Page 94

Allison Schubert
mdschubert@charter.net
Page 223

Judith Serebrin
serebrin@pacbell.net
Page 100

Patricia Smith
Page 169

Chrissy Grant Steenstra
cgsteenstra@comcast.net
Page 84

319

Acknowledgments

I'd like to say thanks to the many people over the years who have inspired (and nurtured) my creative output, in all its forms: my mom and dad, my sisters Carrie and Laurie, my children Alex and Jack, Marc, Deb, Kim, David, and Betsy. Thank you for always encouraging me to use my creative talents, harness the power of my imagination, and never stop reaching for the stars.

Special thanks to Rochelle Bourgault, who first developed the idea for this book, then turned to me to fill the pages. Without her expert editing skills and keen creative sense the book would only be half as good. Thanks, also, to Betsy Gammons for helping coordinate the artwork and spearhead the project, and to Winnie Prentiss for giving me a chance to write this book in the midst of many personal changes.

Thanks to all the various contributors who provided me with their ideas, musings, original artwork, and own sources of inspiration. My words alone might tell the story or capture the feeling, but your unique and amazing artwork brings the story to life, adds beauty and joy to the tale, and absolutely completes this book.

About the Author

Barbara R. Call (who also has written as Barbara Call Bourassa) is a professional freelance writer and editor specializing in crafts, food, and health and wellness. She is the author of five books, including *Beyond Scrapbooks: Using Your Scrapbook Supplies to Make Beautiful Cards, Gifts, Books, Journals, Home Decorations and More* (Quarry Crafts, 2006) and a four-book children's series called *Get Active!* (QED Publishing, 2008).

Her professional accomplishments include developing and launching several magazines, among them *Handcraft Illustrated*, *N magazine*, and *Wellness Every Day*; twenty-plus years of writing, editing, and management experience for book, Web, and magazine publishing companies; teaching magazine writing and editing at Emmanuel College in Boston; and operating her own writing and editing business, Wren Creative Services, LLC. She lives in North Andover, Massachusetts, with her two sons, Alex and Jack, and her dog, Cody.